BEYOND THE MAINSTREAM

CONTEMPORARY ARTISTS AND THEIR CRITICS

This series presents a broad range of writings on contemporary art by some of the most astute critics at work today. Combining the methods of art criticism and art history, their essays, published here in anthologized form, are at once scholarly and timely, analytic and evaluative, a record and critique of art events. Books in this series are on the "cutting edge" of thinking about contemporary art. Deliberately pluralistic in approach, the series represents a wide variety of approaches. Collectively, books published in this series will deal with the complexity of contemporary art from a wide perspective, in terms of both point of view and writing.

German Expressionist Painting, 1957

New Images of Man, 1959

The Work of Jean Dubuffet, 1962

Emil Nolde, 1963

Max Beckmann, 1964

Sam Francis, 1975

Art in Our Times, 1981

Art in a Turbulent Era, 1985

Chillida, 1986

Max Beckmann: The Self-Portraits, 1992

Theories and Documents of Contemporary Art, (with Kristine Stiles), 1996

Max Beckmann, 1996 (revised)

BEYOND THE MAINSTREAM

ESSAYS ON MODERN AND CONTEMPORARY ART

Peter Selz

University of California, Berkeley

PUBLISHED BY THE PRESS SYNDICATE OF THE UNIVERSITY OF CAMBRIDGE
The Pitt Building, Trumpington Street, Cambridge CB2 1RP, United Kingdom

CAMBRIDGE UNIVERSITY PRESS
The Edinburgh Building, Cambridge CB2 2RU, United Kingdom
40 West 20th Street, New York, NY 10011–4211, USA
10 Stamford Road, Oakleigh, Melbourne 3166, Australia

First published 1997

Printed in the United States of America

Typeset in Stone Serif and Gill Sans

Library of Congress Cataloging-in-Publication Data
Selz, Peter Howard, 1919–
Beyond the mainstream : essays on modern and contemporary art /
Peter Selz.
p. cm. – (Contemporary artists and their critics)
Includes index.
ISBN 0–521–55413–6 (hc). – ISBN 0–521–55624–4 (pbk.)
1. Modernism (Art) 2. Art, Modern – 20th century.
3. Postmodernism. I. Title. II. Series.
N6494.M64S43 1997
709'.04 – dc21 96–46613
 CIP

A catalog record for this book is available from the British Library.

ISBN 0 521 55413 6 hardback
ISBN 0 521 55624 4 paperback

CONTENTS

ILLUSTRATIONS

BEYOND THE MAINSTREAM

INTRODUCTION

The seemingly disparate essays in this volume, their subjects ranging from Ferdinand Hodler to Rupert Garcia and Bedri Baykam, are linked by their deviation from the aesthetic and critical concerns of mainstream art. I am writing this introduction at a time when many of my colleagues in the field of art history are uncomfortable with an agenda of genuine ethnic diversity that places this dominant mainstream itself in question. But in my work as a historian, teacher, critic, and curator, I have always questioned both the concept of universal values in art and related theories concerning a timeless visual language of significant form.

Long before the theories of deconstruction became current, I had dissented from hegemonic claims of a simple and verifiable mainstream in aesthetic affairs. I strongly believe that standards and values in art, as in mores, are culturally determined. Artists do not live or work in isolation and are hardly impervious to the social environment, contrary to what Formalist critics have maintained. The historian or critic must do more than analyze pure pictorial and aesthetic values. Form has meaning, but we must also investigate the meaning of form and be constantly aware of its historical, sociopolitical context.

Mainstream art has always held less interest for me than what might be called art's peripheral manifestations. In late eighteenth-century England, Sir Joshua Reynolds painted fine portraits of privilege – but how much more fascinating are Henry Fuseli's Nightmares, or William Blake's images based on biblical and classical texts. In late nineteenth-century France, the academic *pompiers* were still very much in the public eye and official purse. But the very canon that was established for modern art to legitimize Impressionism quickly entrenched it as the dominant and soon-to-be-popular mode. This left little room to account for simultaneous developments of Symbolism, which remained marginalized for some time. Yet its sense of subtlety and mystery and its search for expression and evocation of interior sensations seemed to me to be of equal importance. When I was asked, in 1962, during my tenure at the Museum of Modern Art, to organize an exhibition of nineteenth-century French art, my interest in the re-evaluation of Symbolism made me decide to show the work of Rodolphe Bresdin, Gustave

Moreau, and Odilon Redon, masters of this alternative tradition marginalized in its own time.[1]

A few years later, I felt that the Rodin retrospective, which I directed in 1963, needed to be succeeded by a show of Medardo Rosso's little known sculptures, works that are sensitive fusions of the palpable and the evanescent. Umberto Boccioni, speaking for the Futurists in 1912, had discerned that Rosso "is the only great modern sculptor who has attempted to widen the scope of sculpture by rendering plastically the effect of the environment upon the subject, as well as the ties that bind it to the surrounding atmosphere."[2] But soon after the Futurists took a brief interest in Rosso, the work of this precursor of modernist sculpture was passed over – no doubt because very few of his bronzes and waxes ever came on the market. Thus the Rosso exhibition, also of 1963, came as a minor revelation.[3]

Rosso's Swiss contemporary, Ferdinand Hodler, though highly esteemed in his lifetime and in his own country, was almost unknown in the United States until 1973, when I was able to present his work at Berkeley, Harvard, and the Guggenheim Museum. We exhibited his spirited renditions of Alpine landscapes, his large Symbolist canvases that affirm a cosmic harmony, and his incisive portraits of the living as well as his clinically ruthless images of the dying. It seems appropriate to begin this collection with excerpts from the catalogue published for the Hodler retrospective.[4]

In general I have preferred to study and advocate an art that evinces the conflicts of our era and affords insights into the tragic aspects of the human condition in a century characterized by societal turbulence and personal anguish. These components of modern life were by no means to be found in the mainstream of modernist painting and sculpture.

Personal history has great bearing on my bias which, in its questioning of entrenched authority, made me search for art that was marginalized. I arrived in the United States at age seventeen, a refugee from Germany, where my family had been engaged for several generations as art dealers of Renaissance and Baroque paintings, sculpture, and *objets d'art*. I grew up in a secular family in Munich; we were barely aware of being Jewish until the Nazis threatened to destroy our very existence.

Soon after arriving in New York in 1936, I discovered that I was distantly related to Alfred Stieglitz. I subsequently spent a good deal of time at An American Place, listening to the grand old man in the black cape, who combined the active and the contemplative in his thoughts and actions, both contentious and wise. He meditated aloud on the meaning of art and life. I was fortunate that he took an interest in me; from him I would learn a great deal about how to look at art. During that time I translated poems by Rainer Maria Rilke, a poet then relatively unknown in this country. I was overjoyed that Stieglitz encouraged me to publish some of them in *Twice a Year* (VIII–IX: 1942), a magazine subtitled, "Book of Literature, the Arts, and Civil Liberties" and edited by Dorothy Norman under the inspiration of Stieglitz. I was delighted to see my first published work along with that by writers such as Thomas Mann, André Malraux, and André Gide.

Stieglitz, in his own photography, in the work he exhibited, and in his verbal elucidation, conveyed his ideas of what it means to be an artist, especially an

artist in America, a country in which business, rather than arts and letters, is of central concern. The artists Stieglitz extolled and exhibited – Dove, Marin, O'Keeffe – were hardly in the mainstream in the 1930s, when Regionalism and perhaps Social Realism were the dominant trends. As Arthur G. Dove wrote: "there was an esthetic revolution going on and they didn't know it and Stieglitz knew it all the time."[5] And indeed, a painter such as Dove rather than Grant Wood knew better how to interpret the American landscape.

Many years later, in 1958, I was able to advance a new interest in the artists of the Stieglitz Circle by curating an exhibition of this name to inaugurate a new museum that I helped establish at Pomona College in California, where I had been teaching.

In the pre–World War II years in New York, I also met J. B. Neumann, who became another mentor. A remarkable and lovable individual, J. B. showed me contemporary art of my native country. He was convinced that Beckmann and Klee and Kirchner were truly great artists, and he loved talking about their work with personal knowledge and enthusiasm. In his gallery, J. B. also had paintings by El Greco, drawings by Blake, and woodcuts from the German Renaissance and *ukiyo-e* woodblocks from Japan, as well as African sculpture and contemporary American painting by Max Weber and Mark Rothko.

In the early 1940s I was drafted into the American army as an "enemy alien," becoming an American citizen while in the service. I served in the O.S.S. and subsequently studied at the University of Chicago on the GI Bill. When the time came to decide on a dissertation topic, I had little doubt that I should write about German Expressionist painting. In America little attention had been paid to German modernist art. The Armory Show had made Americans equate modern art with the School of Paris. In fact, both the Italian and Russian avant-garde were totally absent from the Armory, and modern German representation was limited to one painting each by Kandinsky and Kirchner, and one sculpture by Wilhelm Lehmbruck.

This situation was reflected and perpetuated in the art market. The Museum of Modern Art, to be sure, had a few fine pieces acquired by Alfred Barr under the tutelage of J. B. Neumann. The only other museum with a respectable collection of modern German art was the Detroit Institute of Arts: Dr. W. R. Valentiner, an earlier director, had come to Detroit from Berlin in the 1920s. A substantial collection of paintings by Kandinsky and Rudolf Bauer, acquired by the Baroness Hilla Rebay and displayed in sacrosanct halls to the music of Bach, was on view in Solomon R. Guggenheim's Museum of Non-objective Art. In California, Galka Scheyer still retained her own collection of paintings by Feininger, Kandinsky, Klee, and Jawlensky.

In Germany during the Nazi period, the Expressionists had been denounced as "degenerate," and their art was condemned by Hitler as "abortions of the brain." It may seem surprising, however, that during the early post–World War II years, little attention was given to the Expressionist heritage. But in the museums and galleries of the Federal Republic, the new abstraction was favored. Tachism from France and Abstract Expressionism from America seemed to embody the newly found artistic freedom. This free, gestural painting seemed more in keeping with Western models than the figurative painting and sculpture as-

sociated with the failed Wilhelmian empire and the ineffectual Weimar Republic. In East Germany, by contrast, Social Realism was the only accepted style during the early days of the German Democratic Republic; the leading Marxist theorist, György Lukács, argued that Expressionism, with its emphasis on the subjective and the irrational, was one of the tendencies that led to Fascism.

But it was precisely Expressionism's inner vision that fascinated me. I valued the passion for the personal, the affirmation of individuality in the face of both standardization and fragmentation of modern society. I admired the Expressionists' resistance to bourgeois conventionality, their Nietzschean "transvaluation of values." I was (and remain) engrossed by the paradox of profound pessimism and chiliastic optimism of the Expressionists and their art's demand for active participation by the engaged viewer. Locating in some depth one aspect of the culture of my native land also helped me in the establishment of my own cultural identity. In my work I related Expressionist art to its intellectual milieu, to simultaneous trends in philosophy, psychology, and the sciences, as well as the general ambiance of the period.

My dissertation of 1954 turned into my first book; it became the basic source for the study of German Expressionist art for several decades of scholars and also for some of my own later work. Most of the essays in Part I of this anthology are the result of my continued interest in Expressionism and modern German art. I remain preoccupied with the work of Max Beckmann, who is finally being recognized as one of the giants of twentieth-century art. Too precise in his rendering of the human figure to be called an Expressionist, too visionary in his paintings of dreams and premonitions to be considered a realist, he defies classification. Behind the veil of an arresting painterly beauty and the vigorous sexuality of some of Beckmann's images lies a deep anxiety and despair that responds to his own inner turmoil and the turbulence of his time. But they also reflect a firm belief in the "final release and absolution of all things, whether they please or torment"[6] and, like the novels by his contemporary Thomas Mann, his work is proof that "a work of art, even if it is one of despair, can ultimately only be interpreted as a belief in life."[7]

I have also included an unpublished paper, "Schoenberg and the Visual Arts." First delivered in 1974, it addresses Arnold Schoenberg's part in the intellectual and artistic life of Vienna and I also examined the simultaneous achievements of the composer and the painter Wassily Kandinsky. During the time that Schoenberg explored atonal music, Kandinsky discovered non-objective painting. A zeitgeist, it seems, caused the most radical innovations in music and art just prior to World War I.

"German Realism of the Twenties: The Artist as Social Critic," deals with the New Objectivity, the successor of Expressionism in Weimar Germany. After World War I, the inner-directed art of the Expressionists and their belief that art had the ability to transform both individuals and the community could no longer withstand the daily chaos of life. Artists such as George Grosz and Otto Dix made disturbing and at times grotesque pictures to assail the hypocrisy of the bourgeois establishment. This was a noteworthy episode in the history of modern art when, for a brief time, a close interweave between art and politics existed, and the socio-

economic situation acted as catalyst for the production of compelling works of political art.

This section also includes a report on the reconstruction of the Degenerate Art exhibition with which the Nazis defamed modern art in 1937– an exhibition that was recreated at the Los Angeles County Museum of Art in 1991. I am also presenting my Introduction to the catalogue of the exhibition of art from the German Democratic Republic. Mounted at the Busch-Reisinger Museum of Harvard University in 1989, the show, which we expected to be the initial survey of the art from East Germany, turned out also to be the last one from a country that ceased to exist that same year with the razing of the Berlin Wall. The work in the exhibition was related to the renewed interest in the human body, typical of the international Neo-Expressionist trends of the 1970s and 1980s, but was largely characterized by its emphasis on the communicative aspects which painting can provide and by an emphasis on public life as well as personal identity.

In 1949, while still a graduate student at the University of Chicago, I had begun to teach at the Institute of Design (ID), Moholy-Nagy's New Bauhaus. I was extremely fortunate in starting my teaching career at this seminal school, the nexus of new concepts and utopian visions in art and design. ID's program truly revolutionized old standards of art education. It emphasized experimentation, exploration of materials, and above all, a belief that the education of the artist and designer must not be a matter of narrow specialization, but should address the emotional and intellectual needs of the individual with the purpose of creating a better social order. The school also produced some of the finest photographers in America and brought about radical changes in graphic and industrial design. Although several books have been written about ID's sister school, Black Mountain College in North Carolina,[8] this essay is actually the first attempt at a brief history of an institution that has never been given the importance which is its due.

This essay on the new Bauhaus, "Modernism Comes to Chicago," is in Part II, "Atlantic Crossing." Again, perhaps because of my background, I have been very much aware of the currents that move between America and Europe. In 1993 I was invited to write "Americans Abroad" for the voluminous catalogue, *American Art of the 20th Century*, which accompanied the exhibition at the Royal Academy in London and at the Martin-Gropius Bau in Berlin. Here I comment on important contributions by artists from Marsden Hartley to Edward Kienholz, who worked mainly outside the United States.[9] Conversely, "The Impact from Abroad: Foreign Guests and Visitors" deals with artists from Europe and Mexico who had a significant effect on the art of the San Francisco Bay Area in the early years of an evolving modernism in California.

In 1958, when I was appointed Curator of the Department of Painting and Sculpture Exhibitions at the Museum of Modern Art, New York, I placed European and American artists together in the first exhibition I directed, *New Images of Man*. It comprised twenty-three painters and sculptors from the United States and Europe, and ranged from established artists such as Giacometti and Pollock to younger artists of scant renown, such as Leon Golub and Nathan Oliveira. At

that time I was aware of the Existential attitude toward the human predicament which had made itself felt across the oceans and generations in response to the anxiety and dread that pervaded the post-war period. I suggested that "the imagery of man which evolved from this [outlook] reveals sometimes a new dignity, sometimes despair, but always the uniqueness of man as he confronts his fate."[10] I asked the theologian and philosopher Paul Tillich to write a preface to the catalogue in which he stated: "These artists . . . fight desperately over the image of man and by producing shock and fascination in the observer, they communicate their own concern for threatened and struggling humanity."[11]

The exhibition included Pollock's late black and white figurations, which Frank O'Hara called the *Chants de Maldoror* of American art. The show compared de Kooning's fierce, shamelessly erotic women with Dubuffet's contemporaneous, brutish, graffiti-like *Corps de Dames*. Other rooms held Francis Bacon's unhinged popes and screaming figures and Giacometti's isolated, inviolate, and inaccessible men and women. Also present were Rico Lebrun's compelling tragic paintings of fragmentation and disfigurement depicting victims of the Holocaust as seen by an empathetic artist who fused the Baroque tradition of tragedy into a modernist idiom. Theodore Roszak's convulsive welded steel figures, the wild faces by Karel Appel, and H. C. Westermann's humanoid boxes, those perplexing and sardonic comments on human irrationality, beautifully crafted in wood, were also included.

New Images of Man produced much controversy. The fact that almost half of the artists were sculptors was highly unusual at the time. Clement Greenberg's advocacy of an art which was purely self-referential was then ascendant; an exhibition of art that was not purely abstract but emphasized human content was dubbed passé and deprecated as "humanist." Several critics pronounced the core of the heresy to be that just at the time of the triumph of American art, when "New York had stolen the idea of modern art, hastening the eclipse of Paris as the center of excitement,"[12] I had dared exhibit artists from France, England, Holland, and Austria as well as from the American hinterland (three from Chicago, three from California) on a par with the very principals of the New York school. Not surprisingly, many attacks were leveled against the exhibition. An especially vituperative review appeared in *Art News*, the magazine that championed Abstract Expressionism and the leading critical journal of the time. Manny Farber, a painter and film critic, called the exhibition a "monster show" and then took aim at various artists, referring to Dubuffet's figures as "baked funny paper people." He disliked Diebenkorn's "gloomy figures" and asserted that Francis Bacon's paintings were "like housepainting in rayon." Leon Golub was labeled as "a trickster," and Karel Appel seemed "oafish" to Mr. Farber, who also christened Nathan Oliveira a "fast shuffle artist" and de Kooning's *Marilyn Monroe* a "Sadie Thompson-ish tootsie."[13]

Not everyone concurred with Mr. Farber's assessment. Emily Genauer, the critic for the *New York Herald Tribune*, voiced the opinion of quite a few other critics when she judged the show as "one of the most arresting, dynamic, exhilarating, yet deeply troubling exhibitions of [MoMA's] long career."[14]

The exhibition seemed "beyond the mainstream" at a time when it appeared

that figurative art had been laid to rest by the New York art establishment.[15] Yet, despite all the controversy, I was supported by MoMA's director, René d'Harnoncourt, a man of urbane sophistication, and by my esteemed elder colleague Alfred H. Barr who, after all, had been preaching revolutionary gospel of modern art ever since he founded the Museum in 1929.

Soon after the closing of *New Images*, I took responsibility for the performance of Jean Tinguely's *Homage to New York*, against the advice of most of my colleagues, who pointed out that a museum was in the business of preservation and not the destruction – or self-destruction – of works of art. But as Bill Klüver recalled: "When on March 17, 1960 [Tinguely's machine] was put into action, the spectacle was one of beautiful humor, poetry, and confusion."[16]

Six years later, in 1966, Jean Tinguely was one of fourteen artists from Europe and the United Stated in the first exhibition I curated at the University of California, Berkeley. At the time when mainstream sculpture in America had reached the apogee of stasis in Minimalism, I organized a major exhibition, "Directions in Kinetic Sculpture," in which movement was an essential part of the work.

But, to return to my years at the Museum of Modern Art: in 1960 I addressed the sources and interconnections of modern art, architecture, and design, a relationship which had helped define the Museum's identity since its beginning. The large *Art Nouveau* exhibition, which I directed in 1960, comprised a scholarly reappraisal of a significant movement at the beginning of the modernist era. It was seen by many as *retardataire* and an attempt to rehabilitate a decorative style in the arts and crafts, one which had been thoroughly disparaged by the International Style and which had no place in the austere white cubes of the Museum of Modern Art.

There was certainly no controversy regarding the Mark Rothko retrospective, which I curated in 1960, but I followed it with an exhibition of Jean Dubuffet, turning over a whole museum floor to the art of a post-war Frenchman, thus questioning again the cultural hegemony of New York. I also went beyond the political bounds of the West, moving to the periphery and exhibiting painting from Communist Poland in 1961. To the consternation of the disinformed public, this art from behind the Iron Curtain was not mere Communist propaganda but rather, as *Newsweek* found: "Out of the agony of fifteen years of Nazi occupation and Stalinist oppression, there has emerged a renaissance of painting in Poland that has few parallels in the rest of Europe."[17]

All along I saw myself as the outsider on the inside, and I think I was perceived similarly by the art world. In 1963, when Pop Art seemed to take a dominant position on the New York art scene, it was suggested that MoMA jump on the bandwagon with an exhibition of the "neo-Dadas," as they were erroneously called. I did not advocate such an exhibition. In fact I reproached the Pop artists in an article, "The Flaccid Art," that appeared in *Partisan Review* in 1963, for its apparent lack of commitment to anything but the prevailing consumer culture. I charged it with being "as easy to consume as it is to produce and, better yet, easy to market because it is loud, it is clean, and you can be fashionable and at the same time know what you are looking at."[18]

But, having moved to northern California in 1965, I became engrossed by a

regional movement that prevailed in the Bay Area and which I helped identify. "Funk Art," as we called it – unlike Pop – paid absolutely no attention to the market. It was a totally irreverent art, indebted to the Beat movement and possible only in a place where there was no art market – its lack actually became a liberating force for artists to do exactly as they pleased. Typically, Funk artists worked from a position of irony and paradox. They disparaged the establishment, and deprecated themselves. I wrote: "Funk [unlike Pop] is hot rather than cool; it is committed rather than disengaged; it is bizarre rather than formal; it is sensuous; and frequently it is quite ugly and ungainly."[19]

Funk was strictly peripheral to American art. In the late 1960s, mainstream art consisted of Pop and color-field painting. Both these directions, I felt, lacked truthfulness to inner experience, which has always seemed to me to be an essential ingredient of modern art, if not of all art. Paul Klee had described his art as the path toward greater insight, but an enlarged comic strip panel, or a color-field painting lacking the passion and deep intelligence of works by Rothko and Newman, certainly do not add to our understanding of life. Moreover, I have always thought that a painting or sculpture that can be understood in a single instant cannot hold much promise of duration or profundity.

The painting of Sam Francis was very different from the color-field painters with whom he has at times erroneously been grouped. Francis, as James Johnson Sweeney observed, was "the most sensuous and sensitive American painter of his generation."[20] Recognized in Europe and Japan, Francis was consistently underrated in his own country, partly because he, like Mark Tobey, was never part of the New York art world. More significantly, the Puritan streak in American culture made it difficult to embrace the pure sensuousness and joy emanating from this artist's work. For me, personally, his painting embodied a complete antithesis of the often tragic art that occupied so much of my concern. Francis's jubilant explorations of light, space, and color emanates an invigorating energy. For this anthology I have selected a brief essay on his "Blue Ball" series of the early 1960s – paintings of organic forms that could be either atomic particles or vast constellations floating in space.

Another artist who, like Sam Francis, was undervalued in the United States was Eduardo Chillida, and I decided to write a book on the distinguished Spanish/Basque sculptor. Chillida's sculptures, like Francis's paintings, activate the void – a preoccupation that informs much of modernist sculpture, and which can be seen in the work of artists as different as Naum Gabo, Henry Moore, and Giacometti. Chillida has worked in iron, wood, steel, concrete, alabaster, and earthenware. His sculptures set up a unique dialogue with the space that surrounds them. Martin Heidegger asserted that "Emptiness is not nothing. It is also not a matter of absence. In plastic embodiment the void acts like the searching and projecting establishment of space."[21] Chillida's work seems to embody this thought.

The great iron prongs of the *Windcombs*, on the promontory of the Bay of San Sebastian, seem to search for one another and relate to sky and sea. For the center of the Basque city Vitoria-Gasteiz, Chillida designed a large triangle where the empty space of an urban place is articulated into a carefully composed public environment. And *Our Father's House*, near the sacred oak of Guernica, appears

like the bow of a great ship that has arrived at its destination; it emanates a sense of silence and peace.

In the early '70s, many of us became interested in the phenomenon of Conceptual art, which articulated the limits of Formalist art and its criticism. The Conceptual artists, like Duchamp before them, postulated the primacy of the mental process that goes into the conception of a work of art, and many artists of the group would have agreed with Lawrence Weiner that "the piece need not be built."[22] But I held that text was not sufficient for a work of visual art. I became fascinated with the work of Agnes Denes, an artist who does not fit into any standard niche and who was, therefore, marginalized by the commercial art world. She nonetheless "created an amazing body of work, distinguished for its intellectual rigor, aesthetic beauty, conceptual analysis, and environmental concerns."[23]

After arriving in California in 1965 as the founding director of the University Art Museum and professor of twentieth-century art at Berkeley, I began studying the contemporary art of California and writing about it with some consistency, discussing such opposite manifestations as Funk sculpture and Sam Francis's painting.

For this collection of essays I also selected five brief articles. Llyn Foulkes was among the innovative artists who were part of the Los Angeles underground until they surfaced at the Ferus Gallery in 1957. Foulkes made paintings that resembled ordinary postcards, but they were surprisingly different. They were endowed with a uniquely unsettling and haunting magic. His rather bleak imagery, however, was not compatible with the largely Abstract Expressionist work favored by Ferus. Similarly, Harold Paris, an artist of extraordinary versatility in the use of techniques and materials, and creator of austere environments and powerful clay, bronze, and paper sculpture, could never be part of the gritty Funk atmosphere that prevailed when he arrived in California from Europe in 1960. Though as a teacher he influenced a whole generation of artists, he remained the noted outsider. As Dore Ashton also observed:

> What sets him apart is not only his experimentation with new materials but his ability to find the appropriate medium in which to express his empathy, his kinship, his despair. He was not essentially a lyrical artist but rather a tragic artist in the large sense: he did not lack humor or wit or even playful impulses, but finally he subsumed them in his deep sense of the tragic.[24]

Tragic also are the flags that Hans Burkhardt painted in response to the Persian Gulf War of 1990–91, the euphemistically named "Desert Storm." This Swiss-American painter, approaching his ninetieth year, created a series of paintings and collages based on the design of the American flag and indicting that war. He had done so earlier in portentous Abstract Expressionist pictures denouncing the Spanish Civil War, and others protesting the slaughter in Vietnam. Donald Kuspit considers the latter "among the greatest war paintings made – especially modern war paintings – but they are more than history paintings. They summarize the brutality and inhumanity not only of the Vietnam War but of the twentieth century as a whole."[25] The essay contrasts Burkhardt's deeply felt and emotionally charged paintings with the use of the flag in the celebrated paintings by Jasper

9

Johns, who employed the same symbol simply to emphasize the planar structure of the fabric.

A more aggressive political stance was taken by the much younger Chicano artist Rupert Garcia. His use of photographs and silkscreen may be related to Pop Art, but Garcia employs them in the making of a truly committed political art. Pronouncing Warhol's works "provocative, but passionless, leading to emotional sterility," Garcia wrote early in his career.

> My art is committed to the paradox that in using mass-media I am using a source which I despise and with which I am at war. In using the images of mass-media I am taking an art form whose motives are debased, exploitive, and indifferent to human welfare, and setting it into a totally new moral context. I am, so to speak, reversing the process by which mass-media betray the masses, and betraying the images of mass-media for which they are designed: the art of social protest.[26]

In general, the dominant culture continues to marginalize political art as well as "ethnic" artists, whether Chicanos, African-Americans, or Turks, denying them full access to the global topography and its marketplace. This Eurocentric arrogance and American xenophobia was the reason for Bedri Baykam's manifesto of protest, which I received when participating in a panel discussion on Neo-Expressionism at the San Francisco Museum of Modern Art. Baykam, a highly talented and articulate artist, is able to fuse his own Turkish culture and personal experience with the contemporary international idiom, creating an art with an authentic voice. I supported his protest against the hegemonic power exercised by Western taste makers of the mainstream.

At the time of this writing, I feel that even the current token adherence to "multiculturalism" is often little more than a patronizing capitalist designation for "The Other." But we also witness serious inquiry in which the dogmas of the past are rethought and debated. Indeed, the periphery is affecting the center in many ways, and previously marginalized cultures are not only influenced by but also act upon the mainstream culture. New paradigms are called for, and new artists will find them, and new critics will have something to write about.

Peter Selz
Berkeley, California
February 1997

EUROPE

FERDINAND HODLER

In 1913, just before the outbreak of World War I, President Poincaré of France personally decorated Ferdinand Hodler with the "Légion d'Honneur" when he exhibited at the Salon d'Automne in Paris.* During the same year the German Kaiser was present for the unveiling of the Swiss painter's large mural in Hannover. Hodler had met Rodin and Degas; he was celebrated in Vienna when he was the featured artist of the Vienna Secession exhibition in 1904. He was acclaimed by Gustav Klimt and exerted a certain influence on Egon Schiele. Emil Nolde, Alexeij von Jawlensky, and the German Expressionists in general acknowledged their debt to the Swiss master. Indeed, he was compared to Cézanne as one of the giants of early twentieth-century art. More recently, Alberto Giacometti paid homage to his great Swiss predecessor.

Hodler is unique among the artists of the late nineteenth century. He came from a very isolated place, he was never part of any artistic community, had little tradition to continue or even to rebel against. He was not only a self-taught artist, but also a self-generated individual, who would follow his own vision of his mission and managed, quite fortuitously, to meet individuals who willingly would help him. Coming from the city of Bern, uneducated and poverty-stricken, he must have possessed potent inner resources and energies he could tap to overcome the inertia of the circumstances of his birth and upbringing.

Ferdinand Hodler was born into the Swiss proletariat in the poorest quarter of Bern in 1853. His father, an impecunious carpenter, died when the artist was still a child, and was eventually followed in death by his mother, who was remarried to Gottlieb Schüpbach, a widowed house and sign painter. Of the twelve children in these combined households, Ferdinand and five others survived; the rest died in infancy and youth, most of them of tuberculosis. The image of death was

* This essay originally appeared in *Ferdinand Holder*, © 1972 University Art Museum, University of California, Berkeley. Reprinted by permission of the University of California, Berkeley.

ingrained in Hodler's mind and vision: he was to paint it in many versions throughout his life.

From his eighth year, Ferdinand helped Schüpbach in his work. At about the age of fifteen, in 1868, he was apprenticed to Ferdinand Sommer, a painter of mountain views – perhaps not as unusual a transition from the stepfather's paint shop as it might seem at first glance: paintings of landscape for sale to tourists were the precursors of the landscape photographs of today. During the three years of Hodler's apprenticeship, Sommer conveyed to the young artist the rudiments of painting. But Hodler, despite the deprivation of his childhood, was eager to learn about art, science, religion, and life. Hoping to leave humdrum provincial existence behind him, he decided in 1872 to leave the Swiss countryside near Bern. He walked to Geneva without money, without education, with the slightest knowledge of French, and without a friend to greet him at his destination. He knew only that Geneva was a cultural center of considerable importance and that it might be a place where, having left behind the sadness of his childhood, he could hope to enter a new life, perhaps as a new person. (It is interesting to note that Gottlieb Schüpbach had left Switzerland in 1871 after the death of Hodler's mother, and settled in Boston.)

When Hodler came to Geneva, it was the only city in nineteenth-century Switzerland boasting an active contemporary artistic culture, animated mainly by François Diday and Alexandre Calame, Swiss landscape painters active in Geneva in the early half of the century but renowned throughout Switzerland. But Hodler was more drawn to Karl Vogt, whom he knew by reputation, a great naturalist who taught geology, paleontology, and zoology at the University of Geneva and who ultimately became its rector. Vogt, who before emigrating to Switzerland had been active in liberal politics in pre-1848 Germany, was able to give the young Hodler some contact with the world of the mind.

While engaged in making copies at the Musée Rath, Hodler encountered Barthélemy Menn, an accomplished painter who really became the artist's teacher. Menn, born in Geneva in 1815 and very influential in the artistic culture there, had studied with Ingres and had gone to Rome with the master. Later on, he also became a friend of Delacroix, Corot, and Daubigny. Menn painted carefully balanced, intimate landscapes with soft contours and high tonalities. Menn, like his teacher Ingres, believed in the primacy of line and structural form. Hodler, coming from a rural environment, was able to enter the great French classic tradition thanks to the six years he worked with Menn as a student in the Ecole des Beaux-Arts in Geneva.

While a student with Menn, Hodler painted one of his earliest self-portraits, *The Student*. In the course of his life Hodler painted at least forty self-portraits, constantly exploring his own image, searching for the key to the deeper meaning of his face and gesture. This self-portrait, done when he was twenty-one, is remarkable for its clear construction: the tall figure occupies the center of the narrow, vertical space; all the parts of the body are based on linear directions and their relationships. A contemporary critic, seeing this painting in an exhibition of the Société Suisse des Beaux-Arts in Geneva in 1876, made the acute observation that "Hodler makes us aware of the epidermis, the weight and the cubic form of his subjects."[1] In this portrait the artist sees himself as a young student with

books and canvases in the background. In his left hand he holds a T-square in perfect balance which must signify the interest he took in science and construction. His right hand is raised in an oath and his earnest countenance speaks cogently of his dedication to his life as an artist. But the oath also seems tenuous, the young man's posture is questioning, the expression is still uncertain. Hodler painted his image down to above the knees, probably in order to achieve the desired verticality of the composition; but what a strange place to truncate the figure!

Soon after painting *The Student* Hodler's interest in linear structures, the placement of the figure, and balanced composition, was reinforced by his encounter with Holbein's work during a visit to Basel. Holbein and Dürer, whose works he was to copy and whose theories were to occupy his mind, were the artists of the North whom Hodler admired most throughout his life. Yet he had equal regard for Michelangelo, Leonardo, and Raphael, whose *Miraculous Draft of the Fishes* he considered "perhaps the most beautiful composition an artist ever made." Although his Symbolist work must be counted among the major breakthroughs of Post-Impressionism, Hodler, like the somewhat older Cézanne, was firmly grounded in tradition, creating a new present with the values of the past.

Hodler continued working with no tangible success. In 1878 he was impelled to move, and suddenly left Geneva for Madrid. Although Florentine masters of the Italian Renaissance remained Hodler's heroes, rather than Titian, Velazquez, and Ribera, whose work he encountered in the Prado, the sheer physical dimensions of their paintings must have had great impact on the artist, who, having begun with small landscapes, was to become one of the great muralists of his time.

Watchmaker Workshop Madrid, made during his stay in Madrid, is a very small painting. Here he put three men carefully into a room, placing all objects and figures along a perpendicular structure. This rigorously constructed simple interior, facing the light of a window whose rectangular transparent panes give a view of a bright outside world, relates the Swiss painter to the tradition of German Romantic painting, going back to such artists as Caspar David Friedrich and Georg Kersting, who also created moods of silent intimacy in their Biedermeier interiors. It is fascinating that during a trip to Spain Hodler should relate to North German artists of the early nineteenth century.

THE SYMBOLIST PAINTINGS

The painting that gained him international recognition, however, was *Night*, which he began with few prior studies in 1889 and completed in 1890. Here for the first time Hodler uses the human figure, as well as color and light, to create a symbolic Parallelist painting. The Parallelism created by the extended horizontal figures is clearly emphasized by areas of light and dark – bodies and their garments – that form a domino pattern throughout the painting. Leaving narrative painting behind, Hodler achieves a work which no longer describes an event but rather evokes a feeling. *Night* suggests a unique fusion of eros, sleep, and death.

Six of the eight figures in the composition are asleep. As in a dream, the stage-

like space is crowded. Some of the figures are modeled after people close to Hodler's life, while others are related more directly to art. The woman who sleeps alone on the lower left with her body covered and her knees, feet, and elbows crossed in a position of closure is his friend Augustine Dupin. The sensuous and seductive nude embracing a young man on the lower right is not his new wife, Berta Stucki, with whom Hodler lived only about as long as he worked on this major composition. The figure on the upper right, which certainly appears to be another self-portrait, resembles the lying Diogenes in the center of Raphael's *School of Athens* (a point also made by von Tavel in his book on *Night*). It is highly significant that in the very painting which marks the turning point in Hodler's work toward the future, the "most important painting, in which I reveal myself in a new light,"[2] Hodler reaches back to the world of the Italian Renaissance. It is not only Raphael, but also Michelangelo's Medici tombs and Signorelli's *Pan* which come to mind when confronted by this major work. The central figure is the artist, who had known death so well throughout his early life, suddenly awakened and terrified by a black hooded figure. The message is clear. To make it even more so, Hodler wrote on the frame: "Plus d'un qui s'est couché tranquillement le soir, ne s'éveillera pas le lendemain matin." Yet what a strange image of death: it appears here as a seducer, crouched implacably on the artist's genitals. His attempt to push this threatening figure away from him seems to be of no avail. This painting clearly recalls the eighteenth-century Swiss canvas, Fuseli's famous *Nightmare,* in which an incubus, a sneering demon, crouches on the chest of the sleeping figure of a sensuously entranced girl. But instead of the enigmatic, provocative, and feverish eroticism of Fuseli's pantomime, Hodler, a century later, deals with the nightmare of sex and death in measured rhythm and symmetry.

In 1891 *Night* was withdrawn from the municipal exhibition at the order of Geneva's mayor. Hodler then exhibited the painting most successfully at his own expense, in a space he rented elsewhere in the city. Hodler sent it to the Salon du Champ-de-Mars, where it was received enthusiastically and admired by Puvis de Chavannes. The artist himself traveled to Paris and was elected a member of the Société National des Artistes Français. Joséphin (Sâr) Péladan, founder of the Rose†Croix Esthétique and for a brief time very influential in cultural matters, called the picture "unforgettable, a work of art which bespeaks a great future."[3] In 1892 the painting was shown officially in Bern and in 1897 it (along with Hodler's *Eurythmy*) was awarded the coveted gold medal at the VII International Art Exhibition in Munich. In 1899 it was sent to the III Biennale in Venice and the following year it was again in Paris, this time at the World's Fair, where it (with *Eurythmy* and *Day* received a gold medal, and Hodler's reputation as a modern master was established. In 1901 *Night* was finally purchased, together with three other major works, by the Bern Kunstmuseum.

One of these works was another large symbolic canvas, *The Disillusioned*, which was sent to Paris almost immediately upon its completion in 1892. In fact, Count Antoine de La Rochefoucauld, financial backer of the Rose†Croix Esthétique, traveled to Geneva to invite Hodler to exhibit this new work in Paris in the first salon of this heterogeneous group of painters, at Durand-Ruel's in March 1892. Although Péladan's pronouncements were very doctrinaire, the many divergent

talents exhibited in the Salon included not only followers of Puvis, Moreau, and Gauguin, but also Redon and Toorop, all of whom shared an anti-Impressionist and anti-contemporary point of view and were perhaps in some sort of agreement with the Sâr's neo-Catholic metaphysics. Certainly Hodler belonged to a new group of artists who considered nature only a source which would help to symbolize emotion. Like his great contemporaries Gauguin, Van Gogh, Munch, or Ensor, Ferdinand Hodler saw in art a means toward edification rather than mere delectation.

The Disillusioned represents five old men sitting on a bench, having renounced their struggle, accepting the inevitable fate of old age in silent despair. Although this painting may be based on sketches Hodler made of men sitting on the benches of the parks of Geneva, these figures in their timeless garments are an allegory of human despondency and desolation rather than a realistic rendition. Two darkly garbed figures on the left correspond to two on the right, while the central figure differs in dress and posture. The repetition and axial symmetry carry the message that this is not a fortuitous grouping of men, but a carefully arranged symbolic representation of man's fate. The repetition frees these men from solitude and creates a symbolic human community. The clear and emphatic contour lines, the vertical lines of the men, the horizontal one of the bench – everything is placed on a shallow, stagelike space. Although the figures are copied from nature (Hodler must have had his models seated in the positions in which they are portrayed), he joined the leading post-Impressionist painters in emphasis on the picture plane, in free and symbolic use of color and line, and above all in the identity of form and idea. No wonder, then, that Hodler was taken up with enthusiasm by the Symbolists and Nabis of Paris. Félix Vallotton, a younger Swiss compatriot and a member of the Rose†Croix Esthétique, reported from Paris in the *Gazette de Lausanne* of March 18, 1892, that he found the five figures "powerfully restrained in black and white against the rose-colored background of a hill truly unforgettable" and commented further that it would be necessary to go "far back into the past, to the frescoes of Orcagna and Signorelli, to find such power of drawing, such dignity of form."

The rhythmic arrangement of parallel figures, with a central one differentiated from the pairs on left and right in a shallow frontal plane, is repeated in *Eurythmy* (1894–1895). This was one of Hodler's favorite paintings, "because of its simplicity, its large parallels, its white garments with their simple folds that make delicate ornaments at the man's feet."[4] In this picture, Hodler breaks the stasis of his former large figural compositions and introduces rhythmic movements by the motion of the figures themselves. Five old men, whose faces recall those of Dürer's *Four Apostles* in Munich (a likeness pointed out by Ewald Bender), are dressed in festive, white loose-fitting robes. They move fluidly from right to left, from life toward death.[5] The figures, consuming almost all of the space, are monumental in appearance. Hodler's Parallelism, which expresses his metaphysical vision, may remind us of the hieratic frieze of saints in Sant' Apollinare Nuovo, with the measured rhythms created by the procession of saints and virgins. Yet the fluidity of the movement is distinct from the static ritual enacted at Ravenna. In his Fribourg lecture, Hodler speaks of the artist "searching for the linear beauty of a

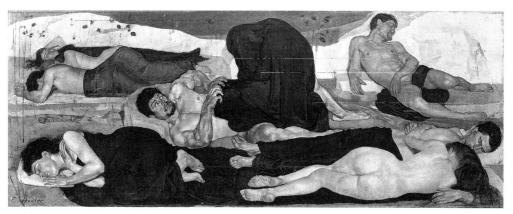

FIGURE 1. *The Night* 1889–90, oil on canvas 45¾ × 17¾", Kunstmuseum, Bern.

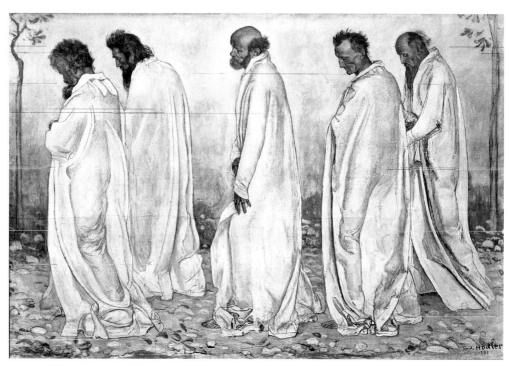

FIGURE 2. *Eurythmy* 1895, oil on canvas 65¾ × 96½", Kunstmuseum, Bern.

contour," "stressing the movements and the parts of the human body," "expressing its rhythm," and he explains further that "the outline of the human body changes according to its movements and is in itself an element of beauty."[6]

In this attitude Hodler closely approaches new ideas in dance which developed during his lifetime. The figures in a great many of Hodler's large symbolic compositions after 1890 assume the stance of modern dancers.[7] (His biographer and student, Stephanie Guerzoni, tells how he worked directly from dancing models.)[8] During the last decade of the century, it must be remembered, art increas-

ingly moved toward the nondiscursive condition of music and dance. In this respect, his later friendship with Emile Jacques Dalcroze, a distinguished musicologist, choreographer, and professor at the Geneva conservatory of music, was also important. One of the great innovators of the modern dance movement, Dalcroze was indebted to Loié Fuller and Isadora Duncan and taught eurythmics long before Rudolf Steiner. There is little doubt that Hodler saw Dalcroze's performances, that he supported the younger man's work and was, in turn, inspired by it, particularly by Dalcroze's exercises with successive movements. When Hodler died Dalcroze wrote a moving obituary; ten years later in an article entitled "Ferdinand Hodler et le Rhythm," he stated that "the principal inspiration in Hodler's work was rhythm, . . . his painting appears eminently musical in the Greek sense of the word." Seeing "rhythm and meter as the foundation of art," Dalcroze continues: "This continuous preoccupation with movement is just made to interest musicians. Hodler is certainly one of them. None of them better than he possess the art of associating and disassociating movements, of accenting unisons, of creating counterpoint, of treating human sentiments symphonically, of choosing for their expression the gestures and positions appropriate for their orchestration."[9]

But long before Hodler's acquaintance with Dalcroze, we find that dreamlike movements and ritual gestures animate his figures and give them their symbolic significance and psychological content. Even seated figures – the five old men in *The Disillusioned* or the five young women in *Day,* indeed even recumbent figures like the couples in *Love* – are articulated by the heightened stage gestures of mimes or dancers. Frequently Hodler's large figures, whether standing, sitting, or lying, are static and at complete rest, but even the walking men in *Eurythmy* move in measured steps through frozen time and space. It is certainly this use of the seemingly static and overstated gesture that over the years has been the source of much critical objection to Hodler's stylizations. But it is precisely the measured gesture of his hieratic figures which evoke the viewer's reaction along the lines determined by this Symbolist painter.

Symbolism and Art Nouveau, movements in which Hodler participated at the turn of the century, are characterized in painting by the evocative use of flat linear form and, "Like his Art Nouveau contemporaries, Hodler worked in terms of the plane enriched with a decorative pattern, where a tense line becomes the important carrier of emotion."[10] This trend becomes most apparent in *Day* of 1899–1900. Here the five figures are seated on a flatly patterned mountain meadow in a linear dancelike movement. Again the Parallelist composition consists of a central figure flanked symmetrically by two figures on each side. Their gestures are repeated in the rising hill in the background, if indeed we can still speak of a background in so flat a composition. The young women are nude, and the theme of daybreak is developed in their bodies and movements. The two on the outer edge of the painting have their legs in a guarded and closed position while their arms are folded as in prayer. They are introverted figures. The two women next to them turn more directly toward the viewer, but while their thighs are more open, their arms almost hide their faces in an averting gesture. The severe central figure with her arms in a gesture of open prayer appears like a priestess who channels the emotion of the

group toward the light of day. If *Night* was a painting to symbolize the threat of death, *Day* is a hymn to awakening and light.

Truth, painted in 1903, when Hodler spent six weeks in Vienna and became a friend and admirer of Gustav Klimt and the Jugendstil artists of the Vienna Secession, combines the decorative arabesque with allegorical meaning. Strained and contorted figures standing on a stylized meadow fuse with the surface of the picture. A nude woman with arms outstretched symmetrically stands in the center, banishing the six half-draped demons at her side. Unlike Klimt and many of his Art Nouveau contemporaries, Hodler does not treat woman as a languidly sensuous decorative object. The slender young girl here is seen as the liberator, the symbol of the good and the true, while the men with faces covered and averted are unable to bear the vision of naked Truth which stands before them. It is the male figures who are partly draped in an almost provocative manner, while Truth herself – we are reminded somehow of Titian's allegory of love – is completely naked and pure. Color is used to emphasize the meaning, which is surely the victory of light and day over the dark and morbid forces of the night.

A few years later, in his magnificent composition, *Love,* the artist has moved beyond the allegorical decoration of Jugendstil. Stylizations and mannerisms are rejected in favor of a deeply felt realistic rendition of the human form. On a long, ribbonlike, horizontal canvas three couples are stretched out like waves at the edge of the sea. Rarely has his use of color been more forceful and meaningful, and never has he painted the human body more masterfully. It seems as if all the problems and threats and fears of *Night* have now been resolved in this painting of frankly assertive physical love. If the couples in *Night* were meant to symbolize death, the three couples in this large mural are images of life, of the completion of passion and love. This painting has an elemental power lacking in his more symbolic compositions. Parallelism is no longer a matter of doctrine at this point, but appears in the natural and easy flow of three couples embracing at the edge of the sea.

With the exception of *Love*, there is generally a heavy and didactic element in Hodler's large compositions symbolizing the human condition. They seem to be done by a painter different from Hodler the landscapist. His landscapes, mostly pictures of mountains, are done with much greater freedom and spontaneity. Yet, especially in his landscapes executed before the turn of the century, we find similar uses of parallel structure and similar attitudes toward the meaning of color. "Color has a penetrating, harmonious charm, independent of form. It influences emotions . . ." and Hodler goes on to explain that we associate certain colors with certain feelings. White, for instance, "usually means purity."[11] *Eurythmy* is predominantly a white painting. His beautiful landscape of 1892, *Autumn Evening*, is composed of golden browns. The painting is unified in its color scheme; there is no aerial perspective, but instead a completely even color intensity. In order to give the landscape a universal and motionless aspect, he has suppressed the presence of figures and painted over the original female figure walking on the road. In his search for parallel structure in nature, Hodler now rejects totally the transitory quality of the Impressionist landscape. The composition is symmetrical. The chestnut trees, moreover, are not shown growing naturally and at random, but have been arranged so as to infuse man's order into

nature. The absence of shadows adds to the austere quality of this structural land-scape. The avenue is greatly foreshortened, moving rapidly to its vanishing point. Yet for all its measure and structure – and this is perhaps the essential aspect of this fine landscape – the road itself not only goes into the sunset, it leads into infinity, to the immeasurable. The leaves fall aimlessly, announcing the approach of winter.

Hodler's desire for measure within his pantheist awe of the boundless universe seems almost analogous to the sentiment of the great Symbolist poet Rainer Maria Rilke:

FALL

The leaves are falling, falling from afar
as though far gardens withered in the skies;
they fall with constantly denying gestures.

And in the night the heavy earth is falling
from all the stars into its loneliness.

We all are falling. This hand falls,
and look at others: it is in them all

And yet there is One, who holds this falling
in his own hands with timeless tenderness.[12]

The symmetry of *Autumn Evening* is a quality Hodler retained in landscapes for some time. Often, instead of using a vertical axis, he orients his landscapes on a horizontal one. For the remainder of his life, he painted many views of Lake Geneva, often as seen from Chexbres or Vevey. He would look down at the expanse of the lake and make a large oval form in which the near shore is echoed by the sweep of the mountains on the far side, while clouds in the sky are reflected in the waters of the lake. In *Lake Geneva from Chexbres* of 1895, a high sweeping cloud formation repeats the defining curve of the near shoreline. Hodler combines a sense of realism and place with his theoretical principle of Parallelism. The numerous variations of the wide view of Lake Geneva attest the constant refinement of his vision.

ART IN A TURBULENT ERA

GERMAN AND AUSTRIAN
EXPRESSIONIST PAINTING
RE-VIEWED

Emerging from relative obscurity to wide recognition in the past twenty-odd years, the movement known as German/Austrian Expressionist art has revealed itself to be so protean in nature that it has rendered its label as a singular, art-historical category, little better than a term of convenience.* The cultural climate that surrounded what we have come to call Expressionist art gave rise to artistic phenomena which assumed separate and distinct forms in Dresden, Vienna, and Munich. These artistic centers served as background to the production of a number of works that ultimately have only their diversity in common. In these three cities and in Berlin, where many Expressionist artists were eventually to establish residence and gain recognition, Expressionism was elaborated and enriched by artists generally more concerned with spiritual vitality, emotional content, and passion, than with purely formal problems. This emphasis on content, particularly in painting, was carried to a degree almost unparalleled in western art.

It is my contention then that German Expressionism lacks the formal coherence which could justify its being called a "style." The reader of these pages and the viewer of this exhibition will find ready evidence of the unique qualities of personal expression for which the so-called Expressionist artists searched at the beginning of the 20th century, the qualities which above all justified the shock and outrage with which a complacent Europe received their first works.

If there is an Expressionist "style," it resides not in the collective nature of the works themselves but in the character of the underlying ferment – social, aesthetic, philosophical, political – that called them into being. During the first decade of this century, life in Europe appeared to be attaining an apogee of security. A long period of peace and colonial and industrial expansion had seem-

* This essay originally appeared in the Museum of Contemporary Art catalogue accompanying the exhibition *Art in a Turbulent Era: German and Austrian Expressionism*, which was supported in part through a generous grant from the National Endowment for the Arts, Washington, D.C. Reprinted by permission of the Museum of Contemporary Art, Chicago, © 1978.

ingly brought with it the promise of full prosperity; "civilized" man could look forward to the uninterrupted continuation of a well-established social order, to ever-increasing production of goods and services, and to decreasing human want and toil. In Central Europe the long reign of Kaiser Franz Josef – benign, remote, exceedingly oppressive – seemed to ensure the tradition and continuity of the prevailing social and political systems. Even a relative upstart like Kaiser Wilhelm II, it was thought, could eventually be absorbed into the fabric of this linear cultural evolution. Science and reason, it was generally assumed, would soon explain whatever remained of the inexplicable: Progress was Man's fate.

All of these premises were ephemeral. Many were false. But Nietzsche's announcement of God's demise was not heard by leaders of church and state; missionary Christianity continued to be implanted with imperialist fervor among the heathen of Africa and Asia. Darwin's theory of biological evolution was misapplied to human culture. His genetic model of survival of the fittest was cunningly employed to rationalize prevailing social injustices.

In these few pages it is impossible either to document the complex illusion that comprised the maquillage of *fin-de-siècle* European institutions, or to report in detail the events that undermined them and brought them crashing to ruin. But to understand the implication and inherent strength of the currents running counter to established social norms is prerequisite to understanding why creative individuals at large, and the German Expressionist artists in particular, made their art.

In 1913, the French poet Charles Péguy wrote: ". . . the world has changed less since Jesus Christ than it has in the last thirty years."[1] Indeed, at the end of the 19th century profound changes of thought and attitude were sweeping through European intellectual and artistic circles. The structure of the old world was not nearly so secure as its surface appearance misled many to believe. It was, in fact, breaking asunder, and the Expressionists were among the animators of this fracture, along with many other intellectuals who had become painfully aware of the degree of alienation that permeated all aspects of western life beneath its masks of progress and prosperity. Writers, philosophers, poets, composers, painters, and sculptors throughout Europe had for some time been possessed by the need to shatter the complacencies of their age. Some turned their creative energies to seeking renewed cultural authenticity in the realms of myth, ritual, the non-rational, a congeries of esoteric religions and spiritualism. Images of utopian communities inhabited by noble savages living in simplicity and purity once again piqued the imaginations and zeal of philosophers and artists. None of this was new under the long sun of Europe, where revolution in other times had always been nurtured by the intelligentsia and eventually emerged upon its own barricades with its own spokesmen, and with its arts redemptive of mankind.

But this time, the false visions of an entire social fabrication evaporated in worldwide holocaust. The outbreak of World War I and the slaughter of at least ten million human beings between 1914 and 1918 finally brought home the fallacy of holding continued faith in the securities and comforts that had seemed to prevail at the start of the 20th century.

Few generalizations are effective in discussing the independent and individualistic artists who have been gathered under the label "Expressionist." By and

large, the German Expressionists were strongly aware of their heritage in the German Romantic tradition. Many of them placed the highest value on the late medieval art of Northern Europe. Artists as different as Kirchner and Beckmann admired the Gothic, which seemed to them to be the last artistic manifestation of the Northern spirit. They opposed what they considered to be the Impressionists' shallow preoccupation with surface, and would have agreed with Odilon Redon, who accused his *plein-air* contemporaries of being "parasites of the object." The Expressionists found immediate sources in *Jugendstil* and in the work of painters who stressed the symbolic and emotional aspects of art. Gauguin and Redon, Cézanne and Hodler, Van Gogh, Munch and Ensor were important to them.

The Expressionist artists, driven by an inner need to utter their personal feelings and emotions and to project unresolved conflicts with society, saw their work as a meaningful declaration about life, not merely a well composed and formal artistic statement. They searched incessantly for their own identity, while simultaneously maintaining a fervent dialogue with the viewer. In 1899 during his first trip to Paris Edvard Munch, the Norwegian painter who exerted such a substantial impact on the German movement, wrote in his notebooks: "No longer should you paint interiors with men reading and women knitting. There must be living beings who breathe and feel and love and suffer."[2] And years later, in his eulogy to Munch, Oskar Kokoschka described Expressionist art as "form-giving to the experience, thus mediator and message from self to fellow human. As in love two individuals are necessary. Expressionism does not live in an ivory tower, it calls upon a fellow human whom it awakens."[3]

The Expressionist artist sought to understand him, or herself, and then hoped to establish the I–Thou relationship of a Martin Buber. The artist's relationship to the spectator was both intimate and urgent. Some of the artists, indeed, pursued their art with a truly religious fervor, dreaming of a brotherhood of man, or, beyond that, fulfillment of the Romantics' yearning for a fusion of man and universe. They saw themselves as the prophets of a new social order which they announced in their art or poetry. They idolized the poet Georg Heym who wrote in his diary in 1910: "In waking dreams I see myself as a Danton or a man on the barricades. Without my Jacobin bonnet I can't even think."[4]

DRESDEN

Jugendstil or Art Nouveau, the movement that immediately preceded the Expressionist generation, was still imbued with a utopian faith in art as that factor which could effect a harmonious design for living. As late as 1908 Joseph A. Lux, the Viennese *Jugendstil* critic, could still affirm that every person is a born artist (a concept, which to be sure, has recurred with predictable frequency throughout the century). By contrast the Expressionists saw the artist as a uniquely endowed being, as a genius, or indeed a prophet. Men of the earlier generation like Henry van de Velde, August Endell, Peter Behrens, turned from painting to the crafts and eventually to architecture. By complete contrast the artists who founded Die Brücke in Dresden in 1905 – Ernst Ludwig Kirchner, Erich Heckel, Karl Schmidt-

FIGURE 3. Max Pechstein, *In the Forest near Moritzburg*, 1910 oil on canvas, 27⅛ × 30⅜", Brücke Museum, Berlin.

Rottluff and Fritz Bleyl – were all originally students of architecture, a profession to which only Bleyl returned later. The Brücke artists turned their backs on their more utilitarian training and decided to become painters. In so doing they could achieve the sense of personal freedom they desired. They felt that only by means of complete personal affirmation and total liberty could an authentic new art be achieved. Against the *Jugendstil* idea of artists and craftsmen, designers and architects working for the common good of a bourgeois society, the Expressionists postulated a different community, consisting of free and audacious artists "to carry the future." The contrast between community and society, between the authentic, nurturing and often *völkisch Gemeinschaft* and the rootless, mechanical, urban and rational *Gesellschaft* – first postulated by the sociologist Ferdinand Tönnies[5] and later on used by the Nazi Party – is of great importance here. Certainly, the young painters who formed their close commune in Dresden felt that a genuine and authentic self-expression, and not decoration, was the essence of art.

The Brücke painters entered their thoughts in an ephemeral and now vanished manuscript which was, significantly, entitled *Odi profanum* after Horace's ode "I hate the uninitiated crowd." But this is not to imply that the Brücke painters or other Expressionist artists subscribed to a *l'art pour l'art* point of view. On the contrary, they wanted to find an authentic contact with the *Volk* and looked to late medieval German art and to the art of "primitive people" in the hope that

their own often irrational art would regain the emotional and primordial power of the iconic object.

At the same time, they felt themselves a part of a new wave of European art. Partly through exhibitions that they saw in Dresden and on their travels, partly through reproductions in the art press, they were familiar with the work of the giants of the older generation in Paris. In addition, Hodler was a major influence, as was Munch, who exhibited twenty paintings at the Saxon Art Association in Dresden in 1908.[6] A year later they may have seen Matisse's 1909 one-man show at the Cassirer Gallery in Berlin. If Kirchner denied these influences, it must be remembered that the artistic purpose of the Brücke painters was quite different from that of the older Norwegian artist or their great French contemporary.

The Brücke artists lived in a closely knit community, worked together with exorbitant intensity, discussed their problems, severely criticized each other's work, and were far more embroiled in the excitement of creation than with the finished product. Kirchner probably had the most inventive ideas; Schmidt-Rottluff coined their name and was the most stable member of the group; and Heckel was its most active agent. The furniture in their workshop – benches, stools, and chests – was created by the artists themselves. The distinctions between fine and applied arts were eliminated and an almost primitive unity between art and life – quite different again from the more sophisticated Art Nouveau interior – was achieved in their abandoned cobbler shop in Dresden. "Their canvases, frequently painted on both sides, were hung on the walls (or piled on the floor) along with their murals, and their painted burlap and batik."[7] Their erotic wood carvings stood in the corners.

The first Brücke exhibition took place in 1906 in a lampshade factory in a suburb of Dresden. Few people paid any attention to it. The group, however, felt the need to expand to be a "bridge to attract all the revolutionary surging elements" to itself.[8] Emil Nolde was asked to join the group. He was a significant member for a short time (1906–1907) and developed his own characteristic style – his own visionary and religious fantasies and paintings of the land, his masks, his exotic heroes, his deeply felt flower pieces and paintings of the ocean – all rendered in sonorous symbolic colors. It was also in 1906 that Max Pechstein joined the group and remained a very active member for its duration. Cuno Amiet, the Swiss Symbolist painter, became a member, as did the Finnish Symbolist Alex Gallén-Kallela; and Kees van Dongen, who was in close touch with Matisse and the Fauves. Edvard Munch was actually asked to participate in the first graphic exhibition of the group that was held in 1906, but refused.[9] Finally, in 1910 Otto Mueller became a member. This gentle painter from Silesia may have brought a softening influence to bear on the work of his tougher companions.

The landscapes of the Brücke painters, such as Schmidt-Rottluff's *Blossoming Trees*, 1911, or Heckel's *Forest Interior*, 1911, are wildly exuberant. Often they are peopled by nudes. In their search for direct and immediate expression, the Brücke painters rejected the posed nude professional model – set up much like a still life – employed by the Academy. They found their models in their own neighborhood and on the streets and studied the nude in natural movement or lying erotically about on couches in their living studios. Or they would take their

women companions to the countryside where they depicted their bodies freely moving in natural surroundings as an integral part of the landscape of trees, lakes, and hills. They affirmed the Dionysian sensuality which Nietzsche had celebrated in his writings. But when they were impelled to paint city scenes, they portrayed streets inhabited by individuals trapped in the nervous surroundings of the urban environment which Spengler described as "deserts of daemonic stone." Clearly the Brücke painters preferred the freedom of the countryside and searched romantically for roots in the soil and the land, roots which were not to be found in the urban environment. Yet around 1910 most of these painters relocated in the metropolitan world of Berlin. By 1913 the group broke apart, largely due to Kirchner's somewhat self-glorifying publication of the *Chronik der Brücke* and the ensuing controversies.

VIENNA

Dresden, although it was the residence of the kings of Saxony and could boast a great art museum, theaters and opera, remained a provincial city in Central Europe. Vienna, on the other hand, was one of the great centers of European civilization and a cradle of new ideas. In the early years of the century it was a place of unequaled intellectual and artistic energy and ferment. Traditionally the center of music, Vienna now produced Gustav Mahler's *Eighth Symphony*, the "Symphony for 1000," which indicates the gigantic ambitions prevalent among artists and intellectuals in the capital of Dual Monarchy. Soon Arnold Schoenberg would radically alter the history of western music. This was the period in which Arthur Schnitzler had pinpointed the decadence of the *fin de siècle* in his brilliant series of plays, enveloping his accusations of a hypocritical bourgeoisie in a diaphanous veil of satire. The poet Peter Altenberg wrote brief "photographic" poems, commenting on the intellectual and moral life of his time, and more significant, Karl Kraus, the brilliant cultural critic and polemicist, became the literary and political conscience of an era, communicating his thought about language, culture and politics in his unique magazine, *Die Fackel*. Hugo von Hofmannsthal developed a visionary romanticism with a melancholy evocation of an idealized 18th-century grace. Eventually he became the collaborator and librettist for Richard Straus. Franz Werfel concerned himself in his early poems with the problem of man's relationship to God and the liberation of the soul. Stefan Zweig, writing in a highly civilized prose style, was one of the innovators of the 20th-century historical novel at its finest.

Sigmund Freud and his Viennese collaborator Alfred Adler developed the theory of psychoanalysis, delving into heretofore little-explored realms of dream and fantasy and penetrating basic human desires and needs which an overcivilized society forced man – and, even more, woman – to conceal and suppress. Freud's theories of the unconscious self and his interpretation of art as the successful exploitation of the libido toward creative pursuits are highly important to an understanding of the art of his time.

In philosophy we find such divergent approaches as Ernst Mach's scientific investigations, Ludwig Wittgenstein's analysis of linguistic forms, and Martin Buber's philosophy based on the spiritual and often mystic beliefs of the Hasid.

Art historians like Franz Wickhoff, Alois Riegl, Max Dvorak, and Hans and Erica Tietze broke with previous biographical and formalistic practices and related the discipline more intimately to the broader history of culture, thus opening the art of the past to a much deeper understanding.

A new kind of architecture, related to Art Nouveau, followed the precept of the towering figure of Otto Wagner and was practiced by his disciple Joseph Maria Olbrich, who had designed the boldly geometric exhibition hall for the Vienna Secession, and by Josef Hoffmann, a man of extraordinary design sensibility. They were followed immediately by the more radical anti-Secessionist Adolf Loos, who propounded a total simplification of architectural form. Pronouncing that "ornament is crime," Loos' buildings were among the first examples of the new rationalism and functionalism in European architecture which was ultimately to change the appearance of the human environment.

The cause for the unparalleled outburst of energies may very well lie partly in the highly divergent cultures which fused in the Hapsburg capital, the city on the Danube that reigned over ethnic groups that spoke German, Hungarian, Czech, Slovak, Polish, Rumanian, Slovenian, Croatian, Serb, Yiddish, Italian, Ruthenian, etc. But the ferment was undoubtedly also partly due to the number of brilliant and cultivated Jews who rebelled against the austerity of Orthodox Judaism as well as the repressive hypocritical moral code of a worn-out aristocracy to which they had no access. They were also subjected to the constantly rising wave of anti-Semitism among the populace, exemplified by Karl Lueger, mayor of Vienna from 1897 until 1910. We must remember that it was in Vienna that Hitler developed his political polemics; and also that Theodor Herzl, journalist for the *Neue Freie Presse*, formulated his ideology of Zionism, based on the belief that the true emancipation – so deeply longed for by his intellectual confreres – was neither possible nor desirable.

Vienna was a city which did not have a truly great tradition in painting. At the turn of the century Gustav Klimt, president of the Vienna Secession, moved from elaborate decorative paintings toward evocative symbolist murals and sumptuous portraits of Viennese ladies. He became the most sought-after portraitist for depictions of women who were almost imprisoned in their luxurious environment. His women relate to characters who in the plays of Schnitzler and Hoffmansthal are part of an illusory stage world without a power of their own. These women seem to live a life of luxuriant futility, part of an overripe civilization far gone toward its decline.

Klimt, Austria's first modern painter, was of great importance to the younger Austrian artists, Oskar Kokoschka, Max Oppenheimer, Richard Gerstl, and Egon Schiele. These men, coming of age slightly later than the Dresden group, no longer believed in the idea of a "community of artists," but saw themselves as separate, indeed isolated and lonely artists entirely alone in their search for artistic and personal identity. Indeed, Adolf Loos spoke about a "monstrously powerful individuality." Their highly introspective portraits – and portraiture was the prime subject matter of the Viennese Expressionists – depict the anxiety and pain of Vienna's intellectuals and are indeed mirrors of that unquiet sensibility.

Typical of Oskar Kokoschka's series of analytical portraits is that of his friend,

the architect Loos, the man who very early on recognized the young painter's great talent and introduced him to the realm of Vienna's intelligentsia.

Kokoschka, who had come to Vienna from a small town on the Danube near the Czech border in order to study painting, had achieved full maturity as an artist when he did this painting at age twenty-three. In these early portraits the artist projected himself into the painting, while simultaneously showing deep psychological insight of the personality and character of his sitter. The artist painted this canvas fluidly with nervous rapidity by means of brush, hands, and rags. He used a flickering light to emphasize the essential elements, head and hands; and renounced the world of bright color for the darkness he needed to give substance to his vision of anxiety. Although not a friend of modern art, Sir Ernst Gombrich, who himself grew up in pre-war Vienna, recognized the depth of insight and radical breakthrough of these portraits, and wrote that "it is the intensity of the artist's personal involvement which made him sweep aside the protective covering of conventional 'decorum' to reveal his compassion with a lonely and tormented human being. No wonder, perhaps, that the sitters and the public felt at first uneasy and shocked by this exposure."[10]

After a difficult period and serious injury in the war, Kokoschka settled in Dresden for a brief time, long after the Brücke painters had left the Saxon capital. His work slowly became less imbued with tragedy and he could do a fresh watercolor such as *Lovers with Cat* in 1917 in which the movement of the brush has become of even greater importance and in itself carries the psychological message. This is a painting of the actress Käthe Richter and the poet and playwright Walter Hasenclever in a composition based on Lucas Cranach's *Apollo and Daphne*. Hasenclever, like the early Kokoschka and so many other Expressionist writers and artists, was concerned with the utopian emergence of the "New Man" in the turbulent post-war period.

Beginning in 1924 Kokoschka set out to paint his *Orbis Pictus* of the great cities of Europe and the Middle East, such as *Jerusalem*, 1929. These cityscapes are generally seen from a distant vantage point and infused with light. They are more related to Impressionist painting as well as Kokoschka's own native Baroque heritage and move away from his early restless Expressionist visions.

Max Oppenheimer, known as Mopp, was a member of the Viennese avantgarde. He also painted emotionally charged, incisive portraits during the first decade of the century. In 1911 he began working with Franz Pfemfert for the vanguard left-wing periodical *Die Aktion* in Berlin, while Kokoschka became for a time the collaborator and art advisor to Herwarth Walden's *Der Sturm*. By 1916 when Mopp painted *The World War*, he had clearly absorbed the impact of Cubism and Futurism and used typography to carry his anti-war message by using French, English, Italian and American newspapers, envelopes and cigarette wrappers for his *trompe l'oeil* picture.

Richard Gerstl, too, painted several psychological portraits – mostly self-portraits – of sexual torment. At the same time he painted pictures in bright Fauve colors, applied with vigorous brushstrokes, of the Schoenberg family, who were his friends. Arnold Schoenberg himself was entirely self-taught as a painter, but took his painting very seriously and often turned to it for the experimentation with ideas that he could not work out musically. He has sug-

FIGURE 4. Egon Schiele, *Vally in Orange Blouse*, 1913, pencil, water-color, and gouache, 12¾ × 16⅜", Sabarsky Collection, New York.

gested that the almost hallucinatory color visions that he made around 1910 may have been done in some kind of trance. Wassily Kandinsky, whose own creation of a new and radical kind of painting was parallel in many ways to Schoenberg's essential contribution to the history of music, appreciated the composer's painted apparitions and pointed out that "Schoenberg does not really think of the picture while painting. Renouncing the objective result, he seeks solely to ascertain his subjective emotion and needs therefore only those means which appear to him unavoidable at the moment."[11]

Schoenberg, Kokoschka, and Mopp, realizing that the focal point of the Central European avant-garde was moving to Berlin, went there before the outbreak of World War I; Gerstl had committed suicide in 1908, at twenty-five. "There remained only one artist capable of producing a valid version of Expressionism out of the indulgent sensuousness of the Secession style: Egon Schiele who reached maturity only a few years before he died in 1918."[12]

Schiele's *Self-Portrait* of 1910 shows the young twenty-year old artist in a rigidly frontal pose. The flat, two-dimensionality of the painting and the emphasis on the evocative quality of line clearly derives from the older Gustav Klimt, who in many ways was Schiele's teacher. But, where Klimt's line is subtle, languid and passive, Schiele's contour is hard, brittle and angular; it has become an active agent, which, instead of flowing like water, pushes hard over obstacles. Klimt's patterned decorative background has been eliminated and there is only the isolated figure, stark and austere, framed by wavy lines.

Schiele, preoccupied with his own identity, painted many searching portraits of himself; but perhaps his most important work revolves around the female figure, which he often explored in its most intimate aspects. He revealed

women and girls in the most unexpected erotic poses. He painted and drew them in various states of undress, singly or in lesbian embrace as in *Friendship*, 1913; in half-dressed, seductive poses; or naked and pointedly exposed. Although he was incarcerated in 1912 on a charge of immorality and seduction, Schiele advanced beyond pornography by the very intensity of his artistic expression, by the vitality of line and the seriousness of his conception. The viewer can feel that Schiele drawing his nudes was even more passionately engaged in the act of drawing than in the erotic content. His adolescent and preadolescent girls are not Lolitas, but highly neurotic creatures with odd, oversized heads who display a guilt over their exhibitionism, their masturbation, the lesbianism to which they seem driven. Schiele's women do not enjoy themselves. Rather, like Bosch's creatures, they seem to be compelled to engage in their sexual activities.

Schiele even more than Kokoschka exemplifies the strange combination of erotic hedonism and anguish which characterized the febrile state of pre-war Vienna, likened by Karl Kraus to an "isolation cell in which one is allowed to scream." The artists pointed at the symptoms, as artists often do. The civilization to which they belonged was not to last.

MUNICH

"If I had a son who wanted to be a painter I would not keep him in Spain for a moment, and do not imagine I would send him to Paris (where I would gladly be myself), but to Munik [sic] . . . as it is a city where painting is studied seriously without regard to a fixed idea of any sort such as pointillism and all the rest."[13]

Unlike Vienna, a city which seemed to excel in just about every intellectual pursuit but had a relatively minor tradition in the visual arts, Munich was the European art center, second only to Paris at the turn of the century. It was the center of *Jugendstil*; it was the city where important international exhibitions of modern art were held with regularity, including one-man shows of Munch, Hodler, and Van Gogh. Artists from all over Europe and America came to Munich to study, to work, to meet colleagues and even to sell their work.

The attitude prevailing in Munich was much more form conscious than in other German centers. It was there that the sculptor Adolf von Hildebrand worked and published his influential book, *The Problem of Form in Painting and Sculpture* in 1893. At the University, Theodor Lipps formulated his theory of empathy and his student, the *Jugendstil* architect August Endell, announced his totally abstract art – at least in theory – as early as 1897, writing: "We stand at the threshold of an altogether new art, an art with forms which mean or represent nothing, recall nothing, yet which can stimulate our souls as deeply as only the tones of music have been able to do."[14] In 1904 Julius Meier-Graefe issued the first critical history of modern art in which formal values, as manifested chiefly in French painting, form the main criterion. Perhaps the most consequential book was Wilhelm Worringer's *Abstraction and Empathy*, published in 1908.

In 1909 a group of advanced artists formed their own art association, the *Neue Künstlervereinigung* (New Artists' Association), a loosely organized group of painters and sculptors, as well as musicians, dancers, and poets. Their exhibitions were

31

characterized by the very absence of a specific style. From the beginning their work differed sharply from the vehement Expressionism of the Brücke and from the compulsively introspective art which was so characteristic of their Viennese contemporaries.

The membership of the group included artists from France, Italy, and Austria as well as Germany. Its chairman and most influential force was the Russian Wassily Kandinsky, who had come from Moscow to study in Munich with Anton Azbé, and then Franz von Stuck, an artist who painted fantastic subjects in an academic style. In Stuck's atelier Kandinsky had his first encounter with Paul Klee, who had come from Berne and with Alexeij von Jawlensky and Marianne von Werefkin, both of whom had been students of Russia's fine Symbolist painter, Ilya Repin in St. Petersburg. Gabriele Münter arrived from Berlin to study at the Phalanx School which Kandinsky established in 1902. Most of the artists had experimented with Impressionism and rejected it in favor of a more definite form, imbued with evocative thought. Their ideas can be compared with those of the Symbolists. In their early gatherings at Werefkin's studio they were, in fact, joined by Gauguin's disciples Paul Sérusier and Jan Verkade, the latter now in habit and known as Father Willibrod of the abbey Beuron.

Soon, in the third year of its existence, controversies about the nature of modernism caused the New Artists' Association to split; Kandinsky and Franz Marc formed *Der Blaue Reiter*. The name itself had many associations with tradition from the medieval and romantic periods. The legendary first Blue Rider exhibition in December 1911 included work by Kandinsky and Marc, Münter, and Kubin, the artists who had seceded from the earlier group, as well as paintings by Henri Rousseau, Robert Delaunay, August Macke, Albert Bloch, David and Vladimir Burliuk, and others. It was to travel to Cologne, where it was shown under the sponsorship of Emmy Worringer, sister of the young Munich art historian, and then in Berlin, where it helped inaugurate the phenomenal series of avant-garde exhibitions in Herwarth Walden's Sturm gallery.

At the same time Kandinsky and Marc assembled material for the first (and only) almanac *Der Blaue Reiter*, a book which in retrospect appears to be the most important printed document of early 20th-century art, precisely because it was *not* a compendium of aesthetic theories and was consequently neither didactic nor formalist. It proposed a program of modern art by finding relevant links to the past – links, not traditions. "Traditions," Marc declared, "are lovely things – to create traditions, that is, not to live off them."[15]

For the first time, works of art that seemed totally unrelated were placed together: Egyptian shadow puppets, children's drawings, Bavarian glass and mirror paintings, Gothic, African and Pacific sculpture, paintings by the *douanier* Rousseau and Baldung Grien, by Matisse and Cézanne and El Greco, by Picasso, Delaunay, and Kandinsky, Russian folk prints and Chinese paintings as well as Byzantine mosaics. The book, like the exhibitions of the group, established connections among artists in all countries working in new directions and broke through periods and genres, searching solely for the inner spirit that motivated the result. For the first time, as Klee stated later, the personal commitment, the concept and attitude of the artist was more important than the actual result. Franz

FIGURE 5. Wassily Kandinsky, *Composition IV*, 1911, oil on canvas 62⅞ × 98⅝", Kunstsammlung Nordrhein-Westfalen, Düsseldorf.

Marc explained: "We went with a divining rod through the art of the past and present. We showed only that art which lives untouched by constraint and convention. Our devoted love was extended to all artistic expression which was born of itself, lives on its own merit and does not walk on the crutches of habit. Whenever we saw a crack in the crust of convention we hoped to find an underlying force that will someday come to light."[16]

In their search for the basic organic rhythm underlying all of man's artistic, religious and philosophical expressions, they also hoped to bring about a synthesis of all the arts. Frequent references were made to poetry (e.g. Maeterlinck), and Kandinsky was very close to mystical religious ideas, especially as synthesized by Mme. Blavatsky and Rudolf Steiner. Above all, a close relationship was established to music. The almanac contains scores of the new music, rejecting traditional harmonic passages: there are contributions of scores by Schoenberg, Webern and Berg. While these scores were written prior to the full development of the twelve-tone scale, they were characterized by sustained intensity, complex tonality, and the expression of "inner necessity." Kandinsky himself, in fact, published the "script" for a "total stage composition," *Der Gelbe Klang (The Yellow Sound)*, in the almanac. Here he tried to realize the idea that drama, like music and painting, must discard naturalism and return to its mystic-religious origin. It attempts to communicate a total aesthetic, indeed a synaesthetic experience, extending the paradigm of Wagner's *Gesamtkunstwerk*. The action in this "mystery play" consists largely of changes in color and light as well as movement of gigantic pantomime figures which are more like live marionettes than actors. There is no narrative commentary but there are random sounds and phrases, as

33

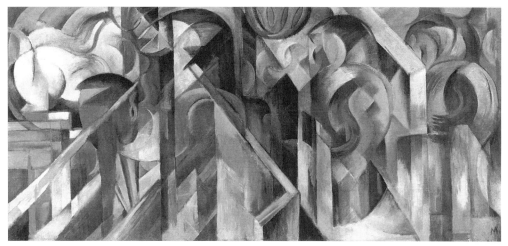

FIGURE 6. Franz Marc, *Stables*, 1913, oil on canvas, 29 × 62", Solomon R. Guggenheim Museum, New York.

Kandinsky felt that the human voice should not be obscured by words. The final aim of this color spectacle – much like Scriabin's earlier experiments with the color organ – was to elicit inner responses from the audience, to reach the spirit, or as Kandinsky would have it, "to cause vibrations in the soul." This, then, was the incredibly ambitious purpose of the new kind of art which brought about totally abstract painting on the part of Kandinsky. The Blue Rider indeed travelled into mysterious and unexplored territory, into dreams, into fantasies and toward the creation of new artistic formulations, which were often based on a total identification of the artist with nature itself. Paul Klee, who had a small drawing reproduced in the almanac, noted in his diary in Tunisia in 1914: "I myself am the moonrise of the South."[17]

In a painting by Kandinsky such as *Winter Study with Church* of 1911 we experience this feeling of empathy with nature, in this case the snowy Murnau landscape, expressed in enhanced color and more concerned with the feeling inspired by the subject than the subject itself. By 1913 and 1914 the painter had left the realm of representation behind. The secure barriers of the known world are abandoned as the artist, following his "inner necessity," explores the world of the unknown. The pictorial cosmos of these paintings has become independent and autonomous; a new and free world has been unveiled.

Kandinsky and Marc – as well as Paul Klee – believed that art follows nature in its spiritual inner laws, not in its external manifestations. Franz Marc sought to paint pictures that would recreate the internal rhythms of nature: "We will no longer paint the forest or the horse as they please us or appear to us, but as they really are, as the forest or the horse feel themselves – their absolute being – which lives behind the appearance which we see."[18] He uses the expressive force of strong color for his evocation of the power of nature and eventually, under the influence of Kandinsky's oceanic abstractions and Delaunay's cosmic visions, Marc created what he referred to as his "inner mystical constructions." *Stables*, 1913–14, is a painting in which form, color and light are transparent and pervade each other, a painting which, unlike the work of the Expressionists of the North,

establishes a lucid sense of order, but an order that has been reached by a pure sense of intuition.

It was August Macke who had introduced his friend Franz Marc to the joy of color. Macke himself knew about Fauvist color and Cubist structure and shared Kandinsky's and Marc's thoughts on the spiritual possibilities of color. Never a mystic, however, Macke painted some of the most truly enchanting pictures of the period in which even the people in the parks are part of the visual joy. Macke, like his friend Franz Marc, was killed in the trenches of World War I.

Among the painters who followed the lead of Kandinsky and Marc were Heinrich Campendonk, who, like Macke, came to Munich from the Rhineland and painted imaginative semi-Cubist paintings, and the American Albert Bloch who had come from St. Louis and did charming carnival-like paintings of dancers, harlequins and pierrots. After considerable success in Germany, Bloch returned to the United States, where he was head of the art department of the University of Kansas for almost thirty years.

The deep mystical longing for a new religiosity of the Blue Rider, however, was to find its protagonist in Alexeij von Jawlensky. Jawlensky, originally a Russian officer, felt the need to become an artist and studied in Munich and travelled a great deal. He had come under the influence of Gauguin – he even painted in Pont-Aven for a while – and then found his own way to sonorous color compositions by way of Matisse and Kandinsky. In the pre-war years in Munich Jawlensky painted heavily outlined landscapes in powerful contours, and strong heads such as *Spanish Woman*, 1912, where the features have solidified into a hieratic painted idol. The solidity of form in this head and the emphasis on definite shapes – the lines of the eyes, the line of the nose, the lines of the mouth – and the resonant palette led Jawlensky eventually to his iconic meditative heads of the post-war period.

BERLIN, FRANKFURT, WEIMAR

Whereas Paris and London had for centuries been centers of cultural activity, Germany had no such single focal point. Instead, largely because of the late political unification of the country, Germany sustained its tradition of small but important cultural centers in various principalities and semi-independent kingdoms, such as Bavaria and Saxony.

After the unification of Germany in 1871, however, Berlin grew into a cultural center of considerable significance in spite of the Kaiser's bellicose attitude toward all arts but those of war. The new capital of the Reich began to emerge as the point of cultural focus for the entire country. First performance of revolutionary plays by Ibsen, Strindberg, Hauptmann, and Wedekind had put Berlin stage drama in the forefront of the development of a new theater. Max Reinhardt converted the traditional stage into a magic world of symbols. Replacing the scene painter with the "stage architect," he created a stage "at once tribune, pulpit and altar." Reinhardt in turn was soon to be replaced by the daring constructivist Erwin Piscator as the leader of the avant-garde. Playwrights, actors, poets, novelists from all over Germany settled in Berlin.

In the visual arts, the Berlin Secession, founded in 1892 under the leadership

of Max Liebermann in protest against the closing of an exhibition of paintings by Edvard Munch, assumed a position of leadership in German art and grew into the rallying center of German Impressionists. The galleries of progressive art dealers such as Paul Cassirer, Alfred Flechtheim, and later Fritz Gurlitt, I. B. Neumann and Herwarth Walden, became meeting places for appreciators and collectors of modern German and foreign art. Artists and intellectuals of all descriptions lived in an environment mingling Prussian respectability with Bohemian cosmopolitanism. The name of the cafe where many of these people congregated – *Grössenwahn* (Megalomania) – is typical of the self-conscious cynicism of Berlin's bohemia. After the war, Berlin, capital of the Weimar Republic, became the vortex of a country in turmoil, the focal point of political, social and cultural ferment, the fabulous, depressing and exuberant stage of Bertold Brecht's plays.

Around 1910 most of the Brücke painters moved to Berlin, where they rallied once more with the foundation of the New Secession, in response to the refusal by the old Berlin Secession to show the work of the avant-garde. It was in Berlin, in fact, during the remaining years of peace, that the Brücke artists created what may very well be their finest works. Otto Mueller, an artist who in many ways was more traditional than the original Brücke group, had moved to Berlin as early as 1908, where he was close to Wilhelm Lehmbruck, whose sculpture of the human figure is also characterized by restrained, sensitive elongation. Mueller's thinly painted distemper pictures were in significant contrast to the heavy brush favored by his more impetuous friends from Dresden. Mueller's are quiet, lyrical, idyllic works, such as the intimate *Woman in Boat*, 1911, a painting of gentle curvilinear rhythm in blue and beige. The motif is similar to Pechstein's nudes in the forest: it is also based on a liberated attitude toward nudity and nature, but the mood is quiet and meditative. Some of the nature of Mueller's personality is evident in Kirchner's portrait of his friend, painted in 1913, but Kirchner's painting is highly dramatic, owing to the strong contrast of light and dark, the heavy brushwork and the angular V-shapes, so characteristic of his work after his move to Berlin in 1910.

Kirchner, a highly sensitive individual, was drafted into the German army, which brought about his physical and emotional collapse. The malaise of his military service is represented in his *Artillerymen*, 1915, in which a large number of emaciated naked men are pressed together in a small shower room under the surveillance of one of the officers. The painting expresses the extreme constraint and confinement of life in the barracks. In his *Self-Portrait as Soldier* of the same year, he appears in a pose similar to that used to depict Otto Mueller. He envisages himself with an amputated painting arm. His thin, drawn face stares out at the viewer without expression. In the background is the full-front figure of a nude woman and an unfinished painting hangs on the wall. The picture clearly symbolizes impotence and frustration. "Seen historically, *Self-Portrait as Soldier* expresses metaphorically that state of siege between private life and public death that the bitter war with its sluggish front and fruitless sacrifices had by now become. Unresolvable conflicts are unresolvable: this work is one of the great war paintings of the twentieth century because it so clearly and matter-of-factly indicts Wilhelminian Germany and chauvinistic Europe."[19]

It is revealing to compare two portraits by two Brücke painters: Max Pechstein's

Portrait of Louise Mendelsohn of 1912 is a very positive statement. His likeness of Louise Mendelsohn, the beautiful young wife of Germany's great architect, is represented in vivid color in one of Pechstein's truly flawless compositions. Schmidt-Rottluff's *Portrait of Emy*, 1919, painted after the War, is fraught with tragedy, due to the pensive pose, and primarily the frightening round left eye which seems to float disembodied in front of the model's face.

This troubled mood, however, prevails as early as 1913 in a painting such as Ludwig Meidner's *Apocalyptic Landscape*. A presentiment of the coming catastrophe seems to be expressed by the distorted perspective, compressed forms, and exploding earth and sky. The heaving streets, the toppling houses, all painted with a vehement brushstroke, evoke a sense of terror. Many years later, at the end of another world war, Berlin assumed an appearance not unlike Meidner's prophetic cityscape of doom.

Nolde settled in Berlin in 1905 and painted highly charged messianic paintings of biblical subjects – totally personal visions, often painted as if the artist were in a trance – and also paintings of masks, undoubtedly inspired by his visit to James Ensor in Ostend in 1911. *Masks*, 1911, evokes a feeling of terror not only by the grotesque expressions, but also by the unexpected color and contrast between defined angular masks and others that seem to be almost evanescent. Nolde's own sense of magic is often transmitted in his work. And in far-away exotic countries he could find man in a primordial condition open to magic and mystical experiences. In 1914 Nolde sailed to the South Pacific as pictorial reporter of an expedition, organized by the German Colonial office. Nolde completed a number of remarkable canvases of the Melanesian islands, such as *Nusa Lik*, painted in New Ireland (Germany's colony of New Mecklenburg at the time) in 1914. The whole vast lonely scene with its little boats in the small bay and the green sea under a bank of clouds has been transformed into large and decorative rhythms of blues and greens.

In a watercolor, *South Sea Island Chief*, Nolde offers evidence of his admiration for pure native stock, the Noble Savage, whom he imagined he would encounter in the South Seas. In his diaries he spoke with romantic adulation of the unspoiled races he encountered there. Imbued with a belief in racial purity and a blood-and-soil mystique as necessary preconditions for the creation of pure and good art, Nolde joined the Nazi party very early. When the National Socialists came to power, however, Nolde was ironically smeared as a "degenerate artist" like all the other modernist painters and sculptors, and was prohibited from painting. It was during that time that he made a large number of watercolors, which he called "Unpainted Pictures," in his lonely house in the marshes on the northern border of Germany. In these visionary paintings by a true colorist, "Nolde's private world has been transfigured into a serene realm of human actors, whose chief function is their subservience to the color which gave them birth."[20]

Christian Rohlfs was the oldest of the painters identified with German Expressionism. Born in 1849, only a year after Gauguin, he was at least a generation older than the painters of the Brücke or the Blue Rider. His background, like Nolde's, was the ancient peasantry of Holstein. Rohlfs, artist in residence at the Folkwang Museum in Hagen, Westphalia, saw the art of his friends and German contemporaries and responded to their experiments in a highly personal way.

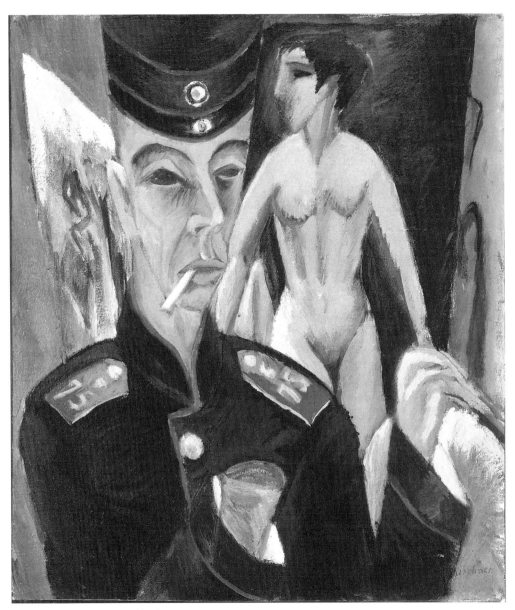

FIGURE 7. Ernst Ludwig Kirchner, *Self-Portrait as Soldier*, 1915, oil on canvas 27¼ × 24", Allen Memorial Art Museum, Oberlin College, Oberlin, Ohio.

The dynamic landscapes he painted early in the century were influenced by Van Gogh's agitated canvases. Later, Rohlfs turned to religious subject matter with a totally personal cast as in *The Return of the Prodigal Son*. In his old age, he painted delicate landscapes, cityscapes, flower pieces and occasional portraits in oils, watercolor, and crayon, paintings in which objects are mysteriously dematerialized and dissolved into veils of color.

By the war's end Expressionism had really run its course. In the presence of political reality, confronted with the brutality of post-war conditions, the Expressionists with their introverted attitudes were largely at a loss as to how to respond. The Berlin Dada group, with its engagement in political action (em-

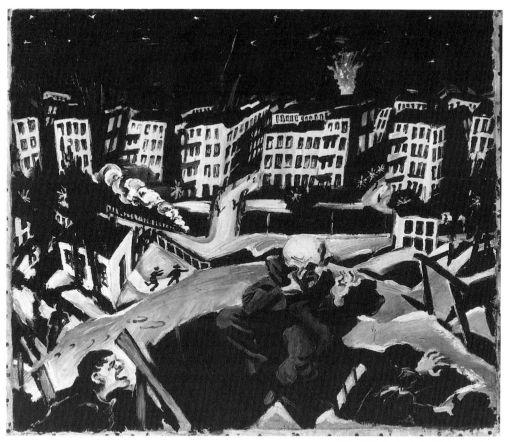

FIGURE 8. Ludwig Meidner, *Burning City*, 1913, oil on canvas, 26½ × 32¼", The Saint Louis Art Museum.

phasis on action!) and its vilification of middle class culture and patronage, directed some of its manifestos against "bourgeois decomposition, lunatic Expressionism and every kind of false emotionalism."[21] The Expressionist group did, however, join in the utopian *Novembergruppe* which, in fact, was co-founded by Max Pechstein, and soon included practically every avant-garde painter, sculptor, architect, composer, poet and playwright. Their utopian programs for the arts would bring about a better future and a new society. Pechstein announced in a revolutionary pamphlet of the Worker's Council for Art the "desire to achieve through the socialist republic not only the recovery of the conditions of art, but also the beginning of a unified artistic era."[22] It seems ironic but it is an indication of the total confusion of post-war Berlin that such faith in the "socialist republic" could still prevail a short time after the Social Democratic regime had been implicated in the murder of the radical leaders Karl Liebknecht and Rosa Luxemburg, but the Expressionists had become close to being the official artists of the Weimer Republic and the artists were eager to put their work at the disposal of the government. "For the first time the artist was deprived not of his social acceptance but of his isolation."[23]

The heightened emotion of the pre-war years could not be sustained and the Expressionist artists themselves now worked in a less amorphous, a more defined

form, clearer delineation, a return to illusionist space, and more attention to detail. In other words, a generally more conservative art came to the fore in Germany as it did in the rest of Europe. The New Objectivity movement of the 1920s was often sober and neutral in its reportage of the urban environment. It gained strength and patronage after the economic consolidation in 1924 following the catastrophic Inflation. The radical left wing of this group consisted of men such as George Grosz and Otto Dix, who were politically engaged and painted savage pictures of accusation and used art as a weapon of revolution. Max Beckmann was included in the first exhibition of the New Objectivity in 1924, but he belonged neither to that nor to any Expressionistic group. In his twenties Beckmann had been a highly successful conservative painter. After his first experience in the War, where he "looked horror in the face," his style changed quite abruptly and gained inner depth. He announced his goal clearly when he said: "Just now, even more than before the War, I feel the need to be in the cities among my fellow men. This is where our place is. We must take part in the whole misery that is to come. We must surrender our heart and our nerves to the dreadful screams of pain of the poor disillusioned people . . . Our superfluous self-filled existence can now be activated only if you love them."[24]

Settling in Frankfurt after the War, Beckmann tossed out all the academic craft that he had mastered and turned to eloquent depictions of the human tragedy, cramming figures into the "dark black hole" of space. Finding affirmation in late medieval German panel painting, he turned toward religious subject matter as in *Christ and the Woman Taken in Adultery*, 1917. The strangely pale color, the pointed angularity of his linear forms, the crowded figures moving in their restricted Mannerist space, carry his dramatic message. The action of many of Beckmann's paintings seems to unfold on a stage and here, the biblical scene is enacted by distorted figures through a silent conversation of hands. There is an existential absence of human contact. A similar detachment exists in *Family Picture*, 1920. Six desperate people are compressed into a small crowded, low-ceilinged room. The artist himself, surrounded by his family, lies on a narrow piano bench, clutching a horn. Again there is no communication, no contact among the members of the family in this picture, which is one of Beckmann's cogent images of the great anxiety prevailing at the time: his "resolve to rationalize the horrible vision of the ravaged world."[25]

The Bauhaus, founded by Walter Gropius in Weimar in 1910, was a very different attempt at finding a rational solution to the turbulence of the time. It was to signal a new union of the arts and crafts and eventually of art technology. It created a new language of form. It was to alter art, design and art education throughout the western world. One of the first painters whom Gropius appointed to be a master at the Bauhaus was Lyonel Feininger, whose woodcut, *The Cathedral of Socialism*, was the cover of the First Bauhaus Manifesto. As early as 1912 Schmidt-Rottluff had asked Feininger to join the Brücke and a year later he accepted Franz Marc's invitation to exhibit with the Blue Rider at Der Sturm in Berlin.

When Feininger first came to Germany from his native New York in 1887, he was still undecided whether to follow a career in art or music. The severe structure

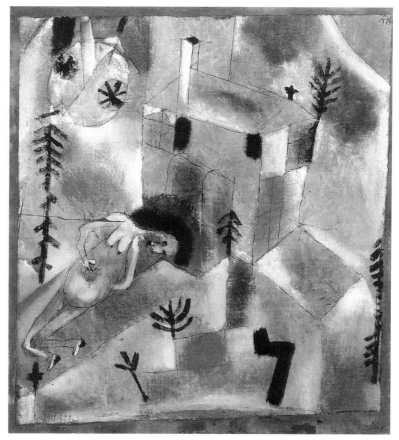

FIGURE 9. Paul Klee, *Death in the Garden (Legend)*, 1919, oil on canvas on wood, 10¾ × 9¾", Col. Joseph R. Shapiro, Chicago.

of music remains visible in all his painting. He felt that his work should come close to the "synthesis of the figure" and this is precisely what he accomplished.

The painting *Side Wheeler at the Landing*, 1913, is an example of his early Cubist fragmentation of form into visionary synthesis. As time went on, Feininger created a crystalline world, whether he painted bridges, medieval churches, or vast skies and ocean beaches. In his clearly articulated paintings he dealt with his personal fantasy with the precision of a scientist.

Paul Klee became a Bauhaus master in 1920. His transparent *Death in the Garden*, 1919, may be read as a metaphor for the troubled times, but it may just as well be personal experience or excursion into the realm of the dream. Klee was to continue ceaselessly to experiment with forms, ideas, techniques, finding his sources in nature, in music, in poetry, in the study of biology and philosophy, in the art of children and the less traditional art of the European tradition, in his thought and dreams. Whether he painted people out walking or flowers that bloom in the dunes or a Sicilian September Klee's eye and mind penetrated deeply into all aspects of creation, and his brush knew that the world "in its present shape is not the only possible world."[26]

This statement made by Klee in his famous Jena lecture in 1924, sums up the

goal of the Expressionist artists, even if most of them did not reach the heights and depths of Klee's own painting. But Klee, teaching at the Bauhaus, was also aware of the problems of the avant-garde artist in society, and concluded that lecture on a note of pessimism: "The people are not with us."

Even so, almost every Expressionist artist was eventually elected to the Prussian Academy of Arts, and the "style" was quite readily accepted; it became semi-official to such an extent that even Joseph Goebbels was willing – for a short time – to adopt it as the German and Nordic art, but it could not conform. The essence of Expressionist painting and sculpture, literature and theater, was its totally in-dividualistic and thoroughly anti-authoritarian attitude. In spite of the Expres-sionists' search for a true community, a spiritual Gemeinschaft, their very subjectivity did not permit them such social coherence except in theory.

Furthermore, most of the artists – former members of the Brücke, some of the adherents of the Blue Rider, or Oskar Kokoschka – could not sustain the almost feverish, anxious and tense quality of their early work and turned toward more traditional forms in their mature years. So far as the Expressionist movement was concerned, Wilhelm Hausenstein, the art historian, announced as early as 1920: "Expressionism, artistically has long since danced itself out . . . Expressionism has its *Glaspalast*. It has its Salon."[27]

The Expressionist phenomenon was, then, in nature transitory. Very few artists in Germany continued the Expressionist legacy and made major contributions to artistic creativity in the inter-war period. Kandinsky in his Bauhaus years (1922–1933) moved into a realm of carefully conceptualized painting concerned with the meaning of form. Max Beckmann and Paul Klee, however, advanced the Expressionist spirit in their unique, personal ways. They also verbally articulated their artistic purposes. Beckmann declared, "What I want to show in my work is the idea which conceals itself behind so-called reality. I am seeking for the bridge that leads from the visible to the invisible."[28]

3 EMERGENCE OF THE AVANT-GARDE

ERSTER DEUTSCHER HERBSTSALON OF 1913

The Erster Deutscher Herbstsalon (Sept. 20–Dec. 1, 1913), organized by Der Sturm in a rented space on Berlin's Potsdamerstrasse, was the first exhibition to focus solely on the art of the prewar avant-garde.* There had been, to be sure, important international shows previous to this milestone; among them were, above all, the salient Sonderbund Exhibition of 1912 in Cologne, and its offshoot, the huge Armory Show of 1913 in New York. But these exhibitions included many of the precursors of the modern movement, with works reaching back to El Greco (in the Cologne exhibition) and Goya (in New York). Nor did they concentrate exclusively on the modern movement.

Roger Fry, who had also visited the Sonderbund Exhibition before organizing the Second Post-Impressionist Exhibition at London's Grafton Gallery in the fall of 1912, exhibited primarily works by Matisse and the Fauves as well as by Picasso and Braque, together with contemporary English painting. But as Herwarth Walden explained in his introduction to the Erster Deutscher Herbstsalon catalogue, the Sturm exhibition presented "a survey of the new movement in all countries." The exhibition emphasized the movement's new and international aspects. The only exception was the grouping of twenty-two works by Rousseau as a memorial to the douannier, who had died in 1910.

Walden, the self-appointed champion of modernism, to which he referred as Expressionism as early as 1912, asserted that he felt justified in the organization of the exhibition for these reasons: "I am convinced by the worth of the artists represented here and because I am a personal friend of the most significant artists of this new movement" – a claim which, although arrogant, was also true.[1]

During its twenty-two years of operation, Der Sturm was a periodical, a publishing house, an art gallery, a school, a theater, and the meeting-place of the

* This essay originally appeared in German in *Die Kunst der Ausstellung* (Berlin, 1991). Reprinted with permission of Insel Verlag, Frankfurt am Main.

FIGURE 10. Title Page of Catalogue, *First German Autumn Salon*, Berlin, 1913.

international avant-garde. It was all that, but it was also strictly a one-man operation. The great Expressionist poet August Stramm summed it up when he stated: "Der Sturm ist Herwarth Walden."

Herwarth Walden was a remarkable man responding to the pulsations of a remarkable age. Born into a well-situated Jewish Berlin family, he studied music, became a concert pianist and composer of considerable talent (in 1897 he was awarded the Liszt Stipendium by the Berlin Conservatory of Music), and continued to play and write music for the rest of his life. He wrote poetry and prose and was a keen critic of literature, music, and art. Walden became an impresario, a great publicist and propagator of novel ideas. Through his own prodigious energy and enthusiasm and the hydra-headed organization he created, Walden became the catalyst of the modern movement and the focal point of Expressionism, a term he made popular. Walden was fascinated by the new, intrigued by the different and the provocative, but he also had a most astounding sensitivity for quality; for a number of years during the prewar period, his critical choice of literature and art coincided with the truly significant new currents of both.

In 1904, when he was still in his twenties, he founded the Verein für Kunst, as a meeting place of the Berlin avant-garde writers, providing a platform for Heinrich Mann, Thomas Mann, Wedekind, Rilke, Richard Dehmel, Alfred Döblin, and Else Lasker-Schüler, who became his first wife. Lasker-Schüler, known as an exotic, highly temperamental person, wrote dreamy, subjective, and very personal poetry. She also decided to change her husband's name from Georg Lewin to the more artistic and mysterious (and less Jewish-sounding) Herwarth Walden. As the polemical editor of a whole series of literary magazines, he became a highly visible and controversial figure in the intellectual life of Berlin. As early as 1909 he published, not only Strindberg, but also an early work by Franz Kafka and

came to the attention of the brilliant Viennese cultural critic and satirist Karl Kraus.

Kraus came to Walden's defense when the latter was dismissed as editor of the theater magazine *Der neue Weg*, largely for his attempt to turn this popular journal into a more intellectual periodical, which was to include new material from the Nietzsche archives, published diaries of E. T. W. Hoffmann, and other substantial fare. When Walden finally issued his own periodical, the weekly *Der Sturm* in March 1910, it was Kraus's brilliantly controversial *Die Fackel* that provided the standard. During the first year of its publication Vienna as well as Berlin appeared on the masthead of *Der Sturm*. Kraus also introduced Walden to his friend Oskar Kokoschka, and *Der Sturm* published Kokoschka's early Expressionist play, *Mörder, Hoffnung der Frauen*, which had scandalized the citizens of Vienna at the Kunstschau in 1908. Indeed Kokoschka became known as *Bürgerschreck* in the capital of the Dual Monarchy. At first the graphics of *Der Sturm* had consisted mostly of caricatures, until Kokoschka began to furnish drawings to the magazine at the end of its first year of publication. Among them were a series of portraits, his *Menschenköpfe*, for *Der Sturm*'s front pages. These included celebrities from different walks of life, such as Karl Kraus, Adolf Loos, Paul Scheerbart, Yvette Guilbert, and Walden himself.

By 1911 most of the painters of the Die Brücke had arrived in Berlin from the provincial capital of Dresden. Although they were still little known, they came to Walden's attention almost as soon as they arrived. He liked what he saw and provided them with the broad audience they wanted. He asked Max Pechstein and, soon thereafter, Nolde, Heckel, Kirchner, and Schmidt-Rottluff to contribute drawings and woodcuts to his journal, which brought it almost immediately into the controversies regarding avant-garde German art that were then raging in Berlin. This was precisely what Walden wanted.

By 1911 these artists, as well as many other members of the German and French vanguard, were called Expressionists, a term that entered the vocabulary of art criticism in France, England, and Germany at about the same time. Herwarth Walden and *Der Sturm*, however, seized upon the term as the appellation of the new art which it was to champion.

During the summer of 1911 Walden published an important essay in which the distinguished art historian Wilhelm Worringer maintained that Expressionism was a historical necessity of the time, one by which the artist, rejecting merely rational forms, seeks a return to the irrational abstraction of primitive and elemental forms.[2] Slightly later Paul Ferdinand Schmidt published an article in *Der Sturm*, "Die Expressionisten," in which he characterized such different artists as Vlaminck, Herbin, Pechstein, and Nolde as being concerned with the direct evocative power of plane, color, and space, and with inner truth rather than external verisimilitude.[3]

Still later, Walden and his group used the term "Expressionist" for anyone whom their hyperbolic criticism blessed with recognition, as when Walden with typical grandiloquence stated in his article "Kunst und Leben":

We call the art of this decade Expressionism, in order to distinguish it from what is not art. We are thoroughly familiar with the fact that artists of previ-

ous centuries also sought expression: Only they did not know how to formulate it.[4]

In March of 1912, Walden decided to organize the first of what were to be hundreds of Sturm exhibitions. For the first show he managed to combine works by Kokoschka with those by the Brücke artists and a large selection from the epoch-making first Blaue Reiter exhibition, which had originated in Munich a year earlier and was one of the milestones in the history of twentieth-century art. A long association of Blaue Reiter artists, particularly Marc and Kandinsky, with *Der Sturm* ensued.

But even before this first and highly important Sturm exhibition was installed, Walden had made a new and to him still more exciting discovery when he saw the first Futurist exhibition at Bernheim Jeune gallery in Paris. Immediately after it was shown at the Sackville Gallery in London, he ordered it shipped to Berlin, where it opened in April of 1912.

In Futurism Walden found a movement most suited to his own inclinations: aggressive in its opposition to the past, insistent on the most active participation of the spectator, who is transposed into the action of the painting – demanding that the modern artist concern himself with the twentieth-century world of velocity and consciousness of molecular movement and simultaneous sense impressions. The March 1912 issue of *Der Sturm* brought the readers Marinetti's original Futurist Manifesto, which frantically denounced tradition and extolled the virtues of racing cars, militarism, war, and a violent – if nebulous – future.[5]

The April issue of *Der Sturm*, announcing the opening of the exhibition, brought an article written by the five original Futurists. Here the Italian painters fault their French contemporaries – artists like Picasso, Braque, Léger, Derain – for only giving new pictorial form to the static world of Poussin and Ingres and returning to pre-Impressionist concepts instead of proclaiming the precepts of the contemporary world. They explained the idea of simultaneity in their work and stressed that the public must forget intellectual culture and tradition and open itself to new art of brutal primitivism as originated by Futurism.[6]

Walden, who actually thought of himself as the prophet of a renewal of life through art, became their clamorous spokesman. He publicized the first German Futurist show so widely that in spite of furious newspaper denunciations, there were days when a thousand visitors paid to see the exhibition. A great deal of the work was sold. Walden brought Marinetti and Boccioni to Berlin to lecture at his gallery, and he published postcards of paintings by Boccioni, Russolo, and Severini as well as reproductions of their work in his magazine.

The Futurist exhibition had an immediate effect on the German painters themselves. Franz Marc, for example, wrote a eulogy on the Futurists in *Der Sturm*, saying that "Carrà, Boccioni, and Severini will become milestones in the history of modern art. We will yet envy Italy its sons and hang their work in our galleries."[7] Similarly, the impact of work and ideas of the Futurists can be seen in the work of Paul Klee and Lyonel Feininger.

But while Walden became the convinced champion of Futurism – at least for a while – his interests continued to expand in many directions. In May 1912 he

commissioned Picasso to do the cover for the magazine while the third Sturm exhibition of French graphic art, featuring Gauguin, Picasso, and Herbin, was installed. This, incidentally, was the first time that Gauguin's color woodcuts from Tahiti were seen in Germany, and here Walden displayed work that was an affirmation of the Brücke artists, whose prints had developed in similar directions.

During the fall season of 1912 Walden's gallery introduced James Ensor to Germany, arranged the first retrospective exhibition of Kandinsky's work surveying his development from 1901 to 1912 and thus showed the origins of nonobjective painting, and arranged a one-man show for Gabriele Münter, one of the original members of the Blaue Reiter group.

In January 1913 Walden opened his first Delaunay exhibition. Delaunay, who had already exhibited in the first Blaue Reiter show, was of central importance in the development of its painters, especially Marc, Macke, and Klee, who had gone to Paris to visit him, to look at his work, and to discuss the significance of color and light in post-Cubist painting. Now Delaunay returned their visit, coming to Germany with his friend Apollinaire. In Bonn they stopped with Delaunay's closest friend among the Germans, August Macke, and then the three continued to Berlin, where Delaunay and Apollinaire gave lectures at Der Sturm. A translation by Paul Klee of Delaunay's essay *Sur la lumière* introduced the exhibition in the journal.

The interaction between Delaunay and the Blaue Reiter painters was most productive. While the French painter exerted perhaps the most important single influence on the development of Macke, Klee, and Marc, he was in turn stimulated by Kandinsky's nonobjective work and began experimenting with the elimination of subject-matter.

In the spring and summer of 1913, Walden presented a retrospective exhibition of Franz Marc, a show of Der Moderne Bund, an avant-garde organization of Swiss artists including Paul Klee.

During all these varied exhibiting and publishing activities Herwarth Walden traveled with frantic speed through most European centers from Budapest to Paris in preparation for his great exhibition, the First German Autumn Salon of 1913.

This exhibition was the climax of Walden's activities and at the same time it pinpointed the unfolding of the modern movement in its numerous diversified and international aspects. The exhibit consisted of 366 paintings and sculptures by some 85 artists. It was truly international, including work from Russia, India, Holland, Switzerland, Czechoslovakia, Austria, Italy, Turkey, China, Japan, and the United States of America, as well as France and Germany.

The exhibition was underwritten by Bernhard Koehler, a Berlin manufacturer and a collector and patron of modern art, who was also a distant relative of August Macke. Without him, Kandinsky recalled later, the exhibition, as well as the Blue Rider would have remained in the world of utopias.[8]

In March 1913 Macke wrote to Walden, who was staying in Paris at the time:

Koehler will guarantee the Herbstsalon to the amount of 4000 Marks under the condition that he will remain anonymous. Perhaps you can now talk to Apollinaire and Delaunay in regard to the representation of art from Paris. I think,

it is important, above all, to negotiate with Matisse and Picasso. Nobody who will exhibit in the Herbstsalon may show at Cassirer's. We can discuss the details later. I will immediately write to Franz Marc. It is most important that the major forces are on our side. . . . [9]

An unofficial selection committee, consisting of Macke, Marc, Delaunay, Kandinsky, and Walden himself was formed to carry out negotiations and preparations. Participating artists and their dealers were informed about the dates, space, transport, consignments, and conditions of sale. Der Sturm charged a commission of 15 to 20%, which seems to have been standard at the time.[10] Nevertheless some artists haggled consistently with Walden, who, actually, was a better impresario than a dealer.

Not everyone whose work was desired was, for one reason or another, able to participate in the great exhibition. Although both Picasso and Braque had been included in earlier Sturm exhibitions and Picasso had contributed a number of drawings to the magazine in 1912, their commercial commitments evidently made their contributions to the Herbstsalon impossible. Similarly, there were no paintings by Matisse, undoubtedly because he had been showing at Paul Cassirer's famous gallery as early as the winter of 1908–09 and had sent the first version of the *Dance* to the exhibition of The Free Secession in Berlin, of which Paul Cassirer was president. This may also account for the surprising absence of the Brücke painters, artists who had been so closely associated with *Der Sturm* since 1912. They too were beginning to be associated with Cassirer's far-flung operations by the time the Herbstsalon opened its doors. Commercial considerations were certainly an important part of the whole enterprise.

In early September Marc and Macke, together with Walden, began to install the exhibition in a space which Walden rented for this purpose at Potsdamerstrasse 75, not far from the regular Sturm exhibition quarters at Potsdamerstrasse 134a. The space for the Autumn Salon measured 1200 square meters. Partitions, 2.20 meters high, were installed for the occasion and the walls were covered with sack cloth.[11]

After the exhibition had opened Marc, back home in Sindelsdorf at the foot of the Alps, wrote to his Blaue Reiter partner in Murnau:

My guiding idea for the selection and hanging of the pictures was at all times to show the extraordinary spiritual engagement and energy, and this impression, I am sure, is designated for the *soul*; I believe that a person who loves his time and is in search for its spiritual meaning, will go through the exhibition with a pounding heart and find it filled with good surprises. . . . [12]

Franz Marc and the Blaue Reiter group were a principal component of the exhibition. Marc himself was represented with his masterpiece, the now lost *Tower of Blue Horses*, and his stunning premonitions of the approaching war in which he himself was to die: *The Fate of the Animals* and *Tirol*. There were important non-objective Compositions and Improvisations by Kandinsky, including works such as the signal *Composition VI* (now in Moscow) and *Painting with White Border* (New York, Guggenheim Museum). Kandinsky's paintings and his theoretical writings were the greatest single influence on Walden's own thinking

FIGURE 11. Fernand Léger, *Nude Model in the Studio*, 1912–13, oil on burlap, 50⅜ × 37⅝", Solomon R. Guggenheim Museum, New York.

and seeing at the time. There was, of course, a good representation of Macke's work, sparkling in their prismatic color and enjoyment of life, and of Gabriele Münter's, which included her *Portrait of Paul Klee*, with its witty rectangularity. The somewhat younger Klee, who had been represented by only a few works in the original Blaue Reiter show, now exhibited twenty-two watercolors and drawings, among them *The Attacked*, done with penetrating wit.

Although Braque and Picasso had to be omitted, there was an excellent representation of Cubist paintings by the Montparnasse group of Gleizes, Metzinger, Léger, and the Delaunays. It is quite possible that Walden and his advisors

FIGURE 12. Sonia Delaunay, Binding for *Der Sturm*, 1913, collage 16 × 12", Musée National d'Art Moderne, Paris.

may actually have preferred the greater involvement in color orchestrations by that group, shortly to be called the Section d'Or, to the monochrome analysis of the Montmartre artists. There were fifteen works by Léger including his *Nude Model in the Studio*, characterized by its rhythmic relationship of simple geometric forms defined by bright pure colors. There were no fewer than twenty-one entries by Robert Delaunay, including a version of his *Cardiff Team* – a brilliant glorification of modern life, as well as several of his abstract color disks of sun and moon, floating in open space. Sonia Delaunay-Terk was represented by twenty-five pieces, ranging from abstract paintings such as the *Danse Bullier* to some of her splendidly designed covers for books of contemporary poetry and criticism.

The Futurists were there in full force with important works such as Balla's *Dynamism of a Dog on Leash*, which was to become the standard epitome of Futurist painting. Severini's *Dynamic Hieroglyphic of the Bal Tabarin* was exhibited, one of the first collages using sequins amalgamated in a rhythmic swirl with words and letters. Carrà, Russolo, and Soffici were represented with their Futurist productions. With his uncanny eye for signal works of current art, Walden also exhibited Boccioni's *Unique Forms of Continuity in Space* (the Futurist version of their disparaged *Victory of Samothrace*), in which the striding figure, bounding on two pedestals, is opened up to act in the surrounding space. Among the sculptures were also two new pieces by Alexander Archipenko, whose works Guillaume Apollinaire praised as coming the closest in their approach to *sculpture pure*.[13] One-person shows of both Severini and Archipenko were held simultaneously with the Herbstsalon. These were installed in the regular exhibition quarters of Der Sturm at Potsdamerstrasse 134a, while a special space had been rented for the Herbstsalon at Potsdamerstrasse 75.

Besides Chagall, who had been living in Paris since 1910, and the Munich-based Russians Kandinsky and Jawlensky, the emerging Russian avant-garde was represented by the Rayonists Nätalia Goncharova and Mikhail Larionov, as well as David and Vladimir Burliuk and Alexander Mogilesvsky. Macke, who knew about the new art appearing in Czechoslovakia, was largely responsible for the inclusion of six Cubist artists from Prague.

Except for the inexplicable absence of Marcel Duchamp, the Herbstsalon

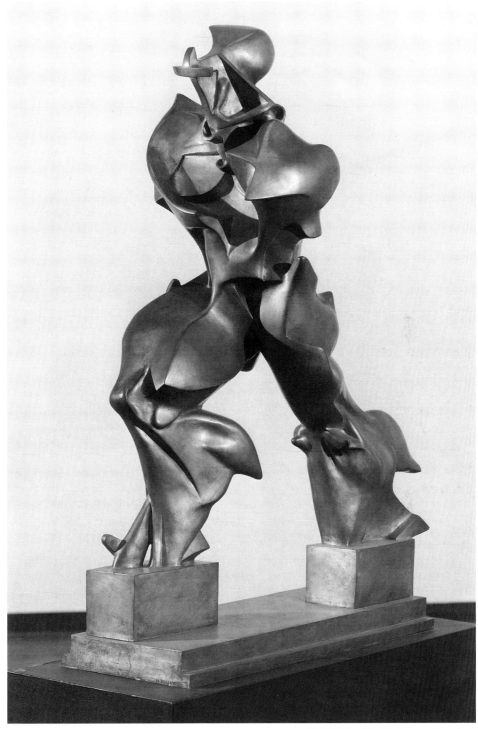

FIGURE 13. Umberto Boccioni, *Unique Forms of Continuity in Space*, 1913, bronze, 43½" high, The Museum of Modern Art, New York.

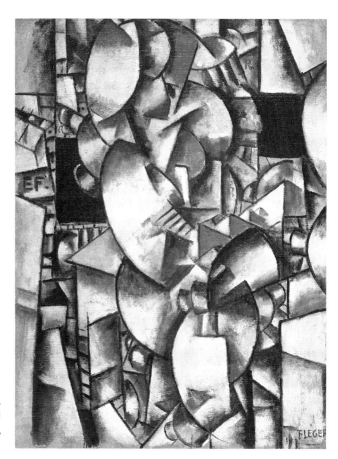

FIGURE 14. Nätalia Goncharova, *The Yellow and Green Forest*, 1910, oil on canvas, 40 × 33½", Staatsgalerie, Stuttgart.

missed very few artists of the international avant-garde: There was Mondrian from Amsterdam, Arp from Strasbourg, Max Ernst from Cologne, Willi Baumeister, living in Amden in Switzerland at the time. Among the entries by Francis Picabia was one of his abstract studies of New York, which he had done during his recent visit to the Armory Show. Three Americans were included in the Herbstsalon: Lyonel Feininger, who had long been living in Berlin; Albert Bloch, who was a member of the Blaue Reiter; and Marsden Hartley, who had arrived in Berlin in spring 1913 and who was invited to participate with five mystical abstractions. In a letter to Munter about her entries in the Herbstsalon Franz Marc referred to Hartley as "decidedly serious, not yet mature, but very fine."[14]

The Erster Deutscher Herbstsalon aroused a great deal of controversy and animosity among critics. The hostility of the press toward the avant-garde in the prewar period is well known. But Walden seems to have been singled out for excessive abuse. Kandinsky's first retrospective exhibition, held at Der Sturm in October, 1912, had prompted the *Hamburger Fremdenblatt* to accuse the artist of "over-life-size arrogance" and of bungling. The reviewer railed against "the fellows of Der Sturm" for their impudence, for their "hunger for sensation," and for lending their space to Kandinsky's "madness of color and form" and his "idiocy."[15] It is worth noting that Kandinsky, these villifications not withstanding, actually was already regarded as the leading Expressionist in Germany by both

critics and the art public as early as 1912. Nonetheless the noted art historian Karl Scheffler, discussing the "Erster Deutscher Herbstsalon," maintained that "the organizer's lack of judgment is doing great harm to the new art."[16] Scheffler directs his indignation specifically at Severini's collages for using actual objects, such as real hair and newsprint. In view of the fact that Scheffler was the editor of *Kunst and Künstler*, a luxurious art magazine published by Bruno Cassirer, whose brother Paul was the dealer and chief promoter of Impressionism in Germany, opposition to the appearance of a much newer art is understandable. Yet one is amazed at the vituperative language employed. Scheffler's article speaks of the *Lazarettluft* permeating the exhibition rooms and of the "proletarian spirit." His warning against the "unclean fantasy" evokes the theory of "degenerate art" first proposed by Dr. Max Nordau in the 1890s and made national policy by the Nazis some forty years later.

Walden and his collaborators Oskar Blümner and Lothar Schreyer responded to these invectives with their own cunning polemics. But, more important, the Sturm Gallery organized new exhibitions with speed and skill. While the Herbstsalon was still in place, an exhibition of the new paintings, sculpture, and architecture by the Czech Cubists from Prague succeeded the Archipenko show in the regular exhibition quarters and was itself followed by a new exhibition of Cubist paintings from Paris.

In 1912 Walden sent the Futurist show from Berlin to Copenhagen, and in 1914 he began the first comprehensive program of circulating exhibitions of modern art. They were sent to museums and galleries throughout Germany and as far afield as Helsinki, Stockholm, Zagreb, London, and Tokyo. The outbreak of the War necessarily stopped this activity and Paris, which had replaced Vienna on the masthead of the magazine, disappeared after August 1914. Otherwise the publication of the periodical and the exhibitions continued unabated. In 1916 Walden had begun his "Sturmabende" of lectures, discussions, readings, and recitals in Berlin, which were replicated in Budapest, Amsterdam, Oslo, Göteborg, The Hague, Copenhagen, Vienna, and Paris. As soon as the armistice was declared Walden organized another major exhibition of contemporary trends: International Art: Expressionists and Cubists in Copenhagen. But by the time the War was over, many of the Sturm artists, such as Chagall, Kandinsky, and Kokoschka had gained high reputations and made arrangements with more established galleries.

When Walter Gropius founded the Bauhaus in 1919, it was seen as a bastion of Expressionism in its early years. Eight artists associated with Der Sturm – Lyonel Feininger, Johannes Itten, Georg Muche, Wassily Kandinsky, Paul Klee, L. Moholy-Nagy, Lothar Schreyer, and Oskar Schlemmer – were on its faculty during the Weimar years. "Our teaching," Schreyer wrote, "was the teaching of Der Sturm, of Herwarth Walden."[17]

Walden had always maintained that art and politics should not mix and kept his magazine and his other activities far from the political realm. But during the Weimar years cultural life in Germany – especially in Berlin – could in no way remain aloof from the world of politics. Also new art periodicals saw the light of day and new galleries of avant-garde art opened their doors. Walden's magazine, which had once appeared bi-weekly, became a quarterly in 1924 and lost its

aggressive fire. The *Sturm-bühne*, the *Sturmabende*, and the *Sturmschule* were discontinued. The last exhibition was held in 1929 and the periodical ceased publication in 1913, when Walden emigrated to the Soviet Union. He was arrested after the German invasion and probably died in prison in 1941.

But in 1913 Herwarth Walden was in the vortex of the modern movement. The "Erster Deutscher Herbstsalon" was the first great manifestation of its authentic strength and international diffusion.

4 SCHOENBERG AND THE VISUAL ARTS

"Prussia is a place where one is free to move, but one's mouth is gagged. Austria is an isolation cell in which one is allowed to scream." A recent and highly disturbing painting by Francis Bacon comes to mind immediately when we read these lines by Austria's brilliant writer, satirist and social critic Karl Kraus, a meticulous master of the German language who unveiled the corruption of the Viennese bourgeoisie as reflected in the misuse of language by the press.* Kraus's spirit as well as his appearance, his real presence, is seen in a portrait painted by his friend Oskar Kokoschka in 1909. A few years later Arnold Schoenberg presented a copy of his *Harmonielehre* to the author with the dedication: "I probably learned more from you than one man should learn from anyone, if one wants to remain independent." Kraus went on to write his drama, *The Last Days of Mankind,* a final verdict on war, which was written primarily for voice and consisted of hundreds of scenes and would take at least ten evenings to perform in its entirety. Like Gustav Mahler's *Eighth Symphony* – the "Symphony for One Hundred" – it indicates some of the gigantic ambition among artists and intellectuals of Vienna before the Great War. Mahler's music went far beyond the Romanticism from which it grew and it helped set the stage for Schoenberg's work in the next generation. But, beyond music, Vienna in the early years of the century experienced an incredible and unequalled intellectual outburst.

Arthur Schnitzler, physician as well as playwright, had pinpointed the decadence of the fin-de-siècle in a brilliant series of plays enveloping his accusation of a hypocritical bourgeoisie in a diaphanous veil of satiric wit. The poet Hugo von Hofmannsthal, romantic keeper of the cult of beauty, hoped that poetry could redeem mankind and could bring coherence to the confusion of modern life through the medium of language. Eventually he became the collaborator and librettist for Richard Strauss. Franz Werfel concerned himself in his early poetry with the problem of man's relationship to the godhead and the liberation of the

* Lecture for the Aspen Conference on Contemporary Music for the 100th Anniversary of Schoenberg's Birth (1974).

soul, longing for a "new man" who would become part of a new brotherhood. Stefan Zweig, writing in a highly civilized style, was one of the innovators of the 20th-century historical novel.

Sigmund Freud and his Viennese collaborators developed the theories of psychoanalysis, delving into heretofore unexplored realms of dream and fantasy and penetrating to basic human desires and needs which an overcivilized society forced man – and even more, woman – to conceal and suppress. Freud's theories of the unconscious self and his interpretation of art as the successful sublimation of the libido toward creative pursuits are highly important toward an understanding of the art of this time.

In the same period a new approach to the history of art, relating it more closely to the history of culture, and removing art historical studies from either mere biographical accounts or isolated formal analysis, was developed by a group of young art historians. Foremost among them were Alois Riegl, Franz Wickhoff and Max Dvorak, as well as Hans and Erica Tietze and the avant-garde critics Hermann Bahr and Arthur Roessler.

In Philosophy Ludwig Wittgenstein, a great admirer of Karl Kraus's pursuits toward the precision of language, investigated the intricate relationship between language, mind and thought. Martin Buber, an early student of the German mystics Jakob Boehme and Meister Eckhart, as well of Søren Kierkegaard, was aware of the modern individual's estrangement and alienation from the authentic self in a goal-oriented technological society and wrote about a genuine interaction of human beings leading ultimately to a utopian socialist community. As a student of Hasidism in its original form, Buber also emphasized spontaneous creativity as a means toward "heightened experience" and a grasp of the unity of the I and the world.

Before turning to the visual arts, I want to raise the question of how to explain the tremendous intellectual creativity, the prolific originality in pre–World War I Vienna. It may very well have been due to the enormous ethnic and cultural diversity of the Austro-Hungarian Empire with its Germans, Hungarians, Poles, Czechs, Slovaks, Italians, Slovenes, Ukrainians and Rumanians. They were kept as Count Taaffe, a long-term prime minister said, in a "balanced state of dissatisfaction." The multicultural heterogeneity in Austria-Hungary made for great tensions, for disruption of the old order and for unique and unexpected possibilities.

One factor, certainly, was the presence of brilliant and cultivated Jews in the Dual Monarchy. Although only about 4% of the population was Jewish, more than a third of the students as the University of Vienna were Jews. But, no matter how assimilated, the fact that they did not belong to the ethnic majority, nor to any of the various nationalities, made them what Hannah Arendt called "state-people," dependent on the fortunes of the liberal establishment and goodwill of the Court.

To be sure, many of the leading Jewish minds rebelled against the puritan austerity of traditional Judaism (a good number of them like Wittgenstein and Schoenberg were baptized) as well as against the false and hypocritical moral code of an outworn aristocracy. The Jews were also subject to a rising wave of anti-Semitism among the populace, epitomized by Karl Lueger, who was the anti-

Semitic mayor of Vienna from 1897 until 1910, and in many ways mentor to Adolf Hitler. We must remember that Vienna was the city in which both Hitler and Theodor Herzl developed their political convictions and polemics. Herzl, journalist of the liberal newspaper the *Neue Freie Presse*, formulated his ideology of Zionism, which was based on the belief that the true emancipation, so deeply longed for by his intellectual confreres, was neither possible nor desirable.

Vienna also made highly important contributions to a new urban architecture at the end of the 19th century, an architecture which was in keeping with modern life. Otto Wagner turned the aesthetic of building from the Academism of the Ringstrasse with its admixture of Neo-Gothic, Neo-Classical and Neo-Baroque monumental buildings toward a more rational style in keeping with new technical and social realities. By the 1890s some of his most talented students together with painters formed the Vienna Secession and Joseph Maria Olbrich was commissioned to design their exhibition building. By its very appearance it indicated a new spirit, very much in keeping with the international Art Nouveau movement called Secessionsstil in Austria. The building, based on elements of geometric forms, appeared like a holy shrine to art, decorated by laurel motifs and bearing an inscription over its formal portal which was the essence of the new liberal thought: "To the Age Its Art. To Art Its Freedom."

The slightly younger architect Adolf Loos protested against even the limited decoration of a building such as this. He wrote about ornament as crime. Just as Freud stood for the breaking down of the disguises and suppression in personal life and Kraus urged the purification of an adulterated language, so Loos was the advocate of purified architecture, eventually to be called "The International Style." Years later Arnold Schoenberg, whose work stood for truthfulness and purity of form rather than "beauty," referred to Adolf Loos as "one of the Very Great."

Otto Wagner hung paintings by his friend Gustav Klimt in his villa and actually called Klimt "the greatest artist who ever walked the earth." Klimt, like Otto Wagner, abandoned historical tradition for new and vital experimentation. In the Gothic revival building of the University he painted murals which are Symbolist abstractions of amorphous figures floating in space. More metaphysical than palpable, they relate very much to Nietzsche's poetry and philosophy, but they found rejection by the academics of the University, leading Klimt to eventually renounce his commission. They were rewarded, however, with a *succès de scandale* and brought great fame to the artist among his champions. Klimt turned increasingly to the painting of portraits of wealthy women, partly influenced by his trip to Ravenna and his love for the mosaics he saw at San Vitale. Examples of this luxuriant and ornate portraiture are the portraits of Margaret Stonborough-Wittgenstein (1905), the philosopher's sister, or the even more elaborate Portrait of Adele Bloch-Bauer (1907).

The Palais Stoclet, designed by Josef Hoffmann in Brussels (1905–1910), is the final and most luxurious masterpiece of the Secessionsstil. Klimt was responsible for the decorative frieze in the Dining Room. A second and smaller version, *The Kiss*, is now in the Belvedere Museum in Vienna and enjoys enormous popularity. The motif of the lovers, symbolized also by the phallic forms on the man's cloak and ovular motifs on the woman's dress is subordinated to a flat ornamental

pattern, all done in the most splendid and sumptuous execution. Here, Klimt approaches the decorative splendor of Byzantine mosaics. This kind of ornamentation signals a significant break from the illusionist and perspective space which had characterized European painting since the Renaissance. It presents a parallel to the end of tonality, which too had outlived its usefulness as far as Schoenberg was concerned. But Klimt's use of abstraction remained anchored in the realm of symbolist decoration. It was up to the next generation of painters, to men like Kokoschka and Kandinsky who were able – like the early Schoenberg – to move toward a free and liberated expression which was unencumbered by rational order.

Oskar Kokoschka came to Vienna from a small town on the Danube close to the magnificent monastery of Melk, and the Baroque tradition remained a very significant aspect of his work throughout his life. This was by no means a matter of Baroque revival but, rather a similar basic emotion evident in his work. At first Kokoschka was very much under the spell of Klimt; his first important work, *The Dreaming Boys*, a book commissioned by the Wiener Werkstätte, was a fairy tale, written as well as illustrated by the artist and dedicated to Klimt. The pubescent figures in this volume are lonely, fragile, lost and insecure in their Garden of Eden. Soon, however, the Baroque-Expressionist nature made itself felt, both in his avant-garde plays, such as *Sphinx and the Man of Straw* and *Murderer, Hope of Women,* performed originally in 1909. The feeling of an explosive violence characterized his plays even earlier than his paintings, and they are generally considered the beginning of the Expressionist theater in Austria and Germany. Both as playwright and painter, Kokoschka searched for *Gesamtkunstwerk,* bringing several of our senses into operation.

The illustrations of *Murderer*, dating from 1908, indicate the deep feeling of conflict in his work, dealing with the cruel and irrational aspects of human feeling and action. And just as he distorted language in his dialogue he distorts the human figure in his drawings. In fact, he became known in Vienna as the *Bürgerschreck* and experienced the same kind of rejection as his friend Arnold Schoenberg, who often spoke with great admiration of Kokoschka. For example, when the composer considered making a film of his music drama, *Die Glückliche Hand,* he wanted a painter to design the main scene and the sets, favoring Kokoschka, with Kandinsky being his second choice.

Kokoschka's portraits of the pre-War period are dark pictures, paintings in which the sitter is revealed behind the outer appearance. He took a radical step beyond Klimt, his one-time mentor. Instead of the beautifully ordered two-dimensional surface of the older painter, Kokoschka's space seems charged with an electric atmosphere. In a certain way the portraits relate to the psychological problems of the Viennese intellectuals which Sigmund Freud explored at the time, and they bear even greater semblance to Dostoyevsky's earlier penetrating analyses of human beings. When looking at the portrait of *Herwarth Walden* (1910), the publisher of the avant-garde periodical *Der Sturm* for which Kokoschka contributed drawings, or at the portrait of *Karl Kraus* (1908) the viewer is subjected to an image of very disturbing revelations. His sitters – largely avant-garde intellectuals of Vienna with their deep eyes and lacerated skins – are individuals in physical and psychic distress. When Schoenberg wrote in 1910 "Art is

the cry for help of those who experience in themselves the destiny of man," he might have been describing Kokoschka's portraits of his contemporaries.

An intimate and personal confrontation occurs in most of Kokoschka's early portraits. Schoenberg, whose own paintings may have been influenced by these portraits, recognized their abstract quality and, when writing his essay "The Relationship to the Text" for the Blue Rider almanac he asserted:

> Karl Kraus calls language the mother of ideas: Kandinsky and Oskar Kokoschka paint pictures in which the external object is hardly more to them than a stimulus to improvise in color and form and to express themselves as only the composer expressed himself previously. These are symptoms of a gradually spreading recognition of the true essence of art. And with great joy I read Kandinsky's *Concerning the Spiritual in Art*, in which a way is shown for painting that arouses hope that those who demand a text will soon stop demanding.

Schoenberg referred to the older Gustav Mahler as a "saintly man" and dedicated his seminal *Treastise on Harmony* to the master. Mahler, in turn, supported Schoenberg's application for a teaching post at the Vienna Academy. After Mahler's death in 1911 Schoenberg remained a close friend of his intriguing wife, Alma, both of them ending up eventually in Los Angeles, where the composer taught at the University of California and Alma lived as the wife of Franz Werfel, her final husband. But in 1912 Kokoschka entered into a fervid love affair with Alma Mahler, which she described in loving detail in her memoirs. It must have been a relationship of great intensity, which is apparent in a double portrait of 1912, painted with a much looser brush and freer form than the earlier portraits. Soon thereafter Kokoschka painted a likeness of his mistress in which she resembles the *Mona Lisa*. Alma is seated in the same position as Leonardo's *La Gioconda*. She wears a dress with the same neckline and the resemblance is carried into her facial features and even a mountainous landscape is indicated in the background. This paraphrase was part of Kokoschka's ambition (similar to Schoenberg's) to relate to the great European tradition, while moving far beyond it. Then, in 1914, Kokoschka painted himself in embrace with Alma Mahler in a large picture, which may very well be his masterpiece, called *The Bride of the Wind*, or *The Tempest*. Here his love is translated into a powerful visual statement. The painter and his beloved, embracing in a boat or large shell, are swept along by the elementary forces of wind and water in a fantastic blue landscape. A dynamic baroque movement pervades the painting. Alma Mahler wrote in her memoirs that "Kokoschka painted me as clinging trustingly to him in rain and wind and mountainous seas – looking to him for help – and he with despotic countenance, calming the waves by the forces radiating from him." As we analyze this historic painting, we sense a closeness as well as despair. Rarely has the sense of the ambiguity of love been expressed as cogently in painting. But in music we find an equivalent in Schoenberg's *Verklärte Nacht*, Op. 4, which the composer wrote fifteen years earlier to Richard Dehmel's poem "Woman and World." It was in this early work that Schoenberg attempted, and perhaps succeeded in, a fusion of the firm structure of Brahms with the sensuous flow of Richard Wagner.

Prior to his enlisting in the Imperial Cavalry in 1914 Kokoschka painted por-

traits of Josef Mathias Hauer, the composer who developed atonal music using the twelve-tone scale simultaneously with Schoenberg, and also of Anton von Webern, Schoenberg's star pupil. Finally, in 1924 after recovering from a severe nervous breakdown in the war and during his professorship at The Dresden Academy, Kokoschka painted his *Portrait of Arnold Schoenberg*. By this time he works in a mode very different from the earlier black paintings. His brushwork is broader and more fluid and the work takes on a more painterly aspect. The portrait also conveys the great energy of the musician, who was said to spend his day teaching and his nights composing.

Kokoschka painted the composer as a powerful, mature fifty-year-old man. His young compatriot, Egon Schiele, had made a portrait of the composer when he was younger (1917) as a gaunt, almost emaciated individual. Schiele, primarily a draftsman, does the portrait in black chalk and watercolor. Like Kokoschka, Schiele was able to reveal the inner life of his subjects and his portrait of the musician with its asymmetrical facial features and intense expression, rendered by pointed and hard lines, may indicate a comprehension by the painter of the analytic complexity of the composer's music.

Richard Gerstl, younger than both Kokoschka and Schiele, worked in isolation from other painters but found contact with musicians and painted Arnold Schoenberg's portrait in 1906– a rather straightforward likeness, concentrating on the man rather than the composer. Later on, while lodging with the Schoenberg family, he painted a very Expressionist picture with heavy impasto and great freedom of form and a brilliant array of color. But it is a curiously unstructured family portrait in which the very faces seem effaced. Gerstl became involved in a love affair with Mathilde Schoenberg, the composer's wife. When, after a brief interlude, Mathilde, persuaded by Anton von Webern, returned to her husband, the highly promising but neurotic young painter Gerstl committed suicide at the age of twenty-five. It is worth noting in this connection that suicide among young artists and writers had reached almost epidemic proportions in Vienna between 1908 and 1910.

Arnold Schoenberg himself began painting in 1907 after a period of personal crisis and had probably been taught the rudiments of painting by Gerstl, something the composer later denied vehemently. At any rate Schoenberg produced an amazing number of art works, some 65 paintings and 160 works on paper between 1907 and 1940, most of them before World War I. He said that his largely visionary paintings originated through "inner compulsion. Something is happening to me. My hand is being guided."

Many of his paintings are visionary heads, which seem to have been painted almost in a trance. They speak of anguish. Often the face barely emerges from the ground and is of the same color and tone. They are true apparitions, undoubtedly deriving from a deep need of self-expression. They are disembodied faces with burning, penetrating eyes. The obsessive gaze looks straight at the viewer.

When Schoenberg first exhibited them in a bookshop in Vienna in 1910, Gustav Mahler bought one of his paintings in secret as a matter of financial support and two years later when a sort of *Festschrift* for the musician was published, the painter Paris von Gütersloh wrote: "He alone could patiently shape these forms

that offer nothing for enjoyment since he seems protected in advance – immunized almost – because of another highly developed art which he comprehends, his music. Men such as this, who already possess boundless security in some field, are the only true discoverers – not the rootless ones who are merely making use of a universal gesture."

Schoenberg also painted an amazing picture, *Self Portrait*, in 1911 which shows a man from the back, walking down a city street, turning his rear to whoever may be looking at this self-portrait. When Kandinsky saw this painting he decided, although it was done by an art amateur, to include it in the *Blaue Reiter* almanac in 1912 and he wrote at the time: "In each of Schoenberg's pictures we recognize the artist's inner desire expressing itself in appropriate form. He renounces the superfluous (that is to say, the artful) in his painting as he does, if I as a layman may say so much, in his music, and he takes the short path to the essential." And Kandinsky, always systematizing, then divides Schoenberg's paintings into "visions" and "external paintings." Among the latter would be a number of landscapes and some portraits, such as one of his student Alban Berg, done in 1910. Schoenberg was very proud of his accomplishments in art and wrote to his publisher, Emil Hertzka, urging him to find portrait commissions, saying that it would be much more important "to own a painting by a musician of my reputation than by some practitioner of painting, whose name will be forgotten in twenty years whereas even now my name belongs to the history of music." He then quotes prices (200 to 400 Kronen for six sittings), saying that these paintings will be worth ten times as much in twenty years, concluding his letter: "I am sure you realize this and I hope you won't make any feeble jokes about a matter, so serious as this, but will treat it as seriously as it deserves."

Kandinsky first became familiar with Schoenberg's work on New Year's Day 1911, when he, together with Franz Marc, Gabriele Münter, Alexeij Jawlensky and Marianne Werefkin, heard a concert of Schoenberg's *Second String Quartet.* Op. 10 (1907–08) and the *Three Piano Pieces*, Op. 11 (1909). He was deeply impressed and, a few days later, wrote his first letter to the composer, beginning a long correspondence between the two masters. The accordance between their work was clearly recognized by Franz Marc, who described his reactions to the concert in a letter to his friend August Macke: "Can you imagine music in which tonality is totally suspended? I constantly thought of Kandinsky's large compositions in which there is no longer a trace of tonality . . . Schoenberg proceeds from the principle that the concepts of consonance and dissonance do not exist. A so-called dissonance is a more broadly conceived consonance, an idea which now occupies me constantly when I paint." And, indeed, Marc's painting becomes more removed from representation, more abstract and arbitrary, striving toward spiritual harmony at this time.

Kandinsky's art was directed toward the spirit of music almost from the beginning. In his autobiographical notes, *Reminiscences*, published in 1913, he recalls critical experiences which affected him deeply, giving their stamp to the rest of his life. When seeing the sunset over Moscow he describes it in musical terms, speaking about the "final chord of the symphony, which enhances each color to its fullest and transforms all of Moscow into a fortissimo with a thousand voices,

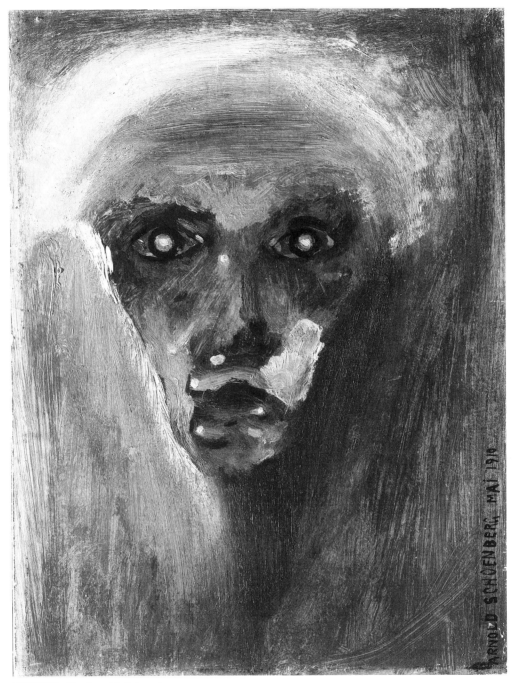

FIGURE 15. Arnold Schoenberg, *Red Gaze*, 1910, oil on board, 12⅞ × 9⅞", Municipal Gallery in the Lenbachhaus, Munich.

and of the alegretto or the bare branches of the trees. To paint this hour, I thought, was impossible, but also the highest fortune of the artist." Listening to Wagner's *Lohengrin:* "I saw all my colors in my mind's eye. Wild, almost insane lines drew themselves before me. I did not dare use the expression that Wagner had painted 'my hour' musically

FIGURE 16. Arnold Schoenberg, *Self-Portrait*, 1911, oil on board, 19⅛ × 18", Arnold Schoenberg Institute, Los Angeles.

. . . Painting can develop just as much power as music possesses."

In his mind and in his work Kandinsky was thoroughly prepared for the experience he had when listening to Schoenberg's expressionist compositions. He had been using musical terms, such as "Impression," "Improvisation" and "Composition" for his paintings, a device which had been used earlier by Whistler. At the end of the 19th century the Symbolists were convinced that a work of art, be it a poem, a painting or a sonata, had an "inner sound" which could evoke a parallel feeling and that the actual "outer form" it takes was only a shell of the true experience. By 1909 Alexander Scriabin, a composer in whose work Kandinsky was greatly interested, had written his *Prometheus*, which calls for a color organ and produces a play of light upon a screen during the performance; then, around 1910–11 both Kandinsky and Schoenberg produced synaesthetic stage compositions. It is not surprising therefore, that they recognized "elective affinities" in each other.

The two artists came from totally different social backgrounds. Wassily Kandinsky, born in Moscow in 1866, came from the wealthy upper bourgeoisie in Moscow and Odessa. He went to the university to study law and economics and was impressed with the Russian peasant folk culture during an anthropolitical expedition before settling in Munich to study painting. Schoenberg's father, on the other hand, operated a small shoestore in Bratislava before settling in Vienna,

and the young Arnold, born in 1874, had to struggle in the city where anti-Semitism was rife.

Both men remained outsiders – Kandinsky the Russian among his Bavarian friends, and Schoenberg, although he had converted to Protestantism in Catholic Vienna in 1889, remained the Jew.

Let us now briefly review the artistic careers of both men prior to Kandinsky's encounter with Schoenberg's music and their subsequent meeting. Early in the century Schoenberg composed his *Gurre-Lieder* and *Pelléas and Melisande*, works which are similar in their narrative content to Kandinsky's early paintings, such as *Motley Life* with its multitudinous figures and events. We also know that early on both artists were very much taken with the formalist Symbolist poetry of the older Stefan George, although neither of them ever submitted to the discipleship which this autocratic high priest of the Nietzschean new Covenant demanded. But Kandinsky's early woodcuts are often so close to George's poems in iconography that they could almost serve as illustrations to the poet's work. He even seems to have identified the image of the Patron of Russia, St. George, with that of the German poet, whose name was George – much as Schoenberg would later identify his face with a vision of Christ. Stefan George also furnished the text for many of Schoenberg's Lieder, including the *Book of the Hanging Gardens,* Op. 15 (1908) where, in the 13th Song, according to the musicologist Heinz Stückenschmidt "the century-old principles of tonality are suspended" and "the music of Europe has entered a new epoch."

It was precisely at this time that Kandinsky gave up perspective and emancipated color and form from their descriptive function in his painting, taking a vital step in painting parallel to that which Schoenberg's atonality signified. Theodor Adorno saw in dissonance an older more archaic form, and we know that Kandinsky looked at primitive art and published African masks, Egyptian shadow pictures and Bavarian glass votive paintings in the *Blaue Reiter* almanac. Furthermore, both artists subscribed to a concept of radical change, a feeling that the old, the traditional, the timeweary needed to be challenged before a new beginning could be made. They, as well as other artists such as Franz Marc among the painters and Alban Berg among the composers, had apocalyptic visions of the universe, and Kandinsky himself painted great abstract compositions on the themes of the Last Judgement as well as premonitions of war.

Both artists, heirs to Romanticism, believed above all in the pre-eminence of the intuitive, but they were also aware of the importance of rational thought and logical theory. In 1911, before they knew of each other's work, Schoenberg published his *Treatise of Harmony* in Vienna and Kandinsky *Concerning the Spiritual in Art* in Munich. Both books formulate new concepts and rules based on the creative spirit, which Kandinsky calls "inner necessity" and Schoenberg "inner compulsion." Kandinsky, who liked to compare himself to Einstein, whom he called his "spiritual relative," summed it up when writing: "When we remember that spiritual existence is quickening, that positive science, the firm basis of human thought, is tottering, that the dissolution of matter is imminent, we have reason to hope that the hour of pure composition is not far away, the first stage has arrived."

Both men, perhaps under the impact of Wagner, felt that the artist should set

himself the task of being at home in more than one art form. Schoenberg engaged in painting as an impulsive amateur; Kandinsky played the cello and the piano for most of his life. In 1908–09 – not yet knowing of each other – they both embarked on ambitious works for the stage. Schoenberg's *Die glückliche Hand*, Op. 18 (1910) requires, as mentioned earlier, the presence of color and light in place of narrative. A year earlier Kandinsky had completed the first version of *Der gelbe Klang* (first printed 1912 in *Der Blaue Reiter*). A music drama with the score by Kandinsky's close friend Thomas von Hartmann, it has no linear development and consists of six images in which the action consists of voices, color, movement and light. More than fifty years before the psychedelic light shows, Kandinsky had designed a true color–light spectacle, which was never performed in his lifetime. But he wrote that "The same internal feeling can be brought forth in the same moment by different arts, each art can contribute its own positive form. All together they can achieve a richness which would not be possible for a single art form." The naturalistic theater which was riding high in Munich and Vienna was rejected by both artists in favor of a new visionary and total synaesthetic stage performance. The stage for them was not a mirror of the real world but a place beyond appearances.

It is not surprising that the two artists felt that they were moving in the same direction in creating radically new forms in music and art. In their correspondence in the Winter and Spring of 1911 they discussed their work and their affinities. In September of 1911, after lengthy arrangements, they met at Lake Starnberg near Munich. Many years later Kandinsky recalled that he, the Russian, was on a boat in the lake, dressed in Lederhosen, while the Austrian was standing at the shore dressed all in white. After the first meeting the two artists wrote to each other with great frequency, discussing their theories on art and music and their new stage compositions. They critiqued each other's work and also wrote about their more mundane activities and travels. Kandinsky wrote adulatory letters to Schoenberg and contributed an article to his *Festschrift* in 1912, while Schoenberg wrote to the painter from Berlin how much he liked his *Romantic Landscape* on exhibition at the Sturm gallery. As soon as they were printed, they sent each other their books, the *Harmonielehre* and *Über das Geistige* with elaborate dedications. Kandinsky arranged for a concert by Schoenberg in St. Petersburg and asked him also to send paintings to the Russian capital for exhibition, inviting him later to show some of his paintings at the Blue Rider exhibition in Walden's Sturm gallery in Berlin, a proposal Schoenberg rejected in all modesty. For the *Blaue Reiter* almanac Schoenberg contributed an essay about music, "The Relationship to the Text," as well as the score to *Herzgewächse*, Op. 20, with a text by the Belgian Symbolist Maurice Maeterlinck, a writer greatly admired by Kandinsky, who called him "the poet of the future." And two of Schoenberg's paintings were reproduced in the book, which was truly a synthesis of the arts. In addition to Schoenberg's music, the almanac also contained scores by his most important disciples, Berg and Webern.

In their extensive correspondence during the next few years, they continued to exchange their thoughts. Rather elaborate arrangements were made for the Schoenbergs to spend the summer of 1914 near Kandinsky and Gabriele Münter

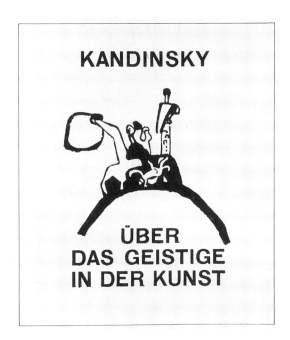

FIGURE 17. Wassily Kandinsky, *Über das Geistige in der Kunst*, 1912, cover of the book.

close to Murnau in the Bavarian Alps. But in mid-summer the War broke out and Kandinsky had to return to Russia. Their correspondence came to a standstill.

The unhampered anarchic freedom which both artists believed in during their Sturm and Drang period before the War could not last. The very fact of real carnage at the trenches made reorientation a necessity, and a sense of structure and order occurred in both artists' work. Kandinsky, partly under the influence of the work by the Constructivists and Malevich which he saw in Moscow, introduced geometric elements in his painting. Schoenberg simultaneously felt the need to curb the rich passions of his atonal music. He started slowly to organize the liberated chromatic music into the twelve-tone scale which appeared in 1921 in his *Suite for Piano*, Op. 25. His serial music is a very organized kind of composition, but his new system was no return to the old hierarchical order of the diatonic scale.

Kandinsky too does not return to an older mode of paintings such as perspective, centralized form, not to mention narrative art. But his paintings of the 1920s are clearly structured, often dominated by circles, squares and triangles. This new style was in keeping with the emphasis on architecture at the Bauhaus, whose faculty in Weimar he joined in 1922.

After his return to Germany Kandinsky once more picked up his correspondence with Schoenberg. He found that the position of director of the Weimar music academy was about to become vacant and asked Schoenberg if he might be interested. Schoenberg's reply, however, was a severe rejection: The composer's letter to Kandinsky of April 1923 accuses the painter of anti-Semitism. It appears that the misapprehension of Kandinsky's anti-Semitism on Schoenberg's part was caused by a rumor initiated by Alma Mahler, formerly Kokoschka's lover

and the wife of Walter Gropius at the time. But, having been subject to the anti-Semitic ambience of Austria, Schoenberg was aware early on that the very existence of the Jews was in jeopardy and wrote that he was not a German, not a European, but a Jew, which would make him ineligible for a major teaching position in Weimar.

His old friend Wassily Kandinsky wrote back immediately, assuring the composer that his perceptions were in error, and ending his letter by saying: "It is no blessing to be a Jew, Russian, German, European. Better to be a human being. But we must strive to be 'supermen'. That is the duty of the select." Schoenberg replies, writing about the violent waves of anti-Semitism in Germany ("the Germans will not put up with Jews"), and is already aware of Hitler and his program, actually anticipating the Holocaust as early as 1923. In 1933, finding refuge in Paris, Schoenberg reconverted to Judaism largely out of a sense of solidarity with what he thought were his people.

In the summer of 1927 Kandinsky and Schoenberg met once more during a summer vacation in the Lake District near Salzburg. In spite of their crucial political disagreements, their work continued to develop along parallel lines. Continuing his involvement in synaethesia Kandinsky illuminated Moussorsky's *Pictures at an Exhibition* (1928) with abstract plays of color and light for a performance in Dessau and also painted geometric murals for a concert hall in the same city. He wrote a new book, *Point and Line to Plane*, published in 1926, which is a methodical treatise, a pictorial grammar. A few years later Schoenberg worked on his major opera, *Moses and Aaron*, which is the final realization of his musical ideas. Glen Gould wrote that Schoenberg had come "perilously close to anarchy and then confronted by anarchy became almost over-organized, over-legislated by superimposed rules, and finally ended by attempting to co-ordinate the system of legislation which he had developed with aspects of tradition, which he had, many years before, abandoned."

Both artists' search for a new system of composition ultimately ended in a synthesis of their early expressionist, anarchist phase with the antithetical period of judicious regulation. Toward the end of his life Kandinsky painted great sonorous pictures such *Tempered Elan* (1944) in which he combined the new theories of abstract formal relationship of the Bauhaus period with the biomorphic, organic shapes from his Expressionist time and a sense of color which recalls Russian icons. At the same time Schoenberg in his late works was also to fuse intuition with intellectual control and referred back to *his* tradition, especially to Bach and Brahms.

In 1933 with the Nazi assumption of power in Germany, the Bauhaus was closed and Kandinsky emigrated to Paris, where Schoenberg arrived the same year, before moving on to New York and eventually Los Angeles. In 1936 Kandinsky once more wrote to his old friend and informed him of recent events in his life and recalls their early friendship: "All our contemporaries from that time sigh deeply when they remember that vanished epoch and say: 'That was a beautiful time'. And it really was beautiful, more than beautiful. How wonderfully life pulsated then, what quick spiritual triumphs we expected. Even today I expect them, and with the most complete certainty. But I know that a long, long time

will be necessary." He ended the letter by saying that he was toying with the idea of some time coming to America to join Schoenberg. But he died in Paris in 1944. Schoenberg, eight years younger than Kandinsky, died seven years later in Los Angeles.

Schoenberg and Kandinsky introduced a new freedom in art and music and then a new discipline and form, based on that liberation. Historians have discarded the notion of *Zeitgeist* some time ago, but, perhaps, it is again a useful way to analyze such parallel developments, what Goethe called "elective affinities."

5 THE PERSISTENCE OF EXPRESSIONISM

THE SECOND GENERATION

Art-historical movements have their duration, as George Kubler taught us in *The Shape of Time*.* A variety of factors, including fatigue, can bring them to a close. As we consider art movements during the modern era, we note that the period of gestation, duration, and termination keeps shrinking, until presently these movements seem to resemble fashions more than historical sequences.

When did German Expressionism find its terminus? Conventional wisdom – including my own at an earlier time – thought that the cataclysm of World War I brought the utopian vision of Expressionism to its end. Although Franz Marc and Egon Schiele died during the war and its aftermath, most of the original founders of Expressionism survived. But their postwar work changed significantly. When we look at the work of Expressionism's leaders – Kandinsky, Kirchner, Kokoschka, and Nolde – we note that the former sense of rebellion and agitation, dissimilar as it may be in the work of each, gave way to a more controlled and formal pictorial mode.

By 1920, Wilhelm Hausenstein, a strong advocate of Expressionism in the prewar period, noted that the "chiliastic madness" had degenerated into mannerisms, and that "Der Expressionismus ist tot."[1] Similarly, Wilhelm Worringer, whose influential 1908 treatise, *Abstraction and Empathy*, had a strong impact on Kandinsky's creation of Abstract Expressionist painting, wrote in 1920 that the Expressionists' "agitated revelations and visionary flashes of light have been handsomely framed, declared permanent, and degraded to peaceful wall decorations."[2]

Was Expressionism indeed dead by 1920? It is true that the Expressionists' dreams of a pastoral unity with nature, as well as their contradictory visions of destruction, had now to deal with the real Armageddon: four years of trench warfare followed by misery, starvation, riots, and assassinations. The carnage that had been predicted by Expressionist poets and painters had turned into daily

* This essay originally appeared in *Arts Magazine*, Vol. 63, No. 8, April 1989, pp. 65–69. This magazine has ceased publication.

chaos. The war had not turned out to be the great cleansing that Franz Marc, among others, had foreseen as a "moral breakthrough to a higher experience."[3] Instead, the war had killed ten million people – including Marc, who fell in action in Verdun in 1916.

The senselessness of it all was an important motive for the attack on all cultural values and the disdain for matters of the spirit on the part of the Dadaists, who became very political in Berlin. They had nothing but scorn for the Expressionists, who, as Richard Huelsenbeck recalled, "have in their struggle with naturalism found their way back to the abstract emotional gesture which presupposes a comfortable life free from content or strife."[4]

In contrast to the iconoclasm of the Dadaists, the constructive idea of the Bauhaus also had its origin within the multiple possibilities of the years of turmoil. Walter Gropius, heralding the unity of arts and crafts and the abolition of class distinctions, called in 1919 for a new school that would create a great architecture, "a single form which will one day rise toward the heavens from the hands of a million workers as the crystalline symbol of a new and coming faith."[5] He looked to the avant-garde painters, men who were associated with the Expressionist periodical and gallery, *Der Sturm*, to join him in this new endeavor. Lyonel Feininger arrived at the very beginning, Paul Klee and Oskar Schlemmer joined the Bauhaus faculty in 1920, and Kandinsky came two years later. But none of the Bauhaus painters continued working in an Expressionist mode during the postwar years. Nevertheless, despite all appearances to the contrary, Expressionism continued during this period, and its banner was carried by a second generation of artists who had largely come of age during World War I.

Stephanie Barron, curator of twentieth-century art at the Los Angeles County Museum of Art, who in 1985 organized a show of German Expressionist sculpture which revealed an unexpected richness of creative output in three dimensions, has now curated an exhibition that denies that the Expressionist movement came to an early death, under the title *German Expressionism 1915–1925: The Second Generation.*[6] One of the significant achievements of this exhibition is its catalogue, edited and introduced by Barron with additional texts by Friedrich Heckmanns, Eberhard Roters, and Stephan von Wiese of the German Federal Republic, the late Fritz Löffler of the German Democratic Republic, and Peter W. Guenther of the University of Houston. Several of the well-informed essays, especially those by Roters and Guenther, help refute the notion of the mainstream, of one movement following another in some kind of chronological order. We owe this erroneous idea of art history to formalist critics and their linear thinking. As we see again in this exhibition, pluralism is not something that comes to us in the postmodern 1980s. It was there all along as an integral part of the modern movement.

We have been thinking, for example, of George Grosz, moving from being the "Propaganda" and political activist to his acrimonious and sarcastic unveilings of greed and lust, as one of the leaders of the New Objectivity (Neue Sachlichkeit) movement. Similarly, Otto Dix is considered the "dominant personality of the Neue Sachlichkeit,"[7] and Max Beckmann's paintings in the immediate postwar period "anticipate and prepare the ways for the Neue Sachlichkeit more obviously than the work of any other artist."[8] But now we see the work of these artists in a different context. We note that their works in those critical early years of war and

revolution are definitely in the Expressionist vein in its more extroverted and aggressive aspect. Beckmann, to be sure, was always concerned with the mystery of the object, indeed of existence, but that, too, is very much a part of the Expressionist attitude and its ambiguities.

In this exhibition, Beckmann is represented only by studies for his masterpiece *The Night*, and by several lithographs of his *Hell* portfolio, which he completed soon after this painting of unmitigated horror. The omission of the traumatic paintings of the period by Germany's foremost painter can be explained solely by their presence only three years ago, in the great Beckmann centennial retrospective that was seen in Los Angeles.

The Beckmann graphics are in "War," the opening section of the exhibition, which sets the stage for an appropriately dramatic installation. The space is divided by partitions, painted in muted colors, on which the pictures are hung in compressed proximity. The spaces meet at acute angles and admit the viewer into compact diagonal areas. These triangular spaces, densely hung with paintings, graphics, and posters, are in themselves apt metaphors for the art of unrest and turbulence that is on display. The show is arranged by themes and styles (War, Revolution, Religion, Abstract Expressionism) as well as by major art centers (Berlin, Dresden, the Rhineland). The War section is inaugurated, appropriately, with *Apocalyptic Landscape* by Ludwig Meidner – one of the prophetic works he painted a year before the outbreak of the catastrophe that transformed his visions of destruction into reality. In this section, two paintings by Gert Wollheim are most memorable. *The Wounded Man* (1919) is a depiction of total violence. This man, with blood spewing out of his belly, is all jagged diagonals that by themselves augur the scream of pain. *The Condemned Man* (1921) is, in contrast, a dark and solemn painting. It shows a blindfolded man, tied to a post, waiting to be shot. A foreboding work, it is painted with a heavy brush. The face of the victim is modeled by the paint, giving an almost three-dimensional reality to this figure of doom. In a totally different vein and palette, he painted *Farewell to Düsseldorf* in 1924, a depiction of gaiety bordering on boredom and of the wistful debauchery that is a perfect metaphor for social life in the Weimar Republic.

It was an excellent idea to intersperse posters with the paintings and graphics in this show, as posters were an essential aspect of the work created by artists who were committed to the revolutionary struggle for the "New Man" who would emerge from all the turmoil. The artists' and writers' dreams of a better humanity may have had little impact on the lives and needs of the masses, but their work stands as a manifestation of politically engaged art. Max Pechstein designed a powerful poster against the terrorism that prevailed in the streets. The lesser-known Heinz Fuchs, in a poster of dynamic Futurist design, urged workers to return to the mines and farms to avoid hunger. Most moving of all is Käthe Kollwitz's exhortation for peace: *Nie weider Krieg* (War Nevermore): a young man, right arm upraised with two fingers extended, is crying out his solemn oath for peace. The lettering is very much a part of the unity of work and image achieved in this unforgettable call for peace, which the artist produced for a Day of Youth in Leipzig in 1924. Kollwitz, whose son was killed in the war, is also represented by a portfolio of seven woodcuts that speak with both anguish and authority about the personal tragedy of war. Writing about them to her friend, the eminent

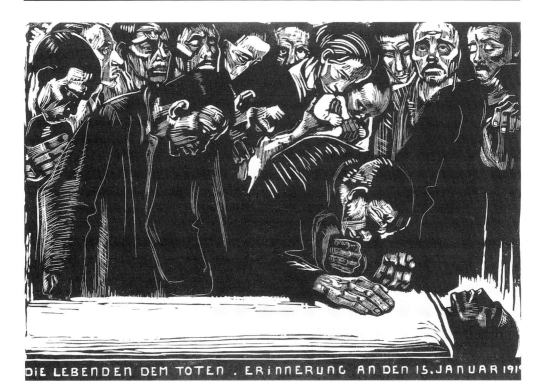

DiE LEBENDEN DEM TOTEN . ERiNNERUNG AN DEN 15. JANUAR 191

FIGURE 18. Käthe Kollwitz, *Memorial Sheet for Karl Liebknecht*, 1919–20, woodcut, 14¹³⁄₁₆ × 20³⁄₁₆", Los Angeles County Museum of Art, The Robert Gore Rifkind Center for German Expressionist Studies.

French novelist and pacifist Romain Rolland, she said: "Again and again I have tried to represent war . . . Now, finally, I have a ready series of woodcuts, which say what I wish to say. Together these prints should wander the world and say to all men: So it was – this have we all borne through these unspeakable years."[9] There are also both the lithograph and the woodcut Kollwitz made in memory of the assassination of the socialist leader Karl Liebknecht in 1919. The brutality of the murderers is countered by her most tender scene of mourning and despair.

The same event is also commemorated in a lithograph by the younger Conrad Felixmüller, a founder of the newly formed Dresden Sezession. He depicts Liebknecht together with Rosa Luxemburg, who had also been murdered in the name of law and order. But Felixmüller, an active member of the Communist Party, mythologizes the revolutionaries as a couple, floating above the city toward the Soviet star, which shines brightly from the heavens.

George Grosz's famous painting, *Metropolis*, highlights the section called Revolution. Painted in 1916–17, that is, during the war and soon after the artist's second discharge from the army as unfit for service, it predicts the chaos about to engulf Germany. Discussing a similar work, Grosz wrote in a letter in December 1917 of "a teeming throng of possessed animals – I am unshaken in my view that this epoch is sailing down to its destruction . . ."[10] The aggressive painting, informed by the dynamic work of the Futurists, is painted all in red. It is the inferno of the Last Judgment. But it is set in the metropolis, with hordes of urbanites rushing between hotels and places of amusement. In the sky we see an eclipsed

red sun and the symbols of capitalism: a merrily waving Stars and Stripes and a large "Benz" sign, which appears like a prediction of the large Mercedes-Benz emblem which now revolves above the Gedächtniskirche in the center of West Berlin.

The consequences of the Great War are presented by Otto Dix in a trenchant canvas, *Die Skatspieler* (1920): three almost totally mutilated former army officers are engaged in a card game in a seedy café. As Stephanie Barron points out, "So deformed are they by their injuries that they are forced to play with prosthetic hands or with their mouths and feet."[11] By this time collage had become an important instrument for relating art to reality: the Dresden newspaper on the wall, the players, cards, even a cardboard Iron Cross, are pasted onto the canvas. In this and other paintings from this period, as well as in his suite of etchings entitled *War* (1924), Dix created the strongest indictments against the horrors of war, images of which, like in Erich Maria Remarque's novel, were based on personal experience in the trenches.

In George Grosz's *Eclipse of the Sun* (1926), we see the solar symbol of darkness on the wall of a room in which a capitalist bureaucrat in a silk hat, with munitions as well as a toy railroad clutched under his arm, whispers orders in the ear of a bloated, bloodthirsty, and bemedalled general. Grosz, we see, knew about the military-industrial complex early on. Around a green table are a number of officials, properly attired but with no heads above their white collars. An ornate cross, a bloody sword, and a blindfolded ass at its trough, are placed around the conference table; a proletarian prisoner and a human skull in the lower right are perhaps a prognosis of the future. Finished in a rather meticulous style, with the objects clarified and the painting process all but effaced, this painting was done after Grosz's Expressionist period. Like Kurt Jooss's satirical antiwar ballet, *The Green Table*, it is a fine allegory of the state of diplomacy during the period between the wars.

Among the over two hundred works, by about seventy artists, in this exhibition, there are certainly a fair number that do not come up to the standards of Dix, Grosz, Kollwitz, and Wollheim. There is no doubt that some of the artists' work in an Expressionist style was turning academic, and that some of the artists resorted to stereotype. The art historian Edgar Wind once remarked sagely, "You can blow the trumpet of the Last Judgment once; you must not blow it every day." I had a similar problem with the section entitled "Abstract Expressionism." The term was first used by Oswald Herzog as early as 1919, in an article called "Der abstrakte Expressionismus." Herzog considered this form "fulfilled Expressionism," equating it with life itself and he states that Abstract Expressionism, of which he considers himself an exponent, "creates objects not taken from nature, but related to nature through their rhythm."[12] The term entered the American lexicon when Alfred H. Barr employed it for his lectures on Kandinsky at Wellesley College in 1929, and for his descriptions of Kandinsky's work in Museum of Modern Art catalogues.

The exuberant paintings by Kandinsky, which by 1913 liberated art from adherence to external reality and were based on what he called the principle of internal necessity, can indeed be considered the ultimate realization of the Expressionist idea. However, Kandinsky issued dire warnings against abstraction

becoming decorative form, and the second generation no longer carries the audacity of the innovators. Oswald Herzog himself is represented by a bronze, *Enjoyment* (1920), which is little more than a facile piece of Art Deco garniture. Certainly there are fine accomplishments in the section, above all Rudolf Belling's *Triad* (1919), with its successful interplay between positive and negative space, and Johannes Molzahn's *Energy at Rest* (1919), a painting of dynamic cones and circles which he saw as a "living and pulsating cosmos," a "steaming universe."[13] But some of the paintings in this grouping appear almost as rather provincial and tardy derivations from Cubism, Orphism, and Futurism. Moriz Melzer's *Bridgetown* of 1923 echoes work done by the Vorticists in England almost ten years earlier.

The close affinity between Expressionism and the spiritual has long been acknowledged, and the section devoted to sacred themes reinforces this conception. The German Expressionists in much of their work confronted the meaning of the ultimate. Paul Tillich, who came of age in a milieu in which Expressionist thought was dominant, wrote at the time:

> Expressionism proper arose with a revolutionary consciousness and revolutionary force. The individual forms of things were dissolved, not in favor of subjective impressions but in favor of objective metaphysical expression. In Germany the painters of the "Bridge Circle," Schmidt-Rottluff, Nolde, Kirchner, and Heckel led the way. Others accompanied them. Naturally the movement turned back to older, primitive and exotic forms in which the inner expressive force of reality was still to be found untamed.[14]

The exhibition presents the acclaimed and consistently moving *Christ* cycle of woodcuts made by Schmidt-Rottluff in 1918, works in which Christian iconography is successfully informed by African sculpture as well as by the artist's own experiences of three years on the eastern front. In addition to these images of solemn intensity, there is the lesser-known suite of twelve hand-colored woodcuts by Max Pechstein, *The Lord's Prayer* (1921), which relate to the early German woodcut in their angularity of line and frontal organization of space, as well as in their narrative pageantry.

It was the suffering St. Sebastian, rather than the saints of grace or mercy who, it seems, was the patron saint of the Expressionists. Otto Schubert, a member of the Dresden Sezession, drew St. Sebastian as a war victim in *Crossroads at Ypres* (c. 1918). Both Willy Jaeckel in an etching and Otto Dix in a drawing, depict the saint in writhing agony. Above all, there is the oak carving by Karl Albiker of Sebastian bound to a tree. The wooden shaft piercing his heart seems to kill him, while at the same time it props him up and keeps him from total collapse, prolonging his anguish.[15]

This fragile wood sculpture, together with some fifty additional works, were lent from East German museums – an unprecedented accomplishment on the part of the Los Angeles County Museum of Art and Stephanie Barron, who has also brought the work of Conrad Felixmüller to critical attention with no fewer than fifteen works by the Dresden artist.

Felixmüller's portraits of 1918 and 1920 were still under the influence of Cubist painting. But his violent *Otto Dix Painting* (1920) depicts his older friend in dis-

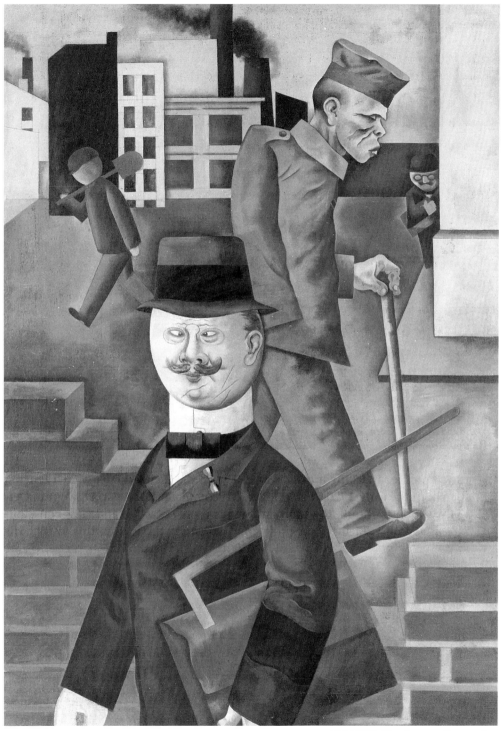

FIGURE 19. George Grosz, *Grey Day*, 1921, oil on canvas, 46 × 31⅞", Staatliche Museen – Preussischer Kulturbesitz Nationalgalerie.

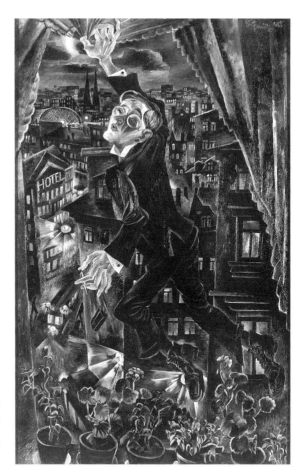

FIGURE 20. Conrad Felixmüller, *Death of the Poet Walter Rheiner*, 1925, oil on canvas, 73³/₁₆ × 51³/₁₆", The Robert Gore Rifkind Collection, Beverly Hills.

torted profile, attacking a canvas as if it were the dreaded enemy in a fencing match. In the early 1920s, Felixmüller, the son of a factory worker, went to Germany's industrial hub, the Ruhr, and made more detached and class-conscious paintings and woodcuts of the proletarian workers in the coal-mining district. His masterpiece, however, and one of the highlights of the exhibition, is *Death of the Poet Walter Rheiner* (1925). Rheiner was an Expressionist poet of note as well as a spokesman of the Dresden Sezession and a friend of the artist. In 1920 he wrote a novel, *Kokain*, which described the life and suicide of an addict. The book was illustrated by Felixmüller. Six years later, living in total poverty, Rheiner died of an overdose of morphine in a shabby hotel room in Berlin. In response, Felixmüller created the painting of an elegantly dressed man jumping to his death, clutching a hypodermic needle in his left hand, while the right hand, holding the curtain of the window from which he jumps, seems to be grasping for the moon. The poet, who has assumed the painter's persona, floats into the cold night of the pulsating city as if "to say a final farewell to an era that had passed."[16]

This may indeed signal the end of German Expressionism's second generation. But it was Walter Rheiner who had claimed:

Expressionism is not a purely technical or formal issue but above all a spiritual (epistemological, metaphysical, ethical) attitude that has been present in hu-

man history not just since this morning or yesterday, but for thousands of years. In politics this idealism is the anti-nationalist socialism that is now radically and unconditionally demanded, not only in the spirit but in the act.[17]

But the art demanded by socialism became the coldly objective analysis of the social and political situation by the Verist artists of the New Objectivity. Under its icy surface, however, Expressionist fires were still burning. While Expressionism was held up for ridicule by the Nazis, and its practitioners were persecuted, the fundamental aspects of Expressionist art crossed the Atlantic and became significant ingredients in the flowering of Mexican mural painting, especially in the work of José Clemente Orozco, including his murals in California, New Hampshire, and New York. Jackson Pollock's early interest in Orozco and Beckmann (as well as Picasso) is well known. Hans Hofmann was an important presence in New York from 1932 on, and Lyonel Feininger returned a few years later. The famous statement by Mark Rothko and Adolph Gottlieb that "the subject is crucial and only that subject matter is valid which is tragic and timeless,"[18] echoes the Nietzschean impetus to Expressionism at the beginning of the century. De Kooning's *Women* pressed Action Painting into the main current of Expressionism at a time when it also found renewed vigor in Europe among de Kooning's Dutch compatriots and their colleagues in the CoBrA group in Belgium and Denmark.

In a grandiose and self-celebrating vein, the movement called Neo-Expressionism arrested the art world with a painting boom in West Germany, Italy, and America in the early 1980s. When the Berlin critic Wolfgang Max Faust announced a new "hunger for pictures," he might unintentionally have spoken for the art dealers as well as the artists. Paintings sensational in content, excessive in size, often encumbered with broken crockery, and boasting appropriation in place of authenticity, inundated the art world, laying claim to the Expressionist tradition. At a time when critics tell us that the artist in the post-modern world can only be a screen, and that replication and simulation is the order of the day, we note that the Expressionists' search for an authentic tragic image still persists. There are the intensely felt expressive confessions by Philip Guston in his foreboding allegories of the 1970s. There is the morally committed work done by artists such as Anselm Kiefer, Arnulf Rainer, Magdalena Abakanowicz, and others working in this country, in England, and on the European continent, both in the West and in the East. It is an art in which passionate content becomes deeply felt form.

GERMAN
REALISM OF
THE TWENTIES

THE ARTIST AS SOCIAL CRITIC

Expressionism, the vanguard art movement of pre-World War I Germany, was primarily concerned with creating works of spiritual vitality, emotional content, and passionate authenticity.* Problems of form were of secondary importance to the Expressionists. They strongly believed that an artistic revolution could help bring about a radical social and political change by purifying and transforming the individual. Abstraction, coming from "inner necessity" could, they hoped, create a new consciousness by affecting the viewer directly on a subliminal and primary level with its universal message of creativity.

In 1912 the German art historian and critic Wilhelm Hausenstein, a strong advocate of Expressionism at the time, concurred with the move toward abstraction, declaring that "art which is tied to the object is a primitive form of art."[1] But eight years later, after the end of the war, Hausenstein reversed his position and welcomed the "salvation of the individual in the object." He now recalled the "limitless intensity of expressionism," its "chiliastic madness and greatness," but also noted that this kind of cosmic painting had degenerated into mannerisms, that it did not explain the catastrophic postwar situation. "Der Expressionismus ist tot."[2]

Similarly Wilhelm Worringer, whose influential treatise of 1908, *Abstraction and Empathy*, was related to Expressionism in its attitude and style, noted in 1920 that in Expressionism "men in hopeless solitude wished to find a community . . . Agitated revelations, visionary flashes of light have been handsomely framed, declared permanent and degraded to peaceful wall decorations."[3]

The Expressionists had rejected realism, that is, an art relying on the visible world, in favor of a subjective search for inner reality. They longed to communicate these deeper values to an undefined "people" and share with them their turbulent and often prophetic visions. But by 1920 Armageddon had occurred; four years of trench warfare, followed by misery, starvation, riots, murders, as-

* This essay originally appeared in *German Realism of the Twenties: The Artist as Social Critic*, 1980. Reprinted by permission of The Minneapolis Institute of Arts.

sassinations. Apocalyptic events occurred daily. The Holocaust had been predicted by Expressionist poets (von Hoddis, Benn, Heym, Trakl) and painters (Kandinsky, Marc, Meidner, Kokoschka), but now in the daily postwar chaos, there was no longer the need for visions. The war had not turned out to be the great cleansing experience which the painter Franz Marc, among others, had foreseen as a "moral breakthrough to a higher experience."[4] Instead the war had killed ten million people – including Marc, who fell in action in Verdun in 1916 – and wounded another twenty million. When it was all over, when armistice was finally declared, the nature of political power had not changed significantly throughout most of Europe, but most of the values of European civilization had been shattered. In 1918 Oswald Spengler published a book in which he thunderously announced *The Decline of the West*.

The armistice of November 1918 was preceded by nausea of war and followed by turmoil. In Germany the Revolution of the Left was quickly aborted by the assumption of power by the moderate wing of the bourgeois Social Democratic Party, which was soon embroiled in bloody battles with the left-wing Spartacist group. There was much bloodshed in Berlin, Hamburg, and Munich, and throughout Saxony. The German bourgeoisie was not ready to accept a revolutionary government of the left, and the Social Democratic Party became the organ of law and order, suppressing revolutionary elements. The threat from the left was answered by the murder of its leaders, Rosa Luxemburg and Karl Liebknecht, in Berlin, and little was done to stop the militant right from assassinating the leaders of the short-lived Soviet Republic of Bavaria. The old order was restored. The Imperial German military, although decimated by four years of war, was reconstituted under its old chauvinistic officers' corps. The unreconstructed judicial system condemned men of the left to death sentences or long imprisonment while rightists were hardly troubled at all. Even Hitler was to serve less than a year in light imprisonment after his *Putsch* of 1923. The ruinous inflation that devastated the economy of Germany (in November 1923 one U.S. dollar was worth 42 trillion marks) hit the average citizen even harder than the war itself; it was finally resolved by an adjustment of Germany's obligations to pay reparations to the Allies. The United States established the Dawes Plan to help rescue a fellow-capitalist country, and the German currency was stabilized. For a brief time during the 1920s businesses and industry recovered; nevertheless the number of unemployed workers rose rapidly from some three hundred fifty thousand in 1921 to over four million ten years later. The old establishment was consolidated, however, when the long-retired general and war hero Paul von Hindenburg was elected president of the German Reich in 1925 and Germany was accepted in the League of Nations the following year.

Soon after the abdication of the Kaiser (November 9, 1918) and the armistice (November 11) artists, architects, writers, and musicians established the Novembergruppe in Berlin, calling on "Expressionists, Cubists, Futurists" to produce a new art for a new time. In 1919 the Workers' Council for Art was founded and published its *Call to All Artists* for a socialist art and architecture, its fervent message still communicated in an idealistic, utopian, Expressionist style. Although these groups intended to attack all bourgeois values, the educated middle class accepted their art while ignoring their political message. The Novembergruppe

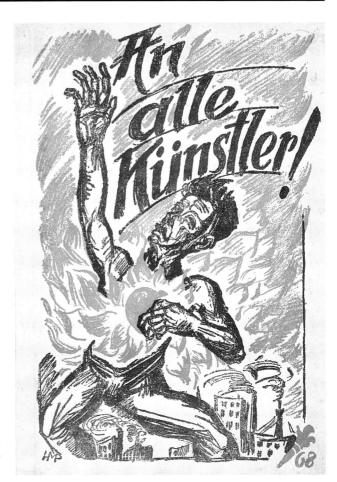

FIGURE 21. Max Pechstein, *An Alle Künstler*, 1919, cover illustration for the Novembergruppe's book, Los Angeles County Museum of Art, The Robert Gore Rifkind Center for German Expressionist Studies.

continued to exist throughout the period of the Weimar Republic. But in place of its earlier program to establish a new relationship between the artist and society, it became little more than an organ for exhibitions.

Even before the end of the war Dadaism came to Berlin. The Berlin Dadas had no use for either the style or the politics of their liberal colleagues, disdaining above all their continuing faith in spiritual renewal. In Zurich, where Dada had its origin, pacifist exiles attacked all cultural values – including art; in New York, Dada was essentially a remote aesthetic manifestation in spite of its anti-art stance. In Berlin, however, Dada was a provocative political event. When Richard Huelsenbeck returned to the German capital in 1917, the possibility of a revolution was very real. He joined the Herzfelde brothers and the poet Franz Jung and the painters George Grosz, Raoul Hausmann, and Johannes Baader, the "Oberdada," all partisans of that revolution. They had nothing but scorn for the Expressionists, who "on pretext of carrying on propaganda of the soul . . . have in their struggle with naturalism found their way back to the abstract emotional gesture which presupposes a comfortable life free from content or strife."[5]

Although Expressionism could no longer survive the reality of daily life in postwar Germany, certain aspects of the movement remained: its innovative form and the conviction that a work of art by a committed artist could reform

FIGURE 22. Hannah Höch, *Cut with the Kitchen Knife*, 1919, collage, 45½ × 36", Staatliche Museen zu Berlin – Preussischer Kulturbesitz Nationalgalerie.

life through new personal awareness and that it could raise the moral level of society. This belief underlay the powerful political statements of brilliant radical artists like George Grosz and John Heartfield, who were largely responsible for the strongly communist direction taken by Berlin Dada in the early 1920s. It is also echoed in the basically utopian theories of the architect Walter Gropius, who in forming the Bauhaus hoped to reinstitute the cooperation among architects, sculptors, and painters that existed under the medieval guild system.

At the Bauhaus significant painters like Kandinsky, Klee, Schlemmer, and Feininger continued their formal experimentation, but most of the art in Germany during the postwar period focused on the external world, dealing with the grim reality at hand. The trend toward realism was by no means unique to the art of Germany during this time. This tendency toward an art of the real is traceable to Picasso's Ingresque *Portrait of Ambroise Vollard* (1916), a pencil drawing which can be said to have inaugurated his "classic" period. At about the same time André Derain's accommodation of the art of the past became paradigmatic for many artists, including the erstwhile futurist Gino Severini. Georges Braque renounced Cubism, and even Robert Delaunay painted representational pictures. Jean Cocteau published his influential *Rappel à l'Ordre* in 1926. In Italy the painters of the Scuola Metafisica, although disrupting logic, gave a new and often mysterious meaning to the object. After the war a group of important Italian painters formed the Novecento group and published the Roman journal *Valori Plastici*, advocating a return to ordered and rational painting in the Italian Renaissance tradition. They were not without sympathy for Mussolini's glorification of the Italian past. English vorticism had come to an early death with the end of World War I, and reactionary government policies brought about the demise of constructivism in the Soviet Union. In the United States also the early experimentation in pictorial abstraction by members of the Stieglitz circle, John Marin, Marsden Hartley, Arthur G. Dove, and Georgia O'Keeffe, came to an end. Each of these artists now developed a personal visual vocabulary to describe the forms and forces they saw in the real, visible world around them.

Just as Berlin Dada was more strongly politicized than its counterparts in Zurich, New York, and Paris, so also was new realist painting more political in Weimar Germany than elsewhere. Even there, however, not all of these new realists were politically engaged artists. When Gustav Hartlaub, director of the Kunsthalle in Mannheim, organized the landmark exhibition in 1925 which he called *Neue Sachlichkeit*, he was very much aware that there was a conservative or "classicist" wing as well as the politically committed left wing. Picasso, with his neoclassical paintings of nudes, belongs in the former category, as do most of the Italianate Munich "Magic Realists" of the 1920s. The more radical artists, whom Hartlaub called "Verists," included George Grosz, Otto Dix, and Georg Scholz, as well as Max Beckmann. Hartlaub sent out a circular in 1923 which first announced an exhibition in which he meant to assemble paintings by artists who rejected both "impressionistically vague and expressionistically abstract" art and whose work was "neither sensuously external nor constructively internal." He appealed to artists "who have remained true or have returned to a positive, palpable reality" which would enable them to reveal the true face of our time.[6]

Hartlaub's term "sachlich" was first used some twenty years earlier by Hermann Muthesius, the head of the German Werkbund, to convey his opposition both to the lavish decoration of architectural historicism and to the nonfunctional linear decoration of Jugendstil. "Sachlich" was applied to trends in architecture and design which began to take form in the early years of the century and which were characterized by functional simplicity. It was a similar factual and honest objectivity or sobriety that Hartlaub recognized in the painting of

"tangible reality," taking shape all over Germany in the early 1920s, the period of stabilization and further industrialization of the German economy.

By the mid-1920s, in fact, "sachlich" was used to characterize not only new architectural and artistic styles, but also the new style of factual journalistic reporting, a new kind of popular fiction, and the new *Realpolitik* of men like Gustav Stresemann. Hartlaub's categories within Neue Sachlichkeit of Right or Classicist and Left or Verist wings have largely been accepted by recent Western scholars on Weimar art. Marxist scholars, on the other hand, use the term "Neue Sachlichkeit" for the "rational," industrialized, and dehumanized art of the middle class during the stabilization period of the Weimar Republic, an art whose pictorial motifs are isolated and not cognizant of the social and political context. They accept the use of the term "Verism" for the left-wing group that developed largely out of Berlin Dada, and which was an art involved in the class struggle. Other subdivisions such as a breakdown by the most important centers – Berlin, Munich, Karlsruhe, Dresden, Breslau, Hanover, Cologne and Düsseldorf – have also been suggested.

There were indeed many differing aspects to the new realism in Germany. A topographic division into specific centers has been proposed. Perhaps the most useful and most precise subdivision, however, is one based on political ideologies which was suggested by Roland März for the large exhibition *Realismus und Sachlichkeit*[7] held in East Berlin's National Gallery in 1974. März discerns the following five groupings:

1. Berlin Dada (Hausmann, Schwitters)
2. Verism (Grosz, Dix, Beckmann, Hubbuch, Scholz, Schlichter, Schad)
3. Neue Sachlichkeit (Grossberg, Radziwill, Räderscheidt, Kanoldt, Schrimpf, Mense)
4. Proletarian-Revolutionary (Griebel, Nagel, Grundig, Völker, Querner)
5. Political Constructivism (Hoerle, Seiwert, Nerlinger)

The present exhibition deals primarily with März's Verist, Neue Sachlichkeit, and Political Constructivist groupings. Almost all the paintings by the "Proletarian-Revolutionary" artists are in East German collections and could, unfortunately, not be borrowed for this exhibition.

Many of these painters adopted a realist attitude in their endeavor to picture without sentimentality a highly charged place and time. Many of them, although politically committed, painted pictures whose formal qualities appear detached. It is, of course, never possible for a painting to be an accurate mirror of reality. To begin with, the two-dimensional surface differs markedly from the three-dimensional world. Furthermore, many of these new realists were engaged individuals who tried to penetrate to a deeper understanding of reality and its meaning. They would certainly have agreed with Bertolt Brecht's observation that "A photograph of the Krupp factory tells us next to nothing about the place."[8]

Individuality was no longer held as a sacrosanct value by many artists in the postwar period who thought of themselves as social beings. At the same time that the Bauhaus set up a program to integrate the artist into a technological society, the Verists and other radical left-wing artists sought to become an integral part

of the social structure. They knew like Daumier a hundred years earlier that "il faut être de son temps." They found a new and tough post-Expressionist form to give form to their polemics. They painted commonplace themes, mostly of urban life. They observed the cabarets, the dance halls, and the night life. Their paintings reflect a world which we know from Brecht's plays and von Sternberg's films. With whores crowding the streets of German cities during the depressed years of the republic, they expressed their disgust with or protest against a system which prostituted many of its women and degraded its men. Some of them glorified the peasant and worker, while others revealed the misery of their existence. Industry and technology become a significant subject. Factories were at times analyzed with cool detachment or even with a sense of promise. The subject painted most frequently by the German realists, however, was the portrait – including the self-portrait – probably because it was there that the cool and sober, static and analytical approach of these artists could find its theme. The clinical analysis of the self or others was a way of investigating the nature of the human race.

George Grosz formed the link between Dada and the later, less frenetic Verist movement. In 1918 when the surviving veterans returned from the trenches, he, called "Propagandada," walked the Kurfürstendamm in Berlin, dressed as Death.

To the idealist message of the expressionists, "der Mensch ist gut" he countered "der Mensch ist ein Vieh." But, above all, Grosz felt that his art had to be in the service of a political and social revolution. "My art was to be my arm, and my sword," he recalled, "pens that drew without a purpose were like empty straws."[9] With a total commitment to the masses, Grosz developed a knife-hard and incisive drawing technique. The individual and his destiny were no longer of prime importance in his analysis of the human figure. People in his polemical paintings, drawings, and prints, although realistic enough, are transformed into signs and ciphers. His work indicates a belief that a person's social position and political stance shape his psychological responses and even his physiognomy. In other words, he developed a truly materialistic, or, if such exists, a Marxist style in his art. People stand for the class to which they belong. They are cogs in the wheel of the socio-political super-machine.

Grosz remained active as a communist artist until the mid-1920s, publishing portfolios of prints and drawings for political journals, and painting powerful oils. In all of these he attacked the ruling class, the military, the capitalists, and the clergy, and revealed the ruthless exploitation of the working class. He also ridiculed the upstanding German Bürger, the "pillar of society," and exposed the sexual depravities that prevailed in postwar Berlin. Three times the artist was arrested and tried by the authorities for slander, blasphemy, and defaming public morality.

His scepticism and pessimism reasserted themselves in the mid-1920s. The revolution in Germany had not materialized and the artist, although remaining loyal to the communist cause for some time, was disappointed by a visit to the Soviet Union. When he gained recognition and began to be shown at Flechtheim, Berlin's most influential gallery of modern art, he shifted his thrust from political to a less controversial social criticism and slowly his style grew softer years before he left for the United States to become a romantically conservative artist and teacher at the Art Students' League.

FIGURE 23. George Grosz, *Feierabend (Time to Rest)*, 1919, photolithograph, 15¼ × 11³⁄₁₆", Los Angeles County Museum of Art, The Robert Gore Rifkind Center for German Expressionist Studies.

Otto Dix was looked on by many artists as the leading figure of the Verist movement. Like Grosz, Dix came from a working class family. He was always enamored of the German Renaissance and romantic masters and under their influence he developed a precise realism. He painted incisive portraits in a pointed and often cruelly realist style. Having served in the trenches, Dix painted and etched the most horror-evoking depictions of the war since Goya. His *War* series was the shocking pictorial equivalent of Erich Maria Remarque's novel *All Quiet on the Western Front*. Dix also painted the crippled veterans, the prostitutes, the beggars – the various victims of war whose appearance was so common in the German cities of the 1920s. His style, far from being soberly detached, is often intensely passionate but always controlled. His figures often strike the viewer as being grotesque, but he worked in and criticized a world that was incongruous indeed. Although most painters of the Neue Sachlichkeit worked in one of Germany's art centers, Otto Dix moved from Dresden to Düsseldorf and on to Berlin, finally returning to Dresden to a professorship at the academy in 1927, and was in contact with Verist groups in all these cities.

Rudolf Schlichter and Georg Scholz were important members of the Verist group. Both had studied in Karlsruhe with the popular sentimental painter Hans Thoma and the impressionist landscapist Wilhelm Trübner. After their return from the war, they were close to the Dada group in Berlin (Schlichter was actually

FIGURE 24. Otto Dix, *Wounded Man, Autumn 1916*, 1916, etching with aquatint, 7¾ × 11⅜", Los Angeles County Museum of Art, The Robert Gore Rifkind Center for German Expressionist Studies.

a member) and thereafter they were active in Berlin radical circles. In 1924 they were founding members of the Rote Gruppe, a communist artists' association dedicated to art in the service of the class struggle.

Schlichter was an almost clinical observer of the Berlin scene, of its sexual obsessions and fetishisms, and of its people: he created incisive portraits of Berlin intellectuals such as Bertold Brecht and the radical journalist Egon Erwin Kisch. Scholz brought his talent to bear on paintings of workers and peasants in which he depicted the frightening effect of industry on the old and established order of life, but he also produced still lifes and sunny landscapes. Karl Hubbuch also came to Berlin from Karlsruhe and painted the city and its people, caustic, cynical, and precise. All three artists were partisans of the left who depicted their sober subjects with clear and severe realism, accusatory without resorting to sentimentality. Along with other painters of the Neue Sachlichkeit, they showed a preference for static and quiet form and for thin application of pigment that did not disclose personal brushwork.

The most meticulous, the most photographic paintings were those of Christian Schad. Schad, although not a politically engaged artist, is generally classed with the Verists in discussions of the Neue Sachlichkeit. Born in Bavaria, Schad became a member of the Dada group in Zurich and Geneva, where he invented the photograph without camera, called "Schadograph" by Tristan Tzara. This was in 1918, several years before Moholy-Nagy originated the "photogram" and Man Ray the "rayograph." In the 1920s, first in Naples, then in Vienna and Berlin, Schad turned to portraiture, presenting himself and his friends with cold detachment. His portraits are painted with painful fastidiousness and seem almost like

FIGURE 25. Georg Scholz, *Indus-trialized Farmers*, 1920, oil and collage on panel, 36 × 28", Von der Heydt Museum, Wuppertal.

surgical performances. His figures are removed from their time and their place and seem totally self-centered, alienated from a world to which they do not belong, alone in their chilling solitude.

Max Beckmann, too, exhibited with the Verists. It is difficult, however, to place Beckmann, one of the towering geniuses of modern art, into any group of movement. Beckmann, who had painted colossal pictures of cataclysmic events in a romantic style before the war, underwent a radical change in style caused by the horrors of war. He felt the need to be engaged in the struggles that embroiled Germany, writing in 1920: "Just now, even more than before the war, I feel the need to be in the cities among my fellow men. This is where our place is. We must surrender our heart and our nerves to the dreadful screams of pain of the poor disillusioned people . . . Our superfluous, self-willed existence can now be motivated only by giving our fellow men a picture of their fate and this can be done only if we love them."[10]

After Beckmann was discharged from the medical corps of the German army in 1916, the works he produced were certainly related to the work of the Verists, and indeed anticipated much of the content and form of the group. He painted pictures of contemporary concern. He painted his observations with great clarity of detail and created pictures in which almost rigid figures exist in precise and

angular compositions with a precise sense of order; painted them in light colors with a thin application of the brush. All these aspects of Beckmann's art relate him to the Verists, but unlike them, Beckmann looked at the physical world as a means of finding his own entry to the metaphysical. His protest against the state of things was not primarily social or political but religious in nature. Even in his most realistic pictures, there is a sense of the mystery of existence. Later he articulated this when he wrote: "What I want to show in my work is the idea which hides itself behind so-called reality. I am seeking for the bridge which leads from the visible to the invisible, like the famous cabalist who once said: 'If you wish to get hold of the invisible you must penetrate as deeply as possible into the visible.' "[11] There was nothing mystical in the work of the so-called Proletarian Revolutionaries. The strongest representatives of this group were the painters Karl Völker, Hans Grundig, and Curt Querner, who worked in the highly industrialized Saxony region. Völker, the oldest of this group, painted a cycle of murals for a Socialist meeting hall in his native Halle in the early 1920s in which he depicted the class struggle within a framework of Christian iconography. Völker became an active member of the Rote Gruppe, and altered his style in the mid-1920s, making it clear, rational, and dynamic. His best-known paintings represent large groups of industrial workers on the move, and are carried out with pictorial economy. While the Verists pictured the misery of the working class, painters like Völker followed a different strategy. His paintings exhibit a mighty proletariat, united in class solidarity and confident in their power.

Grundig and Querner were very close to Otto Dix, who worked in Dresden after his discharge from the army in 1916 until 1922, returning there as a professor of the academy in 1927. Grundig, an active member of the Communist Party from 1926 on, concentrated on explicitly proletarian themes in strong propagandistic paintings. At the end of the decade he painted prophetic pictures of terrifying, ghostly cities with empty streets and threatening skies.

Querner, the artist closest to Dix, was also aware of the masters of the German Renaissance. In the 1920s he drew pictures of the disenfranchised, the unemployed, the hungry. He painted workers on hunger marches and the impoverished peasants working small parcels of poor soil. Querner, even more than his Dresden contemporaries, allowed himself to be influenced by Courbet's famous *Stonebreakers*, that great revolutionary painting of 1849 which occupied a place of honor in Dresden's Gemäldegalerie until it was destroyed by the firebombing of 1945.

The three Saxon artists were members of the "Association of Revolutionary Visual Artists of Germany" (ARBKD), a communist organization that absorbed the Rote Gruppe in 1928. The association's theoretical polemics, as articulated by Alfred Durus, were Marxist in the narrowest sense, defining art solely as a matter of class conflict. Members of the ARBKD were expected to produce agit-props, street decorations, political posters, propaganda sculpture. Much of this work was effective at a time when a communist revolution in Germany seemed possible and when Russia's prestige among German intellectuals and artists still stood high. After the crash of 1929, economic conditions worsened and both the extreme left and right became more militant. Although the ARBKD boasted of

sixteen local groups and close to 800 members in 1933, it did not attract many of the better-known German artists.

When the Cologne group of Progressive Artists applied for membership in the ARBKD, they were refused because of their "anarchist tendencies."[12] In Cologne Heinrich Hoerle and Franz Wilhelm Seiwert, the "Political Constructivists," attempted to combine a radical artistic style with revolutionary politics as had seemed possible in Russia during the years just preceding and following the October Revolution. Like other artists in Germany in the 1920s they were influenced by the metaphysical painters of Italy, but they were also aware of Cubism, purism, constructivism, and de Stijl, and were in touch with many of the artists of the European avant-garde. As radical and humanist Marxists, they objected to the authoritarian program of the Communist Party. In their painting, a faceless human image is part of a technological, mechanical world. The human figure becomes a geometric form and a standardized, objectified, and universal sign.

The Cologne painter Anton Räderscheidt, although apolitical, was a friend of the Progressives. He, more than anyone else in Germany, reflects de Chirico's influence. His figures are lonely and isolated from each other and the world. As he "continued to explore the theme of alienation, so his art acquired a more personal character, transforming the wildness of the expressionist angst into a coolly detached yet brutal psychological study of himself."[13] Most of Räderscheidt's work was lost or destroyed during the time of Hitler, but judging from what has remained and from photographs, his paintings of men dressed in black suits and bowler hats, unrelated to the nude women in the empty space they share, look very much like stills from Antonioni's films.

Human beings are totally absent from Carl Grossberg's cold world of machines and industrial landscapes. Grossberg was fascinated by the new technological equipment, and his own work with its clear, sharp lines, its quick mechanical perspectives, its hard surfaces showing no imprint of the human hand, seems itself to be machine-made. In his technique of thin applications of brightly-colored paint he resembles Charles Sheeler; both artists, furthermore, accepted the technological world without criticism, and were sought out by industrial concerns who gave them commissions to make paintings of their factories, much as English aristocrats in the eighteenth century engaged artists to make paintings of their country houses. It was work like Grossberg's that prompted Brecht to write his poem "700 Intellectuals pray to an oil tank."

Although most of the left-wing artists of the Neue Sachlichkeit were denounced by the Nazis, prohibited from painting, and their work exhibited in monstrous "Degenerate Art" shows, a painter like Grossberg could be tolerated. Art sponsored by the Nazis, glorifying the land, the family, the hero, was generally more painterly, academic and sentimental, but their ideologues could find precedents both in the nebulous folk mythology of the Expressionists and in the idealization of the industrial world, as well as in the clean, realistic style of Neue Sachlichkeit painters. On the other hand they totally condemned both the Expressionists' subjective search for inner truth and the rational attitude and revolutionary political commitment of many Neue Sachlichkeit artists. But like the Expressionists, who felt that their art could change human consciousness, and

many of the Verists, who believed that their art could help in the revolutionary class struggle, the Nazis too took art seriously. Paul Schultze-Naumburg, who was a leading race theorist of the Nazi movement, wrote in 1932, just prior to Hitler's assumption of power: "in German art rages a battle for life and death, no different from that in the field of politics. And next to the fight for power, this struggle must be pursued with the same seriousness and the same determination."[14] And certainly this was done.

That art and politics do indeed mix becomes clear from any study of Weimar Germany. Rarely in modern times has art become more intimately interwoven with the socio-political framework than it was during these turbulent years. In fact, the acute social and political problems stimulated certain artists and helped produce a vital art of realist engagement with the political situation. The socio-political condition acted as a catalyst which energized many of the artists to produce outstanding work. The importance of this stressful stimulation cannot be overemphasized: when the political situation changed with the Nazi assumption of power and the strangulation of the arts, many of the artists went into exile and their work suffered enormously. The sense of direction and the core were gone.

7 MAX BECKMANN

THE SELF-PORTRAITS

Before the events that led up to World War II, Max Beckmann had been recognized as Germany's foremost painter. But during the Nazis's well-organized purge, 590 of his works were confiscated from museums throughout the nation and he was "featured" in the infamous 1937 "Degenerate Art" exhibition in Munich. Beckmann listened to an inflammatory opening speech on the radio in Berlin, in which Hitler promised imprisonment or sterilization for artists who would persist in their "practice of pre-historic art stutterings," packed his bags, and fled to Amsterdam the next day, never to return to his native land. A year later he went to London to speak at the New Burlington Galleries on the occasion of a memorable exhibition sponsored by Roland Penrose and Herbert Read, *Twentieth-Century German Art*. There, in the midst of a highly charged political climate, Beckmann must have surprised his audience by announcing his disinterest in the geopolitical sphere.[1] Instead he emphasized the spiritual realm, the search for the invisible that lies beneath surface reality. He explained the purpose of art as "the quest for our own identity, which transpires on the eternal and obscure path we are bound to travel" and stressed the need to penetrate "the Self . . . which is the greatest and obscurest secret in the world."[2]

Beckmann's compulsive search for self-revelation in the midst of the horrors perpetrated in his time may seem a shortsighted – and seemingly arrogant – disregard of history. But perhaps his decision to focus on self-exploration is better interpreted as a rejection of the collective dogma and autocratic power that plagued his era. In his self-portraits Beckmann's gaze is at times directed outward, and we see the artist as an observer, voyeur, and chronicler of his life and times. He may look at the viewer with aggressive confrontation; at other times, especially in his drawings, we see a vulnerable, introverted person engaged in painful self-scrutiny.

Beckmann's inward search was no doubt related to his readings of occult and hermetic texts. His early study of Schopenhauer led him to explore the Vedas and Indian philosophy. He perused the Cabala and showed considerable interest in the theosophical teachings of Mme. Blavatsky, whose carefully annotated trea-

tise *The Secret Doctrine* was a prized part of his New York library. Beckmann was also interested in Gnosticism, a religious and philosophical movement that taught revelation through the knowledge and understanding of magical reality and the ineffable experience of the Self. When, in his London lecture, Beckmann spoke of "an intimation of the fourth dimension to which my whole soul aspires," he was not referring to Einstein's much-discussed notion of time, but to the mystical experiences of the soul that preoccupied so many of his contemporaries, including Wassily Kandinsky, Kazimir Malevich, and Piet Mondrian.[3]

Beckmann worked by suggestion and indirection. Like the work of the Symbolist writers and painters, his art operates by evocation. Even during the turbulent period following World War I, when the artist felt the need to comment on the horror surrounding him, "to surrender [his] heart and [his] nerves . . . to the horrible cries of pain of a poor and deluded people,"[4] his paintings were never as outspoken and accusatory as those of such compatriots as George Grosz, Otto Dix, and Rudolf Schlichter. There was always a vital tension between the clear structure of his color and form and the enigmatic nature of his figures and their relationships. Beckmann viewed the physical world as a means of entering the metaphysical realm, and spoke of "realism of the inner visions." His protest against the state of things was not social or political, but religious in nature. Indeed, he once wrote to his friend and publisher Reinhard Piper, "In my paintings I confront God with all he has done wrong. . . . My religion is arrogance before God, defiance of God. Defiance, because he created us so that we cannot love ourselves."[5]

When depicting himself, Beckmann often hid behind multiple roles and disguises. His quest for self-understanding caused him to constantly hold a mirror to his own figure. But rarely does he disclose his soul; instead, he uses the armor of concealment. Beckmann's conception of life as a series of role-playing activities is helpful in understanding this aspect of his work. In a revealing letter to his friend and patron Stephan Lackner, Beckmann expounded his belief that life is a chain of intervals, extending over millions of years, in which each of us personifies a highly individualized but boundlessly versatile actor on the stage of existence.[6] Accordingly, many of his paintings depict stage sets in which figures enact dramatic parts.

Beckmann's use of disguise in his compositions is hardly unique in the history of western art. In early Renaissance paintings, artists such as Masaccio and Botticelli often included themselves among the characters in a sacred composition. Albrecht Dürer, in his idealized Italianate *Self-Portrait* of 1500, depicted himself as no less than the triumphant *Salvator Mundi*, and the young Rembrandt often posed as a nobleman or Oriental prince in sumptuous costumes surrounded by exotic paraphernalia.

In his diaries, Beckmann referred to Dürer and Rembrandt, and even more frequently to van Gogh, who seems to have identified with Christ's martyrdom, while Gauguin (whom Beckmann also respected) portrayed himself with a halo (as well as a snake) in 1899. At the same time James Ensor depicted his own image as the Messiah in his epic canvas *The Entry of Christ into Brussels*. Twenty years later, the young Max Beckmann appears as a modern witness – or perhaps already as stage manager – in the large and ambitious painting *Resurrection*. In a very

different work of 1917, the figure of the striding and forgiving Saviour in *Christ and the Woman Taken in Adultery* bears a great resemblance to Beckmann himself.

More than any of his contemporaries in the first half of this century, Beckmann saw self-portraiture as a major genre. From his first awkward attempt at age fifteen to his contemplative and wistful final work of 1950, Beckmann produced more than eighty self-portraits in a variety of media, including oil, pen, pencil, crayon, watercolor, drypoint, lithography, woodcut, and bronze. He portrays himself as performer, conjurer, and mountebank, as harlequin and enigmatic prophet. He is king, Homeric hero, and Christ alike. Once, at a masquerade party in St. Louis, wearing a black domino over his eye, he announced facetiously, "I am Jupiter." He poses as the alienated member of his family or seated with a group of friends. He is the man of the world, appearing in tuxedo or tailcoat, the urbane socialite. But he is also the circus barker, the master of ceremonies, the hospital attendant, and the persecuted emigrant. Like an actor capable of living a variety of lives by means of dramatic ritual, Beckmann assumes multiple masks to enact and observe the human comedy where truth mixes with illusion. He is the spectator gazing at the world around him, the individual wounded by the journey through a modern inferno.

Beckmann's first self-portrait of 1899, *Self-Portrait*, is a small oil that depicts the adolescent artist with short-cropped blonde hair and lips punctuated by vibrant red paint. His features are still undetermined, his expression that of tentative youth. At about the same time he depicted himself in an armchair, his profile outlined sharply against a lonely North German landscape. He called it *Self-Portrait with Soap Bubbles* and we see him gazing into an unknown distance while the bubbles float toward an autumnal sky. Here the art student, only sixteen years old, locates his work in the European tradition: the theme, signifying the ephemeral nature of existence, has been the subject of the more sophisticated paintings of artists such as Jean Baptiste Chardin and Edouard Manet. While a student at the Weimar Academy in 1901, Beckmann made his earliest drypoint – a medium difficult to master but preferred by the artist in later years. He depicts himself screaming – a pose reminiscent of the "character heads" of Franz Xaver Messerschmidt as well as of Edvard Munch's signature canvas.

By 1907 Beckmann presents himself as a well-dressed young man in *Self-Portrait, Florence*, looking at the viewer and the world with a confident, open pose. His large black contour creates a striking contrast to the sunlit Italian landscape seen beyond the window. This is a romantic portrait of the artist as an expectant young man, conscious of early success. Beckmann had just been honored with a purchase award for a painting at the Weimar museum and with a prestigious stipend that sent him to Florence. A few years later he established himself in Berlin and became renowned for his heroic historical compositions *The Destruction of Messina* (1909), *The Battle of the Amazons* (1911), and *The Sinking of the Titanic* (1912). Dubbed the "German Delacroix," Beckmann was by far the youngest artist to be elected to the executive board of the Berlin Secession, and was taken on by one of the most exclusive galleries in Germany. At the precocious age of 29 Beckmann had his first retrospective exhibition in Berlin, which was accompanied by a monograph.

During this period he painted the very tender *Double Portrait Max Beckmann*

FIGURE 26. *Self-Portrait, Florence,* 1907, oil on canvas, 38½ × 35½", Hamburger Kunsthalle.

and Minna Beckmann-Tube (1909), a very private depiction of the artist and his young bride leaning against each other and looking out at the world with dreamy but melancholy expressions. Three years later he returned to the looser brushwork of the Florence picture, and depicts himself with a reserved, taciturn, almost alienated mien in *Self-Portrait with Greenish Background*. In a drypoint etching made just before the outbreak of the war, the artist appears with a more intense and determined look, confronting the viewer with resolute confidence.

Beckmann did not share the general enthusiasm that greeted the declaration of war in July 1914. In fact he told his wife, "I will not shoot at the French. I've learned too much from them. And at the Russians neither. Dostoevsky is my friend."[7] Choosing alternate service, the artist volunteered for the medical corps, serving first on the Eastern front and then in Belgium. Beckmann would regard his war experiences as formative for his life and art, as another "manifestation of life, like sickness, love or lust. . . . Everywhere I find deep lines of beauty in the suffering and endurance of this terrible fate."[8] Although he was profoundly affected by the agony and suffering around him, his art remained of paramount importance and kept him from falling prey to despair. In October 1914 he wrote to Minna, "I have been drawing – this is what keeps me from death and danger."[9]

A year later, however, Beckmann suffered a nervous breakdown and was sent to Strasbourg, where he painted *Self-Portrait as a Medical Orderly*. He appears apprehensively turning his head to face the viewer in a momentary, arrested motion

that reveals his disturbed condition. The only color accent in this somber painting is the Red Cross emblem on the collar of his military tunic. The experience of war and his personal breakdown changed the artist's life. It caused, as he recalled later, a "great injury to his soul," and brought about a highly significant change in his painting style. A similar disclosure appears in a sensitive *Self-Portrait* drawing of 1917. Here Beckmann clutches his throat, looking down at the ground with slit eyes in an expression of great pain. The drawing was done, as we see in his inscription, "at night, four in the morning." All the finesse evident in his earlier work is now discarded for an intimate rendition of a tortured individual. At about the same time he painted *Self-Portrait with Red Scarf*, which is not so much an intimate self-portrait as it is an outcry against the injustice of the world. Coming as close to Expressionism as he ever did, Beckmann distorts his own anatomy as well as the space he occupies. Everything in the painting is angular and sharp. The flesh of his body is corpselike and creates a contrast to the bright red scarf wrapped around his neck. The body language is abrupt gesture; the position of the arms and the frightened face depict him, in James Burke's words, as "the horror-stricken witness of the apocalypse."[10]

The world to which Beckmann returned when he went to Frankfurt to find a temporary home with his friends, the Battenbergs, was totally different from the prosperous Berlin he had left only a year earlier. As the war seemed to linger without end, as the number of dead continued to multiply, and as deprivation and hunger prevailed at home, his own condition of anxiety and agitation persisted. When peace finally came and the Republic was proclaimed in November 1918, there appeared a moment of promise, even euphoria, for a better future. But very soon the new state found itself in total turmoil. Foreign occupation, unemployment, and hunger brought about general hopelessness. The bar in which Beckmann raises his glass in *Self-Portrait with Champagne Glass* is a narrow, confining space. This is an uncanny and forlorn celebration, a distorted image from a desperate café society, which reveals the historical reality of impending doom as well as the loneliness of the solitary drinker. The attempt of the Left to continue the Socialist movement was answered by the brutal murder of its leaders Rosa Luxemburg and Karl Liebknecht in January 1919. Countering the utopian slogan of the immediate postwar period, *"Der Mensch ist gut"* (Man is good), George Grosz commented cynically, *"Der Mensch ist ein Vieh"* (Man is a beast).

Beckmann responded to the monstrous murders with unremitting paintings of horror and tragedy such as *The Night* (1918–19) and *The Dream* (1921), as well as with numerous graphic works. Printmaking was well suited to express the shattering experience of the artist at this time and was to assume a dominant position in his oeuvre. Prints could be executed rapidly and disseminated in the copious new political journals or printed singly and distributed in portfolios. Furthermore, like many of his predecessors in the history of German art, Beckmann's work was principally determined by line. This stress on linear structure also appears in his paintings during the postwar years. It was at that time that he was most attentive to Germany's Gothic masters and the angularity of their form.

The print cycles Beckmann completed during this harrowing period show a chaotic and disparate world. The cities and their people are disassembled by disaster. Each year a new suite came off his press: *Faces* in 1918, *Hell* in 1919, *City*

FIGURE 27. *Self-Portrait with Red Scarf*, 1917, oil on canvas, 31½ × 23⅝", Staatsgalerie, Stuttgart.

Night in 1920, *The Annual Fair* in 1921, and *Berlin Journey* in 1922. His own image appears in many of these prints. In the earliest, which the artist originally called *World Theater* until the eminent critic Julius Meier-Graefe changed it to *Faces*, Beckmann is seen several times in tightly compressed family groups, or by himself in sharp isolation cut into the copper plate with nervous agitation. In *Hell*, a suite of large-size litho-

graphs, he appears on the title page an anxious and frightened individual whose terror is revealed by his eyes, which seem to dart about, witness to various disturbing events. There is also Beckmann's family, with the image of his disheartened mother-in-law and his son wearing a steel helmet and a mischievous smile as he plays with make-believe hand grenades, while the artist himself points accusingly toward the street.

In 1919 Beckmann created the *Large Self-Portrait* in drypoint. The artist, a cigarette dangling from his mouth, directs his large, piercing eyes at the viewer with a probing and quizzical expression. His powerful head fills the entire sheet, giving the print a sense of monumentality. This work and the masterful *Self-Portrait with Bowler Hat* of 1921 have vital presence, partly due to the heavy burrs of the drypoint, achieved by the laceration of the copper plate. Although the artist is now posed as a gentleman with proper jacket, stiff collar, and necktie and wearing an even stiffer bowler hat, he still appears disturbed as he stares at the viewer in severe frontality. A bright lamp in the first state on the left side of the print is replaced by a sitting cat, and a beer mug and kerosene lamp on the right in the later states of the print. There is also more white, both in the background and in the artist's face, to contrast with the deep black in the hat, eyes, and coat. A *Self-Portrait* of 1922 is one of the rare woodcuts made by the artist, yet he is in full control of the technique. The gouging of the wood corresponds to the grim, almost brutal, appearance of the broad, plebeian head, which is fuller and more rounded than the refined linear dry-point of a year earlier. The large piercing eyes are now narrowed beneath the determined brow, conveying a sense of heroic pride, almost defiance. In the drypoint *In the Hotel ("The Dollar")* of 1923, Beckmann depicts himself with a mien of disdain at the very thought of a monetary transaction. In this group portrait his dealer, champion, and publisher, J. B. Neumann, seems to be presenting a dollar bill to the artist. A dollar was indeed valuable property at the time, as it was worth one trillion marks in the fall of 1923. This was also the year Neumann moved his gallery to New York with the chief aim of promoting Beckmann's work in America – a task that took much longer than either dealer or artist had anticipated. Neumann looks at the artist with what seems to be an expression of reverence, to which Beckmann responds with a haughty expression. Marta Stern, a woman from the artist's intellectual circle of friends in Frankfurt, witnesses the transaction with apparent concern.

After the mid-twenties, print production tapered off in Beckmann's oeuvre and painting once more took a primary position. In *Self-Portrait with Red Curtain* (1923), he is posed before a heavy red velvet curtain, the traditional backdrop of ruling aristocrats in Baroque portraiture. A mirror with carved molding and a classic motif on the wall behind the artist add to the grandiloquence of the picture. The painter himself, dressed in a tuxedo, wears his bowler hat on the back of his head, and holds a cigar between two outstretched fingers. The red scarf thrown with deliberate casualness around his neck and shoulders matches the curtain. Here he is, the artist as social lion. Later the same year he depicts himself with a more menacing countenance in *Self-Portrait with a Cigarette*. He is now seated against a golden background that is suggestive of medieval paintings. His cubelike head rests uneasily on the massive structure of his body. The stiff collar adds to the sense of rigidity in the work. Hands, which will assume increasing

importance in Beckmann's figures, set up a rhythm of their own in front of his body. Cubist formal elements, which enter his syntax for a short time, augment the mask of stern inaccessibility in the painting.

In 1925, shortly before his second marriage to Mathilde von Kaulbach, called "Quappi," Beckmann painted *Carnival (Pierrette and Clown)*. The artist has masked himself by wrapping his face in a white cowl[11] and sits with his legs stretched high in the air – a most unusual position. His new wife stands nearby dressed as Pierrette, paying no attention to the buffoon beside her. Although the artist often spoke of his happiness in the new marriage, this picture, with its attitude of weary distance rendered in icy colors, gives us little sense of joy. As in the closely related *Double Portrait Carnival* painted later that year, mask and pose are used as devices to reveal the sense of doubt and loneliness that plagued the artist even during good times. In *Carnival* we see the couple on stage in a carnival tent. The artist, his face painted white, appears as Watteau's *Gilles*, while his new wife, riding an elaborately carved hobbyhorse, seems to be guiding the pair to an unknown destination. As well as gauging Beckmann's psychological state at the time, this work shows the influence of the school of Magic Realism, an international movement in the 1920s that explored the alogical, metaphysical world by transposing dreamlike objects into paintings that were astonishing in their realistic rendering.

Beckmann appears in an entirely different pose in his 1927 canvas *Self-Portrait in Tuxedo*, undoubtedly the most magisterial portrait of his oeuvre. Instead of the angst-ridden jester of the 1925 paintings, we now see before us a formidable figure in full career bloom. He was married to a beautiful young woman with important social connections. He had an impressive number of solo exhibitions with the renowned Flechtheim Gallery in Düsseldorf and received an annual stipend from the New York–based J. B. Neumann. He was appointed to a professorship at the Städelsche Kunstinstitut in Frankfurt and in the same year was represented at the prestigious Venice Biennale. Germany had achieved a new sense of economic and socio-political stability, and Beckmann took this opportunity to write an erudite text on "The Artist in the State." "As the conscious shaper of the transcendental idea," and "of vital significance to the state,"[12] he asserted an identification of man with God, stipulating with seeming irony, "the new priests of this new cultural center must be dressed in dark suits or on state occasions appear in tuxedo, unless we succeed in developing an even more precise and elegant piece of manly attire. Workers, moreover, should likewise appear in tuxedo or tails. Which is to say: we seek a new kind of aristocratic Bolshevism. A social equalization, the fundamental principle of which, however, is not the satisfaction of pure materialism, but rather the conscious and organized drive to become God ourselves." In this elegant canvas, Beckmann confronts the viewer hand on hip in a stance, according to Stephan Lackner, "reminiscent of the classical contrapposto of heroic statues."[13] But behind this image of the modern aristocratic visionary and his immaculate exterior, the sharper play of light and shadow, the contrast of large planes of black and areas of blinding white, suggest an underlying tension and inquietude.

In successive self-portraits during the remainder of his successful Frankfurt years, Beckmann presents himself in a variety of guises. We see him in 1930, in *Self-Portrait with Saxophone*, standing on a narrow stage, dressed in athletic garb

FIGURE 28. *Self-Portrait in Tuxedo*, 1927, oil on canvas, 55½ × 37¾", Harvard University Art Museums, Cambridge, Massachusetts.

and bathrobe, holding a saxophone in his large hands. The saxophone is an allusion to the jazz music Beckmann had grown to appreciate for its novelty and innovation. Writing to his publisher Reinhard Piper in 1923, Beckmann confessed, "I love jazz, especially because of cowbells and automobile horns. That is sensible music. What one could do with it!"[14] The saxophone, which also appears in

several still lifes of this period, has been interpreted by some as a symbol of the life force[15] that sustained Beckmann through hard times. Certainly music in general was of great importance to the artist; he wrote early in his career about his admiration for Bach and Mozart, and both his wives were accomplished musicians.

The bright, dissonant colors that help create the mood of vitality in *Self-Portrait with Saxophone* shift to an icier palette in *Self-Portrait in Hotel* of 1932. There Beckmann stands, his head in dark shadow, a cold forlorn individual in coat, hat, and scarf, hands jammed in pockets. He is pressed into an exceedingly narrow space with mirrors in wall and ceiling that reflect his image at the hotel's entrance. A recurring theme in modern German literature and art, the hotel is a place for wealthy travelers and homeless transients alike. It is a meeting place for businessmen as well as for intellectuals. It is at once the site of open communication and of meaningless anomie. Beckmann himself found the hotel to be a place of continuous fascination, a locus where he could observe and be observed. During his Frankfurt years he would often go to the Hotel Monopol-Metropole near the Central Railroad Station, and toward the end of his life in New York he frequented the Plaza.

Fast approaching the age of fifty, Beckmann's thoughts turned to life's transience, as can be seen in a Vanitas picture entitled *Self-Portrait in Large Mirror with Candle*. Ever since the 16th century, the burning candle has been used as an allegory of mortality, and in this 1933 canvas a green table in the foreground bears the artist's glasses, two bottles, a plant with large leaves and small white blossoms, a burning red candle, and a book opened to reveal an illustration of the planet Saturn. The word "Saturn" had also made its appearance in the *Large Still-Life with Telescope* of 1927, and seems to have been of special significance to the painter. The capricious planet, with its singular relationship to artists and magicians, held a unique attraction to the hermetic painter, who himself was born under the sign of Saturn. In the large mirror, denoting vanity, we see the black shadow of Beckmann's powerful profile against a red curtain with the swordlike leaf of the plant cutting across his forehead.

The rise in power of National Socialism in Germany disrupted Beckmann's art production and left a disturbing mark on what work he did execute. Less a magician now than a humble artist, Beckmann wears the traditional garb of the artist in *Self-Portrait with Black Cap*. Painted after the artist was dismissed from his professorship by the Nazis, Beckmann stands defiantly with arms crossed in front of his chest in self-protection. With an expression of dejection Beckmann is obviously pondering the future in the *Self-Portrait with Crystal Ball* of 1936 – the year in which the Nazis closed the room dedicated to his work in the Berlin Nationalgalerie, and the atrocities of Hitler reached new extremes. The artist holds a large crystal ball in his hand. Dominated by greenish-blue colors, *Self-Portrait with Crystal Ball* is based on the geometry of the sphere: the roundness of the ball is echoed in the half circles of shoulder and lips and again in the artist's forehead, as well as in the dark, almost sinister, cavities of his eyes. Beckmann's eyes do not look into the crystal ball, nor are they directed at the viewer. Their gaze goes beyond, into an unknown and threatening future. Although the artist holds the

means of divination in his very hands, he is helpless and seems to recede into the deep black space behind him.

Shortly before leaving Germany Beckmann depicted himself once more as a member of high society in *Self-Portrait in Tails,* which is in sharp distinction to the 1927 *Self-Portrait in Tuxedo.* The 1937 canvas, with its extended vertical shape and bright color contrasts, is a disquieting picture. The self-assurance of ten years earlier has given way to an almost palpable unease. The sovereign posture of the hands has been replaced by a striking downward gesture. And these hands are now huge, pawlike hanging forms. The stance of the artist is very unsteady – he seems to practically slip off the stairs – and his dark eyes appear again to look pensively into empty space.

Soon after reaching exile in Holland, Beckmann revised an earlier canvas of 1933 in which he presents himself as a golden king. The original figure, with its stern expression of pride, may have been related to the artist's youthful admiration of the Nietzschean concept of artist as superman, but the final version, *The King* (1937), with its inward withdrawal, may indicate Beckmann's increasing interest in the Gnostic belief in the royal origin of the soul. The addition of the wheel to the composition may also be a reference to the Buddha, who put the wheel of sacred teaching into motion.[16] Beckmann filled every inch of space, "that frightening and unthinkable inversion of the Force of the Universe,"[17] with people and objects. The vulnerable king himself is guarded by a figure resembling Quappi, as well as by a mighty protective sword. A short time later the artist visualized himself as a persecuted refugee in *The Liberated* (1937). In this highly revealing canvas Beckmann has unchained himself from imaginary manacles that cuffed his hands and bound his neck to prison bars. The pained and tragic expression on his face, the picture's dark and somber coloration, and the black fateful area behind the window are not signifiers of liberation and freedom, but of death. It could only have been Beckmann's deep sense of irony that caused him to call this small canvas *The Liberated.*

In 1937 Beckmann also furnished seven lithographs to illustrate the Paris edition of the play *Der Mensch ist kein Haustier* by his friend Stephan Lackner. Lackner had begun acquiring paintings when he first managed to see a censored exhibition by the artist in 1933 and became an important patron of the painter during their years in exile. The play deals with revolution, the class struggle and the foundation of a technocratic state. The small vertical painting, *Couple by the Window* (1937), is closely related to one of the lithographs. In both versions, the male figure appears to be a self-portrait of the artist. Here he has identified himself with the brutal murderer, Peter Giel, a man from the underworld, with whom the beautiful princess Louise had fallen in love. In the painting, the dark dominant male figure in the background creates a striking contrast to the light-skinned, angular image of the young woman fixing her hair.

The sense of despair revealed in *Self-Portrait with Crystal Ball* and in *The Liberated* is deepened in the 1938 *Self-Portrait with Horn.* He depicts himself again in prison garb, and holds an instrument in his hands. Now in exile, however, Beckmann's American saxophone becomes a German trumpet, which he holds close to his ear listening to what secret message it may have to reveal as he gazes into

darkness with melancholy eyes, set again into dark cavities. His head is sur-rounded by an empty golden frame, which may denote a painting or a mirror. Although the artist's torso is strong and powerful, the painting relays a sense of dark mystery and veiled desperation.

In May 1940 the German army invaded Holland, making the émigré's life hazardous. In the fall he painted *Acrobat on Trapeze*, a canvas at once connoting this peril and a surprisingly optimistic view of his difficult situation. Although Beckmann's widow has stated this painting was not, in fact, a self-portrait,[18] the features on the equilibrist's face appear to be self-referential. Although high in the air, the acrobat's feet are planted firmly on the footboard, implying a sense of safety in the midst of potential danger. Eight years later at Stephens College, Beckmann concluded his renowned lecture "Letters to a Woman Painter" saying, "We are all tightrope walkers. With them it is the same as with artists, and with all mankind. As the Chinese philosopher Laotse says, we have 'the desire to achieve balance and to keep it.' "[19]

In *Self-Portrait with Green Curtain* of the same year, however, the artist faces his mirror and his viewers with an expression of bitter desolation. He has just made an abrupt turn of the head to confront the spectator, while his torso is still seen from the back. Any action is thwarted by the lack of arms, leaving the figure in a state of impotence. Most of the artist's masklike face is hidden in dark shadow, but the left part is revealed in a harsh, blinding light. His eyes seem unable to focus. The curtain behind the figure with its many x-figurations increases the painting's deep sense of mystery. This seems to have been a period of despon-dence for the artist, who noted in his diary, "I apparently must live, am sentenced to living by some unknown power that finds this inevitable."[20]

Beckmann was not, however, alone in exile. His wife provided some comfort from the alienation that increasingly enveloped his life. In the 1941 *Double Portrait of Max Beckmann and Quappi*, the couple is elegantly attired as world travelers. This narrow, stele-like painting recalls the *Double Portrait Carnival* of sixteen years earlier. Although Beckmann's large figure seems to crowd his wife out of the picture, she is still guiding him through an alien world.

It was in his triptychs, with all their complexities, that Beckmann's genius in structuring intricate compositions and his command of sonorous colors that re-call medieval stained glass became most evident. Here he addresses human cru-elty, passion, anguish and liberation, and the ceaseless search for the Self. The great, continuing potency of these works is partly due to the ambivalence of the allusions and the inexhaustible richness of their multiple references.

Beckmann began working on *The Actors* in May 1941 and completed the trip-tych in July 1942. In the middle of the central panel we see the king in the play thrusting a sword into his own heart. There is a general agreement that this the-ater king is indeed an enigmatic self-portrait of the artist as a younger man en-acting his own suicide. But what is the reason for this act of desperation? Friedhelm Fischer suggests that it is a portentous metaphor of the desperate role played by the dedicated artist, who takes his task deadly serious.[21] In Gnosticism the body is the earthly shell for the kingly self. And in this painting the king commits suicide as the final shattering sign of contempt, the ultimate protest against the forces of fate. Gert Schiff, in his perspicacious discussion of this trip-

tych, relates the central theme to one of Beckmann's favorite novels, Jean Paul's *The Titan*. Schiff argues that Beckmann identified with the book's demonic antagonist Roquairol, and "used him as a parable of the artist, who also 'contrives' his strongest passions, and exhibits his deepest wounds in his work, and for the same reason is deprived of a life of his own."[22]

Les Artistes with Vegetables (1943) depicts an imaginary gathering of the artist with three friends during their lonely years in exile in Amsterdam. Their encounter is imagined, as Beckmann would meet with them only individually. They are, in fact, not engaged in casual table conversation, but each man seems to be absorbed in his own thought and fate. There is a feeling of unspoken ritual in this painting. Each of the men except Beckmann himself holds an edible object. In the lower left Friedrich Vordemberge-Gildewart, the constructivist painter and Beckmann's closest confidant during this period, holds a parsnip – the only vegetable in the painting, despite its title. Next to him, wearing a fur hat and scarf, is the painter Herbert Fiedler[23] holding a fish. Fiedler, whom Beckmann had known during his Berlin days, was a frequent companion of the artist in Amsterdam. On Beckmann's right we see the poet Wolfgang Frommel, who holds a loaf of bread in an almost sacrificial gesture. Frommel, a disciple of the Symbolist poet Stefan George, was also a student of alchemical texts and a person whose company was important to Beckmann during this period. A large mirror or painting is on the wall behind the poet's head. These are men with whom Beckmann was often engaged in serious discussion about everything from the political situation during the war to the meaning of life and theories of the cosmos. Beckmann himself is clutching a mirror that reflects a distorted mask, or possibly the face of a foolish painted clown. The mirror may be a reference to the *Seelenspiegel*, or "mirror of the soul," that appears in the romantic literature of E. T. W. Hoffmann and Jean Paul, German writers whose work Beckmann read with frequency. In the center of the white table and directly above the mirror, creating a central vertical axis, is a flickering candle, a sign of light and a symbol of truth, but also of temporal existence. These men seem to be meeting secretly at night. They are crowded together and a sense of unease is enhanced by the tilt of both floor and table. It seems unlikely, knowing Beckmann and his three emigrant friends, that they are engaged in an underground resistance conspiracy. It seems, rather, that Beckmann has assembled these men in this ritualistic setting at the round table as a foregathering of an intellectual elite of artists. "Art," he wrote earlier, "is the mirror of God, embodied by man."[24]

The mask he assumes in *Self-Portrait in Black* of 1944 is that of Mephistophelian power and darkness. During a period of ten months prior to this work, Beckmann executed a series of 143 drawings for Goethe's *Faust II* for a Frankfurt typefounder – a commission that helped support the artist during this difficult time in exile. In this painting that relates to the *Faust* drawings, Beckmann throws himself aggressively against the viewer. He has placed his large left arm over the chair back while he simultaneously pulls his forearm and hand against the curtain. The figure seems to describe a virtual circle. The chair and the velvet curtain suggest that he is seated in the loge of a theater. His masklike head, mostly in shadow, presents a stony countenance with tightly closed lips and piercing eyes challenging the viewer. There is no access to this man, who seems totally armored against

human contact. Once more, he is dressed in dark formal wear, but this painting lacks the self-assurance of the 1927 self-portrait or the wistfulness of the 1937 painting. Instead, he sees himself as a sinister individual, a modern Mephisto who contends that life is worthless and must be destroyed; at this time Beckmann referred to himself as "the spirit that eternally denies." On December 27, 1943, the artist's journal entry reads: "In the morning completed Self-Portrait with arm over the back of chair . . . Deprimé." And a few days later, on New Year's Eve, "Dark is life . . . is Death."[25]

The tragedy of human existence is also evident in a drawing of himself and his wife – *Double Portrait Max and Quappi Beckmann* (1944). He stands in the frontal plane, facing the viewer, wearing a Jacobin cap. To his left, at a right angle, is Quappi in severe profile, carrying their dog Butchy in her right arm. A few lines, indicating a boxlike room, frame their bodies. Husband and wife are in close proximity but do not look at each other. Their faces are dark. They are silent, although as his style has changed, there is consistency of meaning in Beckmann's work. As early as 1909 in his double portrait with his first wife, he expressed a sense of remoteness. Now, thirty-five years later, the two partners in marriage witness each other's solitude. Beckmann holds the inevitable cigarette in his right hand, while the left points toward the netherworld.

On November 29, 1946, Beckmann noted in his diary, "Germany is dying, et moi – Self-Portrait of 1945 is completed."[26] This undoubtedly refers to the small *Self-Portrait in Olive and Brown*, in which he depicts himself at work. Here the artist, dressed like a monk, works in a small, bare room. It is a composition of utmost simplicity. On the left margin of the work is the white canvas on its stretcher in total contrast to its deep black back. Beckmann's massive forehead is lit brightly from above, his lips are set tightly, his eyes are piercing as he works with concentration, observing himself in the mirror, painting his image with the most demanding visual precision.

Day and Dream (1946) was the last suite of prints created by Beckmann. Commissioned by his New York dealer, Curt Valentin, for the American market, the entire portfolio of fifteen lithographs sold originally for $125.[27] Beckmann made the drawings in Amsterdam and oversaw the printing there. In 1948, now living in St. Louis, he decided to hand-color several of the lithographs that had not been sold. The portfolio, originally called *Time-Motion*, is the closest he ever came to Surrealist imagery. It deals with a variety of motifs, including, in the artist's words, "mythological, biblical, and theatrical subjects and with circus and café of 'all-in-one thing.' "[28] Once again he used a self-portrait for the cover of the suite. Innumerable hatchmarks, going in various directions, give the portrait a dense, sculptural appearance. His hand, holding the ubiquitous cigarette, seems to act as a barrier against the outside world. His eyes, which, as in so many of his self-portraits, are uneven in size, do not look at the spectator but beyond, into an undefined space.

In the summer of 1947 the Beckmanns left Amsterdam for St. Louis, where the artist was invited to teach at Washington University, filling a position vacated by Philip Guston, who had traveled to Rome on a Guggenheim Fellowship. Guston had admired Beckmann's paintings since he first saw them at Curt Valentin's gallery in 1938, and there is no doubt that the German painter had a significant

impact on both the early and the late paintings of Guston. Beckmann had not taught since his dismissal from the Städelsche Kunstinstitut, but with the assistance of Quappi as his translator he was able to communicate with his students. When asked about his attitude toward teaching art, he remarked: "Art cannot be taught, but the way of art can be taught."[29]

During October and November of 1947 he worked in St. Louis on his *Self-Portrait with Cigarette*. A brilliantly painted green scarf is draped with deliberate casualness around his neck. The ever-present cigarette emits a wonderful curl of smoke near his left eye. The eyes look with defiance at the viewer. There is an attitude of remote wariness about his self-image, in spite of the enthusiastic welcome he had received in the art community of St. Louis: A major retrospective was in preparation at the St. Louis Art Museum and his work was being exhibited throughout the United States. His diary entries from this time indicate both satisfaction and despair. A few days before he completed the 1947 self-portrait, he wrote in his diary: "Soon 64, an age incredible for the vitality of my body, but I mistrust it."[30]

In 1947 and 1948 Beckmann taught and painted furiously, giving lectures in different cities, going to New York regularly, and traveling to Amsterdam in the summer of 1948 to take care of his American visa and to make arrangements for his permanent move from Europe to the United States. For the following summer he accepted an invitation to teach summer school at the University of Colorado in Boulder. It was there that he made a delightful, energetic drawing of himself, in a cowboy hat, titled *Self-Portrait with Fish* (1949). A year earlier, on the boat to Amsterdam, he had depicted himself disguised as a sailor anxiously holding an enormous fish tied to a board in *The Cabins*. But now he displays the fish with confidence. In this late drawing the fish is a symbol of life and vitality. The artist, looking considerably younger than his sixty-five, is holding the fish near his face, the eyes of the fish echoing his own. During the same summer, in the Rocky Mountains, Beckmann also drew his *Self-Portrait with Fishing Pole*. He seems to be holding a rope rather than a fishing pole. In the role of a circus performer, he tightly holds the length of rope, which he seems ready to climb at any moment with his powerful arms. His bald head is receding, his mouth is slightly open, his chin sticks out, and his eyes glance defensively at the viewer. In a diary entry from August 27, 1949, his last day in Boulder, he notes the completion of this picture and writes also, "My time has long expired and is prolonged artificially."[31]

Beckmann's last depiction of himself, *Self-Portrait in Blue Jacket*, was painted in his studio on New York's West Side during the winter and spring of 1950. The most startling aspect of this late painting is its brilliant color: the unrelenting cobalt blue of the jacket, the bright orange shirt, and the green chair are set against a deep maroon background. The very brightness of the colors contributes to the two-dimensional appearance of the painting: their disparate, almost cruel, quality give an insolent air to this wistful, contemplative figure. He looks drawn and tired, but still defiant. He no longer assumes roles or disguises. There is no artifice in this picture, and there are no props. He stands alone, leaning against the chair back, drawing on a cigarette as if for nourishment. The large, penetrating eyes of Beckmann, always the observer, are alert. On the left, extending the whole height of the painting, looms the frightening black emptiness of space.

But the large surface directly behind the painter is yet another newly stretched canvas ready for his work. Beckmann had to go on painting no matter how apparently meaningless his existence. For him painting was more than an aesthetic enterprise. It was a moral act, a means to come to terms with what he termed the "mystery of being," with ultimate reality. Toward the end of his life Beckmann wrote in a letter to a friend: "The moral principle is not to be avoided. Ever since ancient Indian wisdom, since the Gnostics and the Essenes, and on to Kant and Schopenhauer, it has always been the same and cannot be denied."[32]

DEGENERATE ART RECONSTRUCTED

In a syndicated column in April of this year Patrick J. Buchanan, former speech-writer for President Reagan and an influential voice of the Right, attempted to rehabilitate the ignominious repression of free speech by Senator Joseph McCarthy.* In this article, entitled "Hollywood's Reds Had It Coming," he asked, "Why should free men and women patronize movies made by secret collaborators of Joe Stalin?" We know too well how free the filmmakers felt when Senator McCarthy was through with them. In the hysterical climate of 1990 the well-known San Francisco photographer Jock Sturges had his studio broken into by FBI agents in the middle of the night and was subjected to search and seizure for having taken nude photographs of children. His assistant, Joe Semien, who had been printing the photos, was hauled off to jail. The NEA, as we all know, has been assailed by reactionary members of Congress, religious fundamentalists, and Neo-Con intellectuals for supporting work by Robert Mapplethorpe, Andres Serrano, Karen Finley, and others. These voices always speak "in the name of the people" and complain about "inappropriate use of taxpayer funds" without questioning whether it is more appropriate to use the public purse for the subsidy of the tobacco industry or for financing the Strategic Defense Initiative and other bizarre means of destruction. But the establishment resents the authentic artist, because he or she represents the consciousness and memory of the time. When in the early 1980s Stephanie Barron first planned to reconstruct the infamous *Degenerate Art (Entartete Kunst)* exhibition of 1937 for the Los Angeles County Museum of Art, she could not have imagined the show's acute relevance of its presentation in 1991. Even here and now several individuals – including a member of the Humanities faculty of Pepperdine University – wrote to the *Los Angeles Times* denouncing the controversial and authentic art in the exhibition and voicing approval of Hitler's art politics. Neither the current crop of art cops, nor the persecutors of the McCarthy era, nor even the executors of Stalin's terror against

* This essay originally appeared in *Arts Magazine*, Vol. 66, No. 1, September 1991, pp. 58–60. This magazine has ceased publication.

the "decadent" avant-garde ever thought of actually exhibiting the work of the despised enemy as the Nazis did in the *Degenerate Art* exhibition. In a calculated attack against free expression they confiscated the finest modern art from the German museums to mock and vilify it for the entertainment of the public. The exhibition that opened in Munich in July 1937 consisted of paintings and sculptures by such masters as Ernst Barlach, Max Beckmann, Marc Chagall, Otto Dix, Lyonel Feininger, Wassily Kandinsky, Ernst Ludwig Kirchner, Paul Klee, Oskar Kokoschka, Wilhelm Lehmbruck, and Emil Nolde, among others.

The Nazi policy toward art had been hanging in the balance for some time. Joseph Goebbels, Minister of Popular Enlightenment and Propaganda, had, in his youth, authored a badly written "expressionist" novel and was one of the individuals who tried to advocate that the National Socialist regime sponsor a "Nordic" art, as produced by such men as Barlach and Nolde, the latter having actually been an early adherent to the Party. Between 1933 and 1935 Goebbels even tolerated exhibitions organized by Nazi students that pointed toward the Germanic character of some Expressionist art, as well as an Italian Futurist exhibition held in Berlin in 1934.

By that time, however, the most extreme cultural racists, the architect Paul Schultze-Naumburg (author of *Kunst and Rasse*) and the political ideologist Alfred Rosenberg (author of *Der Mythus des 20 Jahrhunderts*) succeeded in their all-out attack against *Kulturbolschewismus*. It was the Führer himself who intervened on their side. A failed painter of sentimental kitsch landscapes, Hitler had great pretensions in both art and architecture and supported the most extreme position. His own authority and power would clearly be enhanced by the promotion of an art that could easily be enjoyed by an unquestioning populace and that would simultaneously propagandize his political agenda. Once the German machinery was set in motion, it operated with utmost efficiency and thoroughness. About 16,000 works of modern art by some 1,400 artists were confiscated from German museums, and 650 of them were presented for public ridicule as *Degenerate Art* in a shabby and crammed installation in the old building of Munich's Archaeological Institute. In their speedy organization the art commissars managed to overlook the posters that advertised the show: some of them were still Expressionist in style and one was a fine example of Bauhaus typography, the very styles that were ridiculed in the show.

Ironically, the original *Degenerate Art* exhibition turned out to be the forerunner of the big museum blockbusters, and its attendance record has still not been equaled. After having been staged in Munich, it went to a number of other venues in Germany and Austria and was seen by almost 3 million people. Part of the superb documentation of the Los Angeles exhibition was a piece of original footage filmed at the initial show. It disclosed viewers walking rather stiffly through the Munich "Chamber of Horrors," staged like a sideshow of freaks. To be sure, some of the visitors were surprised by what they saw. The young Gustav Sprengel, for example, eventually assembled one of the greatest collections of German Expressionist art, now housed in the museum bearing his name in his native city of Hanover. But the majority found modern art incomprehensible. Many of them shared the Nazis' antagonism toward the distortions of Expressionism, the biting

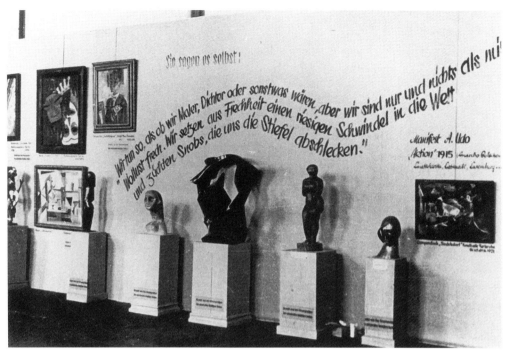

FIGURE 29. "Degenerate Art" Exhibition, Munich, 1937. View of an exhibition gallery.

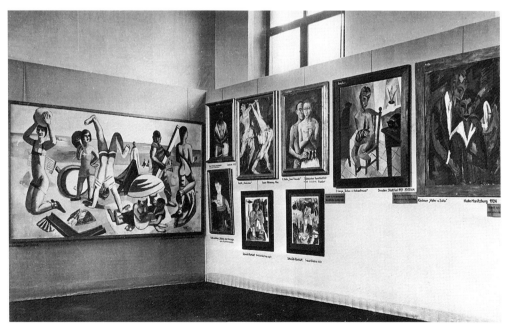

FIGURE 30. "Degenerate Art" Exhibition, Munich, 1937. View of an exhibition gallery.

social criticism of *Neue Sachlichkeit,* and the apparent meaninglessness of abstraction.

Simultaneously with *Degenerate Art*, the Nazis showed officially sanctioned art of comely landscapes, folksy family pictures, exalted military subjects, spiritless portraits, heroic, covertly homoerotic male nudes, and chaste, naked women at the *Great German Art Exhibition* in the newly inaugurated Haus der deutschen Kunst. Here the people could enjoy an elaborate display of true Aryan art. Public discussion was impossible, as Dr. Goebbels had outlawed art criticism during a full-dress meeting at the Reich's Chamber of Culture in Berlin's Philharmonic Hall in the fall of 1936. With any kind of critical discourse prohibited, the Nazi control machinery could no longer be questioned.

Some original footage in the Los Angeles exhibition showed the great public fanfare at the opening of the new neoclassical building, the first example of Nazi architecture. With its mighty row of columns it is an overpowering structure: architecture, too, was a political weapon in the authoritarian state. For the dedication, the whole center of the city was transformed into a scene of great pageantry, enjoyed by 800,000 spectators. The city streets were decked out in brilliant color with huge banners of swastikas and great floats of Pallas Athena, Viking ships, and Gothic cathedrals, born by maidens dressed in white togas and young men in knightly costumes. All of Western civilization was to fuse into "Two Thousand Years of German Culture." One of the appeals of Fascism was its presumption to aestheticize politics. Hitler himself opened the exhibition, pronouncing that the art here to be seen was to last for eternity, whereas artists who would persist in producing the kind of work displayed in the *Degenerate Art* show across the park would either be judged to suffer from genetic problems of vision, in which case forced sterilization would be in order, or, if, indeed, they planned to proceed in their "prehistoric art stutterings," they needed to be picked up and liquidated. This was the day Max Beckmann packed his bags and took the train for Amsterdam.

Two of Beckmann's great religious paintings of 1917, *Christ and the Woman Taken in Adultery* and *Deposition*, were the first works the visitor encountered in Room 1 of the original show, a position duplicated in the Los Angeles reconstruction. The biblical canvases were done in 1917, soon after Beckmann's discharge from the army, where he served as a medical corpsman. They are terrifying images typical of his work at the time, images reflecting the social and political turmoil of a desperate period. The *Deposition,* now in New York's Museum of Modern Art, is an indictment of human passivity in the face of evil. Here are emotionally inert witnesses to the Crucifixion, where the figure of Christ is one of suffering rather than triumph. In the pendant loaned by the St. Louis Art Museum, we see the hatred of the brutal populace juxtaposed with the forgiving figure of Christ. Both of these works owe a great debt to Grünewald and other late-medieval German painters so greatly admired by Beckmann. Whereas Beckmann all but renounced color in these pale canvases, the biblical paintings by Emil Nolde almost burst with luminosity. *The Last Supper* (1909), now in the Statens Kunst Museum in Copenhagen, is one of the glories of 20th-century religious art. Nolde painted it during a period of severe illness and great inner tension. He tells that he followed "an irresistible desire to represent profound spirituality and ardent religious feel-

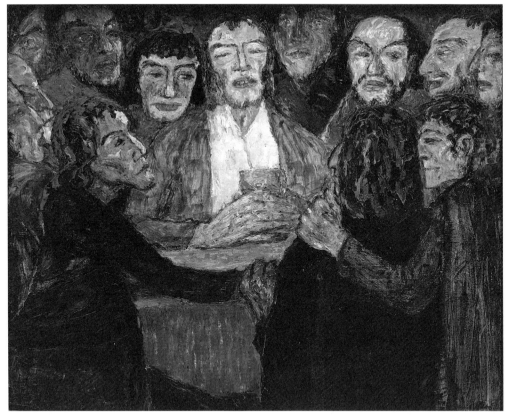

FIGURE 31. Emil Nolde, *The Last Supper*, 1909, 34⅜ × 42½", Copenhagen, Statens Museum for Kunst.

ing without much intention, knowledge, or deliberation." Color and light are used evocatively, reaching their climax in the figure of Christ with his golden-yellow face, red robe and hair, and white garment. The Apostles around him imply a great symbolic embrace. The painter saw "Christ and the apostles too, as indeed they had been . . . as simple Jewish country people and fishermen"[1] – an unexpected interpretation from an avowedly anti-Semitic artist. In *Christ Among the Children*, which hung next to it, we see similar types among the bearded men in the dubious crowd on the left, while the children are rendered in bright, flickering colors. With 27 paintings, Nolde, despite his early adherence to the Nazi party, was ironically the artist with the largest representation in the *Entartete Kunst* exhibition. In fact, the Nazis showed relatively few pieces by artists of the radical left (such as Otto Dix and John Heartfield), perhaps because their visual messages were too clear and too revealing. It seemed safer, somehow, to pillory artists who subjectified reality than those who depicted the cultural constructs with icy realism and looked at art as a political commitment.

Among the religious paintings was Christian Rohlfs' poignant *Elijah Being Fed by Ravens* (1921), now in the Robert Gore Rifkind Collection. In his old age, Rohlfs, the oldest of the Expressionist painters, worked in colors that seem to be immaterial and diffused into floating light used to animate the ancient prophet in a gesture of deep meditation. Karl Schmidt-Rottluff's *Pharisee* (1912), in contrast, is a painting of wild agitation. The four red heads are indebted to the block-

like forms of African carvings. They are transformed into intense, pulsating, two-dimensional abstract shapes. This room in the original installation also included one of Schmidt-Rottluff's series of great religious wood-cuts from 1918, which refer to his war experiences. A head of Christ, with the date 1918 branded on his forehead and the legend HAS CHRIST NOT APPEARED TO YOU below, seems to communicate the thought that only the experience of horror and dread can lead to a better life. The Expressionist attitude toward the spiritual and religious renewal was responsible for some of the most profound works of Christian art in this century and presented a sharp contrast to the *völkisch* Nazi ideology of an Aryan super race and its culture of violence.

The work of these artists, much like Andres Serrano's *Piss Christ* some 80 years later, was so offensive to the ruling powers because it dared defy the trivialization of religious experience with powerful new images. There is more of a continuum between Nazi suppression and present censorship than most of us would like to admit.

Note: In 1962 the Hans der Kunst in Munich mounted an exhibition: *Entartete Kunst* to commemorate the 25th anniversary of the original "Degenerate Art" exhibition. The present exhibition differs significantly in that it actually reconstructed the original show instead of merely showing work by the defamed artists.

REVIVAL AND SURVIVAL OF EXPRESSIONIST TRENDS IN THE ART OF THE GDR

Expressionism in Germany was a genuine and vital movement that had a life span of about a generation during the first quarter of this century.* But Expressionism was also an attitude toward art and life, which was characterized by contradictory psychic tensions. Expressionist art, distinguished by both introversion and emphatic assertion, is a posture that appears in many artistic manifestations throughout the century now coming to its close.

Many of the images produced by the painters currently working in the German Democratic Republic relate to the Expressionist position. Their attitude toward the usable past is not post-modern in the sense of replication, appropriation, or simulation. Many of these artists, merging their subjective feelings with observation of objects in the external world and the interpretation of history, have looked at earlier Expressionist art as an appropriate vehicle on which to construct their own formulations. Instead of "simulacra" (Baudrillard) we are dealing with "elective affinities" (Goethe).

Herwarth Walden, the foremost champion of Expressionism soon after its inception, was also an enthusiastic impresario of the modern movement during the heroic years before World War I. In the foreword to the catalogue of the First German Autumn Salon of 1913, the first exhibition that focused solely on the art of the international avant-garde, he even paraphrased the Faustian Chorus Mysticus when he wrote: "The painter paints what he sees in his innermost feeling and expresses his own being. For him all things that fade are but reflection. He takes a chance on life. Each external impression becomes an internal expression."[1]

Soon the epithet "Expressionism," which originally included French painters and was seen as the counter-movement to Impressionism, was appropriated to

* Reprinted with permission, from Peter Nisbet, Dore Ashton, et al., *Twelve Artists from the German Democratic Republic* (Busch-Reisinger Museum, Harvard University Art Museums, 1989).

express a particularly German *Kunstwollen* (artistic purpose). Wilhelm Worringer, the distinguished theorist and historian, saw in Expressionism an art that, in contradistinction to the rationality and tectonic formalism of classical art, dwells in the mysticism of the Gothic; he saw this as part of the Nordic spirit. When Paul Fechter wrote the first book called *Expressionismus* in 1914,[2] he interpreted it as a manifestation of the soul of the German people. In his emphasis on the spiritual, he was clearly influenced by Wassily Kandinsky's pivotal 1912 essay, "Concerning the Spiritual in Art," particularly the Russian's chiliastic beliefs and metaphysical concerns. Deeply informed by Kandinsky, Fechter nevertheless used the head of a prophet by the German Max Pechstein for the cover of his book and characterized the movement as "giving an intensely concentrated formulation to the experience of feeling."

But as early as 1911, the critic Paul Ferdinand Schmidt discerned little stylistic resemblance among various artists labeled "Expressionist," and stated that "the common name is the product of a dilemma – it signifies little."[3] And, indeed, Expressionism was never a "style"; it lacked such formal coherence. Furthermore, it had no center of operation. Within the German culture, Expressionist tendencies, assuming different forms, made themselves felt in Dresden, Munich, and Vienna during the first decade of this century. Although Expressionist characteristics can be found in the art of many countries, and later French critics such as Germain Bazin and Bernard Dorival claimed Expressionism (together with all other art movements of importance) for the French, Donald Gordon seems correct in considering the German production as the key to the entire phenomenon.[4] This emphasis is not meant to imply, however, that Expressionism is to be seen solely as a manifestation of the "Teutonic soul."

In his thought-provoking and incisive book, *Expressionism, Art and Idea,* Gordon places this phenomenon largely under the aegis of Nietzsche. Both the vitalist aspects of his teaching as well as his pessimistic diagnosis, both the renascence and the decadence, as well as the ambivalence resulting from this dialectic, necessitated a total "revaluation of values," which found echo and denotation in Expressionist art.

Earlier than other thinkers, and with poetic power, Nietzsche, in his piercing critique, was clearly aware that the old order, apparently so stable, was actually in a state of decay. Only self-transformation could bring about a renewed art and language. His percepts were embodied in verbal and visual form by the Symbolist poets and painters. The breakdown of positive values caused an anxiety, which emanates from Munch's and Hodler's preoccupation with death; it is the basis of Gauguin's rejection of European civilization, of Ensor's deep cynicism, and of van Gogh's almost hallucinatory intensity. These "proto-Expressionists," along with many other intellectuals, had become painfully aware of the alienation that permeated all aspects of modern life beneath its masks of progress and prosperity, and they animated this fracture in many ways.

In homage to Nietzsche and his critique of Christian religiosity and bourgeois morality, the Brücke painters in Dresden inscribed their house-book with *Odi profanum vulgus* (I hate the plebian crowd), while in Munich Kandinsky articulated the Expressionists' debt to the philosopher and their need to turn toward their own individuality: "When religion, science, and morality are shaken (the

last by the mighty hand of Nietzsche), when the external support threatens to collapse, then man's gaze turns away from the external toward himself."[5]

But at the same time, the Expressionist artist also was in almost desperate need to establish a relationship with the outside, to move beyond the self to the "other." Oskar Kokoschka described Expressionist art as "form-giving to the experience, thus mediator and message from the self to fellow human. As in life, two individuals are necessary. Expressionism does not live in an ivory tower, it calls upon a fellow human whom it awakens."[6]

This communicative aspect of Expressionism became emphasized in the years during and immediately following World War I. A second generation of Expressionist artists, motivated by the experience of war, revolution, hunger, and uncontrolled violence in the streets, came to the fore.[7] In contrast to the often pastoral romanticism of the first Expressionist generation, artists such as George Grosz, Otto Dix, Käthe Kollwitz, Conrad Felixmüller, and Gert Wollheim, all of whom came of age during the war, produced paintings and graphics of aggressive political commitment.

While earlier Expressionism was largely an aesthetic rebellion against the bourgeois art of the German Wilhelmine empire, the later Expressionists often allied themselves to the revolutionary Spartacists in opposition to the newly established Republic. Indeed it was the work of this generation of artists that came to exert a particularly strong impact on present-day painters in the GDR, although some of the radical intoxication is given no place in the post-revolutionary state of the GDR.

In the wake of Germany's defeat in World War I and the cultural turmoil that prevailed, artists and intellectuals postulated a vague concept of the "New Man," who would create a better world. In a spirit of cooperation and optimism they formed the *Arbeitsrat für Kunst* (Workers' Council for Art), followed by the *Novembergruppe,* which was joined by many of the leading progressive artists and architects. Max Pechstein designed the cover for the latter's pamphlet, *An alle Künstler,* depicting an apocalyptic image of a man rising from the flames and reaching out mightily toward a fellow human. For a short time a sense of euphoria obtained throughout the land, and Expressionist art seemed its most suitable vehicle. Pechstein, frequently a spokesman of the movement, saw in it the emergence of a new day of unity between art and the people.[8] Ludwig Meidner, who had painted cataclysmic visions of destruction before the war, now declared that artists were to join workers in a new "holy alliance" in which socialism was the creed that would create "a world of justice, freedom, and charity."[9]

It was surely within this general sense of euphoria that Walter Gropius heralded the unification of the arts and crafts with no class distinctions of barriers, toward a great architecture, "a single form which will one day rise towards the heavens from the hands of a million workers as the crystalline symbol of new and coming faith."[10]

But as Bertolt Brecht wrote so cogently, "Die Verhältnisse, die sind nicht so." The revolution of 1918 was quickly aborted when power was assumed by the moderate wing of the Social Democratic Party, which was soon embroiled in much bloodshed in Berlin, Hamburg, and Munich, as well as throughout Saxony. The German bourgeoisie was not ready to accept a revolutionary government of

the left, and the Social Democratic Party became the organ of law and order, suppressing revolutionary elements. The threat from the left was answered by the brutal murder of its leaders, Rosa Luxemburg and Karl Liebknecht, and little was done to stop the militant right from assassinating the leaders of the short-lived Soviet Republic of Bavaria.

Under these circumstances, the visions of the Expressionists and the deep sense of ambivalence that pervades their art, combining utopian optimism and a sense of anguish and despair, were shattered. Edgar Wind made the fine observation that "you can blow the trumpet of the Last Judgement once; you must not blow it every day."

At the very time of its innovative exhaustion, Expressionism rose to the dominant position as the accepted style of the bourgeois social democracy in the Weimar Republic. Kokoschka and then Dix were appointed to professorships at the Dresden Academy. Similar appointments were given to Beckmann at Frankfurt and Otto Mueller at Breslau (Wroclaw). Feininger, Kandinsky, and Klee became masters of the state-supported Bauhaus in Weimar, and Schmidt-Rottluff was elected president of the Berlin Secession. In view of the visible creative exhaustion of Expressionism, Worringer now wrote in 1920 that the movement's agitated revelations and visionary flashes of light had become handsomely framed and degraded wall decorations.[11] And art historian Wilhelm Hausenstein, also an early advocate of the movement, announced its epitaph, saying that "der Expressionismus ist tot."[12] Many of the artists and writers themselves were offended by their new popularity and their acceptance as part of the official culture.

The necessity to deal with the political situation became paramount in postwar Germany. Dadaism in Berlin, which held a place of consequence for a brief interval, certainly had a political stamp. Expressionism had reached for the stars; now artists wanted to feel the firm ground under their feet. A different kind of art was called for. The *Neue Sachlichkeit* (New Objectivity) movement, which arose in Germany in the 1920s, must also be seen in the context of an international trend toward conservatism in art in the postwar dilemma, a tendency that Jean Cocteau propagated as *rappel à l'ordre*.

The New Objectivity painters found their subjects in the life of the time mostly in urban centers. Especially in Berlin, painters dealt with nightlife, cafés, prostitutes, entertainment, and violence. The "Red Group" – Grosz, Schlichter, Scholz, and John Heartfield – were committed to picturing the class struggle, and often did so with cynicism as well as passion. Many of the left-wing artists formed the Association of Revolutionary Visual Artists of Germany (Asso) in 1928 and urged artists to join in the endeavor to overthrow the capitalist system and to establish a socialist society as the condition for the liberation of humanity and the creation of meaningful art.

It was in Dresden that the left-wing group of the New Objectivity had its most vigorous force. There Conrad Felixmüller, after joining the Communist Party in 1919, used the unbridled violence of late Expressionist style for an art that dealt with the political and social reality of the time. As his art developed it became less subjective in response to his need to grasp the problems present, and he often did so with cynical analysis. He undoubtedly influenced the older Otto Dix, whom he recruited for the *Dresdner Sezession Gruppe* in 1919. In his depictions of

war and the plight of mankind, Dix, perhaps the most influential of the New Objectivity painters, worked with an Expressionist vehemence grounded in subjective experience. It was only later that he too developed a more sober and cynical style to face the iniquities of life.

Younger painters in Dresden were prominent members of the Proletarian-Revolutionary group among the New Objectivity artists.[13] Karl Völker produced a cycle of murals for a Socialist meeting hall in his native Halle, in which he depicted the class struggle within the framework of Christian iconography. Hans Griebel produced a large didactic canvas, *Die Internationale*, in the late 1920s; it was seen as a major work of revolutionary solidarity uniting the suppressed German and the liberated Soviet proletariat. Wilhelm Lachnit painted portraits that were often more symbolic and allegorical in nature. Otto Grundig concentrated on explicit proletarian themes in strong propagandistic paintings. Curt Querner, the artist closest to Dix, like the older painter was informed by the masters of the German Renaissance: his pictures of the disenfranchised, the unemployed, and the hungry were executed in a meticulous manner. He painted workers on hunger marches and the impoverished peasants tilling small parcels of poor soil. Even more than his Dresden contemporaries, he was influenced by Courbet's famous *Stonebreakers*, the great revolutionary canvas of 1849, which occupied the place of honor in Dresden's Gemäldegalerie until it was destroyed in the firebombing of 1945. These were all artists whose impact on current painters in the GDR remains significant.

Soon after the assumption of power by the Nazis, all modern art in Germany was banned and artists were persecuted. The left-wing New Objectivity painters were prime targets of the new regime. George Grosz was in New York, and John Heartfield was first in Prague, then in England. But among those who remained in Germany, Otto Nagel, Otto Griebel, Wilhelm Lachnit, as well as Hans and Lea Grundig were incarcerated by the Gestapo. After a brief debate, the Fascist government also went on the offensive against the Expressionists. It is true that Joseph Göebbels himself had written an Expressionist novel in the early 1920s and that his wing of the Nazi party had a certain amount of sympathy for the art of Nolde and Barlach and their search for *völkisch* values through a primitive past. Emphasis on the irrational and on mythology certainly appealed to Nazi sentiments, and the powerful distortions and vitality of Expressionist graphics managed to survive in early Nazi posters and placards. But the racist ideology of Alfred Rosenberg, together with Hitler's own petit bourgeois taste, prevailed. Expressionism, with its inherent ambiguities, presented a danger: only a pure Aryan art could project the aims of the Third Reich, and it had to be an art free of all modernist international "isms" and offer direct access to the man in the street. In Nazi Germany, art was forged into a powerful propaganda tool of the Fascist state.

Upon the collapse of the Third Reich in 1945 German culture found itself in what has been called *Stunde Null* (zero hour). Although defamed by the Nazis, Expressionism did not come into favor in either part of the newly divided country. In the West, when art began to make a slow reappearance, it was largely abstract and took its cues first from Paris and later from New York. The presumptive freedom of total abstraction was seen as an earmark of political freedom and

became a trump card of the West as the Cold War accelerated. Few Expressionist artists were still present in Germany, and figurative art was out of style; Dix and Pechstein, for example, were rejected in juried exhibitions.

Although the reasons were very different, Expressionism was also disparaged in the early years of the GDR. In the first two decades after the war, East Germany called for an art that, like its literature and all other cultural manifestations, was to be used as a weapon in its policy of radical anti-Fascist reforms. The highly regarded Marxist theoretician Georg Lukács had condemned Expressionism as regressive and proto-Fascist. In a seminal essay, "Expressionism: Its Significance and Decline," the Hungarian cultural critic maintained that "expressionism is undoubtedly . . . one of the many tendencies in bourgeois ideology that grow later into fascism," and that it was "not accidental that fascism accepted expressionism as part of its inheritance."[14] Lukács's argument was based not only on the involvement with Expressionism of men such as Göebbels, but also on the refusal of many Expressionist writers to become engaged in the reality of the class struggle and their inability to produce a political ideology. He thereby damned them for accepting by default the bourgeois establishment of both Wilhelmine and Weimar Germany.

The 1940s heard a great deal of debate and discussion – largely based on anti-Fascist convictions – among artists and critics about the future of art in the newly established GDR. Expressionist tendencies managed to survive in the work of older artists such as Wilhelm Lachnit and Hans and Lea Grundig, who were appointed to professorships at the Dresden Academy, as well as Horst Strempel, Hermann Brusse, Gottfried Richter, and Paul Schultz-Liebisch in Berlin. The discourse, however, led to a general rejection of any kind of experimental art; it was deprecated as being "formalist." The new painting, sculpture, and graphics in the newly established socialist state was obligated to adhere to the prescriptions of Social Realism: artists were to celebrate and edify the life of the working class in traditionally painted pictures that were simple both in their message and appeal to the masses. "Art was understood almost exclusively as visual communication of political ideology."[15] Expressionist features, when discernible, were certainly not promulgated, and most of the official art was modeled after Soviet paradigms.

At the end of the 1950s and beginning of the 1960s, pivotal conferences held in Bitterfeld called for a direct and close contact between artists and workers. Declarations were issued that recalled the manifestoes of some forty years earlier. The reality of the new demands by the state left little room for the introspection and ambiguity of Expressionist art.

But as the state was consolidated, both economically and socially, and as its borders were secured, partly by the erection of the Berlin Wall in 1961, greater artistic freedom of expression became possible. The concept of Social Realism broadened to include personal experiences and visions. By the mid and late 1960s, furthermore, the heritage of the Bauhaus in Weimar and Dessau and, in turn, of Russian Constructivism, began to be recognized. There was a new acknowledgment of the class-conscious bite of Dresden artists such as Otto Dix and Curt Querner, and of Käthe Kollwitz in Berlin. Artists and critics paid attention to Renato Guttuso's Realismo – anti-Fascist, Communist, but also informed by modernism; the Italian's exhibitions were highly praised.

THEODOR ROSENHAUER

In the early 1960s, works by individual artists who stayed aloof from propagandistic pursuits, but who dealt with spheres of personal life and of simple commonplace objects, began to find their place in the GDR art world. Between 1962 and 1969, for example, Berlin's Nationalgalerie acquired six canvases by Theodor Rosenhauer.[16] Born in Dresden in 1901, Rosenhauer did not participate in the ecstatic late Expressionist painting of the Dresden Sezession in the postwar years. He painted portraits of his Dresden neighbors and dispassionate still lifes and landscapes of secure and solemn presence. The sobriety of his work was related to the nonpolitical, nontendentious wing of the New Objectivity. In his unembellished still-life paintings, Rosenhauer anchors his objects to their support and relates them thoughtfully to each other and the surrounding space. In his search for the inner reality of simple objects, these paintings have affinity with Paula Modersohn-Becker's proto-Expressionist still lifes. Rosenhauer's landscapes, far from *plein air*, are studies whose dark colors and heavy impasto textures often endow them with a feeling of foreboding. In *View of Cemetery Court in Winter, East Radebeul* (1965), a little girl walks down the path between the gravestones and pollarded trees toward an ominous red brick building. The simple dark picture can be seen as a quiet reflection on mortality without the violent distortions of Edvard Munch's painting of death.

WILLI SITTE

Death more immediate in its presence was the theme of the large painting that greeted the visitor of the Tenth Art Exhibition of the GDR in 1987–88.[17] Willi Sitte, president of the Artists' Union of the GDR, was represented with a vertical diptych showing the bodies of assassinated men, covered with sheets and spread out on rough wooden boards. Beneath the corpses we see a quiet still life of an earthenware jug, a candle, open books, an exercise sheet with letters of the alphabet, a pencil stub, and a picture of Sandino. Entitled *They Only Wanted to Teach Reading and Writing*, this painting is a powerful testament of Contra terrorism in Nicaragua.

Sitte was one of the artists who, back in the 1960s, altered the concept of Social Realism from a fixed formula to a more personal expression in which formal language itself changes with the context of the historical period. *Leuna* (1969), a huge synchronous panorama of the great chemical factory, consists of dynamic and fragmented images indebted to the Cubist and Futurist tradition of the modern movement. In keeping with contemporary thought and praxis, the narrative here is no longer linear. Works such as this, together with personal pictorial statements by the Leipzig artists Werner Tübke, Wolfgang Mattheuer, and Bernhard Heisig, helped transport painting in the GDR into the modernist current. In the last two decades Sitte has located his work increasingly in the great tradition of European painting. His robust baroque nudes recall the opulent bodies and sensuous colors of Rubens, and their vigorous realism acknowledges Courbet's sense of the palpable. Working in twentieth-century Germany, he is also very much part of the Expressionist lineage. The exuberant expressive gestures of his paintings are rem-

iniscent of Corinth and Kokoschka, artists of whom Sitte speaks with great admiration.[18] A painting entitled *Homage to Lovis Corinth* depicts a couple in postcoital position with a self-portrait of Corinth at his easel on the right-hand margin.

Sitte wants his pictures to have an immediate eye appeal that involves the viewer in the work. At the same time, he eschews idealized beauty. His nudes are human forms with real weight and mass. They are gritty naked bodies, heaving and sweaty physical beings, assertive of life.

Sitte's work is by no means always public in nature. At times he paints very private pictures of his artist friends, of his mother, of himself. His *Self-Portrait in a Swamp* (1984–86) depicts his realistically rendered head submerging. Its darkly suffused reflection is perhaps related to the importance Carl Jung gave to the "realization of the shadow." Unlike Adelbert von Chamisso's *Peter Schlemihl* – the source of a series of woodcuts by Ernst Ludwig Kirchner in 1916 – who sold his shadow to the devil to his eternal regret, Sitte accepts his shadow as an essential part of himself.

BERNHARD HEISIG

In 1962 Bernhard Heisig produced a pivotal history painting, *The Paris Commune, III.* He continues to be preoccupied with history painting that deals with both the first proletarian revolution in Paris and with the catastrophic events of World War II, when he was both participant and victim. Very much like the second generation of German Expressionists who came to dominate art after World War I, Heisig gives visual form to the chaotic inferno haunting his memory: in his case this was the cataclysm surrounding the fall of his native city, Breslau. Although his own work is more fluid and disordered than Dix's, he speaks with great esteem of the angry indictments by Otto Dix and his ability to destroy all sentimental illusions. Heisig has a similar high regard for the parallel description of the war experience in Erich Maria Remarque's *All Quiet on the Western Front.*[19]

Heisig's close affinity to earlier Expressionists was discussed by the GDR art historian (and Marxist ideologue) Ulrich Kuhirt when writing about the artist's entries in the Eighth Art Exhibition of the GDR:

> The relationship between his manner of painting and that of Corinth and Kokoschka is apparent and has frequently been analyzed; certainly there is in his oeuvre something of Corinth's power display and of the intellectual analysis of contradictory human character by Kokoschka. But it is Beckmann's painting that is reflected with the greatest intensity and sensitivity in Heisig's work. There is a similar far-reaching and universal understanding of the situation of the human problems in our time, the complicated and conflicting relationship of the individual to the social-historical process – of the anxieties of the time. Certainly Heisig pursues the process along an ideological path which was proscribed to Beckmann, but the latter's greatness, his implacable desire to carry out his creative intentions, signifies a strong impulse for Heisig, who seeks his own expressive synthesis of content and form.[20]

Heisig is deeply committed to the process of painting. He never thinks of any one of his paintings as truly complete. He will continue to rework the surface, to

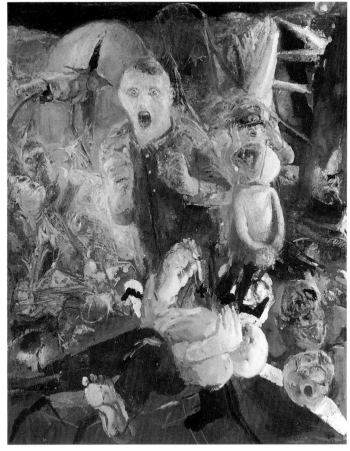

FIGURE 32. Bernhard Heisig, *The Volunteer*, 1987, oil on canvas, 60 × 48", courtesy Galerie Brusberg, Berlin.

make changes in works which seem to have their own organic sense. Unlike many of his contemporaries in Germany's Federal Republic to the west, whose strident vehemence rarely penetrates beneath the surface, his paintings are authentic depictions of the human figure, yielding images deeply aware of the plight of existence. Indeed, he thinks very much like Max Beckmann when he says: "You cannot prevent war with art. But I can work at it by drawing a hand, for example, which will make everyone feel that this hand must not be destroyed."[21]

SIGHARD GILLE

Sighard Gille was a student of Heisig's at the Leipzig Academy and has in many respects continued on the course set by his master. Although very controversial on account of his nontraditional compositions of boisterous workers at parties, he received the highly prestigious public commission to decorate the huge ceiling of the foyer of the new Gewandhaus in Leipzig, which he completed in 1981. Inspired initially by Mahler's *Lied von der Erde*, it is highly complex in both composition and meaning. In his canvases Gille presents depictions of anxious drivers going mad on jammed highways, curious personal encounters, and jovial social gatherings.

121

In Gille's *Fête in Leipzig* (1979), a heavy-set bearded man with serious mien, lifting his right hand to his heart, seems to reflect or dream of real and imaginary people in his life: immediately behind him on his right is the staring face of a large woman, arms akimbo. On both sides, half-nude females display their sexual charms. On the top, we see a raucous couple who kiss without embracing. There is a masked woman cradling a sheep, an official-looking bureaucrat seen in profile and holding a bottle next to a smirking bespectacled fellow. A crude, fat man is shouting out of the picture, and next to him a thin, dark, intellectual type comes forward to confront the viewer. Painted in bright colors and with fluid brush, this rather chaotic assemblage of people is crammed together, jostling and rubbing against each other, but attaining no genuine contact. Sharing a crowded space, the figures are individualized and separated as deeply as the men and women in Antonioni's *festas*. But it is again Max Beckmann who is the progenitor. *Fête in Leipzig* reminds us of the numerous paintings of parties, dances and balls, carnivals and all manner of social encounters – the sardonic masquerades that the older artist, also born in Leipzig, painted to hold up a mirror to often grotesque human social behavior.

WALTER LIBUDA

Born in Berlin, where he now resides, Walter Libuda was also a *Meisterschüler* of Heisig's in Leipzig and assisted Gille for a time on the Gewandhaus decorations. Being almost ten years younger than his colleague, his work has moved further into the realm of abstraction. Again Beckmann's imagery comes to mind in a painting such as *The Fish* (1986–87). For Libuda, however, titles are not descriptive, but are metaphors of his personal associations, and the fish is hardly visible in this canvas. Libuda is, above all, involved with color and pigment, with the substantiality of the paint material. His color schemes, his materialization of space, his sensuous and sumptuous color structure, are informed by Nolde and by Kokoschka's Dresden period.

But we also think of de Kooning's brushstroke in this painter's work. The process of painting will lead Libuda intuitively to unexpected results, which are then again altered toward ever new explorations in which figure and ground become conflated. In *Ceiling Runner II* (1985), we are able to distinguish an acrobat with arms on a bar and his feet on the ceiling. This upside-down figure is turned around for reasons totally different from Baselitz's practice. Only figments of fantasy would cause Libuda to place an open eye on the figure's stomach. The upturning, overlaps, and interpenetrations turn the body into a flawed anatomical exercise and force the viewer to question which parts of the body are actually signified. Ambiguity in Libuda's work is not a foible but results from inner necessity.

In many of Libuda's paintings – *The Courtship XV* (1985–87) is an example – the human relationship between the figures, with their disturbed facial expressions, is left undefined. The shifts from foreground to background and the overall compulsiveness of the surface tension in his paintings tend to obliterate the figures, which, nevertheless, insist on their presence. If the dislocation of the objects depicted leads to their disappearance, the substance of the paint is greatly emphasized, and a voluptuous surface of glowing color is the result.

Libuda's sense of painting as adventure, his search for personal identity by means of painting, his almost automatic handling of the medium, his fusion of dream and reality, are related to a pictorial tradition that extends from Surrealism to Abstract Expressionism, but, as the GDR critic Matthias Flügge points out, Libuda's painting is also a manifestation of a peculiar and consistent synthesis of introversion and expressive impulse so characteristic of German art.[22] Like the art of the earlier Expressionists, Libuda's painting is filled with anxieties and ambiguities. It evokes dreams and desires and describes personal passions, especially the passion to paint.

THOMAS ZIEGLER

Belonging to the same generation as Libuda, Thomas Ziegler paints in what appears to be a totally different style. Instead of a rough impression of an agitated brush, his surface is characterized by the neutral finish of thin pigment; the personal touch of the painter has been eliminated. His depictions of the figures in *Soviet Soldiers 1987* are clear and dry. The figures are contoured precisely against the assertive monochromatic red background. The painter assumes the role of neutral observer and paints what he sees with meticulous incisiveness. He pictures four men of different ethnic types in their bemedalled olive-green uniforms, sitting precariously on narrow red boards. They are posed; their self-protecting body language conveys uneasiness. Rather than being presented as human subjects, the figures in *Soviet Soldiers 1987* are objectified against the solid red field.

In 1925 the art historian and photographer Franz Roh wrote a significant treatise entitled *Nach-Expressionismus*. He noted that a new style of painting had emerged in Italy and Germany with the premise that art is an observation of the eye rather than an inspiration of the dream. Palpable reality had taken over from visionary utopias. Roh noted that the painting once more mirrored the tactile quality of objects. He postulated an emergence of a new art that was by no means a revision of nineteenth-century realism, but rather utilized the constructive tectonic discoveries of Cubism, the sensual depictions of surfaces by the Impressionists, and the Expressionists' awe of the human figure toward a dialectical confrontation with reality. He therefore named the new art Post-Expressionism – rather than New Objectivity, a term coined by his colleague Gustav Hartlaub at the same time. Roh saw the new painting as "an art which neither invents nor copies, but constructs the painted object as a rendering of the inner vision by means of the given external world."[23]

Portraits by painters who worked in Saxony, men like Otto Dix, Conrad Felixmüller, Curt Querner, and Karl Völker, who portrayed their subjects with hard angular outlines and with uncompromising verity, are the sources of such a work as Ziegler's polyptych. But whereas in the mid 1920s there was still some kind of chronological time frame in which one movement followed upon another, in the late 1980s – in the GDR as elsewhere – the situation has become pluralistic. Ziegler's work can now share the space at the Tenth Art Exhibition of the GDR with paintings by Libuda or graphics by Carlfriedrich Claus.

There are a number of artists in the GDR whose work, of a highly private

order, is tolerated rather than publicly acclaimed, and whose relationship to earlier Expressionism is more a matter of mental attitude and personal stance than artistic style. Like their predecessors, exemplified by the Brücke painters in Dresden, they have preferred to work outside the establishment in their quest for aesthetic authenticity. As Herbert Marcuse pointed out in *The Aesthetic Dimension* (significantly subtitled *Critique of Marxist Aesthetics*), "the flight toward 'inwardness' and the insistence on a private sphere may well serve as bulwarks against a society which administers all dimensions of human existence."[24]

CARLFRIEDRICH CLAUS

The work of Carlfriedrich Claus relates more to calligraphy than painting and was recognized early in the West when it was included in Dietrich Mahlow's pivotal exhibition *Schrift und Bild* in 1963.[25] Like a number of postwar artists, Claus is primarily concerned with the interaction between text and image, between linguistic and pictorial values. His works on paper appear at first glance as abstract drawings, related to *art informel* or to the phenomenal work of the Belgian poet, draftsman, and painter Henri Michaux. But in contrast to Michaux's experiments with automatic writing and with psychedelic drugs, Claus's work is more carefully controlled. Many of his drawings, etchings, and silk screens are based on scholarly inquiry into philosophy, history, psychology, language, and politics. The texts, moving wildly across the page vertically, diagonally, in circles, and back and forth, often turn out to be meaningful statements. His political engagement became apparent as early as 1958–59 in his *Erinnertes Gedicht eines jüdischen Mädchens*, a poem in which he confronted, somewhat like Celan's poem and Kiefer's later paintings, the annihilation at Auschwitz. His spontaneous-looking drawings are actually in the nature of ideological propositions with explanatory titles, such as *Conjunctions, Unity and Struggle of Oppositions in Landscape Related to the Communist Problem of the Future, Naturalization of the Human Being, Humanization of Nature*. Claus grounds his firm belief in the ecological solidarity of man and nature on similar precepts to be found in the early expositions by Karl Marx. Considering himself a true Marxist, he sees his *Sprachblätter* (visual texts) as exemplifying a dialectical process. The ambidextrous artist writes his thesis on the recto of these sheets with his right hand; then, using his left hand, he draws the antithesis on the verso. The synthesis is provided by viewers when they hold the sheets to the light to receive the message.

MICHAEL MORGNER

Michael Morgner belonged to a small group of private artists in Karl-Marx-Stadt (formerly Chemnitz) for whom Claus, living in nearby Annaberg, was the guiding spirit. Morgner, also primarily a graphic artist, works with the human figure, often rendered as an emblem that occurs in serial imagery throughout much of his work. Exploring a variety of materials and graphic techniques, he juxtaposes linear patterns with violent bursts and splashes of

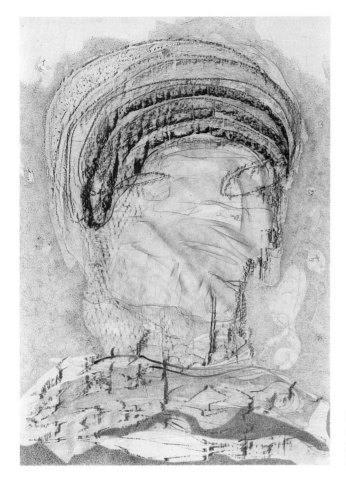

FIGURE 33. Gerhard Altenbourg, *Unveiled*, 1972, oil on canvas, 40¾ × 28¾", courtesy Galerie Brusberg, Berlin.

ink. In some of his abstract embossed drawings the surface itself becomes the image. The intensity of Morgner's dark color recalls the paintings and prints of Rouault, whom the German artist discovered early in his career.[26] The anthropoid image, which keeps appearing in his work, is that of a figure set adrift in a hostile world, frightened, distorted, but also enduring. Among the signs occurring in his graphics is frequent reference to the cross, and his *Crucifixion* (1987), with its energetic thrust into the viewer's space, is a powerful Expressionist image of authentic force. In comparison with the explosive energy of this drawing, the religious graphics of his predecessors, Nolde, Schmidt-Rottluff, and Pechstein, seem calm and restrained.

GERHARD ALTENBOURG

Gerhard Altenbourg's relationship to the Expressionist tradition goes back to his childhood. He recalls having been impressed by Feininger, Schmidt-Rottluff, Lovis Corinth, and Otto Dix's *War* triptych, which he saw at the Museum Moritzburg in Halle in 1931 at age five. He also points to Expressionist poets, to Jacob von Hoddis, August Stramm, and Gottfried Benn, as well as to Arp and Schwitters, who had a decisive impact on his thinking. In an autobiographical letter of 1955,

Altenbourg stresses his admiration for Schwitters by quoting several of the Dadaist's poems, and he acclaims Schwitters' exploration of form, his pulsating order, his innovations, his hard rhythms and soft fusions, and his astonishing vitality.[27]

After serving and being wounded in Germany's tank corps on the Eastern Front, Altenbourg worked as a journalist and writer before studying art in Weimar in the late 1940s. At that time, he could not have known about Paul Klee, who had worked and taught in that city some twenty years earlier; in the post–World War II era, the art of the Bauhaus was still suppressed in the GDR. But in the library he saw and cherished reproductions of "Arp's growing forms, of Schwitters' new media and Hans Bellmer's erotic gardens."[28]

When Altenbourg began his work as a graphic artist and painter in a suite such as his *Ecce Homo* (1949), he established an immediate relationship to the Modernist-Expressionist tradition, recalling Beardsley, Ensor, Schiele, and Dix. In the succeeding decades his affinity to Klee, that is to say, to the spiritual and transcendent wing of Expressionism, became more pronounced. His work, kept small in scale, is like that of Klee or Wols in a minor scale and is concerned, above all, with the source and the process of creation. His line, like that of Klee, resonates with nature and partakes of its rhythms. Altenbourg's colors are related to the organic colors of the earth and its flora and fauna. He explores a host of techniques, working with watercolor, tempera, Chinese ink, pencil, crayon, pastel, chalk, and many other media on carefully selected handmade papers. Many of his drawings and watercolors are based on landscape motifs, on the hills of his native Thuringia where he lives in seclusion in his garden near the old town of Altenburg from which he took his nom de plume (adding the "o," as he said, to make his name more international). His paintings are silent and lyrical meditations on the germinating energies of nature. He reaches a level of abstraction by the most meticulous observation and by means of empathy with the natural forces. His landscapes often resemble cross sections based on observation from within. Sometimes his landscapes metamorphose into heads and figures of imaginary beings, of nymphs, clowns, leprechauns, chimeras, sprites, gremlins, hobgoblins, or personages resembling Dubuffet's concoctions. These phantoms easily become parts of his depictions of nature, of moors, grasslands, swamps, hillsides, and forests.

In its own highly individualist way, Altenbourg's work is also a link in the chain of the German Romantic tradition. We think of the interlaced landscapes of Altdorfer and the Danube School or of the transcendental paintings by Caspar David Friedrich, to whom he dedicated the drawing on the cover of his autobiographical notes in 1972. Schelling's precept that the artist should participate in the ever-creative energy of nature applies to Altenbourg as it did to Klee. It was Klee who announced in his treatise on modern art, that the world "in its present shape is not the only possible world"[29]– a *truly* revolutionary concept. But this was not the kind of revolutionary art that the GDR supported during its earlier years. While Altenbourg received considerable acknowledgment in the West by artists such as Bernard Schultze and dealers such as Rudolf Springer, who exhibited his work in his West Berlin gallery as early as 1952, it took a long time for him to be recognized in his own country. As late as 1968, an exhibition of his

work was officially closed in Leipzig, but a retrospective of his work was held in the GDR's three major museums in 1987.

Not long after the impact of Expressionist art on the praxis of GDR artists, art historians, critics, and museum curators began the official rehabilitation of the Expressionist movement. An impressive number of group shows as well as individual retrospectives were mounted in museums throughout the GDR in the early and mid 1980s. In 1984 the Museum der bildenden Künste in Leipzig organized a Max Beckmann retrospective to honor the artist's 100th birthday in his native city. A large catalogue was published, which itemized all of Beckmann's works in GDR collections and published nine essays on different phases of his work. The exhibition was sent on to the Nationalgalerie in Berlin and to Dresden. Lectures about Beckmann's works, concerts in his honor, and television programs accompanied the exhibition. The bulletin of the Leipzig museum published an issue devoted to Beckmann and the venerable Reclam Verlag printed a portfolio of graphics in Beckmann's honor. It included prints by Bernhard Heisig, Harald Metzkes, Wolfgang Mattheuer, Volker Stelzmann, and others. Many GDR artists, it became clear, considered "Beckmann's work and its effect as the point of departure and criterion of their own art."[30]

Then in 1986 a major exhibition was mounted in Berlin to celebrate the 125th anniversary of F. A. Stübler's fine neoclassical building of the Nationalgalerie. The exhibition was a centerpiece of East Berlin's celebration of the 750th jubilee of the city. Almost four hundred works by forty-four artists were assembled from East German collections and six foreign countries. The beautifully printed catalogue was also a serious scholarly enterprise toward a theoretical investigation of the Expressionist movement and its relationship to the art of the present. The introduction, written jointly by the three responsible museum directors, states: "The Expressionists of those years (1905–1920) were the trail blazers of an anti-bourgeois art of freedom, which was imbued with the breath of revolution."[31] They went on to point to the dialectic between the group consciousness of the early associations and the molding of strong individual personalities that led toward a movement of revolutionary impetus. In an important essay, Erhard Frommhold argues that the graphic cycles by Beckmann, Grosz, Meidner, or Masereel are political statements as radical as the declarations by Rosa Luxemburg and Karl Liebknecht.[32] Willi Geismeier, in another article in the same publication, rejects Lukács's condemnation of Expressionism and points out that this doctrinaire attitude toward Social Realism changed in the 1960s when the heritage of Germany's proletarian-revolutionary art found new recognition. Geismeier sees a straight line from Expressionism to the politicized radical art of Weimar, which continued into the present. He concludes his essay with these words: "A renewed encounter with Expressionist masterpieces can be of great benefit for current artistic reclamation, for scholarly discourse, and, not least, for the cognition and enjoyment by the public."[33]

The new valuation of a personal authentic art is part of a new attitude toward the concept of realism in the GDR. In much of the current discourse, a great deal of emphasis is placed on the communicative function of art, on its reception as well as its production. Instead of insisting on a form of realism that presents a mirror image of the appearance of reality, or on art that is merely polemical in

content, the viewer's response is given greater value. A work of art, it is argued now, should provide greater insight into reality – public or private, subjective or objective – and thereby increase the viewer's consciousness. This attitude among East German critics and theorists finds a resonance with Herbert Marcuse, who stated, "Art cannot change the world, but it can contribute to changing the consciousness and drives of men and women who can change the world."[34]

CHAPTER

10 EDUARDO CHILLIDA

SCULPTURE IN THE PUBLIC DOMAIN

By tradition, sculpture is a public art, which in the past – from Angkor Wat to the Piazza Navona – has created communal experiences, ranging from enchantment to mystical participation.* But in the nineteenth century, public sculpture was mostly evidenced in heroic monuments in which rulers of ostentatious pomposity or generals on horseback exalted established social institutions, their privileges and victories, and at least figuratively subdued thoughts of change. The twentieth century, often questioning traditional values, came to find little relevance in such sculptures. Today even such idealistic monuments as the Statue of Liberty or the Triumph of the Republic have become little but tourist attractions, and the multitude of monuments to military victories are no longer capable of rousing the patriotism of the citizenry.

It took a very long time for modern concepts in public sculpture to find acceptance. The Constructivists in particular attempted to create meaningful symbolic sculpture for a dynamic revolutionary society in the twentieth century, but Vladimir Tatlin's materialist design based on the theme of a rotating spiral, the *Monument to the Third International* (1920), remained, ironically, a utopian vision, and it was not until 1957 that a Constructivist sculpture appeared in the public arena, when Naum Gabo was commissioned to make a large work in stainless steel and gilded bronze for the front of a Rotterdam department store.

Brancusi's ensemble of the *Gate of the Kiss, Table of Silence,* and *Endless Column* was erected in the 1930s as a sculptural environment both spiritual and secular in meaning, symbolizing the mystery of human existence. But it is in the very remote Romanian village of Tîrgu-Jiu, at the foot of the Carpathian Mountains, almost at the edge of Europe. In fact in 1938, the year this group was completed, Lewis Mumford wrote: "The notion of a modern monument is veritably a contradiction in terms: if it is a monument, it is not modern, and if it is modern, it

* One section of this essay originally appeared in *Chillida* (1986). Reprinted by permission of Harry N. Abrams, Inc., New York. Another section was published in *Arts Magazine*, Vol. 63, No. 1, September 1988, pp. 84–87. This magazine has ceased publication.

cannot be a monument."[1] It is certainly true that most of the finest and most innovative modern sculpture has been highly personal and autonomous, following little but the artist's individual concepts. Largely self-referential, modernism postulates that artists' standards are their own, and the audience is welcome to meet the artists on their own ground. It was not until the post–World War II period that the public gave increasing acceptance and patronage to abstract sculpture. Much of it seemed in accordance with an expanding industrial and technological society, and it appeared with increasing frequency in art dealers' showrooms, museums, private collections, and public spaces. Furthermore the realization grew that sculpture is a concrete, material object rather than a symbol of hieratic values. Very rapidly, however, the very ideas, concepts, and techniques of the pioneers of modern abstract sculpture became sterile as the new academies produced a generation of sculptors who fabricated a plethora of soft biomorphic or hard geometric constructions and plunked them down in public spaces with little thought given to site, scale, or purpose. Corporations as well as government agencies opted for cosmetic artifacts which managed to express a sense of power without offending anyone. Attractive as some of these basically mobile sculptures are, they demonstrate the absence of a sense of place in the works and, indeed, the homelessness of modern society.

Chillida's first public sculptures were placed in preexisting public spaces. In the mid-1960s, after having constructed large wooden pieces, the sculptor wanted once more to carve in stone on a large scale. He expressed this desire to James Johnson Sweeney, who was preparing a retrospective exhibition of the artist's work for The Museum of Fine Arts in Houston. Sweeney arranged for Chillida to be commissioned to create a work for the South Garden of the museum. The sculptor found the right material, rose-colored granite, in an abandoned quarry in Galicia, in northwestern Spain. To launch into this vast project he made a wooden maquette, *Abesti Gogora I (Rough Chant I)*, which was "far from the character of the final realization," he assured the director of the museum, "because of the difference in scale and material."[2] He began carving the granite blocks in the mountains near Budiño, in Galicia. Then after working on it for about a year, he had them trucked to the port of Vigo for shipment to Houston, where the sixty-ton work was assembled by large cranes. Because of illness, he was unable to supervise the final assemblage and installation in 1966 of the fifth and final version of *Abesti Gogora*. The three huge stones with their semigeometric forms create a striking contrast to the arboreal surrounding. A stone sculpture – itself a piece of nature, quarried from the rock and formed by man – is set in a garden environment, also cultivated by man. *Abesti Gogora V* is set in view of Gunsaulus Hall, Mies van der Rohe's pure, classical addition to the museum. The sculpture itself is very architectural, but instead of the rectangular symmetry of Mies's glass and steel building. Chillida's stone is rough, irregular, and full of surprises. The positive space of the granite block and the negative space of the void are in a state of tension. In fact, the space itself seems to hold up the heavy granite. There is a powerful interrelationship of balanced discontinuity between the interlocking vertical, horizontal, and diagonal slabs. It invites the visitor to enter, to walk through; each position yields a different spatial experience.

Much like this fifth version was the ultimate work in the *Rough Chant* series.

Chillida's serial steel pieces *Around the Void* found their final statement in the fifth piece, *Around the void V* (1969), installed in front of the World Bank in Washington, D.C. The work consists of stainless-steel cubic forms that appear meticulously formed and finished. The joints, stretched and stressed as they are, show the power of the industrial forge. The squared components, with one arm stretching out in a powerful cantilever, surround an intricate space cell. They appear to have been wrenched apart and to be in the process of reassembling around the central empty space.

In 1971 the Thyssen Company installed a large sculpture by Chillida in front of its corporate headquarters in Düsseldorf. This commissioned piece was made at the Thyssen works in Hattingen under the artist's supervision from large sheets of Cor-ten steel that were supplied by the Thyssen plant in Oberhausen. Here a work of art was fabricated by a huge industrial concern, using highly advanced technological processes in the production of a durable alloy, as a monument to its own success. It was then donated to an industrial and financial urban center and placed in front of a large and impressive, but undistinguished, late International Style high-rise office building on a major traffic artery – not an ideal location for a sculpture by Chillida. In fact, *Monument* (1970–71) was originally intended for a different place on the site. But it holds its own here with prodigious eloquence. In a way it contradicts rather than passively accepts its site. Its presence sets up a new and unexpected relationship among road, building, and city. It gives life to its site and poses new questions about sculpture and the nature of reality.

Monument is a remarkable three-part work. The central, vertical spine of this anthropomorphic piece is like an articulated backbone with a series of vertebrae bent inward and upward in a steplike succession. This vertical element is a highly complex and active contrapuntal support of a long diagonal bar which stretches far outward until it reaches the ground. This, in turn, is balanced by a heavy square cube, hanging in the air, in fact seemingly held up by the space underneath it. In *Monument* Chillida combines spatial tension with geometric clarity and extraordinary vigor.

Although there is an enormous difference between Bernini's sculpture in which the marble looks like flesh, and Chillida's in which the steel looks only like steel, they share certain formal concerns. Some of Chillida's work, such as *Monument*, is close to the Baroque master's in its disregard for spatial limitations, its unexpected and precarious asymmetrical composition, its use of twisted forms, and its daring appearance of instability.

WIND COMBS

Soon after Chillida's return to San Sebastián in 1951 he resolved to create at the end of the city a large environmental sculpture dedicated to the wind and the sea. At the time, however, although he was remembered as the goalkeeper of the San Sebastián soccer team, the authorities did not know Chillida the sculptor. He had begun working on designs for a "comb of the wind" as early as 1952, designing three different topologies over the years. In the mid-1960s the city of San Sebastián, in recognition of his increasing fame, suggested an exhibition of his

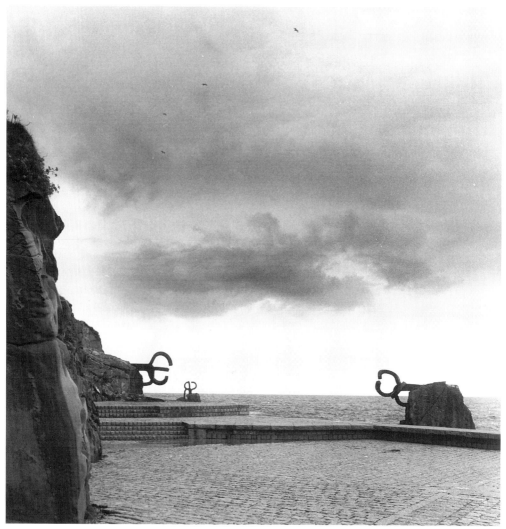

FIGURE 34. *Wind Combs*, San Se-
bastián, 1977. Photo: David Finn.

work, but Chillida proposed instead that the munici-
pality commission a permanent work on the western boundary. Ten more years
passed before he was requested to proceed with the project. The city paid the cost
of the material, and the sculptor contributed his work as a gift to his birthplace.
This was his first opportunity to create a meaningful public space, to develop an
integrated environmental design.

The actual work was largely done in two years, 1975–77, and was a successful
collaboration between the architect, Luis Peña Ganchegui, and the sculptor,
working together almost daily as conditions changed on the site. The engineering
involved in anchoring the large heavy metal pieces was exceedingly complex.
But the work is as permanent as man and the elements can devise: it has been
calculated that the steel will lose approximately one centimeter of its substance
each hundred years. In this project, the artist was supported by the city in doing
exactly as he wished to do, and the result, *Wind Combs* (1977), is one of the most
magnificent modern sculptures in the public area.

The sculpture is on a natural ledge below the steep palisades at the edge of San Sebastián, an area inaccessible before its construction. Now the space is used as a promenade, as a locale for games, performances, or lectures, as a place for silent meditation or for observing the sea, the sky, and the mountains. Sometimes on a stormy day at high tide, the waves will fill the space with spectacular might and a tempest can even cover the sculptures completely. *Wind Combs* appears like ramparts defending the city against the sea. When the hair of the wind hits, it is combed by the elements of the sculpture on its approach to the town.

Martin Heidegger considered sculpture a thing occupying a place and showing forth in space. *Wind Combs* is in its place – the earth and the rock – and is set against the sky. But it also relates to the sea and its tides. Like the three forces – air, rock, and water – it consists of three pieces. They are like gigantic Jews' harps or pliers, grasping the sky. One comb is set into the cliff with its axis parallel to the ground, stretching three of its claws out into the water, while the fourth one helps anchor it back into the rock. The second sculpture is fastened on a rock in the water and points toward the land. The third comb is farther out in the sea, silhouetted against the horizon and oriented vertically, opening its arms to the sky. The three are engaged in a conversation which may be silent or highly animated, depending on the forces of nature. The two horizontal wind combs, the sculptor feels, relate to the past, the vertical comb opens to the future, which is unknown. The water is an essential part of the sculpture, filling the void when the element decides to do so. The noise of the waves is part of this *Gesamtkunstwerk*, as are the sea gulls overhead and the people below.

To give release to the often turbulent power of the sea below the esplanade, the sculptor drilled holes into the granite paving stones of the platform. The seven different designs of these water holes have been named by the people after the seven Basque provinces, a response that pleases the artist, who did not have it in mind when he designed the work. But he declared in 1980:

> Just as the piece of land with its sculpture fights the waves and air to survive and attempts to communicate with the other two pieces nearby, the Basque people are struggling to survive as a distinct culture within Spain.[3]

The location itself is a site of remarkable rock formations. The layers of the stratification, which actually are perpendicular to the sea, are powerful visible reminders of the tremendous forces that formed the Pyrenees, which at this very spot rise from the ocean. The wind combs, reaching for each other, try symbolically to bring together again what was once united in remote geological times. The work deals with, among other things, the condition of separating and connecting. *Wind Combs* is a great metaphor of man's connection to nature. Rainer Maria Rilke wrote in 1902:

> People . . . unwilling to leave the Nature they have lost, go in pursuit of her and try now, consciously or by the use of their concentrated will, to come as near to her again as they were in their childhood without knowing it. It will be understood that the latter are artists: poets or painters, composers or architects, fundamentally lonely spirits, who, in turning to Nature, put the eternal above the transitory, that which is most profoundly based on law above that which is fundamentally ephemeral, and, who, since they cannot persuade Nature to con-

cern herself with them, see their task to be the understanding of Nature, so that they may take their place somewhere in her great design. And the whole of humanity comes nearer to Nature in these isolated and lonely ones. It is not the least and is, perhaps, the peculiar value of art, that it is the medium in which man and landscape, form and world, meet and find one another.[4]

Although a work like *Wind Combs* seems to have become a perdurable part of the land and seascape, not all of Chillida's site sculptures are necessarily permanent installations. He recently placed his *Architect's Table* (1984) in front of his *caserio* in Zabalaga near San Sebastián. (A *caserio* is one of the old Basque farmhouses still to be found around the Pyrenees.) Chillida and his family acquired it as the permanent locale of the Fundación Chillida to house the artist's archives. The seventeenth-century farmhouse, made of timber with masonry facing, has a heavy, solid character and a quality of endurance and simplicity characteristic of much indigenous architecture. It is surrounded by a fine orchard which has grown appropriately wild. Set on fieldstones and facing the wide house is the low steel table. It appears to be a perfect echo: the house itself is almost square in plan; so is the *Table*. The angular apertures of the *Table* seem to respond to the doors and windows of the half-timber facade, while the *Table*'s eroded edge and the rusted patina acknowledge the worn state of the *caserio*. The modern abstract sculpture has found its perfect location and connotes its connection to its own tradition.

PLAZA DE LOS FUEROS

Wind Combs is a prodigious sculptural ensemble set into the forces of nature. A few years later (1975–80) Chillida focused on site-specific work in urban space, redesigning the business center of the lively commercial and manufacturing city of Vitoria-Gasteiz, the capital of the Basque province Álava. Here the artist became an active social designer shaping a participatory space. This work actually preceded much of the most interesting expanded sculpture to be done in the United States in the 1980s. Originally Chillida had been commissioned by the county council of Álava simply to erect a sculpture in the marketplace of Vitoria as a monument to Los Fueros – the ancient laws guaranteeing the privileges and liberties of the Basque people. On reflection, he decided to persuade the authorities to consider a whole new architectural complex for the old Plaza de Abastos (Marketplace). Much of the basic design for the new Plaza de los Fueros was based on the earlier and much smaller Plaza de la Trinidad (Trinity Square), which was a project for games and activities by Peña Ganchegui in the old section of San Sebastián. The square in Vitoria was again a collaborative project between Chillida and Peña Ganchegui. The latter designed most of the public areas, consisting of the large planar *frontón* wall for jai alai, which itself resembles a rectangular architectural fragment, a court for the *bolatoki*, the ancient Basque ox races, a subterranean bowling alley, a small amphitheater, and a labyrinthine area that leads downward to Chillida's steel sculpture, the monument to the defense of Los Fueros. It was during the working process that Chillida, who did not like the site surrounded with inelegant new buildings, decided to change his original

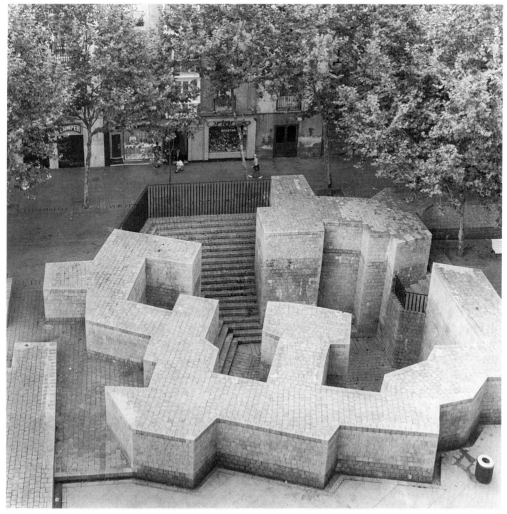

FIGURE 35. *Plaza de los Fueros*, Vitoria-Gasteiz, 1980. Photo: David Finn.

design from a raised labyrinth and pelota court and to dig partly beneath the ground to create a new and distinct identity for the plaza. The whole square is made of pink Galician granite, the same stone the artist had selected for the *Abesti Gogora* in Houston.

The space in the Vitoria city square (eighty-six thousand square feet) is not in the classical mode of many of its counterparts in which broad vistas are addressed to imposing facades. It is rather in the Baroque tradition, full of involutions, mazes, tangles, and surprises. Like the *plaza mayor* (main square) in many Spanish towns, it is not in the very center of the city, but set apart from major traffic arteries. Also in keeping with Baroque urban design, and in significant contradistinction to the International Style planning promoted by CIAM (Congrès Internationaux d'Architecture Moderne), which postulates large open landscape spaces surrounding slab buildings, Chillida and Peña Ganchegui preferred to have the buildings surround the open space.

When viewed from above, the deep angular maze resembles the design of Kufic arabesques, but it undoubtedly originated in the articulation of clandestine pas-

sages in the sculptor's earlier drawings, etchings, and alabasters. Stairs lead downward between stone pylons to a depth of thirteen feet, to a chamber open to the sky, the core of the whole complex. There in the sacred niche the viewer confronts a steel stele that could be a metaphor for both a tree and a fist, and that is meant to stand for the ancient oak tree in Guernica. Guernica, symbol to the world of the horror of aerial bombing and memorialized in Picasso's great painting, has also since medieval times been the site of the venerable oak under which the lords of Biscay came to swear their loyalty to Basque law. The tree remains the symbol of liberty for the Basque people. Chillida's sculpture is housed on the bottom of a deep well, surrounded by tall, protecting walls. Its intertwined arms branch in different directions from its heavy squared base. It stands in a guarded hub of the Basque capital city and signifies the Basque spirit of independence, metaphorically radiating to all the Basque territories in the defense of an ancient culture and its rights.

Chillida continues working on proposals for sculptures in the public arena. He has submitted several versions of a powerful monument for Nashville, Tennessee, which bears a strong semicircular form, a broken circle with all its implications of unfolding and reaching toward closure. A similar shape occurs in the *Project for Hamburg* (1979–80), where a dynamic configuration of several such U-shaped forms surmounts an angular horizontal platform. In 1982 he created his very primal *Monument to Tolerance*, earmarked for the city of Seville, where it was meant to be placed on the banks of the Guadalquivir River near the Torre del Oro. Sixteen feet high and almost forty feet long, it is again based on the variations of the theme of giant semicircular curves, oriented horizontally and vertically at right angles to each other. Its powerful apselike space is meant to receive people who would enter the concrete sculpture near the center of the city. The monument, meant as a totemic sign for freedom, was rejected by the city, because, Chillida suspects, of his Basque nationality.

For the city of Frankfurt, Chillida has designed the *House of Goethe* (1981), a highly ambitious work in which solid slabs of steel alternate with juxtaposed cutouts of voids. The large steel sculpture, stressing the poet's monumental intellectual powers, deals with different aspects of his genius than does the alabaster *Homage to Goethe* series, with its involuted passages of light. In 1985 the city of Frankfurt commissioned Chillida to construct the *House of Goethe* full-scale, in concrete, to be placed close to his birthplace, in the center of the old city near the Main River.

In his works and projects for public spaces, Chillida sets out to shape a specific part of man's environment. Among the depressing mediocrity of most public sculpture in our time, only a small number of works attain real distinction. Those that come to mind are Brancusi's ensemble at Tîrgu-Jiu, Alberto Giacometti's and Joan Miró's groupings at the Fondation Maeght, Dubuffet's *Four Trees* at Chase Manhattan Plaza and Noguchi's garden beneath it, in New York, or Dubuffet's *Closerie Falbala*, in Périgny-sur-Yerres, France, and Noguchi's garden at Costa Mesa, California. There have also been a few memorable temporary installations such as David Smith's at Spoleto and Christo's in Marin and Sonoma counties, California, and elsewhere. Eduardo Chillida's two large public works in his Basque

home territory are outstanding examples of this small group. In these distinguished works the sculptor has scrutinized and calculated the nature and the quality of the space, space, which, Immanuel Kant had noted, infiltrates through each of our senses. While retaining the essentially private autonomy of modernist sculpture, these works relate to the life of the people, providing an opportunity for reflection in a communal situation.

Public sculpture has become an increasingly important aspect of Chillida's *oeuvre*. His public works relate to landscape or city and transform their sites into aesthetically valid environments. Although in the tradition of abstract sculpture, they have become meaningful place markers. The master sculptor assumes a social role, giving aesthetic definition to places of human interaction.

OUR FATHER'S HOUSE

On April 26, 1937, the bombers of Germany's Condor Legion destroyed the city of Guernica. They systematically burned its buildings and machine-gunned the people fleeing from the collapsing houses and even shot the animals in the fields. They laid waste to Guernica, the ancient capital of the Basque people and one of the oldest centers of democracy. The Basques stubbornly adhered to the Republican government in Spain's deadly civil war and had to be defeated by the advancing Fascist armies of General Francisco Franco. The devastation of Guernica was the first instance of saturation bombing. It was the first city to be recorded in the deadly annals of aerial destruction which was to ravage Coventry, Rotterdam, Dresden, Hiroshima, Nagasaki, and Hanoi.

Outraged by this act of unparalleled barbarism, Picasso began working on his great mural, *Guernica*, on May 1, 1937. He universalized the experience of destruction and death, of horror and anguish in his painting which is now installed in the Cason des Buon Retiro alongside the Prado. Picasso's masterpiece "stigmatizes the destruction of a disintegrating society with a power no other artist has equalled."[5]

Now that some forty years of Franco's oppression are of the past, the work by Chillida, installed on its hill in Guernica, is a monument to peace (or at least the hope for peace), to tolerance, to life against death. The Basque sculptor has created a dominant structure, facing the sacred Oak of Guernica. Erected fifty-one years after the devastation of the city, it looks to a better future. The first impression of this powerful monument, which opens its arms in a great protective gesture, is that of a vast vessel. According to *Genesis*, "the earth was filled with violence" and God commanded Noah to build a great ark, "thirty cubits high," which would withstand the forty days of devastating flood and salvage some of the life on earth. *Our Father's House* indeed seems like a huge ark with great sheltering wings that are open to the entrant, but what covenant does it denote in an age without God?

Our Father's House is Chillida's third architectural work in the Basque country. *Wind Combs* (1975–77) was done at the bottom of the great promontory of San Sebastián, in homage to his native city. Beyond that, it is a eulogy on the elements of nature, of earth, sky, and sea. Gigantic steel tongues, set into rocks on land

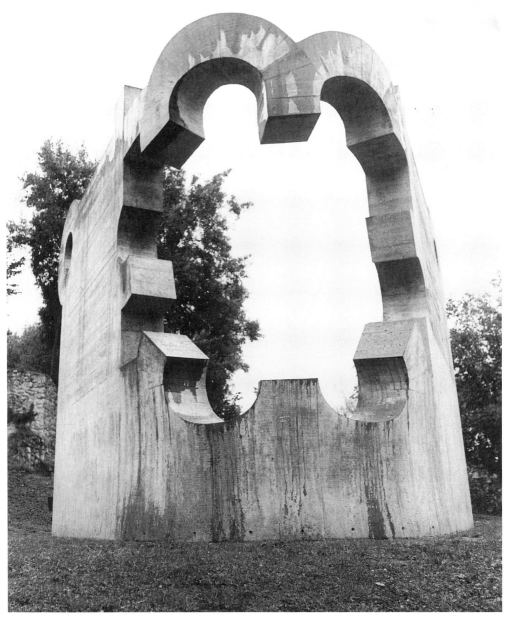

FIGURE 36. *Our Father's House,*
Guernica, 1987. Photo: David Finn.

and sea, are engaged in a permanent conversation which may be silent or highly animated, depending on the power of water and wind. The noise of the waves is part of the total work of art, as are the birds overhead and the people for whom it was made. It is a public promenade; it can be a place for a lonely encounter with nature; it can be a playground. And it defines its place, the border of the city and the point where the mountains meet the sea.

If the public sculpture in Sán Sebastian juts out against the sky, the design of the *Plaza de los Fueros* in Vitoria-Gasteiz (1975–80) is turned into the earth itself.

There, in a former marketplace of the city, Chillida has created his first major work on the theme of Guernica. In this plaza, the sculptor, in collaboration with the architect Luis Peña Gancheguy, has fashioned a splendid urban design, transforming a nondescript square into a noble public space of raised and lowered surface, combining utilitarian with purely aesthetic areas. Stairs lead downward into a deep well, into the Basque earth, and there in a sacred niche stands a symbolic iron tree with intertwined bars moving in different directions from its heavy, squared base, the powerful arms of a tree branching from its trunk. This is not an "abstract" sculpture, but it is a metaphor for the Oak of Guernica that stands for the spirit of independence and the defense of the rights of the Basque people.

The Oak of Guernica was recorded as early as 1452, when a Code of Rights, "Los Fueros," was negotiated under its branches between the Basques and the king of Spain. The ancient seats surrounding the tree have found their way to the Basque parliament house, which was built behind the tree, and generations of oak trees have been planted over the original roots. During the aerial bombardment which created a roaring inferno in the rest of the city, the tree was miraculously saved. Its offspring, the New Oak, is the focal point of Chillida's sculpture. Chillida insisted on the particular place, 200 meters from the tree and the Case de Juntas. The sculpture was created in axial orientation toward the oak with which it communicates.

Before it became a symbol of cultural identity, the Oak of Guernica was a living tree, a very symbol of life. Chillida is acutely aware of the danger to life on this planet posed by deforestation and considers the protection of trees a very important matter. He is particularly given to native trees, such as the oaks and beeches and pines of the Basque country – not the palms and olive trees that belong to the South. He plans to landscape the area near *Our Father's House* with a wood of trees that pertain to the land. The orientation of his sculpture toward the famed oak, then, has not only cultural and historic reference, but also has ecological validity.

Eduardo Chillida received four years of architectural training prior to becoming a sculptor, and he thinks in tectonic terms, in terms of place and space. Furthermore, the material to be used – and Chillida has fashioned great sculpture in iron, steel, wood, alabaster, and clay – is of integral importance. For the large open dwelling place at Guernica he decided on concrete, a material of great endurance and strength. Physically, as well as symbolically, it was appropriate. The artist's process of working toward the final statement was well demonstrated in an exhibition and its accompanying catalogue, arranged by the Tasende Gallery at the Chicago Art Fair in May 1988.[6] It indicates the development of the piece: During 1987 the artist made a number of sketches, drawings and collages as well as various studies both for the interior stele and the embracing piece itself. The final study, *Gure Aitaren Etxea V* (166 cm. high), was installed temporarily near the Oak of Guernica in April 1987; the sculptor then proceeded to build the final work itself. It was done initially in styrofoam in a large factory studio in Hernani near San Sebastián. Then a wooden model was created from the styrofoam. Upon completion of the wooden structure, the work was disassembled and the coded

pieces were shipped to the site in Guernica, where they were reassembled. Then the concrete was carefully poured into the wooden mold and during January 1988 *Our Father's House* reached completion. After the main sculpture was put in place, the carefully selected cobblestones were set on the ground and the corten-steel stele was placed in the epicenter of the work.

Gure Aitaren Etxea is a large piece of sculpture. It is 7.80 meters high, has an outer circumference of 18.20 meters and weighs approximately 188 tons. It was commissioned by the Autonomous Basque government for about 60 to 70 million pesetas.

Titles have a significant place in Chillida's works as they give guidance to their meaning. There are the *Wind Combs*, in San Sebastián, the Plaza de los Fueros in Vitoria, the *House of Goethe* in Frankfurt, the *Elegy to Water* in Barcelona and *Our Father's House* in Guernica. The title is taken from a patriotic Basque poem, *Gure Aitaren Etxea*, which was written by Gabriel Aresti in 1967 and ends with:

> . . . and with my soul I will defend
> my father's house.
> I will die,
> my will would be lost,
> my progeny will be lost,
> but my father's house
> will go on
> standing.[7]

The work was indeed made in homage to the Basque country and its people by the artist who has compared his own artistic persona to a tree with its roots in his place, in his homeland, the country of the Basques. From this autochthonous place, he feels, he can branch out and become a citizen of the world, creating an art of universal meaning.

An additional connection to the Basque heritage was the fortuitous incident that after the work was placed on its site, it turned out to be in direct view of the prehistoric cave of Santimaiñe, which houses a magnificent rendition of a horse among its paleolithic paintings. The Basques, who think of themselves as descendents of the Cro-Magnons (who isn't?) consider this the oldest sanctuary of Basque art.

Our Father's House shares the pure simplicity and stark, formal dignity with the Cistercian abbeys in the North of Spain. It also echoes their extraordinary sense of proportion and knowledge about the handling of the building materials. By avoiding decoration, Chillida, like the Cistercians, learned about the probity of form. Inside *Our Father's House* the steel stele denotes the Oak. It also centers the work, pins it to the ground and directs the visitors to the large serrated opening, the rose window in the apse. But this opening also has a more aggressive, almost explosive appearance, evoking the prow of a ship, while the large circular forms on the top of the walls remind us of the horns of rams in the Basque mountains. Chillida, who once described himself as the enemy of the right angle, has here again avoided the rigidity of 90 degrees as he has also deflected the center of the work from a symmetrical design. There is a great sense of expansion conveyed to the viewer who enters this sculptural environment. The massive walls, almost

2½ feet thick, embrace and hold the space between them. The visitor finds himself in a defined void, which to Chillida is not an emptiness, but the element that animates matter and enlivens space. As you advance into the space you approach the magnificent radiating arc in the sky which transmits a sense of exhaltation.

Like his previous work in the public domain, *Our Father's House* comes to full life only when it enters into a dialogue with the people for whom it was made. Like Duchamp, who insisted that it is the viewer who completes a work of art, like Man Ray, who asserted that a faucet stops when it is not heard, like all modernist art, Chillida's work calls for this discourse.

When asked about his work, Chillida frequently explains that it is a search for the unknown. The unknown, after all, does not need to be created. In a way, his latest work, *Our Father's House*, is another mark in his quest for the unattainable and unapproachable, a search for the limit.

ATLANTIC CROSSINGS

11 AMERICANS ABROAD

In 1766 John Singleton Copley, foremost painter of the American colonial period, wrote to his compatriot Benjamin West in England, lamenting that in the American colonies not a single portrait was "worthy to be called a Picture."[1] Eight years later Copley went to England. There he painted his masterpiece, *Watson and the Shark* (1788), was elected to the Royal Academy, and spent the next forty years as an English painter. West, who had left his native Pennsylvania for London in 1763, eventually succeeded Sir Joshua Reynolds as president of the Royal Academy.*

It was not the last time such a lament was sounded. Even a hundred years later in the mid-nineteenth century, when a number of American painters were composing sublime landscapes in a spirit related to Emersonian Transcendentalism, Thomas Cole, an artist of great spiritual aspiration, spoke regretfully of an American public that preferred "things not thoughts." American artists had to cope with a congeries of adversity in the nineteenth century. The work of the carpenter and the artisan was much more highly valued than the rarefied pursuit of the arts; an egalitarian sensibility in the new republic found it hard to give special respect to the uniqueness of artistic talent; and an ingrained Puritan tradition regarded with suspicion and distrust the sensuous aspect of the visual arts. In short, a fundamental anti-intellectualism, which can be traced back to the Jacksonian period, marginalized painting and sculpture as well as literary pursuits.

While splendid painters such as Winslow Homer, Albert Pinkham Ryder, and Thomas Eakins spent most of their working life in America, their contemporaries James McNeill Whistler, Mary Cassatt, and John Singer Sargent chose to be expatriates. Whistler and Sargent are often classified "British School" in museum catalogues published in England, and Cassatt is quite correctly considered among the "French Impressionists." These artists never denied their American heritage, but in the absence of adequate art schools at home, they studied abroad. Europe

* This essay originally appeared in *American Art of the 20th Century*, © 1993 (pp. 177–185). Reprinted by permission of Prestel Verlag, Munich.

also provided enchanting subject matter: Whistler and Sargent as well as Maurice Prendergast responded with delight to the beauty of Venice, the city in greatest contrast to American cities or the American landscape. In addition, finding a more advanced artistic and intellectual climate, as well as better patronage, they, like Henry James, preferred to work and live abroad. As late as 1917, on the occasion of the "Independents" Exhibition, the hanging committee's refusal to show Marcel Duchamp's *Fountain* prompted the French painter to comment: "The only works of art America has given are her plumbing and her bridges."[2]

A supportive intellectual community of artists, writers, and critics like that prevailing in Paris did not exist in America, certainly not until Alfred Stieglitz established his gallery at 291 Fifth Avenue in New York, a place where new ideas could be exchanged. Stieglitz was a crucial cultural force in twentieth century America. At the suggestion of his friend and fellow-photographer Edward Steichen, he began in 1906 to exhibit modern art as well as photography at the Photo-Secession Gallery at 291. They exhibited Rodin's boldly unconventional drawings of nudes, never before shown anywhere, and followed them with new drawings by Matisse. Then, in rapid succession, they introduced the work of Toulouse-Lautrec, Cézanne, Brancusi, and Picasso. 291 also presented work by children as well as African and Precolumbian sculpture in an art context for the first time.

The 291 gallery also exhibited some of the best and most innovative American art. Between 1909 and 1916 Stieglitz introduced paintings by Alfred Maurer, John Marin, Marsden Hartley, Max Weber, Arthur B. Carles, Arthur G. Dove, Abraham Walkowitz, and Georgia O'Keeffe to the American public. Except for O'Keeffe, all these artists spent an essential period of their early careers in Europe. O'Keeffe, who found her inspiration chiefly in the American landscape and cityscape, did not go to Europe until late in life.

Earlier in the nineteenth century, American artists had gone to Europe for their training – to Rome, and later to the academies in Düsseldorf and Munich. But now, toward its end, they went to Paris not merely to improve their skills, but also to see the avant-garde art and make contact with the artists who had changed the course of painting. Cézanne's work above all first attracted American painters. But once in Paris, they were also swept up by artists living and working in an atmosphere of invention. Alfred Maurer, who arrived in Paris around 1900, was the first American to come under the influence of Matisse and the Fauves. Max Weber, arriving in Paris in 1905, actually studied under Matisse in his famous class, which was also attended by Arthur B. Carles, Morgan Russell, and Patrick Henry Bruce. Weber was also in contact with Picasso during the incipient years of Cubism. He introduced the Spanish painter to his close friend Henri Rousseau and in 1910 arranged an exhibition of the *douannier's* work at Stieglitz's 291 gallery.

Many of the Americans frequented Gertrude Stein's Saturday soirées on the rue de Fleurus. The most celebrated American expatriate and significant avant-garde writer had moved to Paris in 1903, and, together with her brother Leo, acquired key paintings by Cézanne, Matisse, Picasso, and other modernists. With extraordinary acumen the Steins selected the finest of the new art. For almost forty years Gertrude was an important catalyst of artistic and intellectual culture. Stieglitz met her in 1908 and a year later published her biographical sketches on

Matisse and Picasso in *Camera Work*. The Italian-American painter Joseph Stella (1877–1946) described his encounter with Gertrude Stein, which many of his colleagues must also have experienced: "Somehow in a little side street in Montparnasse there was a family that had acquired some early work of Matisse and Picasso. The lady of the house was an immense carcass austerely dressed in black. Enthroned on a sofa in the middle of the room where the pictures were hanging, with the forceful solemnity of a priestess or Sybilla, she was examining pitilessly all newcomers, assuming a high and distant pose."[3]

Stella, who attended the First Futurist exhibition in Paris in 1912, was greatly inspired by what he saw, but only after his return to New York did he begin to paint in a Futurist mode. Similarly, other American painters seemed to have found it necessary to digest their Paris experience after returning home. John Marin as well as Weber and Walkowitz responded to the energy and visual confusion of life in Manhattan with their personal renditions of Cubist-Futurist paintings. Arthur Dove (1880–1946), an artist of more lyrical temperament, had also felt the call to go to France; he lived in Paris, the Midi, and Italy between 1907 and 1909. Back in America, he painted a series of nonrepresentational paintings as early as the non-objective works by Europeans such as Kandinsky, Kupka, the Delaunays, and Balla. Like Kandinsky, whose work he could not have seen at the time, Dove used colors, shapes, and light to suggest underlying natural rhythms, rather than transcribing visible forms.

Marsden Hartley (1877–1943), well-trained artist, familiar with the new trends in painting, had a solo show at 291 in 1912, before sailing for Europe at age thirty-five. In Paris at Gertrude Stein's salon he met the American expatriates as well as French painters. Most important was his encounter with Kandinsky's book *Concerning the Spiritual in Art*. At Hartley's suggestion an excerpt was published in Stieglitz' *Camera Work* in 1913. Hartley's series of abstract mystical paintings, done in Paris in 1912–13, which he called "intuitive abstractions" and "spiritual illuminations," conflated Bergson's philosophy, Kandinsky's theory, and American Indian imagery. Hartley felt that the most significant new art was being done in Germany by the Blue Rider group. He went to Berlin and Munich, made direct contact with Kandinsky and Franz Marc, and had five works included in Herwarth Walden's First German Autumn Salon in Berlin in 1913 – the first truly international survey of the avant-garde.

An American painter, prominently included in this exhibition, Lyonel Feininger (1871–1956), was the first American modernist to leave for Europe. He had arrived in Hamburg as early as 1887 and was an established artist by the time of the *Herbstsalon*. Although he never renounced his American citizenship, Feininger, a Bauhaus master from its inception to its closure, became to all intents and purposes a European artist.

During his stay in Berlin, Hartley, greatly impressed by its military pageantry, combined his response to it with mystic symbolism in strangely emblematic paintings that reached their climax in *Portrait of a German Officer* (1914). Its flags and military insignia referred to an intimate friend who had been killed in action. In these paintings Hartley achieved a tightly knit Cubist-derived structure combined with the vivid intuitive color of German Expressionism. After the war, restless and insecure, Hartley traveled from New York to Bermuda, to New Mex-

ico, back to Paris and Berlin, spent several years in the south of France trying to enter the spirit of Cézanne in Aix, returned to Germany at the beginning of the Nazi period, and then went to Nova Scotia before settling in his native Maine in 1937, where, during the last six years of his life, he accomplished a powerful synthesis of his work. In 1944 Alfred H. Barr paired Feininger and Hartley, two American artists, deeply informed by Modern German painting, in a two-man retrospective at the Museum of Modern Art.

In Munich two American painters, Morgan Russell and Stanton Macdonald-Wright, calling themselves Synchromists, held their first exhibition in 1913, followed shortly by shows in Paris and New York. In Paris since 1917, the pair were familiar with contemporary developments, saw the Futurist exhibition, and were stimulated by František Kupka's bold abstractions. They also knew the color theories of Chevreuil and Charles Rood and the contemporaneous Orphist color experiments carried out by Robert and Sonia Delaunay. The Synchromists decided to push color to a state where painting could become an equivalent to "the highest spiritual exaltation of music." Their work and theories exerted a distinct influence on vanguard American painting. Among their followers were Andrew Dasberg, Patrick Henry Bruce, and Thomas Hart Benton. Benton had lived in Paris from 1908 to 1911 and later repudiated modernism, becoming a vociferous antagonist of foreign influences on American art.

Stuart Davis (1894–1964), arguably America's most important painter of the post–World War I period, had worked in a provincial realist style until he saw the Armory Show, which he described as "the greatest single influence on my work." He then began to use modernist syntax to create distinctly American pictures. Letters and words appeared in his painting, and consumer objects and packages became his themes. At the same time the Bostonian Gerard Murphy (1888–1964) decided to live abroad, went to Paris, was greatly impressed with Cubist painting, and decided to take up art, studying with Natälia Goncharova. Between 1921 and 1929 he painted a series of still lifes of match books, watch gears, razors, ball bearings. Stylistically related to American Precisionism, his paintings, like Davis's paintings of commercial objects, anticipated the modalities of Pop art.

Both Murphy and Davis are indebted to Léger's simplified approbations of machine forms. When Davis finally went to Paris in 1928, he felt at home with the Americans he encountered – Gertrude Stein, Hartley, Calder, Noguchi – and found confirmation for his radical approach to painting. Although his Parisian paintings, mostly street scenes, were rather decorative, upon his return to New York his style matured and became a unique interweave of abstract colors, lines, and texts. Davis, armed with European modernism, was able to translate the harmonies and dissonances of America's greatest art, jazz, into dynamic visual surfaces.

The son and grandson of American sculptors, Alexander Calder (1898–1976) performed a similar function in sculpture. Calder had studied engineering before turning to art. Realizing that "Paris seemed to be the place to go," he sailed for France in 1926. For the remainder of his long career, he divided his time and energy between France and America. In Paris he first made wire animals and

FIGURE 37. Marsden Hartley, *Portrait of a German Officer*, 1914, oil on canvas, 68¼ × 41⅜", The Metropolitan Museum, New York.

FIGURE 38. Alexander Calder, *Josephine Baker*, 1927–28, iron-wire construction, 39 × 22⅜ × 9¾", The Museum of Modern Art, New York.

people. He then animated them to create his famous Circus, which attracted the attention of the Parisian art world.

Calder, inspired by Miró's free organic forms and Mondrian's compositions of equilibratory colors, wanted to make three-dimensional Mondrians. His kinetic sculptures, at first driven mechanically, then floating freely in space, were christened "Mobiles" by Marcel Duchamp. Although these works were preceded by experiments in kinetic sculpture by Duchamp, Gabo, Man Ray, and Moholy-Nagy, Calder introduced infinite fortuitous variations. He invented sculptures that move at random, stirring lightly like leaves in the wind. Alexander Calder changed sculpture from its static, solid state to an art of movement in time. During the 1960s and 1970s he continued making mobiles, as well as "Stabiles" (so-named by Arp), which are monumental in scale and help define the space of their urban environments. More than any other American artist of this period, Sandy Calder was accepted in France, as elsewhere, among the twentieth century masters.

Isamu Noguchi (1904–1988) arrived in Paris a year after Calder and assisted him with the display of the Circus. Noguchi, born in Los Angeles to a Japanese poet and an American writer, spent much of his childhood and youth in Japan before returning to study in the United States. In New York he was deeply affected by a Brancusi exhibition, and in Paris the Rumanian master took him into his white studio as his assistant, initiating Noguchi into the symbolic meaning of pure, abstract form.

In 1930 Noguchi returned to the East. He studied with the celebrated Chinese painter Ch'i Pai-Shih in Beijing, and in Japan he learned to work in clay, largely by studying ancient haniwa sculpture. In Japanese sculpture, theater, and architecture he found again that "simplicity beyond complexity" which Brancusi had first instilled in his mind. Returning to New York, he became part of the incipient New York School and also began an extended association with Martha Graham, creating innovative stage designs. They relate to the sculptural totality of his gardens and landscapes, which later became a major aspect of his work. A restless voyager, Noguchi worked on sculpture projects in Paris, Greece, and India, Japan, Israel, and in the marble mountains of Italy, accomplishing significant civic commissions and proposing many unrealized designs representing his humanist and visionary thinking.

Mark Tobey (1890–1976), like Noguchi, achieved a personal synthesis of Eastern and Western thought. Born in the Midwest, he was also a wanderer as well as a mystic, and like Noguchi he acquired a familiarity with foreign cultures, which he incorporated into his art. At age twenty-eight, living in New York, Tobey became a life-long adherent of Baha'i, a faith uniting all religions. In 1923 while residing in Seattle, Washington, he was introduced to calligraphic brush painting by the young Chinese painter Teng Kuei. With this mode he felt enabled to use his brush to open the solid forms of Western art and penetrate the void of space.

Pursuing his search to go beyond the rational mind, he undertook a crucial visit to China and Japan in 1934, spent sometime in a Zen monastery in Kyoto, and became proficient in *sumi* painting. Tobey returned to Darington Hall in Devonshire, England, where he taught throughout the 1930s. He exchanged

FIGURE 39. Mark Tobey, *White Night*, 1942, tempera on cardboard, Seattle Art Museum.

ideas with colleagues at this experimental school – artists and intellectuals such as Aldous Huxley, Arthur Waley, Pearl Buck, and Ravi Shankar, who were also engaged in a marriage of Eastern and Western ideas.

In the early '40s Tobey began his allover abstractions, often using a mesh of whitish lines. These works, rejecting formal composition, activated the total surface of the painting in energized continuums. Exhibited at the Willard Gallery in New York in 1944, they heralded the much larger allover paintings by Jackson Pollock. Never fully recognized in New York, Tobey was highly esteemed in the Orient as well as in Paris, where he seemed closely related to *art informel* and Tachism. In 1958 he became the first American painter since Whistler to be honored by a gold medal at the Venice Biennale. In 1960 he settled in Basel, where he continued working for the remainder of his life.

For a time French critics suggested the term *Ecole de Pacifique* for Tobey, Morris Graves, and Sam Francis. Born in Oregon in 1910 and brought up in Seattle, Graves first encountered the Orient in 1928, as a seaman in the United States Merchant Marine. Returning to Seattle, he immersed himself in the Asian art collection at the Seattle Art Museum and began his study of Zen philosophy and aesthetics. He worked closely with Tobey, whose calligraphic "white writing"

Graves adopted for his symbolic paintings of "spirit birds," sacred vessels, and pine trees. He shared involvement with Zen with his friend John Cage, who was greatly influenced by Graves's evocative and mysterious paintings, and wrote a series of "dance chants," or word portraits of the painter. For most of his adult life Morris Graves migrated from place to place, always finding spots of seclusion – a rock on Fildalgo Island in Puget Sound, a small isle in County Cork, Ireland, a pond in an isolated area in the northwestern United States – from where he occasionally traveled to Japan and India. The emphasis on meditative stillness in Zen finds a response in Graves's use of the forms of nature.

Sam Francis (b. 1923) went from his native California to Paris (see below) before being drawn to the Orient. He first visited Japan in 1957 and returned many times, often for extended periods. On first arriving in Tokyo, Francis experienced a sense of *déjà vu*, a "return to the non-rational," and felt very much at home. In turn the Japanese, with their tradition that considers art above all a meditative experience, almost immediately responded to Francis's work. The Japanese artist, like the abstract expressionist, sees the working process as eliciting a new consciousness that becomes the work, and Francis found himself closely attuned to Japanese aesthetics.

The sojourn to Europe, almost obligatory for artists before World War II, became less imperative as European artists came to the United States. With Hitler's vituperative censorship of modern art and the Nazi persecution of German artists, followed by the German occupation of France, many European artists left the Continent. By the mid-1940s the United States provided temporary refuge or permanent residence to eminent emigrés, including Josef Albers, Herbert Bayer, André Breton, Marc Chagall, Marcel Duchamp, Max Ernst, Lyonel Feininger, Stanley William Hayter, Richard Lindner, Jacques Lipchitz, André Masson, Matta, Joan Miró, Laszlo Moholy-Nagy, Piet Mondrian, Gordon Onslow-Ford, Amédée Ozenfant, Kurt Seligmann, Yves Tanguy, and Ossip Zadkine.

Some Americans, such as the American Scene painters, were exceedingly hostile to the "foreign" European art, as were a handful of modernists. Clyfford Still had condemned even the Armory show as the "ultimate irony" that "dumped on us the combined and sterile conclusion of Western European decadence."[4] Most New American painters did not share this animosity. Robert Motherwell, on close terms with the French artists, transmitted many of the surrealists' ideas, such as automatism and the function of myth, concepts very important to the abstract expressionists. In 1941 Sanford Pollock reported to his brother Charles that their brother Jackson's "thinking is, I think, related to that of men like Beckmann, Orozco, and Picasso."[5] Three years later in an interview, Jackson Pollock stated: "The fact that good European moderns are now here is very important, for they bring with them an understanding of the problems of modern painting. I am particularly impressed with their concept of the unconscious."[6] De Kooning spoke frequently of his Dutch heritage and of his training in Rotterdam as well as his admiration for Soutine. Rothko conveyed his high regard for Matisse and Miró, and Guston greatly admired Beckmann.[7]

Two German painters, Hans Hofmann and Josef Albers, became the most important art teachers in America.[8] There really seemed no longer any need for Americans to go abroad. Nevertheless, American artists continued to make their

pilgrimages to Europe, chiefly to Paris. World War II veterans could study there at government expense, and many enrolled at the Académie des Beaux Arts, the Académie de la Grande Chaumière, and at the ateliers of Léger and Zadkine. More than 300 young American painters and sculptors came to Paris during the 1950s. Among them were a good many African-Americans situating themselves in France and escaping the discrimination and racism at home and received more attention and better exhibition opportunities. None of them, to be sure, obtained the phenomenal success and the honors attained by Henry Ossawa Tanner, who had lived as an expatriate in Paris from 1895 until his death in 1937. Between the wars, however, a substantial "Negro art colony" was established in Paris, but the artists were much less successful than their celebrated jazz-musician friends. Among the African-American artists in Paris after the 1950s was the widely beloved Beauford Delaney, who exhibited at prestigious Paris galleries. He was a close friend of writers Jean Genêt, James Baldwin, and Henry Miller as well as an older comrade to the younger American painters.

Romare Bearden (1912–1988), who had been a vital presence in the Harlem Renaissance, went to Paris after his discharge from the U.S. Army in 1945. There he was befriended by Brancusi, but, like many newcomers, he was overwhelmed by the culture of richness and diversity of Parisian life. He said that he "was so absorbed in seeing and walking in Paris from one end to the other, that I could never get around to doing any painting."[9] Only after returning to New York did Bearden create the distinctive, syncopating photocollages empathetic with Afro-American culture, and become recognized as a major American artist.

The younger generation of African-Americans in Paris included Bob Thompson (1937–1966), who did some of his finest post–abstract expressionist figurations during his Paris years before his early death in Rome. Barbara Chase-Riboud was given a solo exhibition at the Musée d'Art Moderne in 1974 for her exquisite sculptures, which combine metal and fiber. The sculptor Sam Gilliam had one of his first solo exhibitions in Paris at Darthea Speyer's in 1970; Howardina Pindell was introduced to the art world in the Paris Biennale of 1975; and Raymond Saunders executed many of his mysterious, paradoxical collages during extended sojourns in Paris.

Many Americans enjoyed a sense of anonymity fostered by the unfamiliar ambience and their frequently aloof French colleagues. Others were affected strongly by the French cultural tradition that allowed the artist an accepted role in social and intellectual life. Some of the pivotal French artists – Dubuffet, Fautrier, Richier, Wols, Giacometti – had endured the war and in their work confronted the nature of the human predicament. The Americans, who had no firsthand experience of the war and the Occupation, tended to be more concerned with the reevaluation of painting as gestural evolution or the geometric distillation of objects.

When Ellsworth Kelly (b. 1923) was a student at the Boston Museum School (1946–48), Max Beckmann's visit had the greatest impact on him. The expressionist mode of Beckmann, Kirchner, Jawlensky and, above all, Picasso, informed Kelly's early work.[10] When he went to France in 1948 he immediately traveled to Colmar to see Grünewald's Isenheim Altarpiece. Only when he began making replicas of objects in his surroundings was Kelly able to break from his Beck-

FIGURE 40. Romare Bearden, *Continuities*, 1969, collage on board, 50 × 43", University Art Museum, Berkeley.

mannesque figure painting. By the late 1940s he made flat paintings based on road markers, pavements, windows, ground plans, and walls. He transformed real objects, as he said, "already mades," in a manner akin to photography; the geometric shapes were located and arranged in the artist's eye. Some of these paintings were exhibited at the Galerie Maeght in 1950 along with works by his friend Jack Youngerman as well as by Pierre Alechinsky and Eduardo Chillida.

Kelly connected with the geometric abstract groups in Paris, Abstraction-

155

FIGURE 41. Ellsworth Kelly with "Cité," 1951, oil on board, 56¼ × 70½", photograph courtesy Ellsworth Kelly.

Création and Circle et Carré, and became well acquainted with Michel Seuphor, the leading spokesman of the group of artists and a follower of Mondrian. Seuphor eventually wrote to Kelly, considering him "the best of Mondrian's serious followers."[11] Kelly encountered Vantongerloo and Magnelli, but more significant was his meeting with Jean Arp in 1950. Kelly was much more inclined toward Arp's investigations of the Laws of Chance than the rational discourse of de Stijl and neo-constructivist art. In fact, while the most important work he did during his Paris years, *Colors for a Large Wall* (1951), had the appearance of systemic painting, its organization and choice of colors were entirely arbitrary. This large painting (8 × 8 ft) was in great contrast to the salon-size paintings done in Paris by geometric and tachist painters alike. At this time, Kelly was unaware of the large scale in which Americans like Rothko, Newman, and Still had been working in New York, where he went in 1954 after having seen a catalogue of an Ad Reinhardt exhibition.

Most of the Americans in Paris did not share the predilection for the hard-edge abstraction practiced by Kelly, Youngerman, and Jesse Reichek, but worked in a style more closely related to the expressionist abstraction in the United States. Sam Francis decided to leave his native California in 1950 and, rather than New York, chose to move to Paris because he felt an insistent attraction to the French pictorial sensibility – to Cézanne, Bonnard, Matisse, and especially to Monet. His avant-garde Berkeley paintings of the later 1940s secured him an important place

among the first generation abstract expressionists, but his work underwent a notable change in the diffused grey light of Paris. At first he expunged color from his pictures, painting almost totally white paintings with barely visible brushstrokes. His color later returned with great intensity and energy as Francis filled the space with cellular swarms of pulsating hues. Paintings such as these had not been seen in Paris and helped make the French art world aware of what came to be called the New American Painting.

Jean-Paul Riopelle had come from Montreal to Paris in 1946, and the two North American painters became close friends. They spent much of their time conversing with the perspicacious critic and philosopher Georges Duthuit, who was closely attuned to the work of his father-in-law, Matisse. Matisse's paintings, his "state of condensation of sensations," were of great importance to Francis and the American circle, who included Shirley Jaffe, Al Held, John Hultberg, Norman Bluhm, Frank Lobdell, Robert Rauschenberg, and Kimber Smith as well as Ruth Francken and Joan Mitchell. These latter two artists stayed in France for the remainder of their careers. Mitchell produced sumptuous abstractions based on her responses to forms and events in nature. Sam Francis found a ready acceptance among the French avant-garde, participated in pivotal shows such as "Significants de l'informel" (1952) and "Un Art autre" (1953), and forged a vital link between tachism and abstract expressionism.[12]

Italy, which traditionally attracted American artists, continued to draw painters in the postwar period. William Congdon (b. 1911), associated with the New York School, regularly exhibited at Betty Parsons's legendary gallery. After the war he returned to Italy, where he had served as an ambulance driver. In constant search for the "other," he traveled to innumerable exotic places in Asia and Africa and eventually found anchorage in Venice, in Assisi, and in Lombardy. During the 1950s, Congdon painted turbulent and passionate paintings of Venice which expressed the city's radiant and tragic aspects. A converted Catholic, he has produced profoundly moving semi-abstract religious paintings – a great rarity in this century. In the 1980s, living in a monastery near Milan, he achieved great serenity in small abstract landscapes that focus on the light and color of the Lombardy landscape.

In 1952 Robert Rauschenberg and Cy Twombly, with Rome as their base of operation, traveled to Italy and North Africa. They had been students at Black Mountain College, where they became acquainted with their teachers Ben Shahn, Willem de Kooning, Franz Kline, and Robert Motherwell, as well as with the poet Charles Olson and with John Cage and Merce Cunningham.

In Rome, Rauschenberg (b. 1925) continued his work in photography as well as collage. His visit to Alberto Burri's studio, where he saw Burri's eloquent, stained, rough burlap collages, may have confirmed Rauschenberg's exploration of heavy, encrusted, and ravaged surfaces. Burri arranged for Rauschenberg's exhibition at the Galleria dell'Obelisco in 1953, where Burri himself had shown a year earlier; in reciprocity Burri was given a solo show at the Stable Gallery in New York in 1954. In this venue, Rauschenberg and Twombly had a decisive two-man show in 1955, the former showing his white and black monochromes and the latter drawings and paintings of biomorphic lineaments. After returning to New York that year, Rauschenberg began his crucial combine paintings and con-

FIGURE 42. R. B. Kitaj, *If Not, Not,* 1975–76, oil on canvas, Scottish National Gallery, Edinburgh.

tinued a brilliant and inventive career, challenging many artistic concepts.

Twombly (b. 1929), after living in Spain, North Africa, and Italy and teaching in his native Virginia, settled in Rome permanently in 1957. His paintings, with their scribbles and clusters, their cursive skeins, smudges, and scratches, may not be immediately accessible in their evocation of ancient myths, their allusions to specific loci, their reference to Italian Renaissance painters, but these mediations are the essence of his work.[13] Their titles evoke ancient deities, and allude to Virgil, Hesiod, and to the English poets Shelley and Keats, who also were steeped in Mediterranean culture. These titles, as Roland Barthes remarked, function like a maze in which we have to retrace our steps to become initiated in the work.[14] A careful reading of Twombly's paintings permits the viewer to penetrate an apparent chaos toward their inner silence and the opening of a window to the classical past.

R. B. Kitaj (b. 1932), like Twombly, is a man highly cognizant of art, literature, and history. His collage-like paintings, based on virtuoso drawing, are filled with

multiple allusions, discontinuous allegories, questions, and unexpected relationships, with references to Walter Benjamin, T. S. Eliot, Kafka, Ezra Pound, and Erwin Panofsky, as well as mass culture. Kitaj too has led the life of an expatriate. Born in Cleveland, Ohio, he was adopted by a Viennese Jew, brought up in upstate New York, joined the Merchant Marine, served in the U.S. Army, studied at Cooper Union in New York, the Akademie in Vienna, the Ruskin School of Art in Oxford, and the Royal College of Art in London. After living and teaching in the United States on different occasions, he decided to remain as a permanent emigré in London and considers himself a member of the School of London, a term he invented. At the same time he judges himself as the perpetual outsider, the Jew in the Diaspora,[15] the artist in exile.

German culture, at *Stunde Null* (zero hour) after the war, required time to recover and find a new voice. The West German government resurrected DAAD (*Deutscher Akademischer Austauschdienst*; the German Academic Exchange Service) to bring artists from abroad into the insular city of Berlin, to transform it into a cosmopolitan center of the arts. Among American grant recipients were the poets Gregory Corso, Lawrence Ferlinghetti, Emmet Williams, and Dick Higgins, the composer Morton Feldman, and a great many visual artists.

In Berlin Allan Kaprow, as part of a Fluxus activity, erected *A Sweet Wall* in 1970 with the help of the American concrete poet Dick Higgins and the German painter K. H. Hödicke. This wall enclosed nothing and separated no one, a symbol of paradox. During the 1960s and 1970s many American artists associated with Fluxus worked in Germany which, like the rest of Western Europe, was much more supportive of Fluxus activities than the United States. Other DAAD grant recipients were Duane Hanson, who assembled hyper realistic polyester American types; Charles Simmonds, who created his "Little People" out of a personal, mythical archaeology, and who installed some of his tiny environments in buildings in Kreutzberg; and Colette, who transformed her innovative and intimate living environments into sets and costumes for the Berlin Opera.

Between 1970 and 1990 many additional American artists participated in the Berlin Artists' Program, including Carl Andre, James Lee Byars, Peter Campus, Terry Fox, Newton and Helen Harrison, Ann McCoy, Dennis Oppenheim, Nam June Paik, Kenneth Snelson, and Lawrence Weiner.

George Rickey (b. 1907) accepted a stipend from DAAD in 1968. Rickey was born in Indiana, grew up in Scotland, read history at Oxford, studied painting in Paris with Lhote, Léger, and Ozenfant and design at the new Bauhaus in Chicago. He began to work as a sculptor in 1950 and has created moving sculptural forms of a great many typologies. Like Calder's mobiles they respond to the motions of nature, but they are made of bright steel and are engineered with mathematical precision. Rickey is both artist and engineer, the artist as *homo faber* whose work embodies random order. He is also a student, historian, and collector of Constructivist art and has added significantly to that tradition. In 1964 (when this writer was Commissioner for American Art for Dokumenta III), Rickey was invited to install a 35-foot-high sculpture composed of two tapering stainless steel blades which would oscillate in parallel rhythms in front of the Fridericianum in Kassel. This work confirmed his reputation in Germany, which had been established earlier by important exhibitions in Berlin, Düsseldorf, and Hamburg. Over a pe-

riod of some twenty years, George Rickey has spent half of every year in Berlin, enjoying its "intelligence, attraction and energy." He has received many commissions for permanent installations in Germany. Among them is the precisely equipped *Four Squares in a Square* (1969), placed in front of Mies van der Rohe's Nationalgalerie in Berlin, which it complements perfectly in its classical sense of balanced symmetry.

Edward Kienholz (b. 1927) has also spent at least half of every year in Berlin since his DAAD stipend in 1973. His *tableaux vivants* are biting critiques of contemporary society, its mores and politics, and raise disturbing existential questions. Kienholz was one of the few American artists whose work commented on the disgrace of the Vietnam war; his narratives of reproach were never popular in New York. In Berlin he produced his series of *Volksempfängers*, the cheap old radio receivers of the Nazi period used to hear broadcasts of Fascist propaganda. Now, instead of emitting the voices of Hitler or Goebbels, they resound with Wagner's *Ring of the Nibelung*. The *Volksempfängers* were interventions by a foreigner into German history. Taken out of their original context in the German home, they were exhibited in Berlin's Nationalgalerie in 1977, producing both controversy and acclaim. By using history's relics as his objects, Kienholz reflects on history, but he also comments on the media in general and their control of our lives.

Edward Kienholz, coming from a small town in the provinces in the American northwest – a carpenter, a *bricoleur*, largely self-taught as an artist, a person never fully recognized in his own country – found acclaim only abroad. His life and work embody much of the enduring impetus that has directed many American artists to search in European and Asian culture for aesthetic resonances as well as a deeper sense of artistic tradition and its ramifications.

12 THE IMPACT FROM ABROAD

FOREIGN GUESTS AND VISITORS

Marcel Duchamp's *Nude Descending a Staircase, No. 2* found its first private home in an expansive brown-shingle house in Berkeley.* Frederick C. Torrey, a San Francisco antique and print dealer, had seen it at the Armory Show in New York and purchased it in May 1913 for $324.[1] When Torrey visited Duchamp in Paris soon after, the artist made him a gift of a preparatory sketch. The canvas, Duchamp's chef d'oeuvre up to that time, was the work at the Armory that defined modernist painting. Torrey displayed it in his Berkeley home near the University of California campus, where it served as a background for debates by the Berkeley faculty, often invited for Sunday discussion sessions. A man with a profound understanding of contemporary art, Torrey lectured on new developments in European art in general and on Duchamp and Picabia in particular. Only recently have historians begun to acknowledge his influential role in the story of California modernism. He "should now be remembered for the valiant battle he waged – in the face of resistance and adversity – to foster a better understanding and acceptance of modern art on the West Coast."[2]

Torrey was primarily a businessman, however: in 1919, when the painting had trebled in value, he sold it to Walter Arensberg in New York. Two years later *Nude Descending a Staircase, No. 2* returned to California with other major works by Duchamp, Constantin Brancusi, and other modern masters, when the Arensbergs moved to Hollywood. There they made their important collection of mainly European modern art accessible to many visitors until the early 1950s, when it entered the Philadelphia Museum of Art.

Through the Arensbergs (and other former New York friends such as Beatrice Wood), Duchamp established a California connection. A frequent guest of the Arensbergs in Hollywood, he also visited San Francisco, taking part in 1949 in the historic "Western Round Table on Modern Art." This symposium, organized

* This essay originally appeared in Paul Karlstrom (ed.), *On the Edge of America: California Modernist Art.* Copyright © 1996 The Regents of the University of California. Reprinted by permission of the University of California Press, Berkeley.

FIGURE 43. Photograph of Marcel Duchamp's *Nude Descending a Staircase, No. 2,* hanging in Torrey's home, Berkeley, ca. 1913. Courtesy The Oakland Museum, Oakland, California.

by Douglas MacAgy, the perspicacious director of the San Francisco Art Institute, brought together some of the leading thinkers and makers of modern art: Gregory Bateson, George Boas, Kenneth Burke, Alfred Frankenstein, Robert Goldwater, Darius Milhaud, Andrew Ritchie, and Frank Lloyd Wright, in addition to Duchamp.

This essay describes how international (primarily European) modern art made its way to California: the forms it took, the conduits, and the most significant responses. In other words, what influences were available to interested California artists, and how did they incorporate them into their work? In the history of American art, the Armory Show is generally cited as modernism's "wake-up call." Although the Armory Show itself did not travel west of Chicago, San Francisco organized a much larger, if less radical, exhibition of modern art: the Panama-

FIGURE 44. Photograph of Walter and Louise Arensberg with Marcel Duchamp, ca. 1936. Photo: Beatrice Wood. Archives of American Art, Smithsonian Institution.

Pacific International Exposition of 1915 displayed no fewer than 11,400 works in Bernard Maybeck's resplendent Palace of Fine Arts.[3] Although most of the work was conservative and *retardataire*, there was a sampling of paintings by the impressionists and the Nabis; a group of works by Edvard Munch; and, surprisingly, a section of forty-nine futurist paintings sent from Italy. Because the futurists insisted on showing all together, their works were not exhibited at the armory in New York. Instead, they made their American debut in San Francisco.

The Bay Area painter Gottardo Piazzoni said of futurism: "I have been associated with the movement since its beginnings and am acquainted and in correspondence with the man [*sic*] who started it in Italy"[4]– a truly amazing statement from an artist whose work is characterized by muted tonalism. Piazzoni, who was born in Switzerland, came to California in 1886 and studied at the California Institute of Design; but he returned to Europe, studying in Paris, before settling in San Francisco. His large expansive landscapes in the former San Francisco Public Library (George Kelham, architect, 1916) are the essence of calm, in total contrast to the dynamic explosions of the futurist painters.

The Americans Ralph Stackpole and Otis Oldfield had also gone to study in Paris, where they remained for some time during the early part of the century. Like many of their countrymen, both artists came under the influence of the

modernist trends they encountered there. The large decorative sculptures Stackpole carved for the 1939 World's Fair at Treasure Island and for the San Francisco Stock Exchange were stylized figures, owing a good deal to the cubism of André Lhôte. Paris-born Lucien Labaudt, who settled in San Francisco in 1911, had also been influenced by Lhôte, with whom he remained in close contact. Lhôte and Labaudt collaborated in the exhibition *Ecole de Paris*, mounted at the East West Gallery of Fine Arts in San Francisco in 1928, which included paintings by Picasso, Georges Braque, Georges Rouault, and André Derain, among others, and thus made works by contemporary French masters accessible to the Bay Area audience. In 1930, when Matisse stopped in San Francisco on his way to Tahiti, Labaudt was host to him. The Lucien Labaudt papers in the Archives of American Art indicate a "serious professional exchange between Paris and the American West Coast."[5] With his wife, Marcelle, Lucien Labaudt established the Labaudt Gallery, important for young and emerging artists like Richard Diebenkorn, who had his first solo exhibition there. The "flexibility" of the creative situation in California is suggested by Laubaudt's, Oldfield's, and Stackpole's work in both the modernist and social realist idioms, as in their contribution to the Coit Tower mural of 1930.

Somewhat related to Stackpole's work in style, but typically more exotic in subject matter, was the work of Maurice Sterne. Sterne, born in Latvia and brought to New York by his mother, had studied at the National Academy of Design. He went to live in Italy and Greece and traveled to Egypt and Bali, returning to the United States during World War I. He settled in New Mexico, where he was married for a time to the legendary Mabel Dodge, who served as the catalyst for the colorful artists' and writers' colony in Taos. In 1933 he was the first American artist to have a solo show at the Museum of Modern Art in New York. Subsequently he came to San Francisco to teach at the California School of Fine Arts. Sterne brought a cosmopolitan spirit as well as a modern idiom to the school. As Hassel Smith, a student there at the time, recalled: "Sterne's approach to drawing from the model (nature) was a revelation. I have no hesitation to saying that to whatever extent my intellect has been engaged in the joys and mysteries of transferring visual observations in three dimensions into meaningful two dimensional marks and shapes I owe to Sterne."[6]

William Clapp, who was born in Montreal, had gone to Paris to study at the Académie Julian as well as the Académie de la Grande Chaumière before settling in Oakland in 1917. He became a member of the Society of Six, whose small colorful paintings were open to a wide range of influences, from French and American impressionism to the visual abstractions of Kandinsky. In 1918 Clapp, who was probably the most conservative member of the Six, was appointed curator and later director of the Oakland Art Gallery, a city museum housed in the Municipal Auditorium; when it moved to its present quarters, it became the Oakland Museum. It was without a doubt the most adventurous exhibition space in the Bay Area until Grace McCann Morley founded the San Francisco Museum of Art in 1935.

In his enthusiasm for the avant-garde, Clapp was receptive to Galka Scheyer. Scheyer, born in Braunschweig, had come in 1924 to New York, where she had little success in promoting the work of four German modernists – Wassily Kan-

dinsky, Alexeij Jawlensky, Lyonel Feininger, and Paul Klee – whom she designated the Blue Four. In 1925 she traveled to the West Coast, where she encountered a more favorable response to the German artists. Ironically, none of them was actually German: Kandinsky and Jawlensky were Russian, Klee was Swiss, and Feininger American-born – but they worked in Germany. Scheyer had become an apostle of modern art during World War I after seeing Jawlensky's work and falling in love with the artist. After visiting Feininger, Klee, and Kandinsky at the Bauhaus in Weimar, she decided to bring the work of all four artists to the New World. She came to the Bay Area hoping to obtain a lecturer's position at the University of California, but Eugen Neuhaus, who headed the art department, was no friend of modern art. By 1927, however, she seems to have been a highly successful teacher at the Anna Head School, which was then in Berkeley. She was befriended by Clapp, who appointed her the European representative of the Oakland Art Gallery. The first Blue Four exhibition opened in Oakland in 1926 and went from there to Stanford. Galka Scheyer wrote her artists in Germany that they were being shown "in the most distinguished university in California. . . . Stanford University is worth its weight in gold."[7] But apparently she had miscalculated, for she sold one of Jawlensky's pictures for only twenty-five dollars.

In 1929 the Oakland Art Gallery organized an exhibition including works by Kandinsky that was circulated by the Western Association of Art Museums. With these exhibitions Scheyer offered an ambitious (and expensive) lecture series, titled "From Prehistoric Art to the Blue Four." She would show some five hundred lantern slides, charging those who attended $250 for the series. The fee for the exhibition to the participating museums was at times as low as twenty dollars. When expenses in one instance ran higher than expected, Scheyer suggested a small additional charge, but Clapp explained to her, "If one makes changes in arrangements either financial or otherwise, it irritates those who plan an exhibition. It costs money and entails labor to make changes and if it happens more than once, an art gallery director is apt to become disgusted and to avoid in the future all such exhibitions."[8]

Another exhibition presented by the Oakland Art Gallery in 1929 was entitled *European Modernists*. It included, not the work of French painters, as it surely would have on the East Coast, but that of Emil Nolde, Carl Hofer, Erich Heckel, Karl Schmidt-Rottluff, Max Pechstein, Oskar Kokoschka, and Feininger. While modernist art both in southern California and on the East Coast looked almost entirely to France, that of northern California, especially the East Bay, looked to Germany.

The largest exhibition of works by the Blue Four opened at the California Palace of the Legion of Honor in the spring of 1931 and then moved to Oakland, where additional works were included in the show. It attracted considerable attention and caused a great deal of controversy. Among those inspired by it was Howard Putzel, who was particularly keen on Feininger's work, discerning his sensitized fusion of the human figure into a precisely structured abstract design.[9] It is evident that Putzel recognized the significance of formal qualities in works of contemporary art. A few years later, in 1934, he organized the first Miró exhibition on the West Coast in San Francisco's East West Gallery of Fine Arts, followed by other surrealist exhibitions at the Paul Elder Gallery on Post Street.

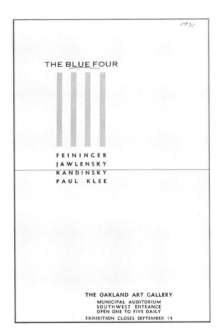

1931

THE BLUE FOUR

FEININGER
JAWLENSKY
KANDINSKY
PAUL KLEE

THE OAKLAND ART GALLERY
MUNICIPAL AUDITORIUM
SOUTHWEST ENTRANCE
OPEN ONE TO FIVE DAILY
EXHIBITION CLOSES SEPTEMBER 14

FIGURE 45. Catalogue Cover, *The Blue Four*, Oakland Art Gallery, 1931. Courtesy The Paul C. Mills Archives of California Art, Oakland Museum, Oakland, California.

In 1935 Putzel moved to Los Angeles, became a major critic, a promoter of modern art, a dealer in it, and eventually the chief advisor to Peggy Guggenheim's Art of This Century gallery. In New York, he also became a passionate advocate of abstract expressionism; it was he who first brought Jackson Pollock to Peggy Guggenheim's attention. Galka Scheyer, meanwhile, had gone to Mexico, where she established contact with the painters there, curated an exhibition of works by Carlos Merida, and became friends with Diego Rivera and Rufino Tamayo. Rivera, his own work of social and political significance notwithstanding, indicated his full understanding of Kandinsky's works when he wrote:

> The painting of Kandinsky is not an image of life – it is life itself. If there is a painter who merits the name creator, that painter is Wassily Kandinsky. He organizes his matter as the matter of the Universe was organized in order that the Universe might exist. I know nothing more true and nothing more beautiful.[10]

Filled with admiration, Rivera arranged for a Blue Four exhibition at the Biblioteca Nacional in Mexico City in 1931. For some time the great muralist had wanted to come to the United States to see the feats of engineering – the skyscrapers, highways, and bridges. He was known north of the border as the master artist, able to combine progressive politics with a significant modern style of mural painting, accessible to the general public. However radical his politics, his first project in the United States was a large fresco in the new building of the San Francisco Stock Exchange, designed by Timothy Pflueger. At first Rivera, a member of the Communist Party in Mexico, was refused entry by the State Department, which feared to admit radicals. When he was finally allowed to enter the country, Maynard Dixon, the well-known painter of western landscapes as well as social realist urban scenes, told the press:

The stock exchange could look the world over without finding a man more inappropriate for the part than Rivera. He is a professed Communist and has publicly caricatured American financial institutions. I believe he is the greatest living artist in the world and we would do well to have an example of his work in a public building in S.F. But he is not the man for the Stock Exchange.[11]

When the Mexican painter and his wife, Frida Kahlo, arrived in San Francisco, they were feted and lionized. In 1930 he was given a one-man show at the California Palace of the Legion of Honor. The exhibition traveled to Los Angeles, where his work was also exhibited at the Dalzell-Hatfield Gallery and at Jake Zeitlin's famous bookstore. In fact, Rivera exhibitions took place throughout the state, and the artist was offered substantial lecture fees at the University of California at Berkeley as well as at Mills College. Living in Ralph Stackpole's studio, he completed the mural for the stairwell of the Stock Exchange Lunch Club, which occupies the tenth and eleventh floors of the Stock Exchange Tower. Almost thirty feet high, it represents the productive resources of California, its agricultural and industrial workers, its ranchers and miners and gold prospectors, and a large allegorical figure of California, modeled after the famed tennis champion Helen Wills Moody.

Rivera's next mural was the fresco at the California School of Fine Arts (now the San Francisco Art Institute). Here the artist subdivided the painting into cells, separated by a scaffolding – the symbol of architectural construction. On the bottom we see Pflueger, the architect of the Stock Exchange; Arthur Brown, Jr., who had designed the school; and William Gerstle, the donor of Rivera's $1,500 fee for the fresco. Engineers, mechanics, painters, and masons are seen at work, with a gigantic figure of a worker gazing out at the apex. The artist portrayed himself sitting on a plank in the very center, a feature some found objectionable. The Seattle painter Kenneth Callahan complained about the artist's "flat rear . . . hanging over the scaffolding in the center. Many San Franciscans chose to see in this gesture a direct insult, premeditated, as indeed it appears to be. If it is a joke, it is a rather amusing one, but in bad taste."[12]

Neither Rivera's rear nor his politics but rather his conviction that modern art had to be abstract prompted Douglas MacAgy, the brilliant, forward-looking, but autocratic director of the California School of Fine Arts, to find the mural too representational and too conservative. But that was fifteen years later. Back in the 1930s Rivera's work had a great impact on the paintings of the twenty-five artists who decorated the newly built Coit Tower, the "simple fluted shaft" designed by Arthur Brown's firm for the top of Telegraph Hill. Rivera became the role model, both stylistically and ideologically. It was he, together with his great colleagues José Clemente Orozco and David Alfaro Siqueiros, who inspired the Philadelphia painter George Biddle to persuade his former Harvard classmate and friend Franklin Delano Roosevelt to establish the Public Works of Art Project (PWAP) that was the predecessor of the Works Progress Administration (WPA). Biddle wrote to the president that the younger artists of America, like the Mexican muralists, were conscious of the

social revolution that our country and civilization are going through and . . . would be eager to express these ideals in a permanent art form if they were given

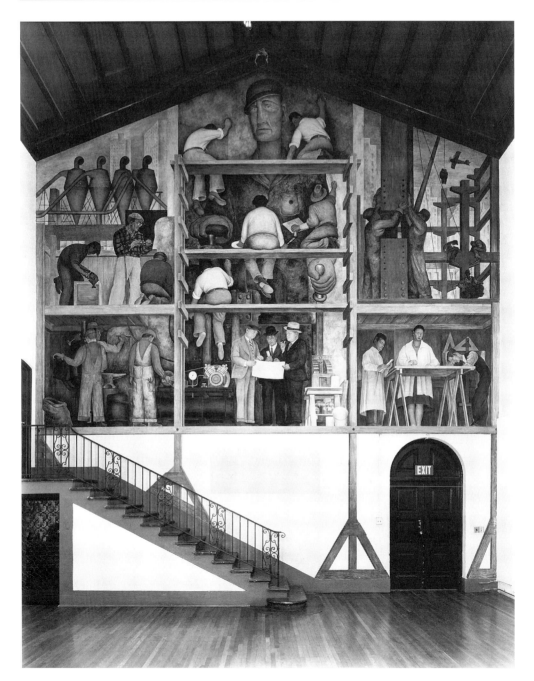

FIGURE 46. Diego Rivera, *The Making of a Fresco Showing the Building of a City*, 1931, true fresco, 22'7" × 29'9", San Francisco Art Institute.

the government's cooperation. They would be contributing to and expressing in living monuments the social ideals that you are struggling to achieve.[13]

The PWAP was put in place throughout the country. In San Francisco the Coit Tower murals were its first and most important achievement. Victor Arnautoff, the project director, had worked with Rivera in Mexico City and Cuer-

navaca in 1930 and 1931. Other Californians, including Clifford Wight and Bernard Zakheim, had also worked with Rivera on various walls. In Coit Tower they followed the old Italian tradition of *fresco buono* as interpreted by Rivera and his colleagues. Arnautoff's *Metropolitan Life* is closely related in its general composition to Rivera's murals at Mexico's National Palace, while Stackpole's *Industries of California* (1934) resembles the great murals Rivera had completed at the Detroit Institute of Arts a year earlier. The physical types of the striking workers in *California Industrial Scenes*, by John Langley Howard, also have their source in Rivera's paintings. The bold modeling of figures and the chromatic scheme of subdued earth colors is clearly indebted to Rivera's work. Finally, the frescoes in the tower embody Rivera's belief that the new mural art could help in the revolutionary struggle to create a more equitable social and political system.

In 1934, when Diego Rivera's mural at Rockefeller Center in New York was destroyed, primarily because of objections to the inclusion of a portrait of Lenin, the newly formed San Francisco Artists' and Writers' Union joined a nationwide protest against this act of political vandalism. During the Pacific Maritime Strike, which occurred later that year, the Hearst press in San Francisco started a red-baiting campaign against the Coit Tower murals, which indeed included radical passages: Arnautoff's newsstands displayed the *Masses* and the *Daily Worker* but no *San Francisco Chronicle*; Bernard Zakheim's *Library* includes a copy of *Das Kapital*; and, most irritating to conservatives, a hammer and sickle appeared next to the National Recovery Administration's blue eagle in the mural by Clifford Wight.

An extended battle ensued, and eventually the Recreation and Park Department and the Art Commission locked up Coit Tower, calling the works of the muralists a "typical Rivera stunt." The most offensive element, Wight's Soviet emblem and its accompanying slogan, "Workers of the World Unite," were over-painted, and eventually the tower reopened.

By 1930 the influence of the Mexican muralists was firmly established in California. Even before Rivera was commissioned to paint his mural in the Stock Exchange Tower, Orozco had gone to Los Angeles to execute the dramatic and powerful *Prometheus* fresco (1930) at Pomona College. Orozco's monumental work in Frary Hall on that campus came to inspire Rico Lebrun to create his mural *Genesis* (1966) in the loggia of the same building. In 1952 Siqueiros, the third member of Los Tres Grandes, completed a large outdoor mural on Olvera Street in the center of the old Mexican section of Los Angeles. The mural, *Tropical America,* represents a man crucified on a double cross with the U.S. eagle perched on top.[14] Soon disparaged as "Communist propaganda," it was covered over with whitewash within a few years and began to deteriorate. The Friends of Mexico Foundation, working with the Getty Conservation Institute, is now trying to preserve it, even if it cannot be restored to its original state.

The political and social message of the Mexican muralists seems to have had less impact in southern California than in the labor-oriented and unionized city of San Francisco. The American murals that sprang up in southern California were

typified by the work of Millard Sheets, who, after his original contact with Si-queiros, turned toward pleasing ornamental wall decorations.

Because of the Mexican mural movement, California modernism was split along ideological lines. During the debate about the Coit Tower murals in San Francisco, Glenn Wessels voiced the opposition's view. He praised the communal spirit of the enterprise, but also hoped that the public mural artist would remain "upon the plane of high generalities with which the majority can agree, unless his purpose is dissension."[15] In other words, art should stay aloof in matters of politics.

Born in Capetown, South Africa, Wessels had also studied with André Lhôte in Paris and had gone to Munich in the late 1920s to enroll in the school founded by Hans Hofmann. Hofmann had lived and worked in Paris before World War I and participated in the artistic revolution there. He was well acquainted with Matisse as well as Picasso, Braque, Sonia Delaunay, and Fernand Léger. But coming from Munich, to which he returned when the war broke out, he was equally aware of the avant-garde movements in Germany, especially the Blue Rider group led by Kandinsky, who believed in the spiritual quality of art. Hofmann's art school, founded in 1915, may have been the best place to learn the new approaches to painting; it attracted students from all over the world. Louise Nevelson, Alfred Jensen, and Vaclav Vytlačil, as well as Wessels, were among those who came from America. Wessels gave English lessons to Hofmann in exchange for his art classes.

At about the same time, the American painter Worth Ryder was a student at the Royal Bavarian Art Academy in Munich. When he met Hofmann in the summer of 1926 at the Blue Grotto in Capri, where the German painter had taken his summer students, Ryder was impressed with his ideas. Appointed to the faculty at the University of California in 1927, Ryder immediately set himself in opposition to the conservative Eugen Neuhaus. To strengthen his position, he invited Hofmann's student Vytlačil to teach at Berkeley and in 1930 asked Hofmann himself to teach summer school there. Wessels accompanied Hofmann on the boat and train and served as his interpreter; he also translated the original version of Hofmann's textbook on the teaching of modern art, *Creation in Form and Color*. While teaching, Hofmann made some brisk and lively drawings of the Bay Area. He accepted an invitation to return to Berkeley in 1931 to teach, and he also exhibited his paintings and drawings, first on the campus and then at the California Palace of the Legion of Honor in San Francisco. The works in this, his first American show, were very much in the School of Paris style, heavily influenced by Cézanne, Matisse, and Dufy. Only in the mid-1930s did Hofmann again seriously develop his own work as a painter.

Hans Hofmann returned to Germany once more, but, with the political situation there deteriorating, he was glad to accept an appointment to the faculty of the Art Students League in New York in 1932. A year later he started his own school, presiding as a father figure over a generation of abstract expressionist painters.

Rivera and Hofmann had arrived in the Bay Area in the same year, 1930,[16] and both had a profound impact on the art of the region. But there could be no greater contrast than that between the social realists, for whom art was a weapon to

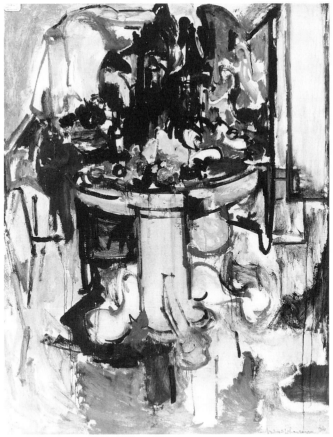

FIGURE 47. Hans Hofmann, *Table with Fruit and Coffeepot*, 1936, oil and casein on plywood, 59⅝ × 47⅝", University Art Museum, Berkeley.

change the social order, and Hofmanns' teaching of art as pure form and vibrant colors interacting on the picture plane. Hofmann changed the teaching of art at Berkeley. Erle Loran, John Haley, and Karl Kasten, all Hofmann's disciples, joined Ryder and Wessels on the faculty. Among those they taught was Sam Francis, who received his master's degree from Berkeley in 1950 before leaving for Paris and becoming famous. Years later, Hofmann gave a significant number of paintings to Berkeley. They are displayed at the University Art Museum,[17] which now has fifty paintings by Hofmann. San Francisco is the site of three major murals by Rivera.

In 1935 the San Francisco Museum of Art opened in the War Memorial Veterans Building. Its primary goal was to present contemporary art and its sources, a task for which its first director, Grace McCann Morley, was eminently suited. Feeling that the city needed to catch up on the early stages of modernism, she presented an exhibition of impressionist and postimpressionist art for the premiere of the new institution. This was followed in rapid succession by the Rivera retrospective and the Blue Four show already mentioned. During the late 1930s, before computers allegedly made things so much easier and quicker, Morley and her small staff organized as many as one hundred shows annually. Of particular importance was a large 1936 exhibition of paintings, sculpture, and graphics by

Matisse, largely borrowed from Michael and Sara Stein, who had recently returned from Paris to the Bay Area, bringing their collection with them. The San Francisco Museum, modeled after New York's Museum of Modern Art, saw itself as the western outpost of the slightly older institution and showed many of MoMA's most consequential exhibitions. Between 1935 and 1940 these included *African and Negro Art; Cubism and Abstract Art; Fantastic Art, Dada, and Surrealism*; and *Picasso: Forty Years of His Art*. Clearly, an active East – West art axis, one that had important ramifications for the development of California art over subsequent decades, had been established.

It is well known that before and during the war, many of the leading European artists – Piet Mondrian, Léger, Jacques Lipchitz, and most of the surrealists – migrated to New York, giving a major impetus to the incipient New York School. But it is less well known that many of the major European artists also came to the Bay Area, primarily because of Alfred Neumeyer, a man of astounding knowledge and cultural breadth. Born in Munich, Neumeyer had studied art history at the University of Munich with Heinrich Wölfflin before becoming Adolph Goldschmidt's student in Berlin and Aby Warburg's in Hamburg. He had received his doctorate from the University of Berlin and had worked at the Cabinet of Engravings in the Kaiser Friedrich Museum. Later he was appointed director of the Press Office of the Berlin museums, where he came in close contact with Germany's modern artists before they were defamed as degenerate. In 1935 he was offered a professorship at Mills College in Oakland. On the recommendation of his erstwhile fellow student Walter Heil, who had recently accepted the directorship of the M.H. de Young Memorial Museum, Neumeyer accepted the offer, becoming the first trained art historian to teach the discipline on the West Coast. The position was greatly reinforced by Walter Horn's appointment to the Berkeley faculty in 1938.

Neumeyer maintained his contact with European artists and intellectuals. In 1937 he invited Walter Gropius, who had just been appointed head of the Graduate School of Design at Harvard University, to teach a course in architecture in the Mills summer session. Gropius had to decline, as did Thomas Mann, then living in Princeton, but the correspondence indicates that Mann considered giving a summer seminar on the Mills College campus in 1938 on humanism in the twentieth century or on art and democracy. Neumeyer built on the reputation Mills had achieved as a center of the humanities: the Russian-born sculptor Alexander Archipenko, who had immigrated to the United States in 1923, taught at the Mills summer session in 1933; his work was exhibited on the campus in 1934. Jules Romains had given a seminar on French culture there in 1936, as did André Maurois in 1941. In 1940, the year Darius Milhaud became professor of music composition, Neumeyer wrote a letter to the New York art dealer Pierre Matisse, suggesting that his father might want to leave France because of the war and consider coming to Mills,[18] but Matisse remained in Nice. As director of the Mills Gallery, a position he assumed a year after his arrival and held for many years, Neumeyer was able to bring in major artists to teach as well as to exhibit their work.

In 1936 Neumeyer organized an exhibition of Van Gogh's etchings. The

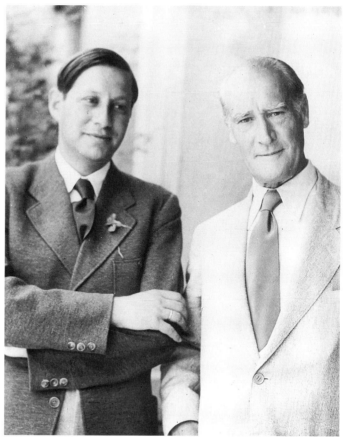

FIGURE 48. Photograph of Alfred Neumeyer and Lionel Feininger at Mills College, Oakland, California, 1936.

same year he offered summer teaching and a show to Feininger. The Bauhaus had been closed in 1933, and Feininger felt increasingly alienated and dispirited in his adopted country. He was glad to return to his native land after a fifty-year absence when the invitation from Mills arrived in his Berlin studio. With his wife, Julia, he sailed to New York and on through the Panama Canal to disembark in San Pedro. In Los Angeles he renewed his acquaintance with Galka Scheyer and Walter Arensberg, who owned some of his work, and then traveled on to Oakland, to teach at Mills. The exhibition of his work, lent mostly by his dealer, Karl Nierendorf, went on to the San Francisco Museum of Art, and some of his works were sold to San Francisco collectors. On his return to Germany, Feininger, who had been one of the country's most renowned artists, was featured in the infamous Nazi *Degenerate Art* exhibition, and 348 of his works were removed from German museums. Clearly his time in Germany had come to an end.

Neumeyer in the meantime had invited Oskar Kokoschka, who had fled to Prague, for the following summer. But when the Austrian painter was unable to come to California, Neumeyer invited Feininger for a second summer session. Feininger later wrote to his friend Alois Schardt, the former museum director, "One day it will be noted that at the age of 65 I arrived in New York Harbor with

two dollars in my pocket and had to start life anew."[19] At Mills a second exhibition was held in his honor that included forty oils and one hundred watercolors. In a lecture at the opening, Neumeyer pointed out that "nothing vague and indefinite exists in these landscapes and seascapes of crystalline form and crystalline light except the undefinable creative musicality of the artist's mind, which reminds us of Redon." The crystal, he declared, is the "symbol of medieval alchemists and mathematicians. The hardest and clearest of all minerals becomes a magic sign in their dream to conquer and explain the divine world. The hardest, the clearest, the highest organized mineral is not by chance the elementary form and symbol of Feininger's art."[20] At the time of the exhibition, Feininger himself cited Caspar David Friedrich's dictum, which he undoubtedly used during his many years of teaching and which has lost none of its relevance: "The painter should not only paint what he sees around him, but also what he sees within himself; but if he sees nothing within himself, he should refrain from painting what he sees around him."[21]

This second Mills exhibition traveled along the West Coast to Seattle, Portland, Santa Barbara, Los Angeles, and San Diego. Feininger was enraptured by San Francisco and its rugged coast, where the remains of shipwrecks in the sea reminded him of his own fantasy seascapes. He said he would love to have remained on the Pacific coast but had to face the challenge of renewing his life as a working artist in New York. He arrived there in September 1937 and experienced almost another twenty years as a productive artist. This career "imperative," going to New York City, confronted virtually all serious artists in California.

In 1938 Alfred Neumeyer organized an exhibition of the work of Karl Schmidt-Rottluff, the important Brücke painter whose work, like Feininger's, was outlawed in Germany. The artist wrote to Neumeyer that an exhibition in America at this time "reinforced his belief that there are still some places in the world with individual and nobler convictions."[22] A year later an exhibition of works by Kokoschka, who was then living in London, and a show of painting and graphics by Josef Albers, then teaching at Black Mountain College, were seen at the Mills College Gallery. Kokoschka presented the gallery with two crayon drawings, while Schmidt-Rottluff donated an early woodcut and the gallery also acquired a fine watercolor by him. A few years earlier two excellent Feininger watercolors had been added to the growing collection on the Mills College campus.

Neumeyer, however, was by no means interested solely in the rescue of German art and artists. He also sought out American artists, approaching those with the highest visibility at the time. He corresponded with Thomas Hart Benton, Grant Wood, Leon Kroll, Eugene Speicher, and Frederic Taubes, asking each whether he might agree to teach summer sessions at Mills. Taubes accepted. Almost forgotten now – he is not listed in the indexes of most books on twentieth-century American art – he was well known at the time, having published eight color reproductions in a single issue of *Life* magazine. Born in Poland, he had studied in Munich and was known primarily for his well-executed and colorful still-life paintings and portraits and for his books on the technique of oil painting. The major occurrence at Mills in the summer of 1939 was not the Taubes exhi-

bition, however, but the presence of the Bennington School of Dance with Martha Graham, Doris Humphrey, Charles Wegman, and Hanya Holm.

The most significant event for art, design, architecture, and art education in California may have been the exhibition *The Bauhaus: How It Worked* in the spring of 1940 at the Mills College Gallery. Circulated by the Museum of Modern Art, it consisted of Bauhaus objects, paintings, graphics, stage design, typography, graphic design, posters, and photography – in other words, the whole range of design of this century's most influential art school. This exhibition was actually only the curtain-raiser for the 1940 summer session, which brought leading faculty from the School of Design established in Chicago by László Moholy-Nagy – it was originally called the New Bauhaus and later became the Institute of Design – to Oakland. Moholy-Nagy arrived with the photographer, theorist, and painter Gyorgy Kepes; the painter Robert Jay Wolff; the weaver Marli Ehrman; the furniture designer Charles Niedringhaus; and the artist, designer, and craftsman James Prestini. This high-powered faculty taught courses in drawing, painting, photography, weaving, paper cutting, metalwork, modeling, and casting, all based on the Bauhaus belief in combining intuition and discipline in work that was meaningful in a technological world.

A large exhibition of work by the visiting faculty that summer comprised twenty-two paintings by Moholy-Nagy, twenty-four paintings and watercolors by Wolff, twenty photographs by Kepes, eleven trays and bowls by Prestini, and a large wall hanging by Ehrman. The classes were extremely successful, attracting both well-established artists like Adaline Kent and art teachers from all over the West Coast. In a letter to Neumeyer, Alice Schoelkopf, supervisor of art for the Oakland Public Schools, expressed her appreciation of the program as an important new experience for the teachers in her district.[23] Indeed, the presence of the New Bauhaus faculty had an indelible impact on the teaching of art and design in the Bay Area: the Institute of Design's philosophy of education became a reality when William Wurster was named dean of architecture at the University of California in 1950. He appointed Jesse Reichek from the institute to create the basic design curriculum along Bauhaus lines, and Reichek, in turn, invited Prestini to return to the East Bay to help restructure architectural training at the university.

A good many years later Sybil Moholy-Nagy recalled in her biography of her husband:

> By the time we arrived at Mills College, Moholy had lost most of his English vocabulary. During the trip he had insisted on speaking only German, which he loved. But even though he had lost his facility of speech, he had regained the spirit of high adventure which had been his most distinguished characteristic as a young instructor. He consented to a schedule of thirty teaching and lecturing hours a week. Together with five of his best teachers he put a group of eighty-three students through an intensified Bauhaus curriculum, including every workshop and every major exercise. Late at night or on the few free Sundays, we would drive into San Francisco. We loved this unusual town, its clean contemporary structure, the golden color of the wild oats on the hillsides and the red bark in the forest. In his painting *Mills #2, 1940* Moholy has translated

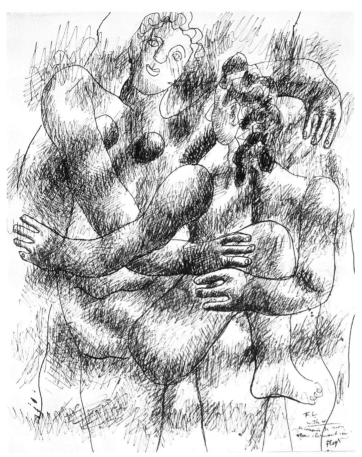

FIGURE 49. Fernand Léger, *The Divers*, 1941, ink on paper, 17⅞ × 15", Mills College Art Gallery, Mills College, Oakland, California.

color-light interplay of the Bay region into a composition of glowing transparency. For the first time since we had left Europe, the atmosphere of a city seemed filled with an enjoyment of non-material values – art, music, theatre – not as demonstrations of wealth and privilege but as group projects of young people and of the community. The museums, co-operative units, studios, and schools offered a hospitality of the spirit that had been unknown to us in America. "One day I'll come back," Moholy said as we drove over the Bay bridge for the last time. "One day I'll have $10,000 in the bank and I'll spend two years in San Francisco."[24]

When Moholy was asked, however, to return to Mills the following year, he declined, wanting to identify his school with Chicago. He recommended Frank Lloyd Wright, who, predictably, was not available. Amédée Ozenfant was seriously considered until Léger, who had come to America in 1940, expressed an interest in coming to Mills – his fourth trip to America. He loved America's engineering feats, called New York "the greatest spectacle on earth," and was captivated by Harlem jazz. To see the country, he took the bus from Manhattan to Oakland. The United States, he said in 1949, "is not a country . . . it's a world . . . In America you are confronted with a power in movement, with a force in reserve without end. An unbelievable vitality – a perpetual movement. One has the im-

pression that there is too much of everything."[25] At Mills he taught summer classes but found his own greatest inspiration in the swimmers at the college's pool. He had been working on his *Divers* series for some time but now painted on with greater energy, turning toward a more definite modeling of the body. He wrote that he was

> struck by the intensity of movement. It's what I've tried to express in painting.
> . . . In America I painted in a much more realistic manner than before. I tried
> to translate the character of the human body evolving in space without any
> point of contact with the ground. I achieved it by studying the movement of
> swimmers diving into the water from very high.[26]

Léger made a number of interesting sketches and preliminary drawing during his stay at Mills, including a fine ink study he gave to the gallery, inscribing it, "Mills '41 en souvenir de mon séjour charmant ici. FLéger." He completed the final version on his return to New York, feeling the impact of Times Square. "I was struck," he wrote, "by the new advertisements flooding all over Broadway. You talk to someone and all of a sudden he turns blue. The color fades – another one comes and turns him red and yellow."[27]

An exhibition of Léger's work was installed in the Mills College Gallery and traveled to the San Francisco Museum of Art. On July 21, 1941, he gave a lecture, "L'Origine de l'Art Moderne," with ninety-four people in attendance. He expressed an interest in a permanent teaching position at Mills or, since there was no opening there, elsewhere in the country. Neumeyer wrote to university art departments and art schools from Seattle to Poughkeepsie on his behalf, but there was no opening anywhere for one of this century's greatest artists. A letter from the chairman of the art department at the University of Illinois is typical of the responses Neumeyer received:

> I think I ought to say, confidentially, that our general University Faculty and
> the townspeople are so conservative in their point of view in art that I am afraid
> a meeting point for sympathetic contacts between them and the artist would
> be almost impossible to establish. I dare say that this situation is not a new one
> to you but seems so widely prevalent among the general faculty in our colleges
> and universities.[28]

During World War II and the immediate postwar period, artists abroad were isolated from those in this country. The energy in vanguard activity here thus centered on the new wave of American artists. Major exhibitions of abstract expressionism were installed at the California Palace of the Legion of Honor, where Jermayne MacAgy was acting director, and at Grace McCann Morley's San Francisco Museum of Art. With the appointment of Clyfford Still to the faculty of the California School of Fine Arts, both the leading schools in the city and the Art Department at Berkeley were teaching abstract expressionist painting, although Still's and Hofmann's disciples worked in a very different manner.

Not until 1950 did a major European artist once more appear to teach in the Bay Area. Max Beckmann, who had gone to St. Louis from his self-imposed exile in Amsterdam in 1947 and had moved to New York in 1949, accepted Neumeyer's invitation to teach the Mills summer session in 1950. A sizable exhibition of his

FIGURE 50. Max Beckmann, *San Francisco*, 1950, oil on canvas, 40¾ × 56", Hessisches Landesmuseum, Darmstadt.

work from the collection of Stephan Lackner, now living in Santa Barbara, was held while he was on his way to Oakland.

In his diaries of that summer Beckmann wrote as much about his depression and the new war that had just broken out in Korea as about his trip to California. He enjoyed spending evenings with Neumeyer, Milhaud, and Alfred Frankenstein, the art critic for the *San Francisco Chronicle*, as well as taking his breakfasts at an American drugstore near the campus. A heart condition made critiques in his classes difficult for him, but he was able to work.

Beckmann made sketches for three paintings while at Mills: *San Francisco, West Park*, and *Mill in the Eucalyptus Grove*, the latter two of the campus. The pictures were completed after his return to his New York studio. Painted from a vantage point high above the Golden Gate Bridge, *San Francisco* is a brilliantly colored dynamic painting with the curved arrow of Doyle Drive rushing past the Palace of Fine Arts toward the heart of the city, which appears to be vibrating. A crescent moon and a sunset appear in the eastern sky in this painting, which combines scenes of the city from different viewpoints. In the immediate foreground he has placed three black crosses, apparently stuck into the black earth of the curving ground. On the right above his signature is the fragment of a ladder,[29] a symbol he used frequently. Beckmann completed his greatest triptych, *Argonauts*, after his return to New York, where he died in December 1950.

Among the students who registered for the Mills summer session that year was Nathan Oliveira. Oliveira's solitary figures, silhouetted against an unlimited space

that is activated by the artist's vigorous brush, owe a particular debt to the expressionist tradition. For Oliveira,

> Beckmann symbolized the old world. Tradition, yes, but on the other hand renewing tradition – in the sense that the past was not being thrown away. It is as if he were saying, "This is it, this tradition, but I'm now dealing with my own reality." Beckmann starts out with a reality which is very fundamental. Over a period of years and through many periods of transition, you see his work become more and more personalized, and the image becomes very particular. I picked that up and that's pretty much what I based my own work on.[30]

Many California artists during the first half of this century, like artists elsewhere, decided to complete their training in Paris. What concerns us here, however, is the presence of European and Mexican art and artists and their impact on the art of California. It is safe to assume that the work of Duchamp and that of the futurists and expressionists elicited a response from California artists. Hans Hofmann at Berkeley and other major European artists like Feininger, Léger, and Beckmann at Mills College produced indelible, though not easily measurable, effects on California artists. And the brief stay of Moholy-Nagy and other members of the New Bauhaus faculty altered education and the praxis of the crafts, design, and architecture in the Golden State. Bay Area figurative painting is often seen as an indigenous development of the 1950s, but it was in fact part of an international movement to extend the emotional range and content of abstraction. As I have already noted, Nathan Oliveira acknowledges a direct debt to Max Beckmann. The two California artists who have achieved the greatest acclaim – Richard Diebenkorn and Sam Francis – were, though originally trained in the Bay Area, indebted to the pictorial condensation of sensations in the work of Henri Matisse. And the presence of Los Tres Grandes in California was continued in the widespread mural production in this state. These influences have fostered the pluralism of form and the multi-ethnic origins of current artistic production in the San Francisco Bay Area and throughout California.

13 MODERNISM COMES TO CHICAGO

THE INSTITUTE OF DESIGN

The fact that the New Bauhaus took shape in Chicago was no accident; the city has a long and distinguished history of modern architecture.* In Chicago the development of the skyscraper had its roots. There, in the 1880s and 1890s, the firms of Le Baron Jenney, Burnham and Root, and Adler & Sullivan formulated this most significant building type of the industrial era.

With few interruptions Chicago has continued in the forefront of avant-garde architecture. Mies van der Rohe changed the face of the city with the elegant purity of his buildings. So did his followers, such as Schipporeit & Heinrich with their North Point Tower on the shore of Lake Michigan, who brought Mies's prophetic designs of the 1910s for a curved glass skyscraper to its realization in 1969. This tradition also animates the work of Helmut Jahn, who designed the State of Illinois Center – an immense public space with a great, rounded facade and an atrium that rises seventeen stories to a huge circular skylight.

In 1897 an Arts and Crafts Society, based on the model of the pioneering London institution of Robert Morris and Walter Crane, was organized in Chicago. This actually occurred ten years earlier than the foundation of the comparable German Werkbund, for which Walter Gropius (1883–1969) designed his first pivotal building long before he established the Bauhaus. Born and bred in the Industrial Revolution, Chicago also became the center for the production of farm machinery as well as meat packing and mail-order marketing. Surrounded by its gigantic steel mills, the Prairie City saw the potential of a new technology and its effect on the physical environment.

Frank Lloyd Wright himself acknowledged the potential of the machine for the future of architecture at an early point. In 1901 he delivered a lecture titled "The Art and Craft of the Machine" at Jane Addams's Hull House in Chicago. Wright's work at the time still owed a great deal to the William Morris tradition of handwork, especially the interiors of his prairie houses. Yet Wright spoke of a

* This essay originally appeared in *Art in Chicago, 1945–1995* copyright© 1996 by the Museum of Contemporary Art, Chicago. Reprinted by permission of the publisher.

"glorious future" for the architecture of the machine at a point that it would no longer be used to imitate handwork, but rather be permitted to follow its own laws to create beautiful, strong, and clean surfaces. He also asserted that the machine, the symbol of technology, was the great forerunner of democracy because it liberated the individual.[1] Wright, going far beyond his major European contemporaries (such as H.P. Berlage, Henry van de Velde, Hector Guimard, and August Endell), proposed a machine aesthetic, later known as Functionalism, at the very beginning of the century. In Chicago technical exigencies were accepted as both necessary and desirable components of the new century.

When in 1882 the Art Institute of Chicago (AIC) was built adjoining a railroad track (which it now crosses), it was founded primarily as a school and only secondarily as a museum. The museum, however, housed one of the truly great collections of modern art, with some of the finest holdings in French Impressionist and post-Impressionist paintings, and early in the century the school had as students such artists as Georgia O'Keeffe and Mark Tobey. It also offered courses in the commercial arts and design to instruct young men (and a few women) on how to make useful contributions in a growing industrial society. In keeping with its original mandate, the Art Institute opened a special program for the industrial arts in the late 1920s. This program was supported by the Association of Arts and Industries (AAI), founded in 1933 and dedicated to "American production of original creative work of modern character." The small department at the AIC, labeled "School for Industrial Art," was under the direction of Alfonso Ianelli, who was at times, it seems, its sole faculty member.

Ianelli, a highly gifted sculptor and designer, had been responsible for the remarkable advanced sculptural decoration of Wright's magnificent but short-lived Midway Gardens complex, located in Chicago. In the mid-1920s, Ianelli went to Europe to study art and design schools. He visited the Bauhaus in 1924, where he met with Adolf Meyer, Gropius's partner on their architectural commissions. After Ianelli returned to the Art Institute in 1927, the Association passed a resolution to the effect that "the hope of art expression lies in the modern movement."[2] It is likely that "modern movement" meant the type of slick, modernistic design conspicuous a few years later in the large Century of Progress Exposition held in Chicago in 1933–34, to which the AAI gave its full support. During the depth of the Great Depression, this impressive world's fair, connoting a sense of order and authority, spread along 3½ miles of the Lake Michigan shoreline. Here a capitalist industry proclaimed the promise of better living through modern technology.

In 1935 Marshal Field's family offered the department store proprietor's large old house on Prairie Avenue to the Association of Arts and Industries, which severed its connection to the Art Institute of Chicago. When Ianelli resigned in 1937, Norma K. Stahle, the executive director of the AAI, wrote to Walter Gropius in Cambridge, inviting him to take over the new school that was planned for the premises. Gropius, who had just accepted a professorship at Harvard, immediately recommended his old friend and former Bauhaus associate László Moholy-Nagy (1895–1946) for the position. Moholy, then in London, received by telegram Stahle's offer of the directorship of the new school, which, she wrote, would function along the lines of the Bauhaus.[3] Invited to come to Chicago for an

interview in July, Moholy accepted the position of director of the "New Bauhaus–American School of Design in Chicago."

Circumstances favored Moholy and this experiment. John Dewey (1859–1952) had come to the University of Chicago in 1894, to chair the departments of philosophy and psychology, and two years later he established the Laboratory School there. This school emphasized the importance of direct, hands-on manual training and experimentation, and its at-times unexpected results. Dewey located aesthetics in everyday life and believed the artist to be an integral part of a social situation: like the philosopher, the artist has an impact on life and changes it. Furthermore, Dewey insisted that any distinction between the fine and useful arts is absurd, and that creative forces can be awakened in every human being.

Dewey's philosophy established precepts not very different from the tenets of the Bauhaus. In fact, direct news of the German Bauhaus had already come to Chicago via Helmut von Erffa, a former Bauhaus student who in 1927 gave two lectures there – "The Weimar School of Modern Art," and "Constructive Theory and Modern Art." When the philosopher Charles Morris, who taught both at the University of Chicago and the New Bauhaus, first introduced Dewey to Moholy's educational concepts, the philosopher was much impressed and eventually joined a group of patrons of the School of Design.

In 1931, the Association of Arts and Industries sponsored a lecture by Frank Lloyd Wright entitled "Glass Houses," which once again gave impetus to modern architecture and design. Also in 1931 the Arts Club of Chicago, an organization that had exhibited vanguard art continuously since its founding in 1916, organized the exhibition *The New Typography,* which included work by Moholy. In that same year a small exhibition of Bauhaus material was shown at the Wrigley Building in Chicago.

The year 1932 also saw innovations. Moholy's book *Von Material zu Architektur,* translated into English as *The New Vision,* became available. In this pivotal book Moholy first outlined the educational principles of the Bauhaus. In the same year the young critic James Johnson Sweeney, who had been writing about modern art for the *Chicago Daily News,* directed an exhibition at the University of Chicago, *Plastic Redirections in 20th Century Painting,* at the Renaissance Society at the University of Chicago. The first exhibition of its kind in America, it included works by Jean Arp, Constantin Brancusi, Alexander Calder, Juan Gris, Jean Hélion, Fernand Léger, Joan Miró, Piet Mondrian and Pablo Picasso.[4] Also in 1932, the Museum of Modern Art of New York launched its major exhibition, *The International Style*, organized by Philip Johnson and Henry-Russell Hitchcock, who also wrote the accompanying catalogue.[5] During his long tenure as Chicago's leading art critic, Clarence J. Bulliet, publishing in various dailies and weeklies, wrote informatively and sympathetically about modern art. In 1927 he wrote an extensive catalogue on Alexander Archipenko, a pioneer of modern sculpture, who a few years later joined the original faculty of the School of Design. In 1928, Bulliet became the first critic to seriously consider Buckminster Fuller's work and drew attention to his concept of a "universal architecture."[6]

Although Bulliet always encouraged Chicago's artists, he was also aware that they were "at the foot of the ladder" and "rated as dust on the sandals of New York."[7] After the Bauhaus opened, he expressed the hope that "our refugees who

can think may cure official stupidity, eventually discovering what is vital in America for the painter and sculptor, dropping the 'isms' that are not workable here."[8] It is important to realize that Chicago, the great pioneer in modern architecture and the city where literature flourished with writers such as Nelson Algren, Sherwood Anderson, James T. Farrell, Ben Hecht, and poets such as Carl Sandburg and Harriet Monroe, did not produce many significant painters in the first half of the century. Chicago was also the site of the Society for Sanity in Art, founded in 1939 with the specific purpose of deriding modernist art in all its forms. Thus, despite innovations, opportunity, and exposure, most Chicago artists of the time seemed preoccupied with romantic nostalgia, whether personal, regional, or social. It can be argued that Ivan Le Loraine Albright was the sole Chicago artist of the prewar period to attain a national reputation.

There is no question that the arrival in Chicago of artists of the caliber of Moholy-Nagy and Gyorgy Kepes had a decisive impact. They and other members of the former Bauhaus were to change the face of architecture, design, painting, and sculpture throughout America. Gropius and Marcel Breuer went to teach at Harvard. Josef and Anni Albers began teaching at Black Mountain College in 1933, where they were soon joined by Xanti Schawinsky. In 1938 Ludwig Mies van der Rohe, followed by Walter Peterhans and Ludwig Hilberseimer, came to the Armor Institute of Technology – later the Illinois Institute of Technology – in Chicago.

Moholy-Nagy was a remarkable man whose person and work synthesized the modern movement. Constantly exploring a multitude of media, he was convinced that rational and coherent art could bring about social change. As early as 1922, as a member of MA, an organization of vanguard Marxist Hungarian artists, he issued a manifesto, "Constructivism and the Proletariat," proclaiming:

> There is no tradition in technology, no consciousness of class or standing. Everybody can be the machine's master or its slave. . . . This is our century – technology, machine, socialism. Make your peace with it. Shoulder its task.[9]

A year after Moholy issued this declaration, Walter Gropius invited him to join the faculty of the Bauhaus in Weimar, where Moholy as well as Albers were to teach the preliminary course, replacing Johannes Itten's expressionist mysticism with modernist rationalism. Moholy emphasized experimentation, spontaneity, and free play and the students' exploration of their natural abilities, ideas which he had published in *Von Material zu Architektur* of 1930. He also directed the metal workshop and taught courses in photography.

Originally a painter, Moholy-Nagy continued painting throughout his life. By the end of World War I, he was working in abstract mode, influenced by Suprematism and Constructivism. He also developed a nonrepresentational syntax for photography and in 1921 produced the first photograms.[10] At the same time he made precise representational photographs and did highly original photomontages. In all media he was preoccupied with light, often using plastics to achieve transparency. Always exploring the possibilities of technology as well as the limitations of chance, he created – as early as 1927– several printings by telephone, giving precise orders to a draftsman on the other end of the line. His work in three dimensions reached its apex in the *Light-Display Machine* (1922–30), a mo-

torized sculpture in which the rotating steel, wood, and transparent plastic shapes create plays of light and shadow. This kinetic sculpture became the source for Moholy's film *Light Display: Black and White and Gray* (1930) in which the mobile creates a new cinematic vision of motion and change. In London in 1935–37, Moholy again used abstract light plays for Alexander Korda's film, *The Shape of Things to Come*, based on the novel by H. G. Wells. Throughout this time he incorporated space, light, and motion into his painting and sculpture, his "Light Modulators" and "Space Modulators," respectively. He also continued producing exhibitions and working as a stage designer.

Above all, however, Moholy-Nagy was a teacher. He believed – a long time before Joseph Beuys made this into a tenet of his theories of art – that "Everybody is talented." This principle formed the basis of Moholy's teaching, first at the Bauhaus in Germany and then in Chicago. Situated within the idealistic era of Modernism, Moholy saw the school as a place where artists and poets, philosophers, scientists, and technologists would work together to create a more vital civilization. Indeed, education was not to be sequestered within the studio or classroom. Students at The New Bauhaus and its successors were to look around them and see that forms have meaning and to understand that art should not be different from life, but within life.

The prospectus and chart of The New Bauhaus clearly stated the five-year program:

> We know that art itself cannot be taught, only the way to it. We have in the past given the function of art a formal importance, which segregates it from our daily existence, whereas art is always present where healthy and unaffected people live. Our task is, therefore, to contrive a new system of education which, along with a specialized training in science and technique, leads to a thorough awareness of fundamental human needs and a universal outlook. Thus, our concern is to develop a new type of designer, able to face all kinds of requirements, not because he is a prodigy but because he has the right method of approach. We wish to make him conscious of his own creative power, not afraid of new facts, working independently of recipes. Upon this premise we have built our program.[11]

The beginning of The New Bauhaus was certainly auspicious. The *New York Times* published an interview with Moholy and soon thereafter pointed out that the United States gained enormously by "importing genius from Europe," naming Albert Einstein, Thomas Mann, and Walter Gropius, but also "Lazlo [sic] Moholy-Nagy, painter, sculptor and photographer [who] arrived here a few days ago to head a school in Chicago, to be known as The New Bauhaus."[12]

Moholy began to appoint a faculty. Hin Bredendieck, who had been his student at the Bauhaus in Dessau, was asked to formulate what came to be known as the "Foundation Course."[13]

Eventually Bredendieck would also be in charge of the Wood and Metal Workshop. Gyorgy Kepes, who had worked with Moholy in Berlin and London, was invited to take over the Light Workshop (photography); Henry Holmes Smith filled in until Kepes arrived in 1937.

Kepes became a major force in Chicago. The photographer Nathan Lerner, one

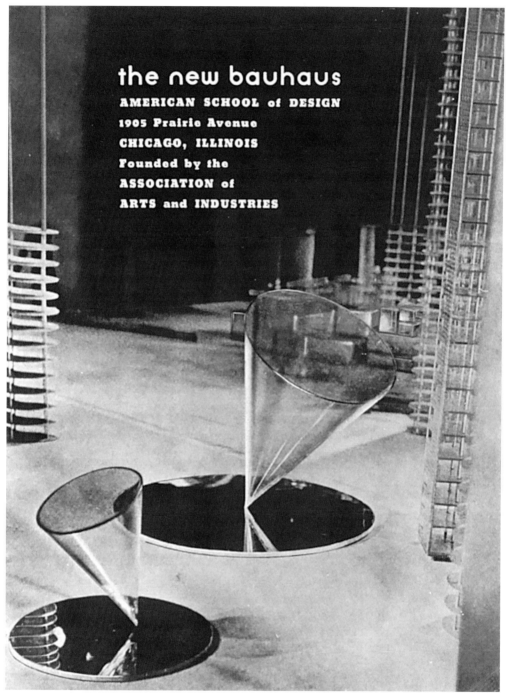

FIGURE 51. László Moholy-Nagy, *The New Bauhaus*, 1937. Cover of prospectus.

of the new school's first students and later an instructor, recalls Kepes as "an incredible mind and human being, who would explain ideas to students, make them comprehensible – someone whom you could truly trust."[14] In 1944, the year in which he published his pivotal book, *Language of Vision*, Kepes left Chicago for the Massachusetts Insti-

tute of Technology, where he became the founding director of the Center for Advanced Visual Studies, which explored the affinities of art, technology, and the natural world.

The Photography Department of The New Bauhaus and its successors, with instructors such as Nathan Lerner (at ID 1937–42, 1945–54), Arthur Siegel (at ID 1946–54 and 1967–78), Harry Callahan (at ID 1946–61); Aaron Siskind (at ID 1951–70); and Arthur Sinsabaugh (at ID 1951–59), gave rise to a new generation of photographers whose work was closer to abstract art than to the observation and documentation that was dominant among the American sharp-focus artists. In accordance with Moholy's assertion that "the enemy of photography is convention . . . ,"[15] experiments in distortion, solarization, and cliché verre were carried on, as well as in photograms and photomontage.

Besides Moholy-Nagy, the most prominent member of the original faculty was Alexander Archipenko, a seminal figure in the development of Modernist sculpture. Archipenko had gone in 1890 from his native Kiev to Paris, where he experimented early on with the interrelationship of concave and convex forms, or positive and negative space, and also made mobile "sculpto-paintings." He immigrated in 1923 to the United States, where he exhibited widely and taught extensively. By the time he took charge of the Modeling Workshop at The New Bauhaus in 1937, his work had become rather stylized, but his understanding of the relationship of solids to voids became paradigmatic for some of the work done by the sculpture students, even if he did play the grand master, smashing work he did not like with his heavy cane.

Although not always successful, Moholy tried to seek out the best people to teach a wide range of disciplines.[16] David Dushkin was an excellent person to head the Music Workshop. In addition to playing music and studying musicology, students were encouraged to build innovative instruments and to investigate the sounds of various common materials such as wood, metal, and grasses. In 1937 Charles Morris offered a course called "Intellectual Integration" and dealt early on with the theory of signs and semantics. A young philosophy professor at the University of Chicago and a former student of the philosopher Rudolf Carnap, Morris believed that collaboration between artists and scientists was both possible and necessary. At The New Bauhaus, his scientific analysis of art was an important influence on the intellectual path of the school. With a view toward integrating science into this unique curriculum, the University of Chicago biologist Ralph Gerard and the physicist Carl Eckart were appointed as part-time faculty.

Although space and money were in short supply, Moholy managed to bring two important exhibitions to the Marshall Field mansion. The first featured abstract sculpture by Naum Gabo, Barbara Hepworth, Henry Moore, and Alexander Calder, and paintings by Piet Mondrian and Moholy-Nagy himself. The second exhibition, organized by The Museum of Modern Art, New York, dealt with the first hundred years of photography.

Moholy's personality and his enthusiasm for Modernist art made an indelible impression on his students. Nathan Lerner recalls:

I first met Moholy-Nagy in 1937, on the day The New Bauhaus opened in Chicago. The walls of his offices were covered with paintings constructed of clear

plastic sheets slightly raised above white panels. The sheets were scratched and painted as to cast shadows on the panels. I also saw surfaces covered with pins casting shadows; to my astonishment they seemed to move even as we talked. Overhead, suspended from the ceiling, thick twisted plastic shapes floated, catching and reflecting light as they moved. The meeting had lasting significance for me. I became aware for the first time that light itself, like clay or paint, could be a medium.[17]

Another testimony of an encounter with Moholy was recalled by Richard Koppe (at ID 1946–63), who was also in that first class at the Field mansion. Koppe remembers Moholy showing his large collection of Bauhaus materials, captivating the students, who

were down on their hands and knees looking through the forest of table legs to illustrate a point he made about space. . . . In classes we were introduced to the photogram, photomontage, hand sculpture, the tactile chart, space modulators, light modulators, the paper problem, machine investigation . . . along with color theory, drawing, lettering, drafting . . . I have never seen so many and so varied results produced by any class within the scope of this curriculum. Perhaps a higher value was placed on inventive creativeness than on aesthetic consideration, though they were part and parcel of the same order.[18]

In addition to actual teaching and running the school, Moholy-Nagy had to persuade his new community of Chicago of the importance of his undertaking, seen by many as quite a radical one. And he was a very persuasive man. John Walley, who later became one of the most esteemed members of the ID faculty, remembers how Moholy brought The New Bauhaus into a "politically and economically depressed" art scene, arriving at the headquarters of the Artists' Union "with a large movie projector, two slide projectors, films and large scale blow-ups. The shock, the impact of the new ideas created a turmoil in the artist group and turned into a marathon debate lasting well after midnight."[19]

The students involved in this new program were exploring all kinds of media and materials and may not have been aware that much of the work was clearly indebted to a Constructivist heritage. E. M. Benson, writing about the "Chicago Bauhaus" in an article in the *Magazine of Art*, warned that imitations of Alexander Archipenko and Moholy-Nagy are not that different from imitations of realist painters such as the popular Alexander Brook and Kenneth Hayes Miller.[20]

When the work of the first ID class was exhibited in the summer of 1938, Bulliet praised it in the *Chicago Daily News*. The reviewer in *Time* was a bit more dubious:

In Chicago this week visitors at the New Bauhaus found an exhibition of bewildering nameless objects: gadgets of wire, wood, sandpaper, linoleum, felt, rubber and ordinary paper, cut in odd accordion patterns. These objects, which sometimes suggest the scraps left in cabinet maker's shops and sometimes the more outlandish contraptions of Rube Goldberg, represented part of the first year's work of the 70 students at the New Bauhaus. . . . [21]

Some of the students with a good deal of art-school training were aware that the German Bauhaus had artists such as Wassily Kandinsky, Paul Klee, Lyonel

Feininger, and Oskar Schlemmer on the faculty. They were disappointed that the Chicago school could claim no advanced work in painting and sculpture; art was considered a private affair to be pursued outside the school. They were not enthralled with the Foundation Course, which required hands-on work with hand and machine tools. That, however, was only a minor problem in the debacle of The New Bauhaus. Almost from the beginning, Moholy felt a lack of real support from the industrialists on the board of the Association of Arts and Industries. Sibyl Moholy-Nagy, Moholy's wife and first biographer, remembered:

> The big industrialists who formed the Board of Directors were glad to leave the functions of an executive committee to smaller people whose vanity was flattered by being sponsors to a cultural enterprise that had aroused international comment. They now offered an unending stream of criticism and naive advice to students, faculty maintenance personnel, founded on no more than the necromancy of the checkbook.[22]

AAI had expected the school to train specialists who would create tangible products for an American industry just beginning to recover from the Great Depression. Instead they saw this array of "bewildering nameless objects." AAI attempted to terminate Moholy, accusing him of "lacking balance, diplomacy, patience and teaching experience."[23] The faculty, however, unanimously signed a "Declaration of Loyalty," drafted by Charles Morris and addressed to Moholy and the board. However, alleging stock market reverses, AAI decided to close the school. Fall classes were canceled; the five-year contract with Moholy was abrogated. Greatly perturbed, but not relenting, Moholy sued AAI[24] and made immediate plans to start a new school of design in Chicago.

Moholy found quarters for the new "School of Design" in an abandoned bakery above the old Chez Parce nightclub at 247 East Ontario Street. Classes began in February 1939 with eighteen day students and twenty-nine enrolled for the evening classes; the faculty worked at first without pay. The school was financed partly by Moholy's earnings as a designer for the Parker Pen Company and Spiegel's mail-order house, and partly by Walter Paepcke, president of the Chicago-based Container Corporation of America and the school's major patron for many years. Paepcke was a truly enlightened capitalist, who also commissioned eminent artists, including Willem de Kooning, Fernand Léger, Richard Lindner, Henry Moore, Man Ray, Ben Shahn, and Rufino Tamayo to create important innovations in graphic design. As well, he founded the Aspen Institute for Humanities and was involved in the Great Books program at the University of Chicago. Subsidies from the Carnegie Corporation and the Rockefeller Foundation were soon forthcoming. Moholy appointed a committee of sponsors that included Alfred Barr, John Dewey, Walter Gropius, Joseph Hudnut, and Julian Huxley. In the introduction for the comprehensive and highly influential exhibition *Bauhaus 1919–1928* at The Museum of Modern Art, Barr concluded that "Bauhaus designs, Bauhaus men, Bauhaus ideas, which taken together form one of the chief cultural contributions of modern Germany, have been spread throughout the world."[25] But as soon as the Nazis assumed power in Germany, they closed the school in 1933.

The School of Design's curriculum differed little from that of its predecessor.

The Basic Design (Foundation Course) and Product Design Workshop were taught by James Prestini, a former School of Design student and a consummate crafts-man and designer, together with Charles Niedringhaus, an educator and furniture designer. The Light Workshop was under Kepes's direction, assisted now by con-tinuing student Nathan Lerner and James T. Brown. The Painting Workshop was led by Robert J. Wolff, a member of the American Abstract Artists group who was joined for a brief time by Johannes Molzahn, a well-known German abstract painter. There was also a Weaving Workshop, headed by former German Bauhaus student Marli Ehrmann, assisted by the Munich-trained weaver Else Regensteiner. During 1941–42, the young John Cage taught music at the school, experimenting with his students on his compositions including nonmusical sound and the total absence of sound. Cage also performed a few concerts using instruments that students had made as product-design problems. Additional lectures from the Uni-versity of Chicago, including the outstanding sociologist Lloyd Warner, aug-mented the students' education. Summer sessions were held, first in 1939 at the Paepcke estate in Somonauk, Illinois, and then in 1940 at Mills College in Oak-land, California. The latter had a direct impact on art education in the San Fran-cisco Bay Area.[26]

During the Second World War, the school contributed to the war effort by offering a course in camouflage under Kepes's direction. Expanding beyond the visual focus of the school, Moholy, who had been wounded in World War I, turned to his old friend from Budapest, the noted Chicago psychoanalyst Dr. Franz Alexander, to work toward an improved therapy for the rehabilitation of wounded veterans.

In 1944 the school was renamed "Institute of Design" (ID) and a new board of directors was created; Walter Paepcke continued to serve as chair. At the end of the war, the school moved to temporary quarters at 1009 North State Street and then, in 1946, to its own building at 632 North Dearborn Street, a fine ex-ample of Richardsonian Romanesque designed by Henry Ives Cobb which had previously housed the Chicago Historical Society.

An increasing inclination toward the tenets of Modernism in America coupled with the availability of the GI Bill to pay college tuition caused enrollment to increase dramatically at ID. Almost 500 students were enrolled by the fall of 1945; a year later the day and evening students totaled almost 2,000. With increased revenue and a rather generous board, the school flourished and it became possible to come close to Moholy's ideal of education commensurate with "the need for a well-balanced social organization, an education for personal growth and not a mere training in skills for the purpose of profit; a social organization in which everyone is utilized to his highest capacity."[27]

As the school grew, so did the faculty. In 1945 Emerson Woelffer (at ID 1942–50) joined the Painting Workshop. An early aficionado of jazz, Woelffer brought a new mode of artistic expression to the school through his painting and sculp-ture influenced by ethnic art and Surrealist imagery. His studio, noisy with jazz musicians, became a vital gathering place for teachers and students, and was se-verely missed when he left for Black Mountain College in North Carolina in 1949.

Also in 1945 Crombie Taylor was appointed secretary to the school and became a teacher of architecture, which was under the direction of Ralph Rapson from

1944 until 1947, when Rapson left, eventually to become dean of architecture at the University of Minnesota; he was an important architectural designer and city planner.

Supplementing the challenging curriculum and extraordinary faculty were prominent men and women from many disciplines, who, in a practice going back to the German Bauhaus, were invited as speakers and visitors. Among them were the architects Alvar Aalto, Walter Gropius, Richard Neutra, Paul Rudolf, José Luis Sert, and William Wurster; art historians Sigfried Giedion and Henry-Russell Hitchcock; artists and designers Herbert Bayer, Naum Gabo, Stanley William Hayter, Barbara Hepworth, Frederick Kiesler, Franz Kline, Fernand Léger, Matta, Henry Moore, and Man Ray; legendary comedian Charlie Chaplin; photographers Ansel Adams, Bernice Abbott, Helen Levitt, Frederick Sommer, and Paul Strand; and philosopher Rudolph Carnap.[28]

R. Buckminster Fuller, a visiting lecturer in 1948–49, was probably ID's most important guest instructor. One of the great innovators of the century, Fuller was interested in comprehensive global strategies "to make man a success in the universe." At ID, Fuller lived in a trailer in a parking lot and taught survival skills. Aesthetics of the Bauhaus and, in fact, any stylistic considerations, seemed irrelevant to his larger concerns. He and twelve of his students constructed the first model of the geodesic dome, and then reerected it at Black Mountain College for further testing. During the summer of 1949, other current and former ID faculty also taught at Black Mountain, ID's sister institution. The ID students, however, found the Black Mountaineers easygoing, esoteric, and meditative, while the Black Mountain students thought the Chicago types were ambitious, aggressive, and businesslike.[29]

Fuller, however, did not overlap with Moholy-Nagy. Diagnosed with leukemia in 1945, Moholy lived for only another year, during which he continued to work at an enormous rate, designing for commercial companies and lecturing around the country. He also created some of his finest work in painting, the "Leuk" series, named after his cancer, and in Plexiglas sculpture. He persevered on what may be his greatest accomplishment, his book *Vision in Motion*, which perhaps summarizes the Modernist position better than any other book written by an artist. Like the final paintings and sculptures, the book was created in Chicago and represents an essential aspect of this city's contribution to modern art. *Vision in Motion* was published by Paul Theobald in Chicago shortly after Moholy-Nagy's death in November 1946.

Nathan Lerner became acting director of ID. Lerner, like so many members of the rotating ID faculty, was a man of great versatility. Head of the Light Workshop since 1945, he also functioned as head of Product Design. Arthur Siegel, a former ID student, took over the Light Workshop, now renamed the Department of Photography. Siegel's organization of the Symposium on Photography in 1946 was the first event of its kind and helped elevate the medium to a new level of seriousness. Among the participants were Berenice Abbott, Erwin Blumenfeld, Beaumont Newhall, Paul Strand, Roy Stryker, and Weegee. ID was one of the very few places in the United States where photography was taught as an academic discipline in which students could actually obtain accredited degrees in the field.

After her husband's death, Sibyl Moholy-Nagy, a self-educated woman of great

intellect and critical flair, began teaching humanities, while also preparing her discerning biography of Moholy, published in 1950. Myron Kozman, a painter and graphic designer who had been one of the five original students at The New Bauhaus almost ten years earlier, joined the staff in 1946 and taught in many capacities into the 1950s. Between 1945 and 1947, four additional painters also joined the ID faculty: John Walley, who began his career working as a cartoonist and muralist, was also a designer and an administrator, but above all, a teacher. During the Depression, as director of the Illinois WPA Design Workshop, he hired students from ID. After serving in the Air Force as a camouflage expert, he became the head of the Foundation Course. After a stint at Black Mountain College, he returned to ID, where he rotated in many of its departments. Part of a generation of idealist Modernists and an individual of great personal warmth, Walley believed that the artist/designer could bring about a better and more humane world by planning for a more rational society. He talked about "personal space" and "body language" long before these concepts became fashionable.

Hugo Weber brought a full background in European culture to the school when he arrived in 1946. Weber had studied with Johannes Itten at the Kunstgewerbeschule in Zurich, and was also a student of art history at the University of Basel, his native city. A friend or colleague of many leading artists such as Marino Marini, Alberto Giacometti, Aristide Maillol, and Hans Arp (with whom he collaborated), Weber brought new ideas to the Foundation Course, which he directed for nine years. As a teacher he would alternate long periods of silence with remarks of great cogency. In his own version of Abstract Expressionism, Weber made paintings with rhythmic energy related to automatism. Richard Koppe joined ID's staff as head of Visual Design. He had studied at the avant-garde St. Paul School of Art in Minnesota before joining the first class of The New Bauhaus, and had been one of the few abstract artists in the WPA.

The fourth artist to join ID in 1946 was Eugene Dana. Dana had also been a student at the St. Paul school, and was teaching at Brooklyn College when he was tapped by Serge Chermayeff, who had recently been appointed to succeed Moholy-Nagy.

Chermayeff arrived at ID in 1947. Born in Azerbaijan in the Caucasus, Chermayeff immigrated with his family to England when he was a child. Educated at Harrow and Cambridge, he spent several years as a professional ballroom dancer before turning first to interior design and then to architecture. In 1913, when Eric Mendelsohn arrived in England, the two architects established a partnership and executed a number of commissions. Chermayeff came to the United States in 1942; he was serving as the chair of Brooklyn College's design department when he received the ID appointment.

Chermayeff's personality was in great contrast to Moholy's. A superb and meticulous designer, he was rather authoritarian, even dictatorial according to some students.[30] Chermayeff focused his greatest attention on the architecture program, bringing in the Swiss architect Otto Kolb, who taught at ID in 1946–51. Gerhard Kallmann, who worked for *Architecture Review* in England after leaving his native Germany, also joined the ID faculty in 1949, but remained only one year. Later, in partnership with Michael McKinnell, Kallmann became well known for his design of Boston City Hall.

Most important for ID, however, was the appointment of Konrad Wachsmann, an eminent engineer as well as architect who had studied with Hans Poelzig in Berlin. He designed a summer house for Albert Einstein, who subsequently sought President Roosevelt's help in facilitating Wachsmann's emigration from Germany in 1941. In the United States, Wachsmann worked with Gropius on prefabricated housing and then with Chermayeff on *"mobilar structures."* As head of Advanced Building Research at ID, Wachsmann and his students developed a remarkable hangar for the U.S. Air Force. This futuristic, experimental structure anticipated later buildings based on system analysis.

Chermayeff made other new appointments. Frank Barr, a highly innovative graphic designer, came to teach typography. Misch Kohn (at ID 1948–72) was the first figurative painter on the ID faculty. After working for the WPA in the 1930s, Kohn went to Mexico, where he looked to José Clemente Orozco as a mentor and became associated with Taller de Graphica Popular.[31] He was considered one of America's foremost printmakers when he was appointed to ID to teach graphic design in 1948. He then rotated with Richard Koppe as head of the Visual Design Department.

In the area of "Cultural Studies" at ID – a designation that seems to anticipate the 1990s – Margit Varro took over music instruction from David Dushkin. Born in Hungary and a friend of Bela Bartok's, Varro gave wonderful lectures and brilliant performances, teaching everything from ancient music to Bartok's use of the Fibonacci series.[32]

In 1949, while completing my doctorate on German Expressionism at the University of Chicago, I became the first art historian to teach at ID.

I offered courses in the history of art (including architecture) that were tailored to the philosophy of the school. The program stressed the initial intuitive and psychological/perceptual insights on the part of the students. In 1952, when I introduced a graduate program in art education, it was clear that the country was ready for an actual teacher-training program based on Bauhaus-ID principles. The theories of John Dewey, Sigmund Freud, and especially Victor Lowenfeld's child development and visual expression studies were very relevant to this program.[33] Its purpose was to lead teachers away from rote activity toward experimentation with materials. It also stressed the importance of thoughtful looking at art on the part of students.[34] The program attracted not only elementary, high school, and college teachers, and art supervisors, but also many former ID students. Quite a few of these students have become noted artists, such as Fred Berger, June Leaf, Robert Kostka, Norman Laliberte, Alex Nicoloff, and Irene Siegel. Elliot Eisner, a graduate student in the program, was able to carry it further as head of art education at Stanford University and as one of the leading art educators in the country. The Getty Center for Education in the Arts has recently promoted a similar approach toward the integration of aesthetics into the school curriculum.

In 1950 Elmer Ray Pearson, who had studied with Moholy at ID and then with Mies van der Rohe at the Illinois Institute of Technology, began his thirty-year teaching career at ID. He also became a chronicler of the school. In the same year Harold Cohen became a member of the teaching staff. Cohen saw John Walley as his mentor and recalls, "When I entered ID, my life started to have meaning – I found who I was."[35] Cohen tried to convey this attitude to his own students at

ID (1950–55), and later as professor of architecture and environmental design at the State University of New York in Buffalo.

During Chermayeff's tenure other appointments ensured that ID's educational ideals would spread across the nation: Jesse Reichek, an ID student in the early 1940s, established a life-long friendship with Kepes and Prestini. After World War II, Reichek taught briefly at ID before spending a number of years in Paris, where he exhibited at the Galerie Cahiers d'Art. He returned to ID in 1951 to head the Product Design Department, but left in 1952 for the University of California, where, in cooperation with Charles Eames, he set up a Foundation Course for the department of architecture at Berkeley. Later joined by Prestini, he taught generations of students ID concepts as well as courses concerned with architecture and the political environment.

ID's vision was probably spread most widely in the arts by the many talented photographers who both taught at and graduated from the school. Arthur Siegel and Harry Callahan were both on the faculty when Aaron Siskind, a master of both abstract and documentary photography and a close friend of Franz Kline and other New York Abstract Expressionist painters, joined ID in 1951. During the same year, Arthur Sinsabaugh, a former student who had studied with Moholy, Siegel, and Callahan, was added. It was, above all, the combination of Callahan's and Siskind's teaching that made ID the leading school for photography. Callahan left in 1961 for the Rhode Island School of Design, but Siskind remained at ID for twenty years.

Never properly funded, the Institute of Design suffered financial difficulties for most of its existence. They increased with the drop in enrollment after the great influx of veterans under the GI Bill. Walter Paepcke, still the principal supporter, began to focus most of his interest on the Aspen Institute. In order to maintain ID, it was found necessary to affiliate with another solvent institution. Negotiations with the University of Chicago, Northwestern University, and the University of Illinois took place as early as 1948.[36] Although members of the University of Chicago faculty had been teaching at ID since its beginning, Robert Hutchins, the university's chancellor, told Chermayeff and Paepcke that "art had no room in a university."[37] Finally, the school turned to the Illinois Institute of Technology, in spite of an early warning by Gropius that considerable antagonism against ID could be expected from Mies and his associates. But Henry Heald, the president of IIT and a prominent member of the Unity of Art and Science movement, welcomed the school and promised that it would retain its autonomy as the affiliation was announced at a special meeting of the board of directors on November 22, 1949.[38]

In addition to the external problems, there had always been controversies inside the school, which grew more pronounced after Moholy's death. By 1951 old disputes between Chermayeff and Wachsmann were so pronounced that the former suggested to President Heald that Wachsmann's Department of Advanced Building Research be separated from ID.[39] Asked by Chermayeff to intervene on his behalf, Gropius wrote to Heald, stating that "Wachsmann with all his charm is so egocentric a man that I believe he should not be a teacher."[40]

This controversy may well have been one reason for Chermayeff's resignation in 1951. Crombie Taylor, a man with meager leadership abilities, became acting

director, facing a difficult faculty and student body. The search for a permanent director commenced at once. Among the twenty-five candidates considered and interviewed were architects and designers Charles Eames, Louis Kahn, George Fred Keck, Paul Rand, Ralph Rapson, and Paul Rudolph; art historians and educators Robert Goldwater, Edgar Kaufman, Herbert Read, and James Thrall Soby; and artists Max Bill, Richard Lippold, Ernest Mundt, Harry Bertoia, Robert J. Wolff, and John Walley and Hugo Weber from within the faculty. But disagreement was rife and staff members shifted their positions constantly. Prior to his resignation from the school in 1953, John Walley wrote an open letter, "Crisis in Leadership at the Institute of Design," in which he speaks of the school's great international reputation under Moholy, the efforts of the faculty to maintain this standard, and the destructive attitude by the "leadership of Crombie Taylor, Hugo Weber and Konrad Wachsmann, demonstrating a philosophy of contempt for students and faculty."[41]

Clearly the situation had become untenable. It was not helped when, without consulting an admittedly divided faculty, IIT simply appointed a new director in 1955: Jay Doblin, a commercial designer with the firm of Raymond Loewy. The installation of a director coming from the marketing branch of design was repugnant to the ID faculty. Their internal battle forgotten, the faculty sent an anonymous letter to the IIT administration stating (in part): "certain fundamental tenets of our approach to education of the designer have been brought into serious jeopardy. . . . The designer must be more than stylist or decorator who caters to fashionable, or opportunistic needs. The designer must be an ethically responsible professional with a developed ability based on the most penetrating scientific and artistic insight of our time." The letter concluded: "This appointment represents a fundamental departure from our educational purpose."[42] The administration did not reconsider; Doblin, a well-meaning and able individual, remained with tenure. In protest Harold Cohen, Charles Forberg (who had been added to the architecture faculty shortly before), Crombie Taylor, Hugo Weber, and I tendered resignations; Arthur Siegel, who had rejoined the photography staff, and Konrad Wachsmann were told that their contracts would not be renewed.

With its greatly reduced faculty, the school moved to the basement of S. R. Crown Hall, the beautiful edifice Mies designed for IIT's architecture department and which formed the center of the campus. In the meantime, President Heald left IIT to become director of the Ford Foundation, and was succeed by John Rettaliata, an engineer. With ID now a department of an engineering school, Doblin's position was extremely difficult. After he himself left IIT in 1969, he recalled: "So there we were, the remains of the foremost school of experimentation (ID), the triumphant school of purism (Mies's Department of Architecture) and a commercial designer, all locked up in Crown Hall. Three divergent philosophies on a collision course."[43] It could very well have closed its doors like its sister institution, Black Mountain College, had done earlier, but ID continued with undergraduate and master's programs in Visual Design, Product Design, Photography, and Art Education. It is now located in a nineteen-story tower on Chicago's South Side at 3360 South State Street. There have been several directors since Doblin resigned in 1969.

Although as Sir Herbert Read observed in 1963, the Bauhaus idea "had spread throughout the world and is the active influence wherever any real advance in living is made,"[44] there were also inherent flaws in its program. The sculptor George Rickey, an ID student in the late 1940s, noted that its "method of teaching has spread all over the world and has changed every art school in Europe, here in America, and in Japan . . . but when the students went into typography or architecture, it's as though they never had that course."[45] Similarly, Jesse Reichek pointed out that "when the students went into Visual Design, Product Design, Architecture, or Photography, they entered into courses of instruction that actually differed little from what other institutions had to offer. The school was never able to build a curriculum beyond the Foundation Course."[46]

The lack of continuity was not the only problem. Probably more important was the collapse of the belief that better design would bring about a better world. Kepes concluded his penetrating analysis of art in the contemporary world by privileging advertising art, "which is not handicapped by traditional forms," as the art that could best prepare "the way for positive popular art, an art reaching everybody and understood by everyone."[47] But, as America and the rest of the industrial and postindustrial world turned increasingly toward a multinational plutocracy, and as the political and cultural climate in the 1940s grew increasingly corrupt, such a belief seemed absurd. Moholy's early idea that the artist-designer could gain control of the means of production turned out to be a grand illusion. In the early days of the modern movement, a new functional architecture created fine public housing for the middle and lower classes, but as developers began using debased Modernist designs for quick profits, the quality of design as well as its purpose became degraded. When, in 1963, Gropius, the model of integrity in modern architecture and the father of the Bauhaus, became the principal designer of the Pan Am tower, a monstrous high-rise blocking New York's Park Avenue, faith in architecture as a vehicle for transformation toward a more humane society began to wane.

The high-rise building, one of the paradigms of Modernism, began to be viewed not as the solution to congestion, but as the culprit that destroys circulation in our cities, isolates its inhabitants, and actually helps destroy the urban landscape. Peter Blake, one of the leading protagonists of the modern movement both as a critic and architect, asserted in 1974: "We have seen and lived the future and it simply didn't work. The Modern Movement – the creed in which we were raised and to which we pledged allegiance throughout our professional lives – has reached the end of the road."[48]

ID also never resolved the obvious conflict between the fine arts, practiced by most of its teachers, and the design of marketable commodities. It placed its emphasis on experimentation, but wanted to leave the practice of art outside its walls. It prescribed that the designer in an industrial society create reproducible products, be they chairs, graphic designs, or photographs, not one-of-a-kind works of art. This position, however, was unsatisfactory to many students and went against the grain in Chicago, which despite – or perhaps because of – its industrial base was inclined toward Expressionism and Surrealism. ID's exclusion of art focused light on the other major Chicago art school of the era, the School of the Art Institute. The focus of SAIC students, while respectful of Bauhaus ideals

and of Mies in particular, was quite different. SAIC students were engrossed with the indigenous and exotic art that they studied at the Field Museum of Natural History. They talked about Surrealist art, which they could also see in the emerging Chicago collections of the Culbergs, the Shapiros, and the Bergmans. The Surrealists' glorification of the absurd and the irrational seemed to them a coherent response to a world responsible for Auschwitz and Hiroshima. SAIC students saw the skills of industrial precision used for purposes of devastation, and they were disillusioned with the promise of the machine. Introspection might be more likely to produce meaningful results in a search for human values.

In the late 1940s the "rationalists" at ID encountered the romantic and irrational and subjective art by SAIC students in the arena of Exhibition Momentum, initially organized as a protest against the Art Institute's policy of excluding student work from their prestigious Annual Exhibitions of Chicago & Vicinity. Almost from the beginning, ID students and faculty were attracted to this new, progressive exhibition opportunity. Hugo Weber wrote a brief introduction to the first Momentum catalogue in 1948; Roy Gussow, an ID student, actually chaired the first exhibition. The 1950 catalogue was designed by Robert Nickle, a teacher of Product Design; Alex Nicoloff, a Visual Design student, designed the 1952 catalogue; Burton Kramer was responsible for the 1954 effort.

In the mid-1950s attitudes began to change at ID, especially among those inclined toward art rather than design. Freud and Jung began to be discussed in the studios and hallways as vehemently as Buckminster Fuller. Some of the students, like their SAIC colleagues, explored a primitivist sort of expressionism with Surrealist overtones. Their incongruous figurations were confirmed by Jean Dubuffet's lecture "Anticultural Positions" at the Arts Club in 1951, in which the French artist emphasized passion and violence. His antirational stance became more acceptable to many young Chicago artists than the clear appeal to reason by Moholy and Kepes. In Chicago, as elsewhere, Existentialist concerns and issues of alienation became paramount.

When we think of Chicago artists of the postwar period, it is the idiosyncratic Imagists, once mislabeled the "Monster Roster," that come to mind: Robert Barnes, Don Baum, Cosmo Campoli, Dominick di Meo, George Cohen, Leon Golub, Joseph Goto, Theodore Halkin, June Leaf, Irving Petlin, Seymour Rosofsky, Evelyn Statsinger, and H. C. Westermann. And then we think of their successors, The Hairy Who, The False Image, and The Non-Plussed Some groups and later individuals such as Ed Paschke, among others, whose expressions, fantasies, and often raunchy vitality relate to the Second City in a manner forming a significant contrast to the utopian optimism of the Bauhaus tradition as exemplified in the Institute of Design.

14 NEW IMAGES OF MAN

INTRODUCTION

Marsyas had no business playing the flute. Athena, who invented it, had tossed it aside because it distorted the features of the player. But when Marsyas, the satyr of Phrygia, found it, he discovered that he could play on it the most wondrous strains. He challenged beautiful Apollo, who then calmly played the strings of his lyre and won the contest. Apollo's victory was almost complete, and his divine proportions, conforming to the measures of mathematics, were exalted in fifth-century Athens and have set the standard for the tradition of Western art. But always there was the undercurrent of Marsyas' beauty struggling past the twisted grimaces of a satyr. These strains have their measure not in the rational world of geometry but in the depth of man's emotion. Instead of a canon of ideal proportions we are confronted by what Nietzsche called "the eternal wounds of existence." Among the artists who came to mind are the sculptors of the Age of Constantine, of Moissac and Souillac, the painters of the Book of Durrow, the Beatus Manuscripts, and the Campo Santo; Hieronymus Bosch, Grünewald, Goya, Picasso and Beckmann.*

Again in this generation a number of painters and sculptors, courageously aware of a time of dread, have found articulate expression for the "wounds of existence." This voice may "dance and yell like a madman" (Jean Dubuffet), like the drunken, flute-playing macnads of Phrygia.

The revelations and complexities of mid-twentieth-century life have called forth a profound feeling of solitude and anxiety. The imagery of man which has evolved from this reveals sometimes a new dignity, sometimes despair, but always the uniqueness of man as he confronts his fate. Like Kierkegaard, Heidegger, Camus, these artists are aware of anguish and dread, of life in which man – precarious and vulnerable – confronts the precipice, is aware of dying as well as living.

Their response is often deeply human without making use of recognizable

* This essay originally appeared as the Introduction to *New Images of Man*, The Museum of Modern Art, 1959. Reprinted by permission of the Museum of Modern Art, New York.

human imagery. It is found, for instance, in Mark Rothko's expansive ominous surfaces of silent contemplation, or in Jackson Pollock's wildly intensive act of vociferous affirmation with its total commitment by the artist. In the case of the painters and sculptors discussed here, however, a new human imagery unique to our century has been evolved.

Like the more abstract artists of the period, these imagists take the human situation, indeed the human predicament rather than formal structure, as their starting point. Existence rather than essence is of the greatest concern to them. And if Apollo, from the pediment of Olympia to Brancusi's *Torso of a Young Man*, represents essence, the face of Marsyas has the dread of existence, the premonition of being flayed alive.

These images do not indicate the "return to the human figure" or the "new humanism" which the advocates of the academies have longed for, which, indeed, they and their social-realist counterparts have hopefully proclaimed with great frequency, ever since the rule of the academy was shattered. There is surely no sentimental revival and no cheap self-aggrandizement in these effigies of the disquiet man.

These images are often frightening in their anguish. They are created by artists who are no longer satisfied with "significant form" or even the boldest act of artistic expression. They are perhaps aware of the mechanized barbarism of a time which, notwithstanding Buchenwald and Hiroshima, is engaged in the preparation of even greater violence in which the globe is to be the target. Or perhaps they express their rebellion against a dehumanization in which man, it seems, is to be reduced to an object of experiment. Some of these artists have what Paul Tillich calls the "courage to be," to face the situation and to state the absurdity. "Only the cry of anguish can bring us to life."[1]

But politics, philosophy and morality do not in themselves account for their desire to formulate these images. The act of showing forth these effigies takes the place of politics and moral philosophy, and the showing forth must stand in its own right as artistic creation.

In many ways these artists are inheritors of the romantic tradition. The passion, the emotion, the break with both idealistic form and realistic matter, the trend toward the demoniac and cruel, the fantastic and imaginary – all belong to the romantic movement which, beginning in the eighteenth century, seems never to have stopped.

But the art historian can also relate these images to the twentieth-century tradition. Although most of the works show no apparent debt to cubism, they would be impossible without the cubist revolution in body image and in pictorial space. Apollinaire tells us in his allegorical language that one of Picasso's friends "brought him one day to the border of a mystical country whose inhabitants were at once so simple and so grotesque that one could easily remake them. And then after all, since anatomy, for instance, no longer existed in art, he had to reinvent it, and carry out his own assassination with the practised and methodical hand of a great surgeon."[2] Picasso's reinvention of anatomy, which has been called cubism, was primarily concerned with exploring the *reality of form* and its relation to space, whereas the imagists we are now dealing with often tend to use a similarly shallow space in which they explore the *reality of man*. In a like fashion

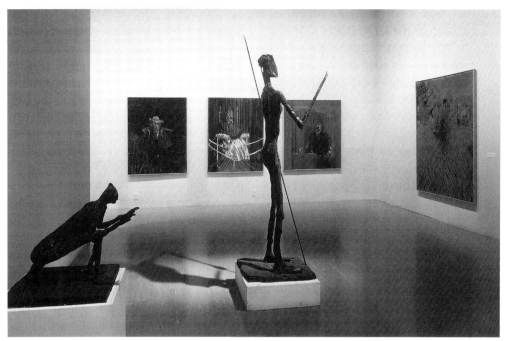

FIGURE 52. Installation view of the exhibition "New Images of Man," Museum of Modern Art, New York, 1959.

the unrestricted use of materials by such artists as Dubuffet and Paolozzi would have been impossible without the early collages by Picasso and Braque, but again the cubists were playing with reality for largely formal reasons, whereas the contemporary artists may use pastes, cinder, burlap or nails to reinforce their psychological presentation.

These men owe a great debt to the emotionally urgent and subjectively penetrating painting of the expressionists from the early Kokoschka to the late Soutine. Like them they renounce *la belle peinture* and are "bored by the esthetic," as Dubuffet writes. Like most expressionists these artists convey an almost mystical faith in the power of the effigy, to the making of which they are driven by "inner necessity." Yet the difference lies in this special power of the effigy, which has become an icon, a poppet, a fetish. Kokoschka and Soutine still do likenesses, no matter how preoccupied with their own private agonies and visions; Dubuffet and de Kooning depart further from specificity, and present us with a more generalized concept of Man or Woman.

Much of this work would be inconceivable without Dada's audacious break with the sacrosanct "rules of art" in favor of free self-contradiction, but negativism, shock value, and polemic are no longer ends in themselves. The surrealists, too, used the devices of Dada – the rags, the pastes, the ready-mades, the found object – and transported the picture into the realm of the fantastic and supernatural. Here the canvas becomes a magic object. Non-rational subjects are treated spontaneously, semi-automatically, sometimes deliriously. Dream, hallucination and confusion are used in a desire "to deepen the foundations of the real." Automatism was considered both a satisfying and powerful means of expression because it took the artist to the very depths of his being. The conscious

was to be visibly linked to the unconscious and fused into a mysterious whole as in Giacometti's *The Palace at 4 A.M.,* where the reference of each object within the peculiarly shifting space – the space of the dream – is so ambiguous as never to furnish a precise answer to our question about it. But all too often surrealism "offered us only a subject when we needed an image."[3] The surrealist artist wants us to inquire, to attempt to "read" the work, and to remain perplexed. In the *City Square*, which Giacometti did sixteen years later, we are no longer dealing with a surrealist object. The space still isolates the figures, but instead of an ambiguous dream image we have a more specific statement about man's lack of mutual relationship.

Finally the direct approach to the material itself on the part of contemporary painters and sculptors, the concern with color as pigment, the interest in the surface as a surface, belongs to these artists as much as it does to the non-figurative painters and sculptors of our time. The material – the heavy pigmentation in de Kooning's "Women," the corroded surfaces of Richier's sculpture – help indeed in conveying the meaning. Dubuffet was one of the first artists who granted almost complete autonomy to his material when he did his famous "pastes" of the early 1940s. Even Francis Bacon wrote: "Painting in this sense tends towards a complete interlocking of image and paint, so that the image is in the paint and vice versa . . . I think that painting today is pure intuition and luck and taking advantage of what happens when you splash the stuff down."[4] But it is also important to remember that Dubuffet's or Bacon's forms never simply emerge from an undifferentiated id. These artists never abdicate their control of form.

The painters and sculptors discussed here have been open to a great many influences, have indeed sought to find affirmation in the art of the past. In addition to the art of this century – Picasso, Gonzales, Miró, Klee, Nolde, Soutine, etc. – they have learned to know primarily the arts of the non-Renaissance tradition: children's art, latrine art, and what Dubuffet calls *art brut*; the sculpture of the early Etruscans and the late Romans, the Aztecs, and Neolithic cultures. When these artist look to the past, it is the early and late civilizations which captivate them. And when they study an African carving, they are enraptured not so much by its plastic quality or its tactile values, but rather by its presence as a totemic image. They may appreciate the ancient tribal artist's formal sensibilities; they truly *envy* his shamanistic powers.

The artists represented here – painters and sculptors, European and American – have arrived at a highly interesting and perhaps significant imagery which is concomitant with their formal structures. This combination of contemporary form with a new kind of iconography developing into a "New Image" is the only element these artists hold in common. It cannot be emphasized too strongly that this is not a school, not a group, not a movement. In fact, few of these artists know each other and any similarities are the result of the time in which they live and see. They are individuals affirming their personal identity as artists in a time of stereotypes and standardizations which have affected not only life in general but also many of our contemporary art exhibitions. Because of the limitations of space, we could not include many artists whose work merits recognition. While it is hoped that the selection proves to be wise, it must also be said that it was the personal choice of the director of the exhibition.

15 DIRECTIONS IN KINETIC SCULPTURE

Lessing's definitive distinction between the plastic arts which exist in space and the temporal arts which develop in time could easily have been contradicted by all the ingenious moving objects which, in the course of centuries, probably have delighted the populace far more than the statue of the Laocoön.* Courts and fairs in the eighteenth century were filled with complicated clocks, mechanical magicians, wizards and conjurers, of fantastic automata and artificial singing birds. The latter, indeed, go back to antiquity and – as we know from Andersen's fairy tale – were present in the Imperial Courts of China. Bishop Lindfrand, in the account of his voyage to Constantinople in 949 A.D., describes the Byzantine Emperor's gilded trees inhabited by chanting mechanical birds; he also tells of bronze lions guarding the great royal throne – lions which could swing their tails and were able, on appropriate occasions, to roar with open mouths and trembling tongues.

In the first century A.D., Heron of Alexandria devised machines to perform religious magic: as the worshipper entered the temple, large doors swung open by themselves, a fine rain of holy water showered down, and bronze birds opened their beaks to sing. Robot priests seemed to perform incredible miracles by placing their hands into the sacred flames to bless them, then completing the curious service by dripping water from their hands to extinguish the flames. Two thousand years later, in the garden of the Museum of Modern Art, Tinguely's self-destroying machine burst into flames of its own volition. The firemen who were called in to preserve the safety of spectators succeeded in quenching flames, machine, and twenty centuries of mystery and holy fear in an ironic, Keystone-cops *finale* that was perhaps not inappropriate to Tinguely's original intention.

Most of the automata of the past were made primarily for public or private entertainment. Perhaps the most intricate device was a great duck which Jacques de Vaucanson built in the eighteenth century. This duck had wings articulated

* This essay originally appeared in *Direction in Kinetic Sculpture*. Reprinted by permission of the University Art Museum, University of California at Berkeley.

by 400 moving parts. It could chatter, eat, digest, and was able to waddle, to the great astonishment of spectators who traveled to see it from all over Europe. Earlier, Leonardo da Vinci devised a lion for Francis I which would walk toward the king and open its mouth to disclose a large bank of white lilies on a blue ground. Despite the eminence of its inventor, the lion was undoubtedly considered chiefly as a clever object for the distraction of the court. The time for a high art of motion had not yet come.

No matter how artfully constructed, the automata of the past could only repeat their actions. The complex clock displays on the towers of city halls, guild halls and churches, with their mechanical figures striking bells and performing dances, were always a great delight to gaping spectators. Some of these devices were poignant enough in their literary imagery, as when the figure of Death would appear and swing his scythe as the hour struck.

Tinguely's contemporary *méta-matics*, whose ballpoint pens, fixed in rapidly moving arms, make colored drawings to the accompaniment of great clamor and rattle, have their precedent in the *dessinateurs* of Pierre Jaquet-Droz. Jaquet-Droz, also a Swiss, constructed a mechanical doll in 1774 – only eight years after Lessing's *Laocoön* was published – which could make a charming drawing of a cupid riding a chariot which was drawn by a butterfly. The important difference between Tinguely's machine and that of his Swiss predecessor, however, is not the gratuitous result as opposed to that earlier decorative vignette, nor the loudly nervous energy expended by the *méta-matic* compared to the deliberate and calm movement of the *dessinateur*, but the fact that the latter could only make four different drawings when properly adjusted, whereas the modern machine's output is infinitely varied and operates according to the laws of chance. Modern kinetic sculpture is fortuitous, not predetermined. Or rather, it is designed to work at random.

Modern kinetic works are distinguished from all the automata of the past and the computers of the present in that their action attempts to be indeterminate. Only the weather vanes and the great fountains, the magnificent water plays at the Villa d'Este and Versailles depend not solely on vast, engineered constructions of dams and hydraulic pumps, but on the uncontrolled force of the wind as well; they give, therefore, a greater visual and temporal delight than the most complicated contrivances which operate only on repetitive mechanisms. Random motion caused by wind and falling water retain their fascination for contemporary artists. If the weather vanes of old have their modern counterparts in the ever-changing constellations of Calder and Rickey, the possibilities of water which currently occupy the talents of men like Hans Haacke, Heinz Mack, Norbert Kricke or Henk Peeters are truly inexhaustible. Richard Buckminster Fuller, cosmogonist, comprehensive designer and mathematician, recently commented on the main assumptions of two seminal theories in physics. His observations reveal important aspects of the attitudes which underlie the development of kinetic art and the artists who contribute to it:

> Einstein shattered the Newtonian cosmos . . . in the famous first law of dynamics, Newton had said that a body persisted in a state of rest or constant motion

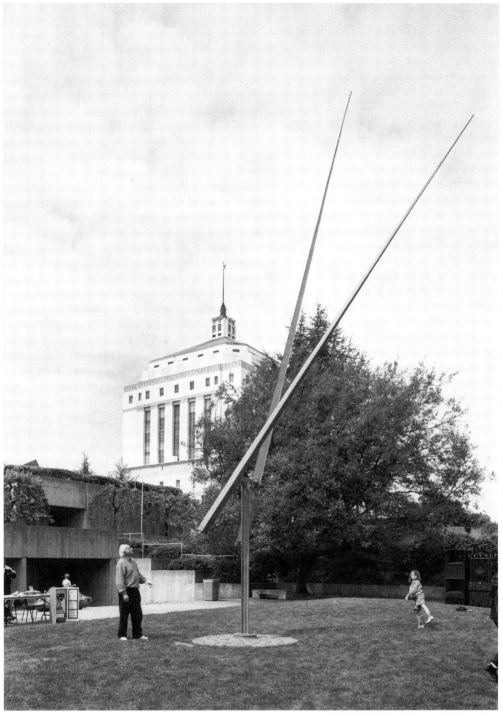

FIGURE 53. George Rickey, *Two Red Lines II*, 1967, painted stainless steel, 32' × 2'7", The Oakland Museum, California. Photo: Dennis Galloway.

except as it was affected by other bodies; he was assuming that the normal condition of all things was inertia. Einstein realized that all bodies were constantly being affected by other bodies, though, and this meant that their normal condition was not inertia at all but continuous motion and continuous change. The replacement of the Newtonian static norm by the Einsteinian dynamic norm really opened the way to modern science and technology, and it's still the biggest thing that is happening at this moment in history.[1]

The whole Cartesian universe, with its inherent schism between man's thought and the physical world, Lessing's neat distinctions between the arts of time and the arts of space, could no longer hold once Einstein's theory of the space-time continuum, in which time is a coordinate of space, had been accepted. Yet, even before the Theory of Relativity was announced, movement and the process of change had become a major concern among artists. When, in the early nineties, Claude Monet exhibited fifteen haystacks and then twenty views of the facade of Rouen Cathedral at Durand-Ruel in Paris, it became quite clear that the artist's subject matter was no longer the inert object, but rather, the process of change itself.

Although Rodin, in his statement about the significance of equilibrium and movement in sculpture, referred to the movement of light animating the surface textures and not to actual motion, it is important to realize that by making bronze surfaces subject to the play of light, Rodin, and even more, his contemporary Medardo Rosso, clearly revealed a new concern with the aspects of change. "Nothing is motionless," Rosso wrote, ". . . every object participates in the swift and multiple improvisations of nature."[2]

The Futurists of the next generation admired Rosso and considered him their unique precursor. But in 1912 Umberto Boccioni in his *Technical Manifesto of Futurist Sculpture* could say:

> The revolution of Medardo Rosso, although of the greatest importance, starts off from an external pictorial concept . . . it thus has the same strong points and defects as Impressionism in painting . . . In sculpture as in painting one cannot renovate without searching for THE STYLE OF THE MOVEMENT . . . by making systematic and definitive in a synthesis what Impressionism has given us as fragmentary, accidental, and thus analytical. . . . [3]

With a violent burst on the public consciousness, the Futurists demanded ". . . that universal dynamism must be rendered in painting as a dynamic sensation."[4] As they were conscious of the fact that ". . . all things move, all things run, all things are rapidly changing . . ."[5] they searched with the fervor of disciples to a new religion for the key which would translate their sense of the dynamic into painting and sculpture. Boccioni's bronze walking man, called *Unique Forms of Continuity in Space* of 1913 and Marcel Duchamp's related but earlier *Nude Descending a Staircase* (1912) are indeed imbued with all the energy of swift movement, even if the energy is still potential rather than kinetic. When Marcel Duchamp mounted a bicycle wheel on his studio stool, however, not only was he carrying out a gesture of Dada insolence, but his little construction turned the way a bicycle wheel does turn, and was therefore a moving object chosen by an artist. By 1920, Duchamp was spinning his rotating discs, pictorial jokes which

would generate the illusion of space. But he soon decided, as he told Richard Huelsenbeck, ". . . life was more interesting than aesthetics," and abdicated from the creation of anti-art as well as art.

Duchamp's friend Man Ray made the first "mobiles" by hanging paper spirals from the ceiling of his studio in Paris to enjoy their rotation. Man Ray also assembled coat hangers on springs in order to let them swing about freely, and in 1923 he put an eye into the wand of a metronome.

Motion and speed, the watermarks of the new epoch, have long since been accepted as integers of urban life in the twentieth century – integers which have altered the realities of the human condition. The Constructivist Vladimir Tatlin, when commissioned to build an architectural monument for the new Communist state, designed a gigantic tower of steel and glass, with a cylinder rotating once a year, a cone once a month, and a cube once a day. At the top, 900 feet in the air, there was to be a restaurant, affording its patrons a continually changing view. It is interesting to note that this monument, which was to be a tribute to modern technology and the symbol of a new way of life, was designed to function as a time-measuring device: in effect, it was to be a calendar, and thereby a first cousin to the guild hall clock-towers which measured the hours and days with performances of their mechanical parades.

In the new Russia, which at that time had not yet decided to return to time-worn aesthetic ideas, Alexander Rodchenko exhibited mobiles of circular hoops constantly turning within a large sphere containing them. At the same time large abstract moving sculptures were designed for parade decorations and stage sets in Leningrad.

A comparison of Man Ray's early "mobiles" with those by Rodchenko shows the two branches of kinetic art which were beginning to be distinguishable: on the one hand there was the playful preoccupation with the absurdities of using ready-mades – such as coat hangers – to make preposterous "works of art"; on the other hand there were the carefully designed kinetic objects of the Constructivists. The latter's position was rational, optimistic, an almost scientific attitude of research. The Constructivists and their heirs hoped to project and communicate a new "vision in motion."

Naum Gabo forecast a great deal of later work, such as the powerful bounding steel sculptures by Len Lye, when in 1920 he constructed a virtual volume from a weighted vertical steel spring set vibrating by a motor. This illusory body was entitled *Kinetic Sculpture*. At the same time he and his brother Antoine Pevsner issued their Realist Manifesto in Moscow in which they stated their belief that space and time are the two fundamental elements of art, that mass and volume are not the only means of sculptural expression, and they proclaimed their liberation "from the thousand-year-old error of art, originating in Egypt, that only static rhythms can be its elements. We proclaim that for present-day perception the most important elements of art are the kinetic rhythms. . . ."[6]

The Constructivist point of view was carried further and propagated by László Moholy-Nagy, who, with Alfred Kemény, issued a manifesto in the influential Berlin publication, *Der Sturm*. Here Moholy clearly saw into the future and formulated a theory of kinetic art which would not materialize for more than a generation. He advocated the activation of space by means of a dynamic-

constructive system of forces and hoped to substitute relationships of energies for the old relationships of form in art. He projected sculpture suspended freely in space, and was careful to point out that, for the time being, this work could only be experimental but that eventually the spectator, instead of being merely receptive in his observation, would be totally engaged as a participant in an event, experiencing "a heightening of his own faculties, and become himself an active partner with the forces unfolding themselves."[7]

This manifesto was published in 1922 just before Moholy joined the faculty of the Bauhaus. There he proceeded to construct his famous *Light Display Machine* (1922–1930), a motor-driven sculpture, connected to many colored light bulbs, which projected a constantly varied display of light and became the source of Moholy's film *Black, White and Gray*. Here solid mass is truly shattered by light and motion.

At the Bauhaus, Moholy's analytic mind and his concepts of free-moving sculpture encountered the work of Paul Klee for whom, too, nothing was static, to whom ". . . movement underlies the growth and decay of all things." Klee began his *Pedagogical Sketchbook*, written for instruction at the Bauhaus, in 1923, by speaking about ". . . an active line on a walk, moving freely, without goal . . ."[8] and writes metaphorically in the last section about the arrow who is the child of thought. Klee knew that ". . . pictorial art springs from movement, is in itself interrupted motion and is conceived as motion."[9] Klee's pictures, literally, have to be read in time, a device that he used to evoke the sensation of metamorphosis.

Kinetic sculpture was widely discussed at the Bauhaus and at its offshoot, The Institute of Design in Chicago. There Moholy-Nagy published his influential book, entitled *Vision in Motion*,[10] in which he postulates that kinetic sculpture is the fifth and last of the successive stages in the development of plastic form.

In the period between the wars, artists continued to experiment with kinesis. During these fertile years of experimentation, Alberto Giacometti, constantly searching for new sculptural concepts, ". . . was interested in the possibilities of obtaining actual kinetic movement and constructed his *Suspended Ball* in which a cloven sphere, held by a thread, can be made to slide along a crescent-shaped object."[11]

It was during that time that Alexander Calder's work reached its first stage of maturity. Calder had come to the attention of the Paris art world with the delightful miniature circus he produced during the late twenties. These articulated dolls and animals, made of wood, cork, yarn reels and wire, certainly are related to the animated toys of the past, but they also had the style and individuality of a modern artist: they were drawings in space as well as mechanically dancing and swinging figures. Soon thereafter Calder entered the field of abstract art, the result of a visit to the studio of Piet Mondrian in Paris in 1930. He intended at first to make three-dimensional vibrating Mondrians, but soon was making little sculptures which had to be moved by hand cranks or electric motors, and which were called "mobiles" by Marcel Duchamp. By the mid-thirties, however, he substituted mobiles which were driven at random by the wind and the air rather than mechanically. Here Alexander Calder introduced infinite, fortuitous variations into art. At the same time, he managed to make marvelous playthings of machines and his ". . . kinetic sculptures stir lightly, like leaves in the wind. His

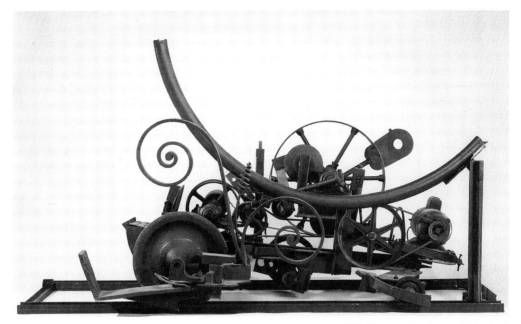

FIGURE 54. Jean Tinguely, *M.K. III*, 1964, steel, steel pipe section, iron wheel, rubber V-belt, flat belt, and electric motor, 36¼ × 82½ × 38½", The Museum of Fine Arts, Houston.

mobiles virtually create the space through which they move, and his work has been so satisfying, aesthetically, that he dominated the field until after the Second World War."[12] While to everyone's delight he has continued to make mobiles, Calder's most important contributions in recent years have been his solid yet open "stabiles," large sheets of iron which carve into space.

The kinetic artists of the postwar period, however, did not pursue Calder's example. In his review of the large Calder retrospective held at the Tate Gallery in 1962, George Rickey, whose own work is also moved by air currents, explained that Calder was too easily imitated, and ". . . he has ignored the vast possibilities of the kinetic art he introduced and left their realization to others mostly outside America and most indebted to constructivism rather than to him."[13]

Yet, although a new generation has explored new possibilities in kinetic sculpture, Calder remains a source of continual delight and joy. His graceful, precise biomorphic mobiles share their quality of playfulness with much of the more recent kinetic work. When we look at Robert Breer's *Styrofoam Floats*, those ridiculous white shapes creeping along the ground, art becomes fun once more. Charles Mattox's little machines are objects of irony: when his *Blue Seven* finally encounters the black ball, it is repulsed by its nasty growl. A little more fortunate, perhaps, is the little feeler in the *Act of Love* which manages to succeed in fondling the object of its affection, although it, too, is unable to establish union. Mattox's games are endowed by the viewer with human characteristics, as are Tinguely's self-deprecating machines that so rarely perform as expected.

Harry Kramer's contraptions, the least abstract works in this exhibition, appear at first glance as though they might be knicknacks produced by some tinker or hobbyist. Not at all; they are bewitched actors in a fairy tale: here is the big foot

which stands still but is all alive inside, here the chair with funny motors on its seat, there a stovepipe, which moves itself, inviting comparison with our sleekly enameled contrivances. Indeed, Harry Kramer, who has been active as a dancer, comedian, film maker and inventor of fabulous mechanical marionettes, has remained a choreographer. The objects which populate his studio are so light and transparent that they hardly seem to be present at all, until their little motors bring them back into the physical world. Kramer discourses on the close relationship of his sculpture to show business as he walks along the unbelievable Pop streets of Las Vegas.

Unlike actual machines, these objects – and all the others in this exhibition – serve no other purpose but their own. The function of kinetic sculpture is an aesthetic one; kinetic sculpture must be seen and judged by the continually changing aesthetic criteria of form and content. Its purpose may be to present an enchanted performance, like Kramer's, or the performance may indeed be frightening and overwhelming in its miraculous power, as when Len Lye unleashes his great *Flip and Two Twisters, "Trilogy"*. The function may also be an optical one, as in the constantly moving disks by von Graevenitz or in Fletcher Benton's disk in which six semicircles are programmed to transform themselves into the *Yin and Yang*.

Bruno Munari, next to Calder the most important precursor of present kinetic sculpture, departed from Futurism to build "useless machines" as early as 1934. An ingenious inventor, he adopted the Constructivist tradition to carry on early experiments with projected light. He also designs books, useful as well as useless objects, and makes kinetic sculpture. He feels that the artist has a clear and present social responsibility ". . . to help his fellow men to develop their understanding of the world in which we live."[14] Munari and his Italian friends and followers are involved in programmed art, a ". . . visual language which can naturally and intuitively communicate the dynamic factors determining our new knowledge of the world."[15] Although their work is abstract and follows Constructivist principles, certain associations drawn from the actual world with its social and psychological conditions are unavoidable and perhaps intended. "In Boriani's *Magnetic Surface*, particles of iron dust are transposed by mobile magnets into constantly ascending groups, only to disperse and disintegrate eventually as the filings descend to their original layer . . . it may be seen as an ontological comment on man's existence."[16] Similarly Pol Bury's sculptures may be seen as commentaries on mass societies, be they ant hills or cities. Yet these slowly moving pins, nails and balls may also be considered as experiments concerning the threshold of perception of visible motion – the point at which we can hardly distinguish mobility from immobility. The multiplicity of meaning and associations possible for kinetic sculpture distinguish such moving objects sharply from actual machines whose behavior they imitate.

Jean Tinguely's anti-machines are similarly sardonic metaphors on the world of the assembly line and conveyor belts. Tinguely seems a worthy successor to Charlie Chaplin, who, back in 1936 (*Modern Times*) characterized the factory as a madhouse. While our temper, our very existence, depends on machines, Tinguely questions them with a sense of humor and bestows on them a rattling human soul. Those who witnessed his splendid white structure, *Homage to New*

York, break itself to bits on that cold slushy evening in March of 1961 emphasized this large travesty on modern society, yet were also angry at the firemen who doused the burning piano and axed the big *méta-matic*: in our civilized culture even a machine wasn't allowed to commit its own suicide. Surely Tinguely's machines, his art of accident and transformation, has implications of which he himself is articulately aware. He told Dorothy Gees Seckler: "People have always tried to fix things into permanence because of their fear of death, but in reality, the only stable thing is movement. Our only chance is to make things move from the beginning, to allow them to eternally transform themselves."[17] Len Lye, whose pure Constructivist work is at the extreme opposite of Tinguely's accumulations of junk, would agree with this statement, it is so basic to the philosophy of kinetic sculpture.

The kinetic sculptor, working with movement and energy, has a much more self-assertive and optimistic attitude than had the leading artists of a previous generation. This is no longer an art of introspection, as in Abstract Expressionism and the New Figuration. If artists as different from each other as Willem de Kooning and Francis Bacon express the despair and irrationality so prevalent in our time, we are here dealing with a new generation which seems perhaps more affected by man's ability to leave the earth and move into outer space than by his failures on this planet. Perhaps this new optimism is partly due to the realization that mankind – thus far at least – seems to have been able to continue with some degree of coherence, even without those absolute values whose loss was so painful to a previous generation.

Kinetic art is more objective, more detached; there is far less stress on the individual act in this art which – by virtue of its essence – motion – tends to be anonymous. Indeed, many of the artists are members of teams, such as *Zero* (Düsseldorf), *Gruppo T* (Milan), *Gruppo N* (Padua), *Groupe de la Recherche d'Art Visuel* (Paris), *Equipó* 57 (Spain), and work more or less collectively. Their attitude, generally, is more rational and scientifically oriented to a point where Bruno Munari even recommends the use of computers for his programmed art. Nevertheless, it is still the highly individual and personal performance of kinetic sculptures by a Lye, a Rickey, a Takis and a Tinguely, which remains paramount.

The Movement Movement, as Hans Richter has referred to it, does not allow for the self-exploring process which was so basic to Abstract Expressionism or Tachism. Yet Action Painting was defined by Harold Rosenberg as an arena where the painter enacts his physical movement: ". . . the action on the canvas became its own representation,"[18] as the artist would explore his voyage into the unknown. This consciousness of action as the essence clearly relates Abstract Expressionism to Sartre, whose Existentialism emphasizes action as the only key to reality; it was Jean Paul Sartre who wrote the introduction to Calder's exhibition in Paris in 1946, in which he expressed his admiration for the sculptor's ". . . pure play of movement."[19] But in kinetic art, instead of retaining on canvas the imprint of expired action, the artist becomes the choreographer of his own work – he creates performances.

Recent developments in sculpture indicate that many sculptors are no longer interested in making pieces predestined for pedestals in living rooms or gardens. Since Kiesler's *Galaxies*, since the environmental sculptures of Ferber and Goeritz,

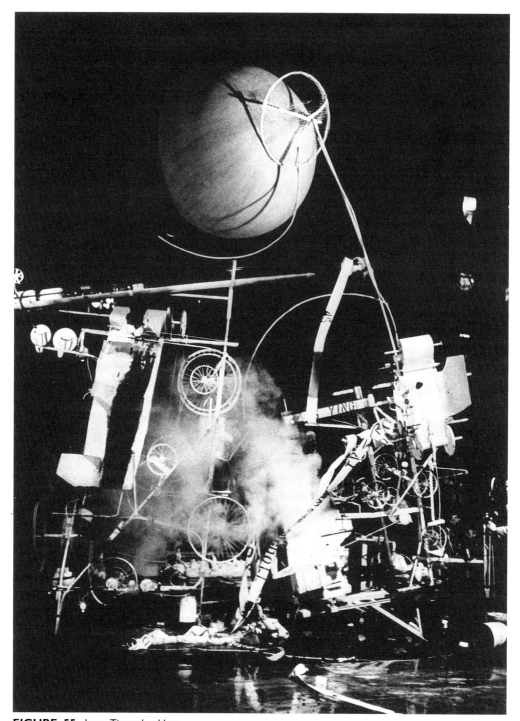

FIGURE 55. Jean Tinguely, *Homage to New York*, 1960, performance piece, the garden of the Museum of Modern Art, New York. Photo: David Gahr.

sculpture has assumed a new relationship with the spectator, who finds himself surrounded by the sculpture he is allowed to enter. In kinetic sculpture the viewer becomes engaged as a participant; he experiences sculpture in time, be

this a noisy neo-Dada performance staged by Tinguely, or the experience of quietly observing Rickey's silent blades of steel serenely measuring space in time. Hans Haacke makes the viewer an active participant. His surging *Waves* must be handled by the observer, who alone can bring them to life. Colombo hopes to engage the spectator into becoming a technician. Charles Mattox lets his *Oscillator Number 4* vibrate vigorously as we approach it; as we walk away, this apparently prescient device calms itself to silence again.

As the theatre has long since moved beyond the confines of the proscenium, so sculpture has moved from its pedestal. All the arts, it seems, are currently intent on the fuller engagement of the observer; in order to achieve this end, they tend toward some sort of Synaesthesia or *Gesamtkunstwerk*. Kinetic sculpture figures as an important element in this general development. Many of the sculptures make noises related to their form: Tinguely's machines rattle, Lye's bellow, and Bury's seem to chirp, while Takis's emit electronic sounds.

The creation of sculpture in motion has attracted artists who were previously engaged in other pursuits: Bury had been a poet, and Takis, too, wrote poetry while he was imprisoned as a member of the Greek Resistance during the war. Lye made abstract films which indeed anticipated his Tangible Motion sculptures. Breer is still primarily committed to the film. Rickey had been a historian and a painter, Munari is well known as an industrial designer and graphic artist, Kramer is a choreographer and dancer. Not only the areas of artistic endeavor, but indeed all fields of human imagination and thought seem to have a bearing on kinetic sculpture. If Kramer is more interested in show business, Takis is concerned with theories of physics and the scientific discoveries of outer space. Kinetic sculptors may be interested in Gestalt psychology, cybernetics, the Theory of Games and Information Theory. They must be consummate craftsmen as well as four-dimensional designers.

Making use of man's accomplishments in this multiplicity of fields, kinetic sculptors like Rickey and Bury achieve parallels to the movements in nature. Others, such as Tinguely, may comment on human society or hope to improve it by the example of their work, which seems to be a goal among the Italians. Or they may define this new universe of the twentieth century, in which matter and energy are indeed transformable, as Len Lye does when he dematerializes his mighty steel masses into visible energy, or Takis does when he permits the invisible energy of the magnet to enter into sculptural form. Takis uses a weightless force together with musical sound. He ". . . unites in him the hidden aspirations of our age: the dream of modern man to liberate himself from the tyranny of matter."[20]

UNITED STATES

16 MAX BECKMANN IN AMERICA

When J. B. Neumann first came to New York in 1923 one of his chief aims was to promote the art of Max Beckmann.* Neumann, a connoisseur who savored the best art of all periods and cultures, a wise and lovable man, a dealer passionately devoted to the work of his artists, had known Beckmann since 1912. He had published some of his graphics, had been his dealer, champion and friend, and in 1926 he mounted a Beckmann exhibition in his New Art Circle in New York, but there was little response. Additional shows, some with special issues of *Artlover* dedicated to Beckmann, were to follow.[1] Three years later Beckmann, who in Germany had now achieved a second period of national fame, received his first recognition in the United States when *The Loge* was given honorable mention at the Carnegie International in Pittsburgh. From Pittsburgh the show went to Baltimore and St. Louis and prompted America's most prestigious art critic of the time, Henry McBride, to write of the "dynamics of his brushes that even Picasso might envy . . . a personage to be reckoned with."[2]

In 1931 the recently established Museum of Modern Art organized the exhibition "German Painting and Sculpture." With six paintings and two gouaches, Beckmann had the largest single representation. Alfred H. Barr, who had organized this first exhibition of modern German art in America, reported the critical response in *Museum der Gegenwart*, quoting many of the leading critics. Whereas a conservative reviewer like Royal Cortissoz found, not unexpectedly, the work "raw, gross and uninteresting,"[3] more positive attitudes were manifested by other writers. McBride felt that Beckmann dominated the show. In an article in *The Arts*, Lloyd Goodrich found Beckmann's vitality "as brutal as any of the other expressionists, if not more so. He has a strength that they lack."[4] The young James Johnson Sweeney, writing for the *Chicago Evening Post*, compares Beckmann's *Family Portrait* to works by Grünewald, Bosch, and Brueghel and speaks of his

* This essay originally appeared in *Max Beckmann – Retrospective*, © 1984 (pp. 159–171). Reprinted by permission of Prestel Verlag, Munich, and the Saint Louis Art Museum.

"obsession for line, contour and volume," counting Beckmann "without question in the first rank of contemporary painters."[5]

In 1938 Curt Valentin, an erstwhile assistant to Alfred Flechtheim in Berlin, organized the first of ten Beckmann exhibitions at his New York Gallery (originally called Buchholz Gallery). This show, accompanied by a modest brochure with quotations from Alfred Barr and Waldemar George, was sent on to Los Angeles, San Francisco, Portland, and Seattle. The triptych *Departure* – its centerpiece – was also shown at The Museum of Modern Art's Tenth Anniversary Exhibition *Art in Our Time* in 1939. The museum acquired the painting three years later. In 1939 Beckmann also received a $1,000 prize for his second triptych, *Temptation*, at the Golden Gate International Exposition in San Francisco. Although prices for his work remained rather low for quite a long time, Beckmann's work began to sell in the United States.

In the spring of 1946 Curt Valentin exhibited fifteen paintings and as many drawings which Beckmann had done in Amsterdam between 1939 and 1945. It was an important occasion. Georg Swarzenski, the former director of the Städelsche Kunstinstitut in Frankfurt and a man thoroughly familiar with the master's work, wrote a brief introduction to the catalogue from Boston, saying "Perhaps never before has his imagination and his style of materialization gained such brightness and engaging persuasiveness."[6] And Beckmann's admirer, friend, and collector, Frederick Zimmermann, recalled later: "Here . . . we were seeing Max Beckmann in the fullness of his career, Beckmann in full control of the techniques and materials with which he was able to realize the rich moments of his powerful and penetrating vision."[7] *Time* magazine commented that "his fiery heavens, icy hells and bestial men showed why he is called Germany's greatest living artist. He has splashed on colors with the lavish hand of a man who wakes up to find a rainbow in his pocket."[8]

INVITATION FROM ST. LOUIS

It was at that time that he once more received calls from America. Henry Hope offered him a teaching position at Indiana University and Perry Rathbone, then the director of the City Art Museum of St. Louis, suggested an appointment at the art school of Washington University, which Beckmann accepted.

Like many artists of this century, Beckmann, however, was filled with heavy anxieties. As these offers for positions in America materialized Beckmann noted apprehensively in his diary:

> It is altogether quite hopeless – although it will probably work out. I still cannot find my way in this world. My heart is filled with the same dissatisfaction that it was forty years ago, only all the sensations diminish with age as the trivial end – death – approaches slowly. I wish I could be more prosaic and satisfied like the Philistines around me . . . Everything is falling apart. Hopeless . . . Oh, no, bad is life, is art – but what is better? The distant land – Oh save me you Great Unknown.[9]

The "Great Unknown" was not the distant land to which he was about to embark. It was death itself – both feared and welcomed. In the final years of his life he

more frequently mentioned death as well as the severe depressions he experienced. He often referred to his heart ailment, and the word *"Weh"* (pain) appears in the diaries in numerous places. Later on, in the remarks he made when receiving his honorary doctorate at Washington University, he said:

> Indulge in your subconscious, or intoxicate yourself with wine, for all I care, love the dance, love joy and melancholy, and even death! Yes, also death – as the final transition to the Great Unknown . . . [10]

These were hardly words normally associated with a formal acceptance speech at an official academic function. But we are dealing with a person who fought conventions all his life, as well as with a man who was now preoccupied with death. Yet together with all this anxiety there was a great affirmation of life. In the very next sentence of the acceptance speech he states:

> But above all you should love, love, love! Do not forget that every man, every tree and every flower is an individual worth thorough study and portrayal![11]

These remarks were made in the spring of 1950 when Beckmann was actually at the height of his renown in America. Three years earlier, before sailing to America, he wrote about the impending departure from Europe as "the last sensation – except death – which life can offer me."[12] Quappi and he sailed on the *S.S. Westerdam* on August 29, 1947, and found Thomas Mann as one of their co-passengers. But little interchange of ideas seems to have resulted from this fortuitous meeting of Germany's foremost painter and its leading writer.

After a brief stay in New York, the Beckmanns went to St. Louis, where his reputation had preceded him.[13] The artist enjoyed the gentle atmosphere of the old American Mississippi city. Provincial yet cosmopolitan, it reminded him of his old residence in Frankfurt. A man enormously attached to the physical aspects of life, Beckmann appreciated an atmosphere so much freer and opulent than his restricted life in Amsterdam had been. He liked meeting people, going to parties, dressing up for masquerades, visiting cabarets, drinking champagne. He often mentioned the food served at dinner parties as well as the people who attended. Perhaps he saw the physical aspects of life as a step to the metaphysical, perhaps he enjoyed them on their own account. After all, as he mentioned very early in his career, quality in art "is the feeling for the peach-colored glimmer of the skin, for the gleam of a nail, for the artistic-sensuous . . . for the appeal of the material."[14] While the style and meaning of his art had changed considerably since his early controversy with Franz Marc, the importance of the physicality of his work remained paramount. This certainly is one of the reasons why his paintings, with their chromatic splendor and dense interlace of warp and weft, have an immediate sensuous appeal which precedes any investigations of iconography.

FRIENDS AND STUDENTS

In St. Louis he enjoyed the company of H. W. Janson, who was the curator of Washington University's museum at the time. Above all, he became a close friend of Perry Rathbone, who organized a major retrospective and published a catalogue in which he wrote an important interpretation of Beckmann's work. This

exhibition, which traveled to Los Angeles, Detroit, Baltimore, and Minneapolis, helped cement the artist's reputation in America.

Assisted by Quappi, who acted as interpreter, Beckmann began to teach again after an interruption that began when the Nazis dismissed him from his teaching job in Frankfurt in 1933. "Art cannot be taught, but the way of art can be taught," he asserted in an interview.[15] His teaching position at Washington University was actually a temporary one, vacated by Philip Guston, who had received a Guggenheim Fellowship succeeded by a Prix de Rome. Guston himself had admired Beckmann's work when he first saw it at Curt Valentin's 1938 exhibition and at that time he bought a monograph on the older artist.[16] He was always fascinated by what he referred to as Beckmann's "compressed" and "loaded" pictures.[17] And there is no doubt that the experience of Beckmann's work – not only his upturned figures with legs sticking in the air or ladders pointing into infinity – had a significant impact on the American painter. In Guston's late work, as in Beckmann's, there is also a particular combination of everyday reality which makes palpable an assumed strangeness and fantasy. There is furthermore a deep sense of the tragic in the work of both artists and a close affinity in their ultimate attitude toward art and its purpose. Beckmann might have stated what Guston stressed in 1965:

> Frustration is one of the great things in art; satisfaction is nothing . . . I do not think of modern art as Modern Art. The problem started long ago, and the question is: Can there be any art at all? Maybe this is the content of modern art.[18]

Stephen Greene, a former student of Guston's who joined him as instructor at Washington University a year before Beckmann's arrival, also admired the German painter for his "crowded, firmly molded compositions," as H. W. Janson observed in 1948.[19] And Greene affirms that "I still deeply admire the man. [His work] has a psychological power, a strong formal manner, it stays as the signpost of what I most admire in twentieth century painting."[20]

Both Guston and Greene had left by the time Beckmann arrived in St. Louis, but his impact continued to be felt by other artists who were his students, such as Nathan Oliveira, who studied with him at Mills College in the summer of 1950 and who recalled that "most of all he was concerned with his own vision and dream and this was critical to me."[21]

Beckmann had painted many portraits of his wife and intimate companion over the years. *Quappi in Gray*, completed in 1948, was one of the last of these likenesses that covered a great range of moods and attitudes. In this portrait she appears with poised assurance, seated with arms crossed in a self-protective manner, holding the world at a distance. This is quite a different portrayal from the more open, pliant, and freer depictions of Quappi in earlier pictures. Much of the mood of this painting is established by the muted colors of related browns, greens, and grays as well as by the narrow, vertical format and the device of framing the sitter rather tightly between a curtain on the right and what appears to be a ladder – a frequent emblem of Beckmann's personal iconography – on the left.

The students at Washington University held regular masquerade parties which

Beckmann greatly enjoyed. The mask, the world of make-believe, the mardi gras were very much part of his life and work. Over the years he portrayed himself in his paintings, prints, and drawings as clown, sailor, musician, sculptor, prisoner, man of the world, ringmaster, and frequently as actor. But he was also the observer, the *flaneur*, who looked at the world as a ship of fools. As with some of the scenes of the 1920s with similar themes, *Masquerade* of 1948 is not a frolicking affair, but a vision of death. The strong man with his absurd satanic mask, tiny top hat, and large club confronts the stout cat lady who bears a large human skull in her right hand.

IMAGES IN THE NEW COUNTRY

Beckmann generally accepted invitations to speak in different cities. In February 1948 he gave a lecture at Stephens College in Columbia, Missouri. This lecture, in the form of "Letters to a Woman Painter," encapsulates many of his thoughts about art, philosophy, religion, and life. One wonders what the young ladies of the college might have thought when Quappi read to them a passage such as:

> Have you not sometimes been with me in the deep hollow of the champagne glass where red lobsters crawl around and black waiters serve red rhumbas which make the blood course through your veins as if to a wild dance?![22]

But this query does furnish deeper understanding of the artist's own visual fantasy and provides greater insight into the meaning of a painting like *Cabins*, which was done in the summer of 1948.

The Beckmanns returned to Holland in the summer of 1948 to take care of their American visas as well as to see friends and make arrangements for a permanent move from Europe to America. *Cabins*, painted in Amsterdam directly after their arrival, was Beckmann's immediate response to the trans-Atlantic passage. It is a difficult, hermetic picture. Life on the ship is seen from its vortex. The narration does not follow linear order or time; different space cells do not mesh. A large fish with an enormous eye in the center of the painting forms a powerful diagonal thrust across the darkly painted surface. But the fish is white, like Moby Dick. A sailor, probably Beckmann himself, is trying to take hold of the monster which is tied to a board. Behind, below, above, and on the sides are episodes of the shifting facets of human life in its passage. Directly above the sailor a violent drama is being staged in this mystery play, while a mourning scene can be observed behind the window on the upper left. Below there is a voluptuous girl lying seductively on a couch. In the upper right a young blonde is combing her long hair. Below a young woman is seen drawing the picture of a ship while large white flowers bloom behind her. A ship sailing at sea inside a life raft on its side is seen on the right edge and the elevation of a blue house on the extreme left. A party seems to be taking place behind the porthole in the lower center. The two blue and orange columns cross the picture diagonally at right angles to the fish: there is no stability. In fact the make-believe world is in a state of collapse, and the sailor will never gain possession of the fish.

While working on this picture in his old Amsterdam studio, the artist began working on *Fisherwomen*, which he completed after his return to St. Louis. The

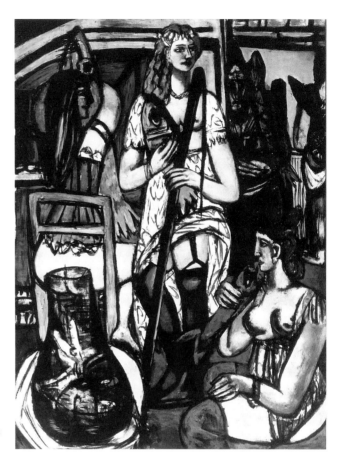

FIGURE 56. *Fisherwomen*, 1948, oil on canvas, 75¼ × 55¼", The Saint Louis Museum of Art.

fish in this picture appear to stand for phalli. Beckmann actually explained the meaning of the fish in his work to his old friend, W. R. Valentiner, who visited him in Amsterdam in July 1948 while he was working on this painting. In a "half serious, half satirical" manner he told Valentiner "that man originated in the sea and that we all derive from the fishes, that every male still has something of a particular fish about him, some are like carps, others like sharks, others like eels, which clearly reveal themselves in their love of life."[23] In this painting the phallic-looking fish are held by sensuous young women in seductive gestures. "These women," Beckmann told Quappi, "are fishing for husbands, not lovers."[24] The three nubile girls make use of all their female allurements: the black and green stockings and garters, negligees and tight corsets, uncovered breasts and thighs. The exposed buttocks of one of the creatures is seen through the neck of a suggestively placed vase. The provocative sexuality of the three young women is contrasted to the withered old hag, holding a thin green fish in the background, a juxtaposition which the artist also used in the slightly earlier Amsterdam painting, *Girls' Room (Siesta)*, where the interlocking bodies of young girls in suggestive poses are contrasted to an old crone who seems to be reading to them. The figures and objects in *Fisherwomen*, outlined by bold and heavy black lines, not only fill the available space, but they crowd it to the point of overload. After all, "It is not

subject which matters, but the translation of the subject into the abstraction of the surface by means of painting."[25]

Beckmann always worked on several canvases simultaneously and all during this time he was involved in the completion of his triptych, *Beginning*, which he had started in Amsterdam in 1946. It was the most autobiographical of his trip-tychs and called forth many early memories. Not long after its completion in the spring of 1949 he set out to Colorado, where he taught at the University during the summer. He liked the Rocky Mountains, managed to do a good deal of climbing despite the high altitude, and made fine drawings such as *Park in Boulder*. He then went on to New York, where he had accepted a permanent teaching position at the Brooklyn Museum School, a job in which he took great interest. His arrival in New York coincided with the greatest moment for Abstract Expressionism, but Beckmann remained isolated from it, just as he had always stayed aloof from all the art movements of his time.[26] Indeed, pure abstraction held little interest for an artist who had stated in his London lecture: "I hardly need to abstract things, for each object is unreal enough already, so unreal that I can only make it real by painting it."[27]

LIFE IN NEW YORK

Except for his own circle of friends, collectors, admirers, and students Beckmann remained relatively isolated in New York but certainly enjoyed being a celebrated European artist. In October he received First Prize at the Carnegie International for his *Fisherwomen*. Göpel lists no less than 23 exhibitions in 1950, 15 of which were held in the United States.[28] Living in New York, first in the Gramercy Park section and later on the Upper West Side, he delighted in going to the elegant bars at the St. Regis and Plaza hotels, not only to look at the passing scene but also to be seen. He explored Chinatown and the Bowery as well as the seedy dance halls of Times Square. In the winter he went for walks and fed the squirrels in the snow in Prospect Park.

The still-life, like the landscape, was always an important subject in Beck-mann's oeuvre. His love for the material aspect of the world found its expression in these "feasts for the eyes." Often the colors create an ensemble of great richness, as in his *Large Still-Life with Black Sculpture*. Again the space is completely filled and the work seems almost noisy with clutter and agitation. There is clearly a *horror vacuii* in much of Beckmann's work, who would speak of his fear of being crushed by the "dark holes of space" and of painting "to protect myself from the infinity of space."[29] It is this impinging of objects on each other which negates any sense of stillness in most of Beckmann's still-lifes. In this canvas the flame of a candle gently outlines the classical sculpture. There is a bowl filled with fish, another candle, a nautilus shell, a group of pears, an epiphyllum plant which bends its blossom toward the sculpture. The lower part of the ornate mirror reflects additional objects which are not on the right table. "Many mirrors are necessary to see behind the mirror,"[30] the artist wrote in his diary just before embarking on this painting. The sickle of the new moon is seen outside the window and on the left is once more the grid of a ladder, set at a diagonal and

occupying a frontal plane. Tucked away near the plant is a copy of *Time* magazine. This piece of current reality prevents any illusion of the still-life from gaining sway and, once discovered, has an alienating effect similar to Brecht's contemporaneous theatre. The painting is certainly indebted to similar and earlier compositions by Matisse and Picasso. Beckmann's painting, however, has greater density; it is filled with ambiguities and enigmas. The Parisian painters would never have introduced a rising moon with all its romantic implications in a still-life painting or held it in place with a segment of a ladder.

Goethe once wrote that "everything is symbol," meaning that everything stands for another thing, transcends itself, be it the ladder or the gigantic figure with outstretched legs in *Falling Man*. Beckmann said that it represents man falling through the sky on his way to earth.[31] But, undoubtedly filled with premonitions of dying, the picture stands for death and quite possibly Beckmann's belief in some sort of reincarnation into "another state of being."[32] The man travels past the burning dwellings of mankind toward magnificent burgeoning plants while supernatural beings – magical birds or angels – float in ethereal boats. The semi-circular object on the left has been interpreted as the railing of a balcony and as the wheel of time. Much of the painting is taken up by the intense azure sky. Never before had Beckmann opened up a picture in this manner in order to make room for space, which, although confined between the buildings, is infinite and without horizon. Ten years after expressing his fear of space in his London lecture, he stated: "For in the beginning there was space, that frightening invention of the Force of the Universe. Time is the invention of mankind, space or volume, the place of the gods."[33]

Soon after completing this transcendent picture, the artist painted a hellish vision, *The Town*. It is closely related to his earlier masterpiece, *The Night*, done more than thirty years earlier. Again the viewer witnesses a horrible act of torture. But now the grayish tints are replaced with rich and heavy colors, the brush stroke is looser, the forms less angular. The visual flow is smoother, but the space is again a claustrophobic room. Instead of the emaciated man being gagged to death on a wooden bench, the central figure has become the voluptuous body of a bound woman on a bier with phallic bedposts. This dominant figure is again surrounded by tormentors, but here they are more symbolic and sardonic than the more literal – but also cryptic – torturers in the earlier picture. In fact no mutilation takes place in *The Town*. The figures in the back, standing in a row, are all different in scale, creating a spatial discontinuum and dissonance, "so that some of the bewildering qualities of a large metropolis are conveyed directly by this means."[34] According to Beckmann's wife, the figures from left to right represent a prostitute, a disillusioned man, a guardsman, a cynic, and a street musician. There is a bar or bordello on the right. Below the bar lies a bottle of champagne, marked "REIMS". The monkey with the mirror might represent vanity, and the naked figure picking up coins in the center suggests avarice. The sphinx with the postman's cap holds a letter addressed to MB. Is he perhaps the messenger of death in medieval symbolism? The skyscrapers with human heads in the background "signifiy nothing in particular."[35] On the left bottom there is the familiar ladder stopping in mid-air.

The central figure of the nude in splayed pose, taken quite directly from the

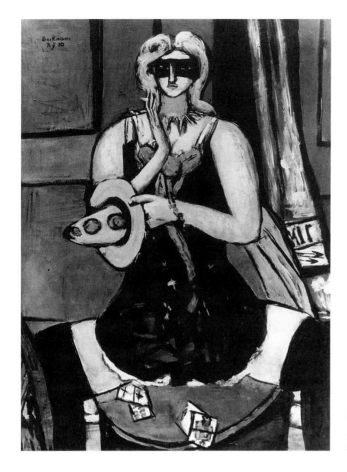

FIGURE 57. *Carnival Mask, Green, Violet, and Pink*, 1950, oil on canvas, 53½ × 39½", The Saint Louis Museum of Art.

Reclining Nude of 1929, is derived ultimately from the classical sleeping Venus or Odalisque, but she is no longer an idealized nude. Instead she represents Lulu, the Earth Spirit, who is about to be sacrificed in some sort of Black Mass by the demonic and disillusioned denizens of an infernal city at night. In the painting, as in other late works, events from daily life are intermingled with dream, fantasy, and myth into an allegory which conveys the ambiguities of existence. Beckmann, like Kafka, who was born just a year before him, presents the absurdity of the human condition by the use of tangible but enigmatic objects and personae.

While working on *The Town* Beckmann painted a major picture to which he first referred in his diary as "Pierette," then as "Yellow Stockings" and also as "Mardi Gras Nude." Curt Valentin called the painting "Mlle D." and it is now usually known as *Columbine or Carnival Mask, Green, Violet, and Pink*. Like Picasso, Beckmann often painted circus performers, mountebanks, clowns, saltimbanques, harlequins, and pierrots – people who like artists exist on the fringes of society. Columbine wears a black face mask and carries a pink pierrot's hat in her left hand. Her right hand, holding a cigarette, is raised to her long grayish-blonde hair. Her red lips are sealed. The woman is placed against a purple wall, interrupted by a green curtain, and is seated either on a chair with round seat or a blue drum. Its surface is covered with playing cards, "marked with rough crosses, suggesting death,"[36] that seem to be thrown out carelessly in front of her lap.

As Friedhelm Fischer has pointed out in his analysis of this painting, both the discordant color and the woman's body are foreboding. It is a threatening painting with this dark Columbine as a monster, an archetypal image of woman, both seductively inviting and ominously menacing. Beckmann was greatly interested in Gnosticism as well as theosophy, and owned a copy of Helena Blavatsky's *The Secret Doctrine*. He had read Carl G. Jung's essay on "The Relation between the Ego and Unconscious"[37] and was probably intrigued by Jung's theory of archetypal unities between the personal and the collective unconscious, the tragic and the timeless, as revealed in this, one of his most powerful and memorable paintings.

The picture was painted in 1950, a year in which two artists of the next generation, Jean Dubuffet and Willem de Kooning, were also occupied with the female image. Beckmann's woman is very flattened out. Except for the volume indicated around her shoulders, she is almost two-dimensional, a feature which is carried much further still in Dubuffet's grotesque *Corps de Dames*, where the female body is totally lateral to the picture plane, indeed becoming a pictorial flatbed. The body of Beckmann's Columbine looks as though it had been wrenched apart and reassembled in an inhuman, hieroglyphic form.[38] Again de Kooning, using a more Expressionist brush stroke, goes one step further in his series of *Women*, called Black Goddesses at one time. The parts of the body – arms and legs, buttocks and breasts – are almost interchangeable in his wildly distorted paintings. Both Dubuffet's and de Kooning's women, however, are endowed with cruel grins while this figure confronts us with a fearful, cold stare.

Ever since his early youth – he painted his first self-portrait at 15 and it is the earliest painting which the artist preserved – "Beckmann held the mirror to his face, studied his personality and his reaction to the world and the world's to his personality . . . Nobody since Rembrandt has examined his own physiognomy with such penetration as Max Beckmann"[39] (see Fig. 28). He completed his last *Self-Portrait* between January and May 1950 during a time of extraordinary activity of painting, teaching, travelling, reading, exploring, even moving to a new apartment in New York. In this final self-portrait Beckmann looks drawn, tired, exhausted – but still defiant and perhaps more elusive than ever before. He draws on his cigarette as though for nourishment and leans against the arm of a high chair. The large flashing eyes of Beckmann, always the observer, are watching. Behind him looms yet another new canvas. The most startling thing about this picture, however, is the brilliant color: the unrelieved cobalt blue of the jacket, the bright orange shirt, the green chair – all against the dark maroon back wall. The very brightness of the colors contributes to the two-dimensional appearance of the painting; their disparate, almost cruel quality give an insolent air to this wistful figure.[40]

TRAVELS IN CALIFORNIA

Soon after the *Self-Portrait* was completed, he left New York for another stint of teaching summer school – this time at Mills College in Oakland, California. On the way he stopped in St. Louis to accept his Honorary Doctorate degree at Washington University, travelled to Los Angeles to renew his old acquaintanceship

with W. R. Valentiner, and then he stayed in Carmel for a month's vacation. He was greatly impressed by the Pacific coast. He wrote about the sea lions he saw at Pebble Beach and indeed painted a picture of them, piled up on a rock, after his return to New York. He was fascinated by the big eucalyptus trees and especially by the giant birds,[41] but he also expressed great concern about the outbreak of a new war in Korea. At Mills College he was received by Fred Neumeyer, who previously had invited Lyonel Feininger, László Moholy-Nagy and Fernand Léger to teach at the Mills summer session. Neumeyer remembered Beckmann looking like a bulldog wearing a white tuxedo; he commented on discussions with the artist about Hölderlin and Schopenhauer, Greek, Indian mythology, and the Cabbala.[42] While at Mills, Beckmann could see the whole range of his later work in an exhibition of paintings from the collection of his great patron, Stephan Lackner.

West Park and *Mill in Eucalyptus Grove* were painted in New York immediately after his return and represent his impression of the Mills College campus. *San Francisco* (see Fig. 50), based on a cursory drawing in his diary, is one of Beckmann's rare cityscapes. Like Kokoschka's portraits of the cities of Europe, it is a panoramic view seen from a high vantage point. *San Francisco* is a brilliantly colored, very dynamic painting with the curved arrow of Doyle Drive rushing past the Palace of Fine Arts toward the heart of a city which itself appears to be vibrating. A crescent moon and a sunset appear in the eastern sky in Beckmann's painting, which combines several aspects of the city seen from different viewpoints. In the immediate foreground he has placed three black crosses apparently stuck into the black earth of the curving ground. On the right above his signature is the fragment of a ladder.

Religious subjects occur frequently in Beckmann's early oeuvre, both in the more traditional paintings such as *The Flood, The Crucifixion*, or the huge Rubensian *Resurrection* canvas during his early romantic period, and also in more Gothic and expressive scenes such as the *Deposition* of 1917. In his late work, however, he veiled his message in more cryptic imagery, adopting instead the sacramental form of late German medieval altarpieces. In 1932, at the age of 48, he began a series of triptychs, completing nine and leaving one unfinished at the time of his death. Without doubt the paintings, which took the greatest concentration and show the deepest profundity, are those in which he was able to synthesize reality and fantasy, the known and the unknown, most completely. In his diaries he refers to them as "Triptiks" (sic), which is the German word for the papers a motorist needs in order to cross the borders. Indeed, Beckmann used these major works to charter his trip through life. These paintings are often hermetic and esoteric, and in his London lecture he cites the Cabbala, saying:

> What I want to show in my work is the idea which hides itself behind so-called reality. I am seeking for the bridge which leads from the visible to the invisible, like the famous cabbalist who once said: "If you wish to get hold of the invisible, you must penetrate as deeply as possible into the visible."[43]

Their message, ambiguous and often concealed, is best comprehended by initiated individuals who have the proper set of mind and feeling. In a letter of 1938 in regard to *Departure* he wrote to Curt Valentin:

. . . If people cannot understand it of their own accord, of their own inner 'creative empathy,' there is no sense in showing it . . . I can only speak to people who consciously or unconsciously, already carry within them a similar metaphysical code.[44]

As we know, Beckmann always worked on several paintings at the same time. Before completing the *Argonauts* he had started *Ballet Rehearsal* telling his wife that "this triptych would not give him much trouble and it would be completed in a much shorter time than all the others. This one would become a humorous and gay triptych."[45]

Left unfinished, this work permits us to observe how the artist committed his first ideas to a canvas which might, in fact, have taken a long time to finish. It reveals his methods in painting, showing all the steps from the original charcoal black outlines to the introduction of oil paint. In his first diary entry on December 3, 1950, referring to this triptych, Beckmann calls it "Artistinnen" (circus performers), and indeed the women on the left wing are ballet dancers which gave the triptych its later name. But on December 5, when, presumably, he was working on the center panel, he referred to it as "Amazons," which recalls his early *Battle of the Amazons*, in which life is asserted with a Nietzschean vitalism and "Will to Power," and where the women are slaughtered in a violent battle with men. Now in this last painting, the only indication of a male is the face (perhaps Beckmann's) which seems to peer through the porthole in the right wing. Except for the lone voyeur, this is a world in which only women are in attendance.[46]

THE LAST TRIPTYCH

Beckmann's last completed triptych, *Argonauts*, can be seen as his testament. The left panel, originally called "The Artist and His Model," shows the painter practically attacking his canvas. The man resembles van Gogh in Gauguin's portrait of his painter friend at work; during the time in which Beckmann worked on the triptych – March 1949–December 1950 – his diaries contain a number of very sympathetic references to "Vincent." In April 1949, for instance, Beckmann noted that he was re-reading van Gogh's letters and in November he went to see the van Gogh exhibition at The Metropolitan Museum. Beckmann must have identified with the energetic painter, yet it is the mask on which the woman is seated which has the greatest resemblance to his features. The woman, representing Medea[47] in the Argonaut saga, brandishes a sword which also looks like a symbol of virility. She can be seen as threatening, but she is probably meant to be a protectoress or an inspiring muse.

The right panel depicts the chorus of Greek tragedy – the intermediary between the action on the stage and the audience. Its purpose is to provide psychological distance and dramatic structure by means of measured comment. Beckmann's chorus is a chamber orchestra of beautiful, calm women playing and singing. While it is for the man to create and to engage in the adventure of life, it is the woman holding a sword who guards or inspires his genius, or the woman with guitar singing of his exploits. The right wing with the women rising in tiers, the stringed instruments on their necks reversed to fit into the oblong composition,

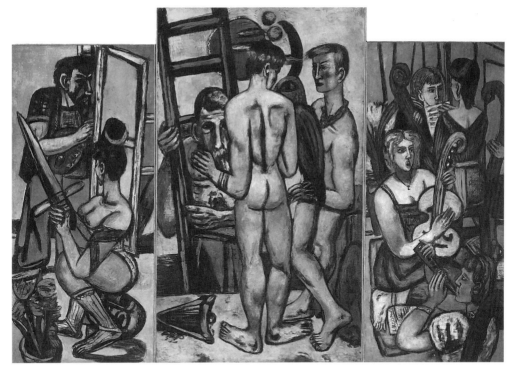

FIGURE 58. *The Argonauts*, 1950, oil on canvas triptych. Left panel: 72½ × 33½", center panel: 81 × 48", right panel 72½ × 33½", National Gallery of Art, Washington.

and the deeply reverberating colors which resemble stained glass combine in one of the most beautifully resolved paintings in Beckmann's oeuvre.

The painter's canvas in the left wing forms an acute triangle with the ladder in the central panel. The two are related. In fact in south German dialect the world *Staffelei* signifies both an artist's easel as well as a ladder. The ladder had often served Beckmann as a symbol of anguish, longing, and fulfillment in the same manner as the canvas is the artist's proving ground. Here the ladder no longer stands empty. The wise old man emerging from the sea has withstood all his trials and has completed the long journey. He now beckons with a prophetic gesture to the two young Argonauts setting out on their heroic adventure. On the right is Jason, a beautiful youth – the final state of an ideal figure which occupied Beckmann for a lifetime and made its first appearance in *Young Men by the Sea* in 1905; we see the same basic composition again in 1943. Both these paintings were important landmarks in his career. The composition is also related to paintings by Hans von Marées, a painter whom Beckmann always held in high esteem. The elbow of Jason rests on red rocks, their color inspired by the Garden of the Gods in the Rocky Mountains near Boulder. On his wrist is a fabulous bird whose blue head, and brown and green feathers, may refer to the magical wryneck which Aphrodite gave Jason to help Argonauts pass through the Clashing Rocks of Symplegades. The gentle youth in the center, adorned with a wreath of flowers in his hair and golden bracelets on his arm, must be Orpheus, whose orange lyre lies on the yellow beach beside him. According to Apollonios of Rhodes, Orpheus was the first of the large crew of Greek heroes enrolled by Jason to sail the *Argo*.

The old man may be Phineus, the king who had advised the Argonauts to send a dove out from their boat to explore the way, and who had been blinded by the gods for prophesying the future. But he may also be Glaucus, builder of the *Argo*, who later became a sea god endowed with the gift of prophesy.

The painting may at least in part be indebted to the interpretation of the Argonaut myth by the Swiss cultural historian, J. J. Bachofen, which was known to Beckmann.[48] Bachofen saw the myth, which describes the first encounter of the Greeks with the barbarians, as referring to the revolutionary change from a more ancient culture in which the "female principle" and greater harmony with nature prevailed over a culture of male dominance and Promethean striving.[49]

In the pink sky above the heroes Beckmann painted a purple eclipse of the sun, outlined by a fiery orange ring. On September 5, 1949, he expressed his astonishment when reading about sun spots in Humboldt and wrote: "I never knew that the sun is dark – very shaken."[50] Two orange new planets were included at this historic moment and they orbit between the sun and the crescent of the waxing moon.

The space in *Argonauts*, when compared with the earlier triptychs and other compositions, is less jammed. The painting is not as violent or disparate, but is imbued with calm serenity and measure. The struggle between good and evil, the old dichotomy of black and white, no longer fully engaged the mature painter. He is now concerned with that spark of human activity which beckons to the great adventure, the quest for the Golden Fleece, and beyond that, to the achievement of peace and transfiguration. The old man-god points, as Beckmann might have said, to a plane of different consciousness.

On December 17, 1950, Beckmann sent his last letter to his son. He wrote: "I am just painting a triptych, *Argonauts*, and in 'Dodona' we shall see each other again."[51] This was ten days before he died. Dodona was the sanctuary of Zeus where an ancient sacred oak communicated the will of the god by the rustle of its leaves to those mortals who could understand the sound.

17 SAM FRANCIS

BLUE BALLS

In the winter of 1960 Sam Francis called his Paris dealer, Jean Fournier, inviting him to his Arcueil studio to see his new work.* Fournier recalls that the large space was covered with paintings and gouaches in white and blue, edge to edge, extending across the floor and standing against the walls. He confronted them in a state of perplexity.[1] In these paintings blue spheres, spirals, globules, and amorphous forms float around the white centers which they envelop. They appear like clouds against the sky, except that the blue-white relationship is reversed. These circles are limpid translucent balls and bubbles of energy moving through space.

When the mysterious series of Blue Balls were first exhibited at the Galerie Kornfeld in Bern in 1961, the response was also one of puzzlement. Critics, accustomed to Francis's bright color-explosions of the 1950s, did not know how to respond to this apparent break in continuity. By contrast, in Japan, the response was positive. Maintaining the tradition of Chinese and Japanese literati painting, in which poetry is often inscribed on the painting as a personal expression of admiration for the artist, Makoto Ooka and Yoshiaki Tono wrote poems about the Blue Ball paintings when some of the Tokyo works were exhibited at the Minami Gallery in 1961. It was not until 1967 that a group of them were finally seen in New York at an exhibition at the Pierre Matisse Gallery. The xenophobic situation in New York precluded an enthusiastic reception on the part of most critics to this exhibition by an outsider. Few were aware at the time of the deep significance of the work by the artist whom James Johnson Sweeney considered "the most sensuous and sensitive American painter of his generation."[2]

The canvases were painted by the artist then travelling and working in Paris, Bern, Tokyo, Santa Barbara and Los Angeles. They have now been assembled for the first time from European, Japanese and American collections, making it possible at last to form a fresh vision of these radical paintings.

Much of Francis's work can be seen as a series of dialogues between fullness

* This essay originally appeared in *Sam Francis: Blue Balls*, Gagosian Gallery, New York.

FIGURE 59. *Blue Balls*, 1960, oil on canvas, 90¾ × 78¾", National Museum of American Art, Washington.

and void, instinct and thought, energy and tranquility, contraction and distension, color and space. The artist, deeply attentive to symbolic meaning, also refers to the dichotomies of masculine–feminine and heaven–earth. Francis had widely travelled, painted large and brilliantly-colored canvases in Tokyo and completed a major mural for the Chase Manhattan Bank in New York before returning to his Paris studio in 1960. Suddenly he relinquished a dazzling palette and the energetic, jubilant compositions of the later 1950s, paintings which recall fireworks or richly colored fantasies in stained glass, for a series of paintings which were limited to the dialogue between blue and white. This modification was not so much a voluntary action on the part of the artist as an intuitive process, like the "intentionless intention" of haiku poetry.

The controlled accident, so central to Francis's work as well as to Abstract Expressionism in general, finds a parallel in *sumi* painting, which is characterized by disciplined spontaneity. On his first visit to Japan in 1957 Francis experienced a sense of *déjà vu*, "a return to the non-rational," and felt very much at home there. In turn, Japan, with a tradition that considers art, above all, as meditative experience, almost immediately responded with sympathy to Francis's work. Instead of imposing virtuosity and skill on the medium, the Japanese artist sees the material itself and the working process as eliciting a new consciousness, which becomes the work. Unlike the Western tradition, man is not seen as the center of the universe. Although Francis shares the importance of painting-as-process, as well as the largeness of scale with his Abstract Expressionist colleagues, his painting, evoking light and space, is also closely attuned to the Japanese sense of aesthetics.

This is not to say that Francis stood outside the Western tradition. Hegel, after all, a solid protagonist of this ethos, conceptualized the goal of human activity as the dissolution into the spirit and saw art as its reflection, which the spirit produced for its own contemplation. This attitude, basic to the Romantic ideal, found its echo in the work of a great many artists in the last two centuries – including American painting of the postwar period.

A lifelong student, if not of Hegelian then of Jungian philosophy, Francis told the French critic Yves Michaud, "The psyche is my only reality. The spirit is what directs the intellect . . . you have to use your intellect the minute the spirit appears. The intellect is an organ of the spirit, developed by the spirit."[3] Typically, when Francis speaks of his admiration of Malevich, whose work he discovered earlier than other artists of his generation, he sees the Russian artist as an "emotional intuitive painter" whose subject matter was pure feeling, which he was able to distill into physical and sensuous artifacts. And for Francis, a painting is indeed a sensuous object. Therefore, when he decided to leave his native California in 1950, Francis chose to go to Paris rather than New York, because he felt an insistent attraction to the French pictorial sensibility – to Cézanne, Bonnard, Matisse, and especially to Monet.

The German artist Bernard Schultze affirms that Francis told him at their 1950 meeting at Nina Kandinsky's home in Neuilly: "I make the late Monet pure."[4] Certainly the experience of enveloping color and space in Monet's mural cycles in the Musée de l'Orangerie deeply informed painters of this period. The evanescent *Nymphéas* have neither foreground nor background, but present a slice of infinity. These paintings, spherical in their allusions, are brushed with gestures that establish their identity at the threshold of abstraction. Disdained by artists of an earlier generation, supposedly for lacking structure, their inherent organization of color expansion was rediscovered in the postwar period, and Francis's all-over paintings of the early 1950s were clearly indebted to Monet's paintings of the water garden at Giverny.

In Paris, Sam Francis met almost daily the perspicacious critic and philosopher Georges Duthuit, who was closely attuned to the work of his father-in-law, Matisse. It was Matisse who had spoken about painting as a "state of condensation of sensations," and Francis's early canvases correspond to that idea. These pictures, essentially monochrome, were first painted in white, then in red and black

as well as blue, and they established the American's reputation as the harbinger of a new type of painting in Paris and, soon, in the rest of western Europe. When he sold his first large canvas – a black painting – from his first one-man show at Nina Dausset's gallery in 1952, it was to Madame Matisse.

Though unaffiliated, Francis was nevertheless very much in the center of the Paris avant-garde in the early 1950s. Michel Tapié, the chief proponent of Tachism, included the recent American arrival in his pivotal exhibition *"Un Art Autre"* in 1952. In his desire to categorize artists into movements, and perhaps also prompted by his wish to market their work, Tapié coined the term *"Ecole de Pacifique"* for Francis, Mark Tobey, and others, actually at times including Rothko and Still. The label made little sense. But, like Rothko and Still, with whose work Francis had become familiar during his student days at Berkeley, he worked with expansive fields of color. Francis was also greatly impressed by Pollock's spontaneous gestural affirmations. But, from the very beginning, the sensuality of color in Francis's work clearly related the artist to the French tradition as much as to the assertive quality of the new American painting. At any rate, Francis would agree with Barnett Newman, who stated that painting is "an accurate representation or equivalent of the artist's inner sensations and experience."[5]

It was also a matter of taking risks. Sam Francis turned to blue as his principal color in 1960 because "blue is the color of speculation. Because it is full of shadow. There is darkness in it. The resident quality of blue is darkness. It's the color."[6]

Goethe in his *Farbenlebre* associated blue with infinity and saw it as the color of transcendence. The search of Novalis and the German Romantics was for the Blue Flower. Their descendants, Marc and Kandinsky, asserting active engagement instead of passive contemplation, chose to call themselves the Blue Rider. For Kandinsky, blue is the "heavenly color, retreating from the spectator, beckoning towards the infinite, arousing a longing for purity and moving towards its own center."[7] Jung, always a mentor to Francis, associated blue with the vertical, the blue sky above and the blue ocean below, and sees a correspondence with the unconscious, which also penetrates vertically. Jung states, "as the unconscious in man has feminine characteristics," blue also is "the traditional color of the Virgin's celestial cloak."[8] It is the color of the anima – the color of both the feminine and the unconscious. Van Gogh in Arles employed blue to fix the mystic experience of emotional truth. Yves Klein postulated Monochrome IKB (International Klein Blue) as the color of the universe and hoped to use it to sensitize the whole planet. At about the same time, Yuri Gagarin, the first cosmonaut, looked at us from outer space and reported: "The Earth is blue."

Sam Francis was drawn to blue from early in his career. There is a small untitled watercolor of the Berkeley hills, done in 1948 during his student days, which consists almost entirely of different hues of blue. In a work from his first Paris period, *Blue Black* (1952), swirling clusters of dark blue petals, painted with interlocking brushstrokes, spread all over tissue vertically down the surface of the canvas. A year later, in *Saturated Blue* (1953), he used the color in its full, intense richness. Then, when he opened his cellular structure in a large painting, *In Lovely Blueness* (1955–57), delicacy and grace took over from the dense character of his

previous work. The name of the painting was suggested by Hölderlin's poem of the same title, a work in which the mystical poet spoke of the simplicity, the holiness and the fragility of painting.

During the late 1950s Francis produced large canvases of rich color such as the kaleidoscopic *Round The World* (1958–60), in which a predominant blue engages in a dialogue with angular red components. He was also painting a series of giant murals for Basel as well as Tokyo and New York. He expanded his scale to relate to the architectural dimensions of great walls in works which "recall those great virtuoso painters of the baroque and rococo period who specialized in large murals such as Pietro da Cortona, Rubens, the Tiepolos, Watteau and Fragonard."[9]

Then, in 1960, Francis abruptly changed to works limited in color range to white and blue. Although blues had been dominant in his palette for almost a decade, the artist's new preoccupation with that color seems almost obsessive. To Jean Fournier, there seemed no longer any reference points in these new works. Blue forms dancing around white centers and articulating the void are subject to multiple interpretations. Organic forms, they suggest blood cells, kidney shapes, eyes. They also have sexual implications and can be seen as breasts, vaginal and phallic shapes as well as testicles. The term "Blue Balls," with its sexual connotation, was first suggested by the Japanese art critic Yoshiaki Tono and approved by Francis for its overtones in American slang.[10]

It is interesting to note that the Blue Ball series in Paris preceded by several months the onset of Francis's serious malady, diagnosed as urogenital tuberculosis in Bern, causing him anxiety about possible sterility.[11] For Sam Francis, almost a disciple of Carl Gustav Jung, the abrupt change in his work could have been caused by a premonition of his future illness, induced possibly by dreams and subconscious suggestions. In an interview with Yves Michaud, Sam asserted: "My painting has come from my illness,"[12] a statement which also refers to his beginnings as a painter during his long siege in army hospitals after his first encounter with tuberculosis, which affected his spine after he suffered an airplane accident in 1944. It was then that he began to paint as a means of survival. He was an invalid for four years: "Painting became a way of life for me," he remembered later; "now it is no longer, but during those four years on my back it was life itself. I painted in order to stay alive."[13]

The blue forms which began to occur in his work in 1960 continued to occupy him for several years. These paintings, like most of his work, can be seen as numinous animations from the unconscious.

In the Blue Ball paintings, the void is as much a part of the form as the "figure" with which it constantly interacts. Again, it seems useful to refer to Asian aesthetics, which places great emphasis on the concept of *ma* – the interval between objects, which is of equal significance to that of the objects. The empty space in Chinese Sung landscape painting is not an unpainted background but is part of a pictorial interaction, much as in Francis's paintings, particularly in the Blue Balls where the white is carefully tinted, not left blank. For Francis, white is the essential color; it is like the space stretched out between objects. It is also the source of light and fills the center of the picture plane with stillness. Early on, Georges Duthuit called Francis the "animator of silence." More pointedly the artist himself wrote:

The space at
the center
of these paintings
is reserved
for you.[14]

At the very beginning of the series Francis painted anthropomorphic allusions, which are relatively rare in his *oeuvre*. In most of the paintings of 1960 and 1961 the blue spheres swirl around the edges of the canvas and splatters of blue paint splash across the white space. At times, vague organisms make their appearance. Slowly in 1962, working now primarily in his new and large Los Angeles studio, the artist allowed the globules to collide or converge. By 1963, elements of other colors, reds and yellows in particular, begin to recur. As Francis regained his health, a new joyousness entered his work. In these paintings amorphous shapes, some transparent and gaseous, others dense and opaque, revolve in generative encounter. A sensuous quality of pleasure reasserts itself in these organic forms floating in open space.

The deep interest in the nature of space is one of the prime concerns of twentieth century thought. It is an essential element of modernist architecture and sculpture. It entered the world of poetry as early as Mallarmé and is central to the music of John Cage. Nothingness or Void was one of the principal considerations of modern philosophers, among them Husserl, Sartre, Bachelard, and, above all, Heidegger, as well as Merleau-Ponty, who insisted that the modern concept of space can no longer follow the mechanical and tangible Cartesian model; rather, space is relative and can be experienced only by the human being from the inside. He submits that "the shell of space must be shattered."[15] Written in the early 1960s, this seems a most accurate description of the luminous occasions of Sam Francis's Blue Ball paintings.

CHAPTER

18 AGNES DENES
THE ARTIST AS UNIVERSALIST

Painting was too restrictive for Agnes Denes's inquiring mind.* When she was very young, in Budapest, Denes wrote poetry. But with her native language no longer available after her move first to Sweden and then to the United States, she studied painting. She went to the New School and to Columbia University and painted in most of the current and not-so-current styles of the period, and exhibited and sold her work. She recalls: "As a poet, the first difficulty came from the loss of my native language, so I welcomed the success of my visual expression, which liberated me from the confusion of having suddenly been silenced, but I found that painting was only a partial solution. Though it seemed easy and effortless, I found its vocabulary limiting. It seemed like someone else's language."[1]

Although working very much in isolation from the New York art world, Denes, like many artists of her generation, rejected what Thomas McEllivey was to call "the traditional male-heroic genre of easel painting." She had to find her own language for her unique vision as a thinker and artist, "a totally open-ended method that allowed for constant growth in every direction." Painting, in its traditional mode, or in the rigidly circumscribed color-field style that seemed dominant at the time, was far too confining for her aspirations. In fact, she began to question the whole art vocabulary of the period with its inherent self-referentiality. She wanted to eliminate boundaries, to find new terrains and new vistas. She even thought of making edgeless pictures, which would be 500 or even 1000 yards long, and actually designed a machine that would dispense an endless canvas, "which would then yield a panorama of a life painted through the years." But even then she would still have to deal with the top and bottom edges of the canvas and not be able to reach the multilayered meanings that she wanted in her art. What she needed was to find a new vocabulary, her own free expression, which would be open to the flow of information from other systems

* This essay originally appeared in *Agnes Denes*, Jill Hartz, ed., Herbert F. Johnson Museum of Art, Cornell University, Ithaca, New York, 1992. Reprinted by permission of the publisher.

and disciplines. At this point, Denes entered an unknown territory and made at first tentative explorations at the edges of knowledge. She left the status quo, she gave up the relatively safe pursuit of painting, breaking the rules of the trade for a high-risk art, for a solitary journey into a "new land of ambiguity and contradiction."

Many years later, in her *Book of Dust*,[2] Agnes Denes points to the benefits, as well as the pitfalls, of specialization in our age. "Mainstream" painting in the late 1960s, it must be remembered, was bound to ever-greater specialization, with Clement Greenberg claiming that "flatness, two-dimensionality, was the condition painting shared with no other art, and so Modernist painting oriented itself to flatness as it did to nothing else."[3] According to the formalists of the time, art had to go through a continuous process of purification, which would increasingly separate it from all other disciplines. Agnes Denes was one of the artists who broke these odious constraints, and she did so in a most unique manner by incorporating the investigation of science and the development of her own philosophy into an art of universal dimensions. Her attitude toward philosophy was different in kind, although no less profound, from the philosophical paintings by artists such as Rothko, Reinhardt, and Newman.

This so-called Information Age is characterized by an ever-accelerating accumulation of data but little comprehensive communication. Denes is acutely aware of this lack of connecting in an era in which literate individuals are no longer able to communicate, to understand each other, where intelligent discourse between men and women schooled in different disciplines has been displaced by expertise and its resulting alienation.

In his famous 1959 lecture, "The Two Cultures and the Scientific Revolution," C. P. Snow expressed his belief that the deep cleavage between the literary and the scientific cultures would retard and possibly immobilize the progress of Western culture. Some ten years later, Denes set out to bridge the gap between the two. As an artist, she utilizes the fields of philosophy and logic, linguistics, psychology, anatomy, botany, biology, ethics, and theology as well as technology in her work. Over the years she has used the latest stages of scientific knowledge for the enrichment of artistic possibilities. She has also worked in any medium that seemed appropriate and has invented new techniques that allowed her particular concepts to find actualization. Her media include drawing, writing, sculpture, photography, music, and direct intervention with the environment. Her work gives palpable form and aesthetic beauty to ideas, concepts, and propositions that have not been visualized before. R. Buckminster Fuller once referred to himself as a "student of large-scale patterns." Similarly, Agnes Denes's work is an ambitious and encompassing enterprise transacted by an artist of enormous vision, whose work defies categorization. A major concern of her art is to see relationships among fields that have seemed separate in order to create visual form and a holistic philosophy, an art, as she phrased it, that "need not feed upon itself, that can imbibe certain aspects from other systems and unify them into a coherent vision without the restrictions inherent in each."

A highly imaginative and profoundly meaningful work in the environment announced much of her thinking, when she carried out a private ritual on the land in 1968. On a verdant piece of earth next to a beautiful brook in Sullivan

County, New York, she planted rice to represent life and growth, chained a group of trees to signify interference with the life process, and buried her own haiku poetry to symbolize human intellect. The haiku verse was the culmination of all her writings to that point, the final essence of her struggle with language. Here she buried her only copies as a ritualistic sacrifice to her past. This burial in the earth can also be seen as a metaphor for initiating future growth. Nearly ten years later, in the summer of 1977, Denes was invited to reenact this effort on a larger scale for Artpark in Lewiston, New York, above the Niagara gorge. In *Rice/Tree/ Burial*, a time capsule with a questionnaire of existential concerns was buried in place of the poetry.

Rice/Tree/Burial was Denes's first environmental piece and probably the first site-specific work anywhere with ecological concerns. It also introduced the concept of dialectic analysis in her work: the planting, the giving of Life signifies the thesis; the interference with growth, Death, the antithesis; and the buried poetry, the Idea, the synthesis of the trichotomy. This dialectical event, dealing with seeding and burial, is also a metaphor for the cycle of life.

In ancient preliterate societies, the Great Goddess was symbolized by the number three and the triangle. Christian theology is based on the trinitarian formula. In *Timaeus*, Plato speaks of the necessity of a third object for completion, because "two things cannot be right without a third." Modern philosophers, chiefly Hegel and Marx, based their investigations of thought and history on the principle of dialectics, i.e., the contradiction of opposites and their resolution. For Denes, "Dialectic means a forever-rising knowledge, a deepening awareness or consciousness through which the trinities are argued and regrouped."[4] Her dialectical process of investigation can result in an intervention with nature or in her continuing series *Exercises in Logic* and *Eco-Logic*, and in *Philosophical Drawings*.

While still at Columbia, Denes began her first "conceptual" work, *Strength Analysis–A Dictionary of Strength*, a highly original inquiry into "linguistics, language systems, and modes of communication."[5] Beginning in 1965 and finishing seven years later, the artist read the entire *Webster's Unabridged American Dictionary*, searching for words denoting strength. Reading intermittently over the years, she selected and attempted to categorize these words. From the alphabetized and inert positions in the dictionary the artist "liberated" these words and "saw this body in terms of sculptural form made up of words, translucent, and buzzing like a beehive. Held together by their own strength, the words created an undulating form like a swarm of bees moving about. Alive and constantly changing, nevertheless it was a sculptural, three-dimensional form, a semantic substance possessing object boundaries."[6] She felt that by assembling and bringing them together (about 3000 words of strength), they had gained in power and intensity. Finally reducing them to three hundred she filled the words into a triangular matrix of concentrated power. The word *silence* – the ultimate signifier of strength? – stands at the apex of the triangle. Triangles and pyramids remain persistent forms in the artist's work and recur again in different guises.

Between 1967 and 1969 Denes worked on a major project, *Dialectic Triangulation: A Visual Philosophy*, which includes *The Human Argument*. This pivotal work consists of a large drawing, 37¼ × 25¼ inches, which is compartmentalized into three sections. The upper part is a rectangle filled with meticulously rendered

notations of a variety of two- and three-dimensional angular geometric figures based on the triangle and signifying different operations and thought processes. It designates the combination of the intellect, instinct, and intuition and, used dialectically, it is seen as the activating force in human thought. It appears in this work in the figure of a pyramid, a triangular matrix, drawn on graph paper and located in the box on the lower left. This triangle, which also exists as a separate drawing, *The Human Argument* (1970), uses symbolic logic from A. N. Whitehead and Bertrand Russell, the prime proponents of the philosophical system of deductive logic that drew heavily on mathematics in an endeavor to prove that human thought could be represented by abstract symbols. *The Human Argument* is a witty comment on human self-importance through a "dispassionate portrayal of complex and profound human thinking processes translated into the language of symbolic logic, 'the medium of correct reasoning.' "[7] She created a *Truth Table* and set this off with a *Lie Table* representing "untruth or falsehood," which "is not simply 'truth' reversed but an attempt to 'argue backwards' from knowledge to ignorance, from sophistication to innocence."[8] Here, as in much of her work, and in her *Study of Distortions* above all, she indicates her fascination with the conflict between reality and illusion, the issues of paradox and contradiction.

The figures on the lower right in *Dialectic Triangulation*, finally, are different triangles, dealing diagrammatically with various fields of knowledge and thought processes in yet another attempt to penetrate to the nucleus of information. Using the logical constructs of symbolic logic, Denes again questions the validity of accepted philosophy in furnishing metaphysical answers. Using art that deals with the unknown, located in the area of risk, she poses questions whose answers hide in an infinite number of patterns still unknown. She arrives at a position related to Russell's warning against accepting propositions on faith as well as to Wittgenstein's later revelations about the inevitable ambiguities and inadequacies of language. Denes herself takes a relativistic position, assuming a multiplicity of truths, since, as she maintains, "truth as ultimate reality is inaccessible to us."

Authentic art has always been a quest for truth, but Denes has dealt with the investigation of truth more directly. In *Dialectic Triangulation* she had proposed that truth as ultimate reality is not achievable for human beings. But in *4000 Years – "If the Mind . . ."* (1975), she postulates the maxim: "If the mind possesses universal validity, art reveals a universal truth. I want that truth."[9] This work again consists of a pyramidal structure. Here, however, the matrix is filled with hieroglyphs instead of the symbols of mathematical logic. She decided to transpose the maxim regarding the revelation of truth into the early civilized past. An Egyptologist whom she consulted informed her that the translation was impossible as conceptual words such as "universal" and "truth" did not exist in Middle Egyptian. Denes did not give up; she began to study hieroglyphics herself in order to select equivalent expressions from another place and some four thousand years in the past. The final result is a superb and rather mysterious and enigmatic drawing of hieroglyphys embedded in a triangulate pyramidal structure, which by itself has an immediate sense appeal and reads like poetry. The visual attrac-

tion was heightened further by a color etching of the same subject completed in 1976.

Limitation and restriction often nurture invention. Early on, color had to be eliminated from Denes's work and did not reappear for some eleven years. At this critical time, color would have interfered with her visualization of mathematics and thinking processes. When color did return to her work, she often selected elusive metallic hues, which would change with the light reflected on the surface relative to the position of the viewer. In her earlier renunciation of color, we are reminded of the limitation of the palette by Picasso and Braque during the analytic phase of Cubism, when these artists painted objects largely as perceived by an encompassing mind, rather than by optical sensation. Giacometti also relinquished most colors, limiting his painting to grisaille, because he too felt that colors adhere to surfaces and his problem was to grasp the location of the human image in space.

The same figures recur in Denes's work with frequency in order to be reexamined and brought into new contexts or simply related to new ideas and concepts. In 1982, at a time when she was working in three dimensions and creating environmental pieces, she came back to *The Human Argument* and, as a finalist for a commission, proposed a sculpture for the University City Science Center in Philadelphia, *The Human Argument in Steel & Crystal with Sundial* (1988). Here the pyramidal structure, made of transparent glass triangles, would give the impression of a giant drawing in space. The work is to be supported by a steel frame and braced by the gnomen of the sundial, which in turn is designed to mark the passage of the sun, moon, and stars, but it is constructed in such a way as to allow *The Human Argument* to cast its own shadow. It is the shadow, which, having no substance of its own, stands in a dialectical revelation to the tangible reality of the human argument. *Dialectic Triangulation: A Visual Philosophy*, (including *The Human Argument*), the original work of this series, was exhibited in the crucial *Software* exhibition that Jack Burnham organized for the Jewish Museum in the summer of 1970. The exhibition was subtitled "Information Technology and Its New Meaning for Art." The show as well as the catalog, sponsored by American Motors, was largely concerned with the medium of electronic technology and with life in a computerized environment.

In addition to *Dialectic Triangulation: A Visual Philosophy*, the artist actually designed two works especially for this exhibition, *Matrix of Knowledge* and *Trigonal Ballet*, both from 1970, participatory works for the computer. Condensing an entire field into a dynamic display, she built "matrices" in *Creative Reason, Evolution, Politics & Systems, Emotions & Passions*, and *A Man's Life*. She challenged the viewer to select and compare ideas from condensed and prepackaged information, envisioning today's information overload and the need for widespread specialization. The drawings were bought by the Museum of Modern Art soon after the exhibition. Denes's own text goes far in illuminating this visionary work, again an analytical statement on an age in which people have been thoroughly alienated by working in their own narrow areas and are no longer able to communicate intelligently – or with free will.

With the *Software* exhibition, as well as the simultaneous "Information"

show at the Museum of Modern Art, preceded by Harold Szeeman's exhibition *When Attitudes Become Form* in Bern in 1969, the official art world gave its approval to an art that was no longer connected to some actual object. It was a reaction against formalism in art and criticism and a rejection of the commodification of the art object. The game had changed and so had the rules. For about a decade, many artists had been trying to dematerialize the art object, as Lucy Lippard observed. If for the abstract expressionists the argument was with Picasso, the new generation looked to Duchamp, the master of anti-art, who rejected "visual thrills." The conceptual artists were more concerned with the idea, with the software rather than the hardware of the thing. Historically, this attitude could be traced back to the Neoplatonic concept of the soul purifying itself from the physical body. By analogy, art could remove itself from the tangible object and become pure aesthetic experience. Or, on a more prosaic level, the distinctions between art and non-art were blurred, as Burnham stated in the catalog of the *Software* exhibition.

Although Denes had little contact with the largely male group of conceptualists, she shared similar concerns with the conceptual artists of her generation. But her probes often went more deeply into essential human concerns. And unlike most of the conceptualists, Denes never renounced the object. On the contrary, her art is endowed with an intensely visual character of broad dimensions and perfection of execution, which is always specific to the particular work in question.

The Debate (1969–70) is a finely crafted mirrored plexiglas 16-inch square box illuminated by neon light, containing small replicas of human skeletons. As in much of her work, Denes has penetrated literally beyond the epidermis, the skin and flesh, down to the skeletal structure. In this reliquary, the two figures sit on round platforms and face each other in an eternal animated discourse. This work of extraordinary poignancy is subtitled *1 Million B.C. –1 Million A.D.*

Closely related to *The Debate* and part of an ongoing investigation of "The Study of Dust" is the work *Human Dust* (completed in 1969). This work consists of a pile of calcareous human remains, the residue left after cremation. Its accompanying text tells the prosaic life story of this deceased artist, with all the vital statistics in a dispassionate, almost clinical manner, ending simply with "34 people remembered him or spoke of him after his death, and his remains shown here represent $\frac{1}{85}$ of his entire body." This work is a cogent and deeply moving comment on the vulnerability of existence. It transports the acts of questioning, reasoning, analyzing, dissecting, and articulating into strangely tantalizing visual form. Denes has created a mesmerizing reading of humanity, encompassing aspirations, hopes, egos, and the inevitable humiliation of becoming a mere statistic.

It was in 1972 that Denes began collecting data for the holistic study *Book of Dust*, an astonishing corpus of scientific data, including her own interpretations and philosophic thoughts about the past, present, and future universe. This is an effort by an artist, who like no other in her generation, has been able to bridge the gap between the "Two Cultures" into an all-encompassing framework. Writing for the Encyclopedia Britannica's *Yearbook of Science and the Future*, Jeannette Murray notes that Denes "like the great artists before her continues to grasp for

a still greater purchase on the total knowledge of humanity. It is this bold purpose that sets the true artist apart – to express something of the unique vision of humankind."[10]

For an extended period of time Denes has been occupied with the "Study of Distortions" series and many of her pieces fall under this rubric. This study takes cognizance of inadequate knowledge and information and analyzes "communication and the various degrees of loss that occur when people attempt to communicate."[11] It is the elusive, inaudible, and invisible messages, patterns, and structures that are mapped by Denes into forms that may assume geometric or perspectival distortions. Often these studies deal with observation, reality, and illusion.

Among the earliest of these were *Studies of Truth* and *Studies of Time*, both completed in 1970, a year during which the artist experienced a burst of creative energy. The latter maps the fluctuating "now" of time, as the future eternally melts into the past. Time seems to fan out into the deep past and the far future like a horizon to behold, while we humans live in the tumultuous present, indicated by wavy lines, like choppy seas.

Later, in the *Book of Dust*, she considers "absolute time, mathematical time, subjective, objective time, perceptual and conceptual time. . . . It is as ephemeral as a puff of smoke . . . a mysterious medium that seems to govern us and the universe."[12] I think it was Kierkegaard who once remarked that "life must be lived forwards and understood backwards."

Among the Distortion series is an intriguing drawing called *Global Perspective*, which deals with the solar system in motion. Here the celestial bodies are tracked by lines that freeze their spinning movement through space. This drawing can be seen as a play on Duchamp's *Nude Descending a Staircase*, but now the artist is playing the game with the sun in orbit.

In 1968 Agnes Denes began her studies for *Introspection I – Evolution* which was completed two years later. It depicts the evolutionary journey of the human species from the separation of man from ape to the beginning of knowledge and, of course, art. This work explores the disciplines of anatomy, genetics, physics, biology, cytology, linguistics, and astronomy. But as in most of her work, Denes "is not interested in researching accepted scientific data, but rather in restructuring available information to provide new insights."[13] Traditionally, art has dealt with life and nature. But instead of merely depicting the visible surfaces, Denes makes use of the energy and rigor of scientific thought to enrich artistic possibilities and investigates the biological developments of the human species. Her wish to create paintings of infinite limits was not within the range of feasibility, but the 17-foot monoprint, *Evolution*, is certainly a work of monumental dimension congruent with its far-reaching scope. As we study the work, our eyes begin to see history evolving in front of us over millions of years. For this print the artist devised a direct surface technique and used presensitized rag paper printed from a 17-foot negative. Although the concepts of scientific information and Denes's own commentary are of paramount importance, the pure visual aspect of the luminous surface containing a multiplicity of pictographic images makes for a sensuously beautiful work that reminds us of Egyptian or Mayan mural painting.

FIGURE 60. *Human Dust*, 1969, calcareous human remains. Text is part of the illustration.

Close to the right-hand margin of this work, that is to say in the later stages of human evolution when homo sapiens became literate, Denes has inserted a section of signs and symbols that were and are used in written communication. This section consists of random texts in a multitude of languages, including Egyptian hieroglyphs, cuneiform, Chinese pictographs, and many other ancient and modern languages as well as signs of symbolic logic. In contrast to *Strength Analysis*, a work in which the meaning of words carried the greatest importance, Denes here employs texts primarily for their visual form rather than for their linguistic signification.

Introspection II – Machines, Tools & Weapons (1970–72) at 21 feet is even more impressive in its dimensions. It is printed by Denes's direct printing technique and literally seems to glow. The monoprint consists of a large number of diagrams taken from old etchings of machinery and engineering tools. As in *Introspection I*, they are spread sequentially over horizontal registers as a pictorial comment on the growth of technology from the time man first climbed from the trees and fashioned his own tools to the technical sophistication of the twentieth century, ending with humanity's destruction by the bomb. This work goes back to the origins and forward to destinies.

Aspects of this work are also tongue-in-cheek. In the lower right of the giant original print is an image, which in contrast to the somber serious machines, is filled with zany humor. This work also exists as a separate drawing called the *Human Hang-Up Machine* (1969). The drawing presents a complicated yet pathetic little contraption, "a machine whose eloquent attempts at surviving the changes around it are endearing." The world changes, "sea levels rise and fall, ecological factors, even the procession of the equinox, shift, while this little machine is

HUMAN DUST

He was an artist. He died of a heart attack. He was born fifty years ago, which means he lived half a century, or appr. 2/3 of his expected lifespan. His father was a tailor and his mother a housewife. He had 4 brothers and 1 sister. He was in love 3 times, married once, fathered 2 human beings, thus beginning a chain of 60 or more human beings added to the world population within 4 generations (counting up to 2000 A.D.). Taking genetic and environmental factors into consideration, 4 of these will be doctors, 2 will write, 34 will bear children, 6 will be engineers or teachers, 1 will have an unusual talent, 1 will be a politician, 1 will collect garbage, 8 will be unskilled laborers, 1 will go to jail, and 2 are uncertain.

During his lifetime he visited 18 countries and spoke 2 languages. He traveled 55,000 miles, not including commuting, and read 4100 books. He attended college for one year. His aspirations were to be a great writer or a great artist. He wrote about 1/2 million words and painted 48 paintings, all told. In his lifetime he earned $160,000.00, was fired three times and held 17 positions after maturity. He was unhappy and lonely more often than not, achieved 1/10,000 of his dreams, managed to get his opinions across 184 times and was misunderstood 3800 times when it mattered. He believed in a god, was fairly religious at the beginning and toward the end of his life, and could be considered superstitious. During his lifetime he consumed 4800 lbs. of bread, 3000 gallons of water, 140 gallons of wine and 360 quarts of whiskey. He ate 56,000 meals, slept 146,850 hours and moved his bowels 18,548 times. He was sick 23 times, caught 31 colds, pneumonia once, 7 virus infections and broke his leg falling off a chair while hanging one of his paintings. He served in the marines, was shot at several times but never wounded. He had relations with 27 women in his lifetime and ejaculated 3858 times. He voted in 24 elections and knew his opinions changed nothing. He was not a popular man—he had honest but uneven beliefs. His work was good but not great, and the last 10 years of his life he resigned himself to this fact. He had 4 friends at various times in his life and was loved by 17 people, including his parents. He was liked by 312. His brain contained 10^{10} neurons and it received 10^{15} electrical impulses from his own sense organs, to each of which he responded. He smoked 210,000 cigarettes and tried drugs twice. 34 people remembered him or spoke of him after his death, and his remains shown here represent 1/85 of his entire body.

© Agnes Denes

trying to deal with its own hang-ups, heroically persevering in the face of apparent futility." Denes knows that we cannot live without technology, but she is equally aware that we destroy our lives with it. The following year, at a time when free sex was a prevalent topic in common discourse, Denes, again working with a sense of satire and wit, produced the *Liberated Sex Machine*. With its "libidinous lubrication," its "apology assembly," and "inhibition clutch" it certainly belongs in the grand Dada tradition of the fanciful human-cum-machine images of Duchamp and Picabia. These contraptions, with their cylinders, wheels, ball bearings, plungers, and assemblies, do not operate according to the laws of mechanics but are nevertheless equipped with many gauges, which are meant, one supposes, to measure human foibles.

In *Introspection III – Aesthetics* (1971–72), Denes uses x-ray technology to penetrate the paintings of the masters. Art conservators have been using x-ray techniques to examine the physical structure of paintings. They are able to see

changes, alterations, overpaintings, pentimenti, and hidden images and can test authenticity and even detect different hands that may have worked on a given canvas. Denes made use of this technology to see through unseen layers of pigment in her effort to reveal "the initial shock of paint applied to canvas." Avoiding the traditional methods of art criticism, she decided to penetrate to the actual work itself. She used x-rays of paintings by Rembrandt, van Gogh, and Picasso, and others, to examine the nature of the pictures by penetrating through the finishing touches of varnish to the pigments and beyond, stripped down the paintings to their very core until they became what appeared to be hazy drawings, reversing the original process of painting. She found that Picasso's paintings were thinner, easier to penetrate than the works of the earlier masters. Working with the x-rays, she was able to enter the paintings.

Soon she decided to move her attention and her x-ray technique from the hand of man to the world of nature. In *The Kingdom Series*, she applied the same technique to objects in the natural world. She made monoprints of columbines, stingrays, embryos in their mothers' wombs, and other organisms. She was able, again, to penetrate beneath the surface, to see the sex organs of a flower, the skeletal structure of an animal, to reveal the beauty of unseen forms and processes, and she achieved images of mysterious presence. In her *Ciliagraphs* (1972), applying the same technique to electronmicrographs, she approached the invisible world.

This series seems to echo Paul Klee, who explained:

> The artist must be forgiven if he regards the present state of outward appearances in his own particular world as accidentally fixed in time and space. And as altogether inadequate compared with his penetrating vision and intense depth of feelings. And is it not true that even the small glimpse through the microscope reveals to us images which we should deem fantastic and over-imaginative if we were to see them somewhere accidentally, and lacked the sense to understand them?[14]

Like Klee, Denes investigated the biological world by means of art to lead us to that land of a deeper understanding. At all times, Denes searches for the often invisible structure, whether a flower, a mathematical concept, or the planet on which we live.

Denes's focus on natural phenomena in the early 1970s led to her interest in the visualization of the thinking process. In the monoprint *Thought Complex* (1972), she used figurations from theoretical crystallography to illustrate the machinery of the brain when the thinking process is initiated. Writing about this piece, she said, "Assume that ideas are balanced for a moment by the surface tension of the mind, just long enough to sprout hairline tentacles that instantly penetrate the machinery of the brain initiating a thinking process."[15] She visualized parallels between the growth of crystals and the development of a thought in the human brain. And just as particles of crystals occupy positions with definite geometric relations to each other, based on the structural arrangement of their atoms, so Denes has projected diagrams that apply to "ideas seeking substantiation, balance, and opposition."[16]

In her explorations of the structure of thought, but related to her earlier work

with Webster's dictionary in *Strength Analysis*, Denes conducted successive dissections of Hamlet and passages from Wittgenstein. By reversal of words and removal of connections in the texts, she emerged with concrete poetry as well as modified prose based on the texts. She also turned to the Bible, which represented both idea and poetry to the artist and pertained to man's fate. In *Morse Code Message* (1970–75), she turned to the Morse code, which offered symbolic connotations.

Morse code is an international and universal means of communication by short and long sounds that can be visually conveyed by an analogue of dots and dashes. It is a very abstract way of communicating, and by 1975 when the work was completed, modern technology had also made this code, used for many decades, somewhat obsolete – a dead language. It was removed from our lives much like the godhead of the Bible. Having read both Old and New Testaments as well as many other religious texts, Denes selected references to God's pronouncements about humanity, his commandments and threats, and his prophecies about the future of mankind. The piece begins with "The Lord shall lay waste the earth and make it desolate," a statement by God in the Bible. It continues, "And he came to be with man and wiped away every tear . . . and death was no more. . . ." Here she detects another paradox: we created God in our own image and then, due to our own fears, we endowed him with benevolence but simultaneously with wrath and punishment.

Most people looking at the resultant work will not understand its veiled predictions of destruction of the planet by natural or man-made forces. By using the fairly incomprehensible symbolic language of the code, the neutral-looking dots and dashes conceal the message of disaster. Again Agnes Denes questions the meaning of language and points to the distortion inherent in communication.

Denes selected the format of a tablet for the work, evoking Moses' Tablets of the Law, and she constructed the piece with enormous care, building a skillfully crafted matte plexiglas slab with a sharp, razorlike edge for the 3,500 particles. She placed these ivory-colored Morse code pieces on the support while lying flat on her stomach on a scaffolding over the panel and used a tiny hypodermic needle to inject the glue under each dot and dash, fusing them to the surface. The process of making the piece, she recalls, was a truly meditative experience.

Denes also realized that the Morse code system was based not only on visual signs but also on sound whose radio-transmitted staccato beat carries a rhythmic language not unlike African drumbeats. In 1978, she began creating sound, fusing it with Morse code, and giving it a new form through resonance. This fusion would make religion both visible and audible.

She composed what "can be earth sounds coming from the soil where processes go unnoticed: sounds of germination and growth, rain soaking into the soil causing roots to generate and seeds to burst; in areas where chemical processes operate and icicles form. . . ."[17] In such a poetic vein she hopes to create synaesthetic sensations in which "sounds create their visual imagery and fantastic patterning, to be experienced simultaneously through the combination of audio/visual senses."

Among other projects on which she was working at the time, Agnes Denes also turned her attention to psychology and the human individual. *Psychograph*

(1971–72) is a piece, both serious and humorous, that takes on the art world. It consists of a psychological test given to a group of artists, their responses, and the interpretations by two psychologists. It used as its tool a sentence completion test. The format allowed creative individual participation. The work included a number of diagrammatic drawings and was clearly a conceptual piece. Just as she x-rayed the art, Denes x-rayed the artists. The questionnaire was prepared jointly by Denes and the psychologists. To respond to the test Denes chose Andre, Golub, Haacke, Huebler, Le Witt, Matta-Clark, Morris, Piper, Venet, and Weiner, and critics Lippard and Perreault.[18] The psychologists, whose identities remained anonymous to each other and the public, evaluated the test results and produced a psychological profile for each individual. The answers to the battery of questions disclosed the artists' preceptions of themselves as well as the outside world's attitude toward them (represented by the psychologists). In addition, the posture of the psychologists was revealed in the procedure. This visualization of hidden belief systems is another dialectic piece with the viewer representing the synthesis. The artist is disrobed of his/her mystique or aura and seen as a human being in society, while the public's conception of the artist is part of the discourse.

The responses of the two psychologists in this experiment are worth noting because of their attempt at objectivity. Often, their separate evaluations came to similar results, thus demonstrating a fair amount of reliability of this test as a personality measuring device. The responses were exhibited at the A.I.R. Gallery in 1972 and the artists came to look. Several resented the psychologists' interpretations, and the psychologists, in turn, resented the artists' resentment. No productive dialogue ensued as each group questioned the others' expertise and rights. *Psychograph* can be seen as a psychosocial study in distortion and paradox.

Among Denes's most complex and sophisticated visual investigations are her *Syzygy* drawings. This truly conceptual work is an "abstract map of reality where isolated events leave echoes like afterimages to be imprinted on the memory of space/time." It is a fusion of art and science, conceived poetically. Random lines, drawn on a piece of paper, are assumed to continue off the paper and move through space, enveloping the universe and then returning to the opposite side of the same sheet of paper. If the universe is circular, it can be deduced that one is holding the center of the universe in the palm of one's hand. "*Syzygy* contains 65 line segments that intersect at 1255 points and form 10,919 different triangles," Denes writes.[19] Mind-boggling variations have been calculated to reach near infinity. The mind and the eye are prompted to discover patterns from these random lines. Triangles are formed, revealing a definite pattern, and make for spellbinding drawings of triangulated grids. Whenever there is a moment of connection or intersection, that event is mapped as "conjunction," "fusion," "combination," "change," "rejection," etc. By means of these conceptual drawings Denes is trying to get a glimpse of the reality of Events by means of catching this reality in the web of straight lines that circle the universe. Again one is reminded of Paul Klee, who wrote in his Notebooks: "Our need for orientation is expressed in a division and fixation into straight lines, precisely located. . . . A scale in itself is already something artful, lines precisely located . . . in synthetic frozen movement."[20]

Her ongoing *Study of Distortions* led Denes to the series of *Map Projections*, which

began in 1973. Consistently the artist was probing and mapping. She mapped the breakdown in communication in works such as *Positions of Meaning*, while *Strength Analysis* maps the multiplicity of meanings carried by words, signs, and symbols. *Morse Code Message* maps the meaning of language as well as theology. The *Introspection* series maps human evolution and the growth of technology, while *Psychograph* is an attempt to map the artist's personality and his/her place in society. In *Syzygy* Denes provides a visual metaphor for space/time infinity and maps the universe and the events that occur within its fabric. *Map Projections* maps space itself by unraveling coordinates and rebuilding them. It is a mathematically correct visual distortion of the globe and means to teach us not to take knowledge too seriously or our facts for granted. This project prompted the artist to create a cycle of maps that combine scientific accuracy with artistic whimsy.

There is no analogous way to locate the image of the round globe of the Earth on a flat surface. Distortion must result when three-dimensional information is placed on a two-dimensional plane. Gerard Mercator's projection, which has been used by navigators and school children since the sixteenth century, is still in general use. The Flemish geographer understood that because the Earth is round, the length of a degree of longitude varies with the parallel of latitude along which it is measured. His method of gridding is greatly distorted by the fact that the land areas are exaggerated in proportion to their distance from the equator, and it does not have a constant scale of longitudinal parallels. Mercator used a cylindrical projection. Other possible renderings, such as azimuthal, orthographic, and gnomic projections, also ensue in distortions of a different kind. In 1939, R. Buckminster Fuller proposed his Dymaxion World Map, which used spherical trigonometry to divide the surface of the earth into twenty equilateral triangles, with the North Pole at the center like a target. In the Dymaxion Map, the land masses are placed in a more accurate relationship to each other, and the continents are projected as continuous, making us aware of the small sphere we inhabit in what the cartographer called Spaceship Earth.

Nearly thirty years later, Jasper Johns used the Dymaxion Map for one of his final map paintings for the American pavilion of Expo '67 in Montreal. For Johns, the map, just like the target, the flag, the set of numbers, was above all a predetermined fixed flat surface to serve his purpose to paint freely, obscuring boundaries, arguing with the picture plane.

Denes's *Map Projections* are very different in function and purpose. In her book *Isometric Systems in Isotropic Space* (1979) she wrote that the series "creates sculptural form in celestial space and presents analytical propositions in visual form."[21] By dint of her unique artistic imagination, she was able to evolve new structures, unraveling longitudinal and latitudinal lines and their intersections to create a new visualization of global relationships. In order to achieve accurate measurements and the highest degree of precision, she computed every degree of longitudinal and latitudinal coordinates, marking land areas. Working with rather primitive devices compared to today's standards, she took four years to complete the piece. In *Map Projections*, she created what she termed "isometric systems in isotropic space" and used such geometric solids as the pyramid, cube, and dodecahedron for her primary projections. Beyond that, her studies included global projections into *The Egg* (sinusoidal ovoid, *The Snail* (or nautilus shell–helical

247

toroid), *The Doughnut* (tangent torus) *The Hot Dog*, and *The Lemon*. Continents are allowed to drift freely in space and the poles become transparent. To fit the egg shape, land masses are elongated and flattened. They are wrapped around the pyramid and the cube. In *The Doughnut*, the poles are imploded to fit together tightly. Polyhedrons are constructed and the angular forms appear like transparent sheets of glass. The pyramid is sliced into a shape recalling a pagoda. In several drawings, only the parallels or meridians are projected in abstractions, without the indication of sea or land masses. Or, to fit into a "hot dog," the whole Earth is distorted by eliptical momentum. In her map game, additional forms such as the lemon and the geoid are discovered. The Earth undergoes many alterations at the whim of the artist, but following a stream of logic, they are not arbitrary. To many of her projections Denes applied carefully chosen colors – blue, orange, purple, and metallic luster pigments – creating drawings of stunning visual beauty. Today these map projections are accepted by cartographers as legitimate eccentric projections and placed alongside the most well-known projections of the world.

Finally, the complex and nearly abstract interwoven *Entropy* drawings (1973) are reminiscent of Leonardo's *Deluge* drawings. De Vinci's works, based on his studies of movement of water, its swirls, eddies, and floods, wind up as symbolic visions of the final deluge, the end of the world. Denes's *Entropy* drawings, subtitled *Amorphous Continents*, signify the depletion of energy as well as its simultaneous renewal in the universe. The straight lines seem to be moving at great velocity, creating webbings, reticulations, and intersecting networks. The visual effect of these linear structures, superimposed on the bare outlines of the continents, is that of cataclysmic destruction. Discussing Leonardo's *Deluge* drawings, Carlo Pedretti observes that it was "Leonardo's aim to reduce natural truth to a scheme that could be readily perceived as a geometrical diagram."[22] A similar goal can be seen in the *Entropy* drawings by Agnes Denes.

Everything is connected in Denes's multifarious work. Her concepts may deal with space, but ultimately her work is focused on the life of humankind and on the human predicament. Increasingly since 1968, she and her art have focused on urgent ecological and social issues, specifically the damage done to the planet and the deterioration of the human condition throughout the world. She is deeply concerned with our inability to think globally when actually no other way of thinking can extract us from our present plight. In the *Book of Dust*, she asserts that at this time, "no clear, unified global philosophy exists"[23] and that "the world seems to be ruled by sheer momentum caused by the cultural and population explosions."[24] She notes that "there is little opportunity for introspection or wisdom. All processes and numbers have accelerated. For the first time in human history, several limits have been reached. We are poised at the height of our civilization and achievements, while all is intermingled and confused, running out of control – primed for disaster."[25] But she also postulated the hope that "very powerful efforts can unify things without diminishing the sharp edge of knowledge attained through specialization – a clear, in-depth overview, using true analogies, painstakingly pieced together from small mosaics of truth. The dedication of the entire world organism is vital to the pursuit."[26]

As an artist, Denes is engaged in creating work that produces such analogies

for humankind. It is art that can transcend such limitations of specialization by its function and its unique ability to combine the intellectual and emotional aspects of life. She would, I believe, agree with Paul Tillich, the theologian and teacher, who writes that "art indicates the character of a spiritual situation. . . . It does this more immediately and directly than science and philosophy for it is less burdened with objective considerations."[27] At a time when absolute objectivity seems no longer possible, Agnes Denes postulates the feasibility that art can deal with the ultimate questions concerning humanity.

19 THE FLACCID ART

Ten years ago painting in America was largely dominated by Abstract Expressionism.* Today there is a wider range of possibility in both style and subject matter. The older Abstract Expressionists are doing some of their finest work and Rothko has just completed a series of impressive murals for Harvard University. But, in addition, the Hard Edge painters are successfully synthesizing Mondrian and the New York School; a group of painters from Washington, Morris Louis and Kenneth Noland among them, have achieved new images by staining their canvases with simple shapes of decorative color; a rising generation of figure painters – Diebenkorn, Golub, and Oliveira – depict the ruined and isolated human beings of a disaffected society. Also the detritus of our culture is being reassembled with often stunning and mordantly amusing results by the "junk artists." But the trend which has been most widely publicized and discussed during the past year is Pop Art.

Artists who make use of images and articles from popular culture – H. C. Westermann, Edward Kienholz, Marisol, Tinguely – are not necessarily practitioners of Pop Art. Westermann's metaphorical statements about the violent and ambiguous quality of contemporary life, Kienholz's incisively bitter social satire, or Marisol's sophisticated and humorous primitivism, the highly inventive constructions of Jean Tinguely, which have electrified and motorized our esthetic concepts, all differ significantly from Pop art works. It is true that Pop Artists owe a great debt to Rauschenberg, but his Combine Paintings transform ordinary objects by fusing them provocatively with Abstract Expressionism.

The Pop Artists, some of whom came out of the advertising world, some out of the world of painting, stand apart as a group in that they not only take their subject matter from mass-production sources in our culture – magazines, billboards, comic strips, television – but they frequently employ commercial techniques as well: the airbrush, silkscreen reproductions, imitated benday screens.

* This essay originally appeared as "Pop Goes the Artist" in *Partisan Review*, Vol. 30, No. 2, 1963. Reprinted by permission of the publisher.

Sometimes, as in pictures by Dine and Wesselmann, actual objects are incorporated in the manner of collage. There is no theoretical reason why such popular imagery, or even the use of commercial art processes, should not produce works of real interest and value. After fifty years of abstract art, nobody could propose an academic hierarchy of subject matter; after fifty years of brilliant invention in collage and assemblage, nobody would be justified in suggesting that any technique is taboo. The reason these works leave us thoroughly dissatisfied lies not in their means but in their end: most of them have nothing at all to say. Though they incorporate many forms and techniques of the New York School (there is a particular debt to de Kooning's women) and the Hard Edge painters, these forms have been emptied of their content and nothing has been added except superficial narrative interest. People who ought to know better have compared Pop Art to the work of Chardin, because it depicts actual objects among familiar surroundings: an eighteenth-century still life, a twentieth-century billboard – why not? Leo Steinberg in the Museum of Modern Art's symposium on Pop Art goes so far as to suggest parallels to the realism of Caravaggio and Courbet. But Chardin, Caravaggio and Courbet created worlds of their own in which the reality of the subject was transformed into an esthetic experience. The interpretation or transformation of reality achieved by the Pop Artist, insofar as it exists at all, is limp and unconvincing. It is this want of imagination, this passive acceptance of things as they are that make these pictures so unsatisfactory at second or third look. They are hardly worth the kind of contemplation a real work of art demands. If comparisons are in order, one might more appropriately be made to the sentimental realism of nineteenth-century painters like Meissonier, Decamps, or Rosa Bonheur – all exceedingly popular and high-priced in their day.

When I was a teacher in the 1950s, during and after the McCarthy period, the prevailing attitude among students was one of apathy and dull acceptance. We often wondered what sort of art would later be produced by these young men and women, who preferred saying, "Great, man!" to "Why?" or possibly even, "No!" Now that the generation of the Fifties has come of age, it is not really surprising to see that some of its members have chosen to paint the world just as they are told to see it, on its own terms. Far from protesting the banal and chauvinistic manifestations of our popular culture, the Pop painters positively wallow in them. "Great, man!"

In the symposium on Pop Art at the Museum of Modern Art, Henry Geldzahler, an enthusiastic supporter of the trend, clarified both the attitudes of these artists and the reason for their prompt acceptance by the art world when he said, "The American artist has an audience, and there exists a machinery – dealers, critics, museums, collectors – to keep things moving. . . . Yet there persists a nostalgia for the good old days when the artist was alienated, misunderstood, unpatronized."

But I doubt that nostalgia is at issue here. What we have instead is a school of artists who propose to show us just how nice everything is after all. A critical examination of ourselves and the world we inhabit is no longer hip: let us, rather, rejoice in the Great American Dream. The striking abundance of food offered us by this art is suggestive. Pies, ice cream sodas, coke, hamburgers, roast beef, canned soups – often triple life size – would seem to cater to infantile personalities

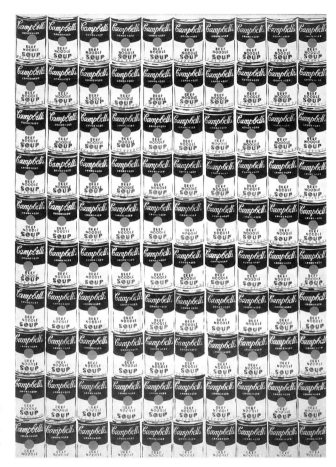

FIGURE 61. Andy Warhol, *100 Cans*, 1962, oil on canvas, 72 × 52", Albright-Knox Art Gallery, Buffalo, New York.

capable only of ingesting, not of digesting nor of interpreting. Moreover, the blatant Americanism of the subject matter – packaged foods, flags, juke boxes, slot machines, Sunday comics, mammiferous nudes – may be seen as a willful regression to parochial sources just when American painting had at last entered the mainstream of world art.

Only in the Pop Artist's choice of subject matter is there an implicit taking of sides. Essentially he plays it cool. He makes no commitments; for a commitment in either love or anger might mean risking something. Aline Saarinen in the April issue of *Vogue* (such magazines are an important part of the machinery that creates art-fashion) aptly says of Warhol: "He seems to love everything and love it equally. . . . I suspect that he feels not love but complacency and that he sees not with pleasure or disgust but with acquiescence."

What is so objectionable about Pop Art is this extraordinary relaxation of effort, which implies further a profound cowardice. It is the limpness and fearfulness of people who cannot come to grips with the times they live in. The Abstract Expressionists dedicated their lives to art and made a point of doing so. And who could have been more committed than Caravaggio, Chardin, and Courbet? But the Pop painters, because of their lack of stance, their lack of involvement, are producing works that strike the uninfatuated viewer as slick, effete, and chic.

They share with all academic art – including, by the way, Nazi and Soviet art – the refusal to question their complacent acquiescence to the values of the culture. And most ironic of all is the fact that this art of abject conformity, this extension of Madison Avenue, is presented as *avant-garde*.

In his brief introduction to the catalog of the Recent Acquisitions for Brandeis University, Sam Hunter suggests that Pop Art uses many of the compositional devices of the "purer expressions of our times." Indeed it does. It uses them in the same manner that a Hollywood movie vulgarized and banalized the teachings of Freud, or, at best, as Truman Capote has popularized and sensationalized Faulkner. It is what Dwight Macdonald calls "Midcult," the exploitation of the discoveries of the *avant-garde*. "It is a more dangerous opponent to High Culture than Academicism," he says, "because it incorporates so much of the *avant-garde*." This, I believe, exactly describes the relation of Pop Art to the tradition of modern art.

What we are dealing with then is an art that is easy to assimilate – much too easy; that requires neither sensibility nor intellectual effort on the part of either artist or audience; that has no more personal idiom than rock and roll music or the standard mystery story or soap opera. It is as easy to consume as it is to produce and, better yet, is easy to market, because it is loud, it is clean, and you can be fashionable and at the same time know what you're looking at. Eager collectors, shrewd dealers, clever publicists, and jazzy museum curators, fearful of being left with the rear guard, have introduced the great American device of obsolescence into the art world. For one thing, many of these objects simply won't last physically, but – more important – they will soon be old-fashioned because "styling" has been substituted for style, and promotion has taken the place of conviction. Like all synthetic art, when its market collapses it will collapse for good.

For this is not a folk art, grown from below, but *Kitsch*, manufactured from above and given all the publicity Madison Avenue dealers have at their disposal. The creator of such objects is not permitted to mature as an artist, for he has allowed himself to be thrust into a role he previously rejected (though it paid well it was demeaning), i.e., that of the designer of tail fins for General Motors. Allan Kaprow, the author of environments and happenings, prophesies that art dealers may indeed turn into art directors, and he actually looks forward to this development with relish.

It has been suggested of Pop Art that "something good may come of it – just give it time." I am not a prophet, but as an historian I must point out that earlier movements of this century – Cubism, Constructivism, Dada, Surrealism, Abstract Expressionism – produced much of their best work at the outset. It is possible that artists of conviction and ability may use some of the imagery of Pop Art in genuine works of art. Some have already done so. But that is a different question.

20 NOTES ON FUNK

funk (funk), v.i.; FUNKED (funkt);
FUNK'ING. [Of uncertain origin; cf. *funk* to kick, also, in dial. use, to shy, kick up the heels, throw the rider (of a horse).] To be frightened and shrink back; to flinch; as to *funk* at the edge of a precipice; to *funk* in a fight. *Colloq. to funk out*, to back out in a cowardly fashion. *Colloq.*

funk, vt. *Colloq.* 1. To funk at; to flinch at; to shrink from (a thing or person); as, to *funk* a task. 2. To frighten; to cause to flinch.

funk, n. *Colloq.* 1. A shrinking back through fear; panic.

'The horrid panic, or *funk* (as the men of Eton call it).' *DeQuincey.*

'That Sahib's nigh mad with *funk.' Kipling.*

2. One who funks; a shirk; a coward.

<div align="right">

Webster's New International (1909)

</div>

Mrs. Martin: *What is the moral?*
Fire Chief: *That's for you to find out.*

<div align="right">

– Ionesco, *The Bald Soprano*

</div>

The definitions in *Webster's* Unabridged are not very helpful in an attempt to find out what Funk[1] art is about. The quote from Ionesco at least gives us a clue to its anti-message content. When asked to define Funk, artists generally answer: "When you see it, you know it." They are probably quite right.*

The term itself was borrowed from jazz: since the twenties Funk was jargon for the unsophisticated deep-down New Orleans blues played by the marching bands, the blues which give you that happy/sad feeling.

* This essay originally appeared in *Funk*, © 1967 University Art Museum, University of California, Berkeley. Reprinted by permission of the University of California, Berkeley.

Funk art, so prevalent in the San Francisco-Bay Area, is largely a matter of attitude. But many of the works also reveal certain similar characteristics of form – or anti-form. In the current spectrum of art, Funk is at the opposite extreme of such manifestations as New York "primary structures" or the "Fetish Finish" sculpture which prevails in southern California. Funk art is hot rather than cool; it is committed rather than disengaged; it is bizarre rather than formal; it is sensuous; and frequently it is quite ugly and ungainly. Although usually three-dimensional, it is non-sculptural in any traditional way, and irreverent in attitude. It is symbolic in content and evocative in feeling. Like many contemporary novels, films, and plays, Funk art looks at things which traditionally were not meant to be looked at. Although never precise or illustrative, its subliminal post-Freudian imagery often suggests erotic and scatological forms or relationships; but often when these images are examined more closely, they do not read in a traditional or recognizable manner and are open to a multiplicity of interpretations. Like the dialogue in a play by Ionesco or Beckett, the juxtaposition of unexpected things seems to make no apparent sense. Funk is visual double-talk, it makes fun of itself, although often (though by no means all the time) it is dead serious. Making allusions, the artist is able, once more, to deprecate himself with a true sense of the ironic.

Funk objects, which are loud, unashamed, and free, may be compared to Dada objects. Indeed Funk, like so many authentic developments in recent art, is surely indebted to the Dada tradition (how paradoxical that we can now speak of a Dada tradition!). Especially in works by artists like Bruce Conner do we find echoes of Kurt Schwitters' Merz collages and the Hanoverian's love for the trash which he rehabilitated. But Conner's fetishist death images, Wally Berman's inventive collages, or George Herms's mystic boxes are really only precursors of the present world of Funk, which is often just as non-formal and arbitrary, but much more flamboyant, humorous, and precise. Perhaps again it is Marcel Duchamp's stance that is of the greatest importance here, his total absence of taste (good or bad) in the selection of his ready-mades, his indifference to form and indifference even to certain objects he created, especially those he made some thirty years after he officially ceased making art. Duchamp's three small plasters of the early fifties, the *Female Fig Leaf*, apparently modeled from a female groin; the *Object-dart*, its phallic companion piece; and the *Wedge of Chastity*, with its touching inscription for his wife Teeny, are actually as Funk as can be. Jean Arp, one of the original leaders of Dada in Zürich, also comes to mind, particularly with his later biomorphic forms existing in the world between abstraction and figuration. But then, Arp's carefully modeled or carved sculptures have a pantheistic spirit which would be anathema to the irreverence of Funk. Closer, perhaps, are certain Surrealist objects, like Meret Oppenheim's fur-lined tea cup or Miró's *Objet Poétique*, a stuffed parrot perched on his wooden branch, surmounting a ball swinging freely on a string, adjacent to a dangling lady's leg, all supported by a man's dented hat. Objects like these are, I think, real prototypes for the current Funk, especially in the similar irreverence, satire, and free association. Like Dada and Surrealism, Funk has created a world where everything is possible but nothing is probable. There is also an important *difference* in attitude in the more recent approach. Dada set out to attack and combat the moral hypocrisy of the public;

255

FIGURE 62. Bruce Conner, *Snore*, 1960, wood, nylon, and metal, 36½ × 17½ × 21½", The Fine Arts Museums of San Francisco.

Surrealism in its prodigious publications and manifestos and programs hoped to establish a new and irrational order based on the revolutionary but contradictory doctrines of Marx and Freud; but Funk does not care about public morality. Its concerns are of a highly personal nature: the Funk artists know too well that a fraudulent morality is a fact of their world, and they have no illusions that they can change it. If these artists express anything at all, it is senselessness, absurdity, and fun. They find delight in nonsense, they abandon all the straitjackets of rationality, and with an intuitive sense of humor they present their own elemental feelings and visceral processes. If there is any moral, "it's for you to find out."

Funk probably owes a considerable debt and momentum to the ingenious use of ordinary subject matter and common objects on the part of Robert Rauschenberg and Jasper Johns. Both Rauschenberg and Johns, like Schwitters before them, attempt to lead art back to life. While avoiding the tedious banality of many Pop artists, the Funk sculptors similarly share a general anti-cultural attitude and wholesale rejection of traditional aesthetics. They too enjoy and often

exploit the vulgarity of the contemporary man-made environment and speak in a visual vernacular. Unlike Pop art, however, the Funk artist transforms his subject matter when and if he makes use of subjects at all. He is not satisfied with simply naming things and instead of a complete confusion of art and life, the Funk artist uses images metaphorically and his work expresses the sense of ambiguity which is the chief characteristic shared by all artistic expressions of our century. Moreover, in contrast to Pop art, which as a whole was passive, apathetic, and accepting, the Funk artist belongs to a new generation which is confident, potent, and often defiant.

Funk art has asserted itself strongly in northern California. To be sure, the international art magazines are filled with idiosyncratic, sensuous, irrational, amoral, organic, visceral, and three-dimensional objects. They seem to turn up everywhere. Still, there is a heavy concentration of such objects in the San Francisco area. It is here that Funk sprouted and grew. In San Francisco Abstract Expressionism, originally under the leadership of Clyfford Still and Mark Rothko, soon took an eccentric direction – it was never really abstract for a long time. Its chief protagonists among the painters turned toward a new lyrical figuration (David Park, Richard Diebenkorn, Elmer Bischoff were the most prominent members of a whole new school of Bay Area Figurative painters), or, even when they remained superficially abstract, they did not exclude symbolic forms. Witty, zany, and unexpected breast forms and bulges can be discovered in Hassel Smith's canvases, and dramatic and disquietingly sensual, often phallic, configurations in Frank Lobdell's heavy impastos. Between 1957 and 1965 when Lobdell was on the faculty of the California School of Fine Arts (now the San Francisco Art Institute), Arlo Acton, Jerrold Ballaine, Joan Brown, William Geis, Robert Hudson, Jean Linder, and William Wiley were among his students. Many of the Funk artists began as painters, and much of Funk art, although three-dimensional, remains more closely related to recent traditions in painting than in sculpture.

Other aspects of the free-wheeling and often rebellious life among the younger generation in California may have had an impact on the development of Funk. In the fifties the Beat poets, with their vociferous disregard of social mores and taboos, were very much on the scene. These poets not only wrote poetry, but they also performed and entertained with it. Their first public readings, in fact, took place at the Six Gallery, successor to the aptly named King Ubu Gallery. With Kenneth Rexroth presiding as master of ceremonies, Michael McClure, Allen Ginsberg, Gary Snyder, and Philip Whalen read their poems, and Jack Kerouac, then on the Coast, was there and recorded it soon thereafter in *The Dharma Bums*. The Beat poetry, read to the accompaniment of jazz, recalls in retrospect the simultaneous poetry and music recitations in Zürich's Cabaret Voltaire (Dada's birthplace) – but in San Francisco it was new and full of excitement, and helped bring about a kind of free environment in which Funk, itself a combination of sculpture and painting, could flourish. Already in the early fifties there were programmed events (similar to the later ''happenings'') in San Francisco, and as early as 1951 an exhibition under the title *Common Art Accumulations* was held. Bruce Conner and his friends in the Rat Bastard Protective Association

257

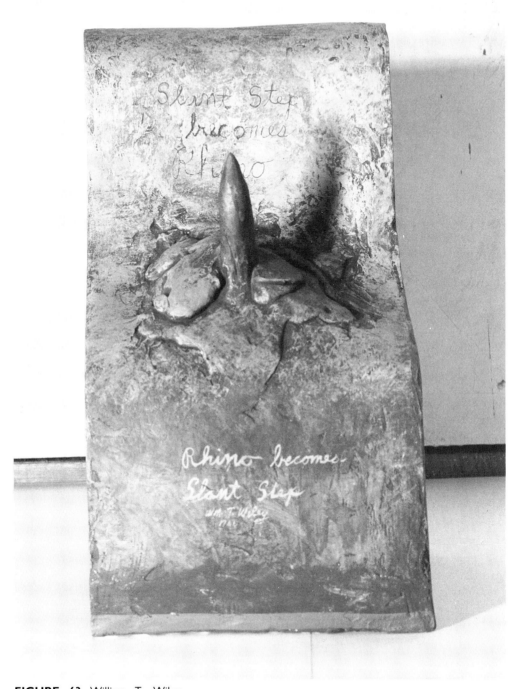

FIGURE 63. William T. Wiley, *Slant Step Becomes Rhino/Rhino Becomes Slant Step*, 1966, plaster, acrylic, paint, and chain, 22 × 12 × 12", Courtesy Wanda Hansen, Sausolito, California.

258

put together ephemeral conglomerations, combining all kinds of uncombinable things, called them "Funk," and didn't care what happened to them.

The art scene in San Francisco with its peculiar general lack of support for the artist may have also sustained the growth of this highly personal art. Here the artist has not yet become a popular idol and, as in New York in the forties, there are only a handful of successful galleries, a paucity of collectors, and meager sales; art has not become a status symbol. Harold Paris, who has himself achieved considerable renown, recently explained this situation in his article on Funk by saying:

> In Los Angeles art is consumed voraciously – a bargain-table commodity. In San Francisco and the Bay Area artists live among a citizenry whose chief artistic concerns are opera and topless. The serious artists, galleries, and museums founder in this "Bay" of lethargy and social inertia. The artist here is aware that no one really sees his work, and no one really supports his work. So, in effect he says "Funk." But also he is free. There is less pressure to "make it." The casual, irreverent, insincere California atmosphere, with its absurd elements – weather, clothes, "skinny-dipping," hobby craft, sun-drenched mentality, Doggie Diner, perfumed toilet tissue, do-it-yourself – all this drives the artist's vision inward. This is the Land of Funk.[2]

Perhaps it is possible that Karl Shapiro was right when he said that San Francisco is ". . . the last refuge of the Bohemian remnant."

In 1959 Peter Voulkos came north from southern California, where he had achieved an important reputation not only for the extraordinary quality of his ceramic sculpture but also for his highly funky endeavor to make useless pots. While Voulkos himself now works primarily in bronze, others have transformed pottery into pure Funk: James Melchert's ceramic pipes, socks, and globular, bumpy, suggestive objects; Manuel Neri's funny, brightly glazed, child-like loops; Arneson's sexed-up telephones; or Gilhooly's zoo, fired in the kiln because, as he writes, ". . . animals just seem right when done in clay."

Kenneth Price, who worked with Voulkos in Los Angeles, has brought the useless pot into the realm of high funk with his beautifully crafted egg forms from which germinal shapes extrude, shapes which evoke divergent but related associations in different spectators. Many of the Funk artists have recently turned toward a greater formality in their work. Even the idea of permanence has occurred to them. Although neatness or sloppiness is not the issue here, there is a general trend toward greater care in execution and more precision, partly due to a limited amount of recognition enjoyed by the artists, and partly facilitated by the use of new materials – all kinds of plastics, including fiberglas, vinyl, epoxy, and the polyester resins. Jeremy Anderson now enamels his redwood sculptures; Arlo Acton uses shiny metal instead of old pieces of lumber; Robert Hudson's sculptures have consistently become more precise and clear-cut; and Jean Linder's sexual furniture looks increasingly antiseptic. Mowry Baden, whose sculpture previously had a rough and hairy finish, now produces a smooth fiberglas object like the *Fountain*; and Harold Paris places his enigmatic organs into neat plexiglass boxes. Jerrold Ballaine and Gary Molitor are using plastics, molded or cut and shaped by machine, which give their suggestive images a hard-

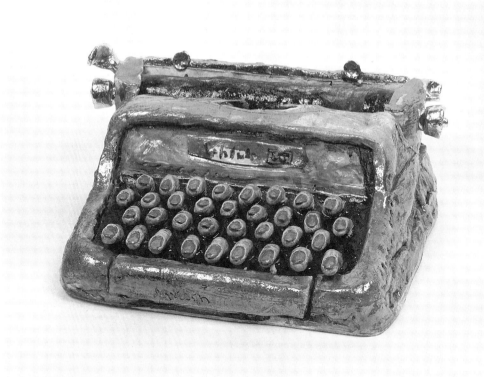

FIGURE 64. Robert Arneson, *Typewriter*, 1965, ceramic, University Art Museum, Berkeley.

edged, shiny, and ultra-clean appearance; Don Potts's constructions are most carefully carpentered; Mel Henderson has created an environment in which forms suggesting snakes, entrails, or pipelines present a highly polished appearance (and are all the more disconcerting for that reason), as does Sue Bitney's *Family Portrait* made of colorful fabric and brightly painted wood. Much of the work currently assumes this greater interest in a well-made finished product. But the imagery, the attitude, the feeling remain funky just the same: the same attitude of irony and wit, of delight in the visual pun, the same spirit of irreverence and absurdity prevail, even when dexterity and careful workmanship are more apparent in the finished sculpture. In fact, this precision of finish only enhances the ironic quality of the work.

Alfred Jarry knew precisely what he was doing when he had King Ubu enter the stage exclaiming "Merdre!" [*sic*]. And, although no one has ever deciphered the meaning, what could be more perfectly composed and more readily felt than:

'Twas brillig, and the slithy toves
 Did gyre and gimble in the wabe:
All mimsy were the borogoves,
 And the mome raths outgrabe.

21 LLYN FOULKES' WORKS OF THE 1960s

IMAGES OF DISRUPTION AND ILLUSION

Modernism – more dogmatic definitions notwithstanding – is by no means merely a movement toward greater distillation and purity.* Quite the contrary, modernism, whether in the novels of André Gide or James Joyce, the music of Schoenberg and Cage, the films from Eisenstein to Godard, or in Futurist painting, Duchamp's invention, or Schwitters' collage environments, is characterized by fragmentation, disjunction, and the synthesis of discontinuity. It is nonlinear in its concept of time. Many artists in the postwar era responded to a world out of joint by reassembling its parts into a new configuration, according to the laws of their own fantasy.

The detritus of the urban environment offered a rich and ample palette to the successors of Schwitters and Cornell. This landscape of waste – the city dumps, the junk yards, the flea markets, and the Salvation Army stores – furnished a multitude of things to be incorporated into new objects, which before long were called "assemblages." Robert Rauschenberg was able to establish his "home rule" that his early combines had to be made of objects he could collect on the streets of New York within two blocks of his studio. By 1961 this practice of two-and three-dimensional collage was impressive enough for the *Art of Assemblage* show to be launched at the Museum of Modern Art.

The phenomenon was international in its manifestations: in New York there were the exponents of Neo-Dada, Rauschenberg and Jasper Johns; in France, Dubuffet, master of assemblage, and the Nouveau Realistes. In California, too, assemblage seemed a natural way to make art. After World War I Simon Rodia, an immigrant Italian tilesetter, invented and built his great towers in Watts, the dismal slum in Los Angeles. Three tall spires and other structures, made of concrete reinforced by steel rods, covered with colored glass, broken dishes, shells, stones, and all kinds of substances and their fragments, created a miraculous collage environment. In the mid-fifties, after Rodia had abandoned the Towers,

* This essay originally appeared in the exhibition catalogue for Kent Gallery, Inc., New York. Reprinted by permission of the publisher.

art critics and artists rediscovered the lacy environment as "a unique creation of inspiring power and beauty, a masterpiece of assemblage."[1]

Far removed from the marketplace, an art that paid little attention to the establishment was able to flourish on the West Coast. In San Francisco, where early assemblage was closely related to Beat poetry and its taste for the mixture of media, the artist Clay Spohn installed his *Museum of Unknown and Little Known Objects* in 1949 at the California School of Fine Arts. Two years later the proto-assemblage exhibition *Common Art Accumulations* was held. Wallace Hedrick made irreverent assemblages, often mixing politics with art. Bruce Conner created his mordantly satirical fetish objects. During the critical years 1957–61 the Los Angeles artist Wallace Berman, who had been close to jazz musicians in the South and to Beat poets in the North, lived in the Bay Area and became a great catalytic force bringing together poets, musicians, and artists, as well as the chief link and messenger connecting the avant-gardes of San Francisco and Los Angeles.

In Los Angeles a new spirit in art found its focus in the Ferus Gallery, which opened its doors on La Cienega Boulevard in 1957. The gallery began its illustrious history with an exhibition of Clyfford Still and the Abstract Expressionist painters of the Bay Area. Soon its imaginative directors, Edward Kienholz and Walter Hopps, attracted the bright young talents of the Southland to their vital new enterprise. The stable included John Altoon, Larry Bell, Billy Al Bengston, Wallace Berman, Llyn Foulkes, Robert Irwin, Craig Kauffman, Ed Moses, Kenneth Price, Richards Ruben, Ed Ruscha, and Paul Sarkisian. And the Ferus also brought in art from outside if it seemed relevant to its purpose, exhibiting work by Kurt Schwitters, Giorgio Morandi, Joseph Cornell, and Josef Albers. In the summer of 1962 the first major gallery show of Andy Warhol's soup cans took place at the Ferus, and soon thereafter Irving Blum, who had taken Kienholz's place as partner in the gallery, arranged for an exhibition of Roy Lichtenstein, which opened almost immediately after Lichtenstein held his first one-man show at Castelli's in the spring of 1963.

All these activities were actively promoted in a new West Coast magazine, *Artforum*, which was founded in San Francisco in 1962 to foster and analyze the work of West Coast artists. Unable to sustain itself in the Bay Area *Artforum* moved its editorial offices to Los Angeles in 1965, when Charles Cowles took over from John Irwin as publisher. The lively discourse between California artists and critics continued until 1967, when the journal pulled up stakes in Los Angeles and moved to New York, where it became the bible of the avant-garde establishment. By that time new museums had been or were being built, California galleries had become more professional, alternate spaces had opened as established options, and the great promise of a new iconoclastic and freewheeling art scene on the Pacific rim had largely evaporated.

But individual authenticity continued in the work of artists like Llyn Foulkes, an eccentric outsider. Born in Yakima, Washington, in 1934, Foulkes studied art and music at the University of Washington in Seattle. In 1957 he went to Los Angeles and enrolled at the dynamic Chouinard Art Institute, where he studied painting with Richards Ruben and drawing with Don Graham. Larry Bell, Joe Goode, and Ed Ruscha were among his fellow students. Before going to art school Foulkes had painted Surrealist pictures influenced by Dali. But by the late 1950s

he was painting dark and vigorous canvases in an Abstract Expressionist style. At the time he left Chouinard in 1959 he was making constructions with multiple images which might incorporate blackboards, chairs, photographs, or just crumpled-up paper. He was aware of Wallace Berman's work, but it was only later that he became acquainted with the assemblages of George Herms and Ed Kienholz and the hauntingly mysterious pieces that Bruce Conner showed at Ferus in 1962. These must have been a great affirmation of his own endeavors.

From 1961 to 1979, when he lived in Eagle Rock, California, a section of Los Angeles opposite Watts, Foulkes created his own assemblage environment – an unruly accumulation of everything from stuffed lions, to eagles, to a collection of old Coke bottles. He made a plaster cast of the head of a mummy, painted it black, added red hair and nylon netting, and put it on the wall together with his own paintings and works by Wally Berman and Paul Sarkisian, an old photograph by Edward Curtis and a more recent one by Dennis Hopper, and an antique anatomical chart of the human skeleton. Not totally different from Rodia's soaring towers of discards, an environment like Foulkes' can be seen as an art (or anti-art) statement of its own. Celebrating the world of the real, physical materials – largely junk and clutter – have been bestowed with new associations and auras. Artists like Foulkes have taken Cornell's magic boxes and moved inside to live and work.

The artist now lives in a beautifully designed house and studio on the top of Topanga Canyon, overlooking the grand and arid mountains and valleys north of Los Angeles. As one enters the house one is greeted by a stuffed MGM lion and a Mickey Mouse clock. The black plaster mummy's head is still on the wall of the living room, where it shares space with human and animal skulls, shells and snake skins, and nests and mounted butterflies, as well as innumerable postcards, mostly of rocks.

Foulkes' early assemblages were dark and sometimes ferocious images. In *Return Home* (1959) the cut-up head of a mannequin is pushed into the surface of a blackboard heavily painted with Abstract Expressionist splatters, as well as impregnated with tar. A newspaper clipping, headlined with "Different Explosions," is pasted onto the assemblage, which is dominated by a multiple photographic image of a satisfied, mustachioed burger. The repeated image recalls both film strips and the boxed plaster casts Jasper Johns attached to the top of his target paintings in 1955. But Foulkes' painting evokes a much greater sense of involvement and violence. In 1960 Foulkes placed a charred chair in front of a burned blackboard, sprayed it all with tar, and chalked a swastika into the composition. This disturbing and macabre work was in memory of St. Vincent's School, which had just burned down. In *Medic Medic*, also of 1960, he encased the image of a head obliterated by black blood in multiple frames. Beneath the "portrait" is a small red cross, and a very large black cross occupies the lower panel. Foulkes says of the imagery in *Medic Medic*, "I guess in some ways I felt I was bearing the cross for all the dead people I had seen in old photos, photos of death and desolation, the Jews in Germany (I was in Germany for two years before going to art school)."[2]

In 1961, during his "black" period, Foulkes created *Geography Lesson*, in which he took partially burned personal letters, sprayed them black, and pasted them

onto a charred blackboard. Collages made of crumpled paper simulating photographs of mountains appear as serial images on the top. The effect of the work is one of restrained violence. Foulkes, like other artists of the period, felt that "the revelations and complexities of mid-twentieth century life called forth a profound feeling of solitude and anxiety"[3] that required an apposite response. *Ellensburg Canyon Landscape*, named after the area where the artist grew up, is made of crumpled paper that suggests mountains, with an explosion of paint sprayed onto the surface. Into the sky of one of the three panels the artist scrawled an almost despondent poem: "Let the endless sky close around me, that I may not view the perpetual hues of sight – perchance within darkness to advance with oblivious fright from the sun."

The dark power of these extraordinary paintings was recognized early on by artists, critics, and curators of discernment. In 1962, the year after the Ferus Gallery first exhibited his work, the Pasadena Art Museum, where Walter Hopps was then curator, offered Foulkes a one-man show. The painter Doug McClellan, reviewing this exhibition for *Artforum*, called Foulkes "an image conjurer of the first magnitude . . . Any tribe in need of strong magic would do well to sign him up immediately."[4]

After these early works of disruption, Foulkes' art entered a more restful period. Moving from assemblage to painting, his work became more adherent to the picture plane, and he designed his paintings with greater concern for purposeful composition. In 1963 he painted a fine cow, applying rags soaked with pigment after having drawn the bovine's contour. *Cow* has a naive, almost folk-art quality that occurs again in *Grade A Cow*, done a year later. *Grade A Cow*, square in format, bears the artist's simple inscription dedicating it to "the dairymen of America." Unlike the earlier cow, which was represented in full profile, this one looks rather pleadingly at the viewer. The view is not unrelated to the realistic cows and bulls that Paulus Potter painted in Holland in the seventeenth century, but never would the Dutch painter have scribbled on the animal's flank or added words like MILK, taken from the world of advertising, to the canvas. In another work of the Cow series Foulkes resorted to a triple image of the animal, now seen as a chart for slaughter. Cattle actually occurred with some frequency in the art of the 1950s and '60s. Foulkes was not familiar with Dubuffet's whimsical and often chimerical cows in the mid-'50s, but Andy Warhol saw Foulkes' cow pictures on a trip to Los Angeles and soon after that, in 1965, made his own depictions of cows imprinted on wallpaper.[5]

During this period life improved for Foulkes. In 1963 he received the first New Talent Purchase Award to be given by the newly formed Contemporary Art Council of the Los Angeles County Museum of Art. After leaving the Ferus Gallery he began to show regularly at the prestigious and avant-garde Rolf Nelson Gallery. Having worked as a taxi driver in 1960–61, he became an art professor at UCLA in 1965. Then, in the late '60s, continuing his love for music, he played drums in rock bands on Sunset Strip. Later he was to build his own one-man sound machine (sometimes called a Foulkes-a-Fone), a wild-looking and wild-sounding horn and percussion instrument. He has animated innumerable old car horns, cow bells, and bicycle bells and sings autobiographical songs to his own enthusiastic accompaniment.

The Pasadena Art Museum and the Los Angeles County Museum organized large exhibitions of Pop art in 1962 and 1963 respectively. Possibly under the influence of Pop painting Foulkes' work continued to evolve toward greater pictorial flatness. In 1963 he painted a traffic signal he called *Junction 410*. Most of the painting's surface consists of black and white diagonal stripes, signifying hazard. On the right margin of the eight-foot-high danger emblem, he placed a band of serial images, rapid views of the mountainside a driver would see from the corner of his eye when approaching the sign. The views are repeated six times, and the redundancy – much as with Warhol's soup cans and Marilyns – is not only a filmic image but also has an almost hypnotic effect on the driver/spectator. Were it not for the yellow and orange framing strip on the top and left border, the painting would almost appear to jump out of the frame and enter the viewer's space.

Soon the mountains, instead of appearing only marginally, took center stage in Foulkes' paintings. The relation of center and edge is reversed as a yellow and black striped device, again signifying danger, is employed as a border around the landscape in *Death Valley* (1963). The military emblem of the American spread-winged eagle appears in triple repetition on the top of the postcard view. The canvas also bears the inscription "This painting is dedicated to the American," which is repeated four times. But this consecration promises little but desolation: the hills of *Death Valley* are lifeless and barren and the colors of the painting are held in monotones of browns and beige. Painted in 1963, during the period of great fervor, of the demonstrations in Birmingham, of Martin Luther King's March on Washington, *Death Valley* also alludes to the Civil War, for Foulkes has added a dedication that recalls the one Ulysses S. Grant used in his memoirs.[6]

Most of the scribbles in *The Page*, also of 1963, are indecipherable, but in the upper right-hand corner the inscription reads: "This picture and These Volumes are dedicated to the American." In this painting twelve views of hills and mountains are placed in a definite grid of perpendicular black lines. The gridwork recalls Mondrian's paintings, and I was reminded of the proposal made by the Dutch painter Constant (Nieuwenhuys), a leading member of the CoBrA group, in regard to the older artist's pure abstractions: "Let us fill Mondrian's virgin canvas, even if it is only with our misfortunes."[7] Foulkes has filled *The Page* with bleak and totally uninviting landscapes, painted in subdued grays.

In 1963 as well the artist found an old stereoscopic photograph of Mount Hood and, intrigued by the possibilities of the three-dimensional effect achieved by the old-fashioned instrument, he bought an old stereoscope at a junk store and proceeded to paint almost identical pairs of the same scene in paintings that resemble old double photographs, even though they are much larger than stereoscopic cards. *Mount Hood Oregon* (1963) comes equipped with stenciled commercial lettering as well as the diagonal black and orange border design, symbol of warning to passing cars. The image here, as in *Canyon* (1964), suggests a view observed quickly from a speeding automobile rather than a landscape explored on a stroll through the countryside.

The monochromatic color scheme in these paintings also recalls old tinted photo-postcards. Foulkes is making pictures from pictures rather than from direct observation, disrupting the romantic tradition of landscape painting. The post-

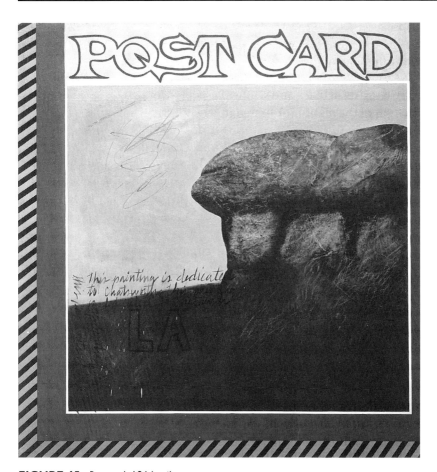

FIGURE 65. *Postcard*, 1964, oil on canvas, 68⅜ × 64", The Museum of Modern Art, New York.

card is a mediating device and the source of the view is known to the viewer of the painting. The artist's use of borrowed images, however, does not result in the kind of purposeful disengagement endemic to much of Pop art and even more pronounced in the photo-realist paintings of the 1970s. Although Foulkes does appropriate the camera view, he does not permit himself to be limited by the photographic information. Instead he uses it to expand his own visual discoveries.

In *Canyon* the dark slope on the frontal plane suggests biological as well as geological formations. As Foulkes continued to engage himself with paintings of mountains, the meaning of the rocks became increasingly ambiguous. Some of them resemble animals, bones, or even human presences. In an interview occasioned by his survey exhibition in 1974 he recalled, "The cow and the rock images were influenced by the 'Rock' in Eagle Rock, California. One day I drove by it and saw it as a cow's skull. Near it was a black and orange striped construction sign that said 'Hood Construction Company.' I realized the earliest double-image painting called Mt. Hood Oregon had orange and black stripes."[8]

In a series of paintings of 1969 the rocks become strong, single images. Again the color recalls faded photographs. But these pictures were painted with both brush and rags and have textures that look very much hand-made. These great

piles of boulders reminiscent of the buttes in Monument Valley also evoke human presences, and the artist gave them titles like *Leonard's Rock* and *Leo Gorcey's Rock*, the latter actually referring to the leader of the Dead End Kids. Like the illusory rock paintings by Magritte, Foulkes' paintings too are illusory in their slippage of meaning. As Wittgenstein suggested, "The aspects of things that are most important to us are hidden because of their simplicity and familiarity."[9]

22 HAROLD PERSICO PARIS

Harold Paris was a most prolific artist, a man whose audacious inventiveness moved beyond art's established frontiers to create a body of work of vital authenticity and emotional tension. Although very much part of his time, Paris remained aloof from all schools and movements. He died in 1979, just before his fifty-fourth birthday, just as he was about to receive the dignity of full acclaim and the recognition due his work.*

Paris's background was the Yiddish Theatre in New York where his father was an actor and Harold a make-up man even as a youngster. Before devoting his full energies to making and teaching art, he directed an advertising agency, and for a while he developed plastic hair for commercial wigs. He studied briefly in Stanley William Hayter's famed printmaking workshop, Atelier 17, in New York, and it was in printmaking that he first excelled.

During World War II, Paris was an artist-correspondent for *Stars and Stripes*. In 1945 he confronted the death camps at Buchenwald, an experience of anguish that determined much of subsequent thinking and imagery. Indeed, soon after his return from Europe to New York he began working on a series of monoprints on the theme of Buchenwald (1948–49), a subject which was anathema to most artists. In 1947 Robert Motherwell and Harold Rosenberg had issued their noted joint statement which implied that art need be separated from political action in the postwar period.

There was also Theodor Adorno's admonition that the holocaust was of such cataclysmic dimension that any discussion in art or poetry would only trivialize the experience of the death camps. Nonetheless Paris's work (from the Buchenwald series) was purchased by the Museum of Modern Art as early as 1949, when the largely self-taught twenty-four-year-old artist's work was included in MoMA's exhibition, "Masterpieces from the Museum Collection." Paris began showing in New York galleries as well as in Philadelphia, and in 1954 he was included –

* This essay originally appeared in the exhibition catalogue for Harcourts Modern and Contemporary Arts, San Francisco. Reprinted by permission of Harcourts Gallery, Inc.

together with Louise Bourgeois, Joseph Cornell and Reuben Nakian – in Belle Krasne's essay "Ten Artists on the Margin."[1] In his own statement, written for the occasion, he allied himself with mystic artists of the past, mentions Redon, Blake, and Munch and posits his attitude as an artist:

> I am concerned with the forces of good and evil that exist not only in man but in myself . . . I feel (man's) anguish of living very much, and his aspirations.
> . . . If people in my work seem to be in pain or anguish, it is, I guess, because I see people suffer . . . and I guess I do too . . . Not being part of the mainstream? It is, certainly, very difficult. It hurts to be left out, to be misunderstood. It hurts very much. After my last show I felt so depressed that I couldn't work at all for three weeks. But that will never happen to me again. I've decided that all I'll ever have will be a small audience – that in all of this, there will be people who understand.

From his studio in a flat on West 42nd Street in the very center of Manhattan, Paris acquired Joseph Pennel's venerable printing press and began working on his Meisterstuck, the Hosannah Suite. Leaving New York on a Guggenheim Fellowship, he carried both concepts and equipment with him to Madrid, Majorca and Paris, always working on the prints. He continued the suite on a Fulbright in Munich and completed it while teaching arts and crafts to the U.S. troops in Nancy, France.

Hosannah, which exists in five different versions and also includes original drawings, consists of some thirty prints done in etching, aquatint, drypoint, lithography, lucite engraving, and metal intaglio, whatever medium seemed most appropriate to the image. Paris was an experimenter, forever fascinated with new and different techniques and materials. This process of exploration is always a major aspect of his work. The *Hosannah* images arise from his private mythology and from existential anxiety. In them the artist found visual expression for human vulnerability and terror as well as a celebration of the human capacity for endurance. These memorable images are of a personal vision that intermingles dream and reality.

In 1957, having completed the suite, Paris sold the first set to the Philadelphia Museum of Art. He continued making prints intermittently for the rest of his life. But in 1954 on a trip to Barcelona, he saw for the first time Antoni Gaudi's architectural sculpture and sculptured architecture, the surreal *Sagrada Familia*. It was then that Paris decided he had to make sculpture. The following year he had the opportunity to learn bronze casting at the Munich Academy. During the later 1960s he made sculptures of organic fantasy whose tortured surfaces relate to the work he had been doing in intaglio and etching. Those sculptures, invested with great energy, can now be seen as part of a movement in biomorphic abstract expressionist sculpture, which was prevalent in America at that time.

In the fall of 1960 Harold Paris came to Berkeley to join the art faculty at the University of California, at a time when there was a great deal of creative energy in Bay Area sculpture. In San Francisco, Bruce Conner and George Herms were creating absurd and often savage assemblages; Alvin Light and Arlo Acton made wild wooden constructions of interconnected organic shapes; Robert Hudson, William Geis and William T. Wiley began forming their rowdy free form sculp-

tures of spirited humor. In Berkeley a new vitality manifested itself in the teaching and making of sculpture. Sidney Gordin, well known in New York for his structured abstract metal sculptures, was invited to Berkeley in 1958, and a year later Peter Voulkos came up from Los Angeles and things never were the same again. As the U.S. commissioner of the 1st Biennale de Paris, I had included some of Voulkos's large ceramic pieces for which he was awarded the Rodin prize. Now America's leading ceramic sculptor set up the "Pot Palace," a makeshift ceramic studio in the basement of an old building on the site where the University Art Museum was later built.

Harold Paris immediately saw new possibilities in clay for his own work. In 1960, teaching at Tulane University in New Orleans and then at Pratt Institute in New York, he had worked on a book of drawings, called *Thoughts on a Sculpture*. Now he was able to realize these thoughts on a heroic scale. He began a series of huge ceramic walls, in which he translated much of the imagery of the *Hosannah* suite into vigorous reliefs.

After preparing preliminary drawings, which he incised into the surfaces of the clay, Paris proceeded in an almost abstract expressionist manner to work on the walls. He improvised with the clay – built it up, scooped and gouged it and in his theatrical manner, cut into the material with a great sword. He created groupings which he then broke apart, to reassemble them in different ways. He built up the clay from the floor, then pushed part of it into the ground and into the viewer's space. The walls assembled from these pieces were then fired and laid together against a back-support. Paris identified with the clay, saying later: "We too are clay . . . My hand and every mark in the clay is a sign that I am here now – At this instant – and this clay is what I am and will be."[2]

Wall I of 1960 (80 × 104 × 24 inches) was done in a single continuous outpouring of energy during a twenty-four hour period. The artist then proceeded to make even larger walls with more complex imagery in 1961 and 1962. The final work, *Wall III* is almost 13 feet long and 7½ feet high and protrudes 4 feet into the viewer's space. He named the walls *Mem* after the thirteenth letter of the Hebrew alphabet, and also for "M" cities – Majorca, Madrid, Munchen, where he had recently lived. These walls with their bulging biomorphic and anthropomorphic forms are sensual and visceral; they are brutal but also very warm in their earthiness. They suggest mythic images of Golems and Molochs and unidentifiable organic beings. As one ponders them at a distance and close-up and under various light conditions, different meanings emerge. Prolonged contemplation arouses almost unlimited associations.

Harold Paris was brought to Berkeley originally because of his knowledge of bronze casting, which he had acquired in Germany. At the university he met Donald Haskins, who had operated a bronze foundry in Minneapolis, and with the vigorous cooperation of Pete Voulkos, the three men built their own foundry, the "Garbonzo Works," in which sculptors were able to cast their own work. Soon these three prime movers were joined by Julius Schmidt, a visiting professor from Michigan, and by their students, including Bruce Beasley, James Melchert, Charles Ross and Stephen de Staebler. The production of the young Berkeley sculptors was so outstanding that they were the sole representatives of the United

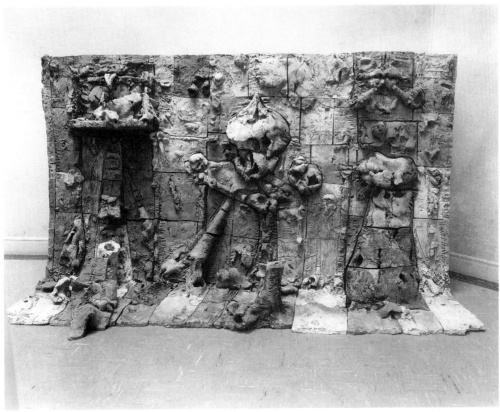

FIGURE 66. *Wall III*, 1962, fired ceramic, 90 × 156 × 48", Collection of Deborah Paris.

States in the 1963 Biennale de Paris in an exhibition called "Onze Sculpteurs Americans," directed by Herschel B. Chipp, professor of art history at Berkeley.

Harold himself entered a period of extraordinary creativity after his arrival in Berkeley. In the same year in which he created his first ceramic wall, he also began work on large bronzes, including a fabulous series of chairs entitled *Clementine* (1960–61), *Elder* (1961) and *Big Momma* (1961). Like so much of his work, these bronzes are open to multiple interpretations. In the newborn *Artforum*, John Coplans spoke of "the human remains attached to the vitrified chairs, and remnants of things, almost as if exhumed after some terrible catastrophe."[3]

Paris saw *Big Momma* as "manifesting itself as a somewhat deteriorated, rejected, and yet, regal woman."[4] Although Giacomo Manzù, working in Rome at the same time, was also casting bronze chairs, Paris's dramatic chairs demonstrate a great contrast to the older Italian's lyrical works.

In addition to the chairs, Paris created an impressive number of other bronzes during the early 1960s. Here his fertile imagination ran wild. He developed fantastic forms, sometimes used found objects, pieces of fabric, plastic bottles, anything at hand. At other times he resorted to his imagination and dreams. When he heard of John F. Kennedy's assassination, he made a form which faintly suggests a broken skull. Often the pieces were split – some geometric, others organic – confronting each other dialectically on the same base. Paris, like so many sculp-

271

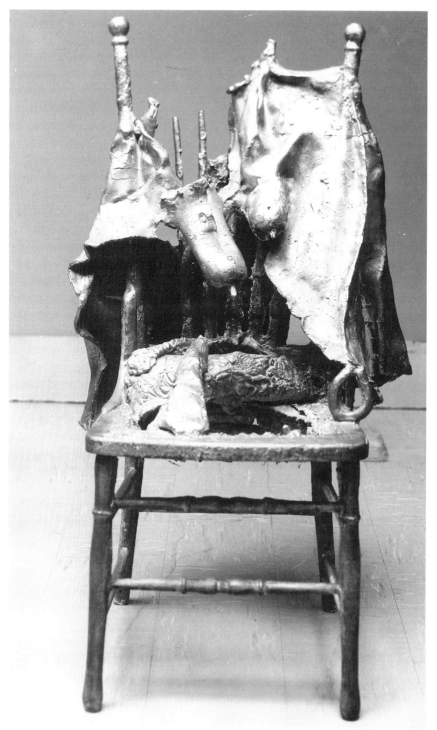

FIGURE 67. *Big Momma*, 1961, bronze, 43 × 24 × 22", Collection of Deborah Paris.

tors of his generation, had the greatest admiration for Giacometti, and, like the older sculptor, he began painting his bronzes around 1965, creating works which usually have allusions to the real world of appearances: an imaginary still life, a horse's head, a broken

mailbox, a mushroom, a twisted wine bottle. Before long the *Mems*, the large walls promoted Harold Paris to create whole rooms. Working in his El Cerrito, California, studio he constructed *Room I* in 1964–65, a work which occupies a significant place in the history and chronology of modern sculpture.[5]

Room I was designed in dialectical terms. The objects inside it – about fifty different elements – are contrasts in soft and hard, solid and hollow, strong and fragile, broken and smooth, geometric and organic, clinically stark and visceral, transparent and opalescent, all in white and black and certainly signaling life and death. In this room, it is no longer a reflection of reality, but assumes the reality of reflection. When Dore Ashton saw it she called it "probably the most audacious experiment to date in governing the total environment."[6]

In 1966 before a second version of *Room I* was built and exhibited at Mills College in 1967, Paris created his *Pantomina Enfanta* for the Balboa Pavillion in Newport Beach, California. This work, designed specially for children, had a black rubber floor, black walls, and surfaces and cast or modeled structures which seemed to have worked as a surreal playground for the youngsters.

In 1966 he also built his *Pantomina Illuma*. Here Paris used electronic devices to achieve additional contrasts of surface temperatures and unexpected oppositions of hot and cold, which astonished the visitors. Certain elements also emitted sounds – squawk, bellows, or moans. Harold Paris was very happy that the work was installed not in a secluded art gallery but in the Grand Ballroom of the UCLA Student Center. In this public work the synaesthetic responses by the viewer suggested a new direction in sculpture. Again it received the highest critical acclaim. Kurt von Meier, who taught art history at UCLA at the time, affirmed that "with this work Paris establishes himself among the most brilliant, inventive, and daring sculptors at work anywhere."[7] *Pantomina Illuma* was also chosen in 1967 to represent the artist's work in the important review *American Sculpture of the Sixties*, at the Los Angeles County Museum of Art.

In 1969, while residing in Milan, Paris created and exhibited his *Pantomina Intima*. In this highly theatrical piece only one visitor at a time could enter the narrow blackened room and labyrinthine cubicles lit dimly by black candles. A sense of mystery, indeed a funerary atmosphere was evoked, enhanced by an entombed sculpture. The title of *Pantominas* imply theater, acting, punning, playing, miming and in this case, a dance of death.

A year later at Galerie Withofs in Brussels, Paris worked with voices and music in *Voices of Packaged Souls*. This environment consisted of a long box enclosing candles. There were stairs covered with phosphorescent plastic that glowed in the dark, and thirteen electronic voices, composed by Suzanne Ciani, emitted mysterious sounds, such as "Sound of Hair Bleeding," or "Sound of Eye Tearing." A black plastic box contained the "Soul of an Unborn Child Killed in Vietnam." At the Vernisage Paris led the guests to a hearse with a coffin and in a cortege of twenty cars, drove through the streets, eventually casting the coffin into the water of a local stream to complete this ritualistic work.

It was during his stay in Milan that Paris began working on his Kaddish environments. *Koddesh-Hakodashim* was eventually installed in the large retrospective of his work at the University Art Museum, Berkeley. There it rose on top of a transparent Jacob's Ladder made of thin transparent plastic sheets and was held

by guy wires about eighty feet above the museum's floor. This environment, which contained all the beautiful objects the artist could fashion, was hermetically sealed, recalling the funerary chambers of Egyptian kings. Written in the artist's hand was his own poetic statement in questions and responses based on the Passover liturgy. But Paris replaced the didactic ritual of the Seder with the Kaddish, the prayer for the dead:

KADDISH

What does it look like?
Like the inside of (a) my soul
Who can see it?
Only the blind with two small
 children
Where does it come from?
 the wail of the shofar
 the 3,000 years
 and a scream in Viet Nam,
Who claimed it?
We, you did.
Why?
So it could be understood
Through the seeing or remembering
sending a message of love.
Do we exist because of it?
 no more than for the
 lack of it.
Is it really there?
No, it is there really.
What should we do now?
Believe
Why is it closed?
 it isn't
There is no entrance
 there is also no exit.
Shall no one ever see it?
 ever is a long time to see.
What is inside?
 all my dreams of the outside.

In 1975, the Jewish Museum in New York invited Harold Paris to create an environment, which remained on exhibition for an extended period of time. He now had two tiny children and he had just seen a documentary film about the children in concentration camps as well as the drawings and poems of the children in the Terezin death camp where only 100 out of 15,000 children survived. In one segment of this last environment, the *Kaddish for the Little Children*, three brick stairs lead nowhere and a small metal ball is placed on the lowest step. The brick floor was exposed to a dreamlike flow of black sand, running from the steps, evoking the thought of children's tears of blood.

During the 1960s, Harold Paris had made his home and studio at the Port of

Oakland, where he was the only person living in a huge area of docks and ships, of freight containers and cranes. At night one could see the ships being loaded with war equipment and boarded by G.I.s destined for Viet Nam. The artist was very much aware of the senselessness of our war in Southeast Asia. At times, when he was not working on the large environments, he made little rubber and plastic microcosms, some of them no more than four inches high. When photographed, these miniature works exhibit a large sense of scale. Encased in transparent plastic boxes, these little sculptures suggest a multiplicity of organic and human associations.

One of the leaders in the application of new materials and technologies in art, Paris investigated the world of plastics and began making a series of vacuum-formed sculptures which he called "Chais" (the Hebrew word for life). He heated, stretched and bent the plastic materials and was able to cast sculptures in which sheets of vinyl became shapes he was able to control during the forming process. The industrial anonymity of their pristine surfaces covered underlying strong cores of vital forms. The Chais are dreamscapes of reflecting light, whose mysterious sheen leaves room for a variety of interpretations. They may suggest melted ice as well as strange objects from a brave new world of science fiction. These draped shapes made domes or suggested female forms, but Paris never allows the viewer to identify specific associations. After having made the plastic sculptures, he then cast some of the Chais into small editions of bronze, transforming their crystalline transparencies into opaque objects. On these, he experimented with various chemicals to achieve a great variety of patinas on the surfaces of the bronze alloys. Their high polish on solid bronze makes these works pick up reflections of light and of life.

At the end of the 1960s Harold Paris, persisting in his investigations of plastic, went back to work in a pictorial format. His "Souls" are slabs of silicon about the size of a sheet of typing paper and two to three inches thick. Embedded in the translucent gel is a great variety of whimsical or arresting paper cutouts, found and saved objects, parts of flowers, butterfly wings and much more. They were collected in great disarray and placed in little boxes and baskets scattered all over his studio. The first series, the "Untouchable souls" (1969–70) were sealed plexiglass boxes. A year later, Paris began making the "Soft souls," a series which continued to occupy his hand and spirit until 1975.

In his "Souls" series he again worked dialectically: he employed highly sophisticated plastic technology to express spiritual feelings of aspirations and tragedy. At one time, Paris told me that he made the "Souls" to give persistence to his dreams. They are works of poetic vision. The "Soft Souls" evoke a sense of tender and human vulnerability, partly because they are made of a soft, fleshy material which responds with a quiver to the human touch. Many of them deal with mystical states and have been given evocative titles such as *Birth of a Soul, Ascending Soul,* and *Two Souls on the Way to Heaven.* There are *Torah Souls* and *Cabbala Souls.* Others refer to artists who had meant a great deal to Paris – Magritte, Redon, Klee, Rothko, Chagall and Man Ray – or they are named after writers like Jorge Luis Borges.

Harold Paris also felt a close connection to the history of art as he saw it and he encouraged his students to gain an understanding of art's continuum, to look at

275

art. The artist himself had a small collection of graphics, including Goya, Rouault, Matta, Magritte, de Chirico, Duchamp and Man Ray. But he was also motivated by the events of life around him. In 1970 Paris made his *Soul on Telegraph Avenue* in memory of James Rector, who had been killed by police during the protests in Berkeley, and in 1971 he created a work called *Requiem for a Soul: Kent State.*

At the same time, Paris made a series of "Souls" in which he infused delicate colorants into the gel before it solidified, creating a mysterious phospholuminescence. These brilliant works are activated by light, reach an apogee of luminosity in about a minute, and then slowly change color, eventually dissolving into darkness. "Especially in a darkened room," Herschel B. Chipp wrote, "the mystical colors animating the gloom evoke the animus of these sensitive and suffering souls in all its mystical power."[8] In the 1972 retrospective a number of these luminous Souls were displayed in a very dramatic manner. Reviewing the exhibition for *Time*, Robert Hughes recognized the affinity of these works to those of an artist Harold so greatly admired. Hughes wrote, "Their like has not been seen in America since Joseph Cornell's boxes. Memory and touch, a poignant archaeology of the self: at its best Paris's work is pure magic."[9]

Working once more on a grand scale, Harold Paris executed a commission in 1976 for the Oakland City Center Plaza just outside the BART station. *Grey Portal in an Afternoon Garden* consists of eleven bronzes, one of them a large square gate and a small waterfall; "One of the most ambitious works of public sculpture to be erected in the Bay region in the modern era."[10] Here, working in a mundane but greatly used space, Paris created a public environment responsive to the particular set of physical and psychological characteristics of the site. Many people lingered in the environment, and children climbed all over the bronze forms. Unknown to most, the sculptor and small groups of his friends buried six "Soul" sculptures in the empty footings before the bronzes were installed. In an act of breach of contract, and with no notice to artist's heirs or anyone else, BART simply moved the bronzes when the plaza was altered. They are now noticed in an unattractive site at the bottom of the MacArthur BART station in Oakland.

In 1974, Harold Paris was confined for fifty days in Providence Hospital in Oakland, recovering from a heart attack.[11] There he made forty-four drawings and poignant collages of dreamlike images, a series called "Sketches from Providence." These small works were done while he was lying in bed in a small room with the only materials available: bandages, gauze, hypodermic needles, cotton swabs, and colored pencils and watercolors. Sometimes he cut pieces from things he could find, such as the pyramid and eye on the dollar bill. Or he would insert pieces of a postcard and an envelope, then add subdued color to the collage. In some instances he put secret messages under a little paper flap. He saw these works as "messages from myself to myself and to those I love most dearly," and when they were complete, he cut uneven mats to conform to the irregularity of the image. The "Sketches from Providence" are about the ever-present peril of death and the fragility and restoration of life.

A great many artists, especially in this century, seemed to have been unable to sustain the creativity and quality that asserted itself in their early work. One reason for the persistence of high quality in the work of Harold Paris is that he gained a renewed vitality by his investigations of new materials and his development of

new techniques. Artists have always used paper as a bearer of images, whether in ink, paint, or print. During the post-minimal 1970s, a period of unusual experimentation with media of all sorts, paper became both medium and message for a number of sculptors. Harold Paris was again one of the pioneers in the fabrication of handmade paper from liquid pulp. Garner Tullis, then at the International Institute of Experimental Printmaking in Santa Cruz, taught Paris to cast the paper and Harold would often color the soft pulp and then cast and form it into new abstract structures. He enjoyed the material's porous textures, ragged edges, and its rough surfaces with the appearance of old stucco walls. And, just as he had impressed all kinds of palimpsest and fragments into the silicon gels of the "Souls," he now imbedded similar snippets and memorabilia into the "Cartas," which he started in 1975. The whole process, he said, "was a ritual which not only immersed the object, but portions of myself, and hence an intimacy occurred and the further relationship to the past, which I so gratefully accepted."[12]

Next, Paris developed a vacuum system, this time for paper rather than plastic, and made handmade paper sculpture on a very large scale. In them he would incorporate incongruous things – a plastic foot or hand, a wooden head, a violin bow given to him by a former student. I also remember a good size table and a piece aptly entitled *The Unreality of Looking Out a Window (Female Version)*; there was also a male version to keep it symmetrical. They literally extended beyond the gallery space and branched out against the window, where they were framed by the San Francisco skyscrapers in a show at the Stephen Wirtz Gallery in 1978.

In the same exhibition Harold showed his series "The 26 Days of John Little." He had had another heart attack, experiencing once more the proximity of death, and then his young brother-in-law, John Little, died at age twenty-six. Harold made twenty-six paper collages in muted colors. He often cut, slashed, and tore the tender images, then covered them with paper tapes. Again, all manner of objects were embedded to recall the life of the friend and relative who had died.

As his heart disease became increasingly severe, Harold dealt more and more with his own fate and mortality. But then, the theme of death had marked his work and mind ever since the early Buchenwald prints and the stark environments, all set in black and white. One of this final series was "17 Steps." These works are drawings, they are collages, they are paper sculptures, always suggesting feelings but never explicitly. Much is left to the viewer, who must complete the artist's offered messages. John Fitzgibbon, a most sagacious critic, has responded to them:

> In these drawings the punctured, peeling, patched and scored paper itself stands for the fragility of the body, while sunrise and sunset, the most fleeting, most spiritualized times of the day, when everything is changed in a moment, provided Paris with ready metaphors for the transience of experience in the cycle of birth, life, death, rebirth, and yearning with each breath again for death.[13]

Art for Harold Paris was a potent force, a serious responsibility, but also a matter of great joy. He said to his students: "Is the making of art a source of infinite happiness to you and can nothing else do it for you? Because if you can find something else that will give you happiness, then art is not the answer."[14]

23 RUPERT GARCIA

THE ARTIST AS ADVOCATE

Rupert Garcia first came to public attention – and I don't just mean attention of the official art world – with his radical political posters in the late 1960s.* His current retrospective of over one hundred posters and prints from 1967–1990 at the California Palace of the Legion of Honor re-affirms the rich bequests of the rebellious 1960s, a time of ferment which gave rise to environmentalism, feminism, anti-racism, political protest, and an anti-war sentiment which may yet save the world from its current threats. The Chicano movement *El Movimento* also had its origin in the 1960s. César Chavez organized the United Farm Workers to strike against the grape growers in the San Joaquin Valley, protesting the terrible wages, bad working conditions and deadly pollution, and bringing even broader issues of civil rights, land rights and a decent education to the fore. On college campuses civil rights and then the anti-war protest movement gave great energy to the need for basic changes in the social, political and economic system. At San Francisco State University a violent collision between a reactionary administration and insurgent students and faculty was taking place.

This was the climate to which Garcia returned after having served in the U.S. Air Force in Vietnam and Laos where he had been assigned to guard napalm bombs that were stockpiled to destroy the land and its people. Questioning American propaganda, he began to read Marxist theory and dialectics and soon saw the war in Indochina as part of an imperialistic scheme for domination. He joined the Third World Liberation Front and it was then that he began making political posters. He was convinced that art, even if it may not be able to directly effect social change, can make us aware of political realities.

One of his first posters, printed in the Student and Faculty Poster Workshop at San Francisco State, shows the well-known head of Che Guevara with the words "Right On" stenciled underneath the portrait. It was done in black and white and has the imperative of a traffic signal. A year later, in 1969, he contributed a

* This essay originally appeared in *Artspace*, Vol. 15, No. 3, March/April 1991. This magazine has ceased publication.

poster to the cause of the UFW, depicting the Union's Eagle, which became an important iconic emblem to *La Causa,* the *campesinos'* labor struggle. In Garcia's poster the stylized black eagle is bisected by the Safeway "S" with the legend "Huelga! Boycott Safeway." Seeing this poster near the entrance to the exhibition made this viewer aware that, in our era of requisite corporate support, it took a good deal of courage for the museum to mount this politically charged exhibition.

In 1969 Garcia, now beginning to work with subtler color, made his anti-pollution poster, DDT. Underneath the large red letters identifying the pesticide a screaming young girl without arms is running from poisonous characters toward us, while the dirty-blue background indicates the polluted sky. The crying girl in her black dress is rendered in crisp, hard-edged outlines which are used to convey the terror of the child. In the same year, and in a more satirical vein, Garcia made his replication of Nabisco's Cream of Wheat trademark with its grinning "Negro" in white uniform and chef's cap serving a steaming bowl of the cereal. He captioned this stereotype with "No More o' This Shit." A few years later Garcia took on the Lipton Tea ad with its well-groomed Englishman in yachting outfit graciously offering a cup of tea. This poster, printed for the Galeria de la Raza, is rendered in white, red and yellow and carries the caption: "Ceylon Tea – Product of European Exploitation." Today, with Sri Lanka liberated from European colonialism, but riddled with civil strife, such an advertisement reminds us of the legacy of a long-gone era.

Certainly, these images, taken from the "low art" of advertising, owe a great deal to Pop Art and, indeed, Garcia was influenced by the Pop artists, whose work was omnipresent at the time. But, instead of a blank acceptance of things as they are, Garcia takes a critical stance. He does not, as Jean Baudrillard would have it, substitute commodities for values. Whereas Pop artists justified the status quo by appropriating its reified images, Garcia deconstructs the advertisement, frequently using a text to leave no doubt about what he is communicating. In general, mainstream American painting of the 1970s – be it Pop, Colorfield or Photo-Realism – lacked political commitment as much as it lacked passion. Garcia and a few artists whom he admires, such as R. B. Kitaj and Leon Golub, were among the exceptions.

The question always arises whether the art world can still be a viable political arena and whether moral and political conviction have a place in creating works of art. Arguing this question from the conservative flank, Hilton Kramer takes a clear stance in his journal *The New Criterion,* a monthly that is heavily subsidized by right-wing foundation sources. Taking umbrage with a number of political exhibitions and publications, he complains that

> We are once again [as in "the heyday of the anti-war movement of the Sixties" and, even worse, "the radicalism of the Thirties"] being exhorted to abandon artistic criteria and aesthetic considerations in favor of ideological tests that would, if acceded to, reduce the whole notion of art to little more than a facile, pre-programmed exercise in political propaganda.[1]

But does Mr. Kramer, a most political animal himself, actually believe that artists can live and work in total isolation from the political context? What are these

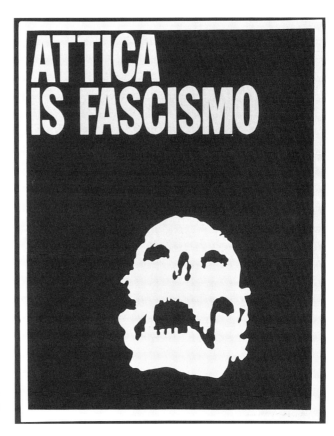

FIGURE 68. *Attica is Fascismo*, 1971, silkscreen 26 × 20", The Fine Arts Museums of San Francisco.

"artistic criteria and aesthetic considerations"? And what was Mr. Kramer's own socio-political milieu in which he acquired his ultra-conservative views?

Rupert Garcia obtained much of his own aesthetics from artists of the past, and in a number of images he pays homage to painters who were also involved with the political issues of their time – artists who used their art, in Picasso's words, "as instruments of attack and defense against the enemy."[2] In a silkscreen of 1973, based on Alexander Liberman's famous portrait photo of 1955, we see Picasso's face emerge from almost total darkness, because Garcia feels that the creative process – here signified by Picasso – emerges from darkness into light. The intense eye, a signal of light, gazes at the viewer. There is also a fine lithographic portrait of Posada – certainly an artist of the people – that Garcia made to advertise a show of his prints at the Galeria de la Raza, an important Chicano gallery in San Francisco which he helped to found.

A portrait of José Clemente Orozco was done in powerful red and black. The face is cropped at the forehead and mouth so that we focus almost entirely on the painter's piercing eyes flashing behind his round glasses. When viewed close up, the bold, dramatic black lines appear to be an abstract configuration, and the likeness congeals only at a certain distance from the silkscreen image. David Alfaro Siqueiros is presented with a striking, carved black shadow cutting into his profiled face.

There are altogether five images of Frida Kahlo in the exhibition, dating from 1975 to 1990. In 1983 Garcia published a bibliography on the artist, who has also

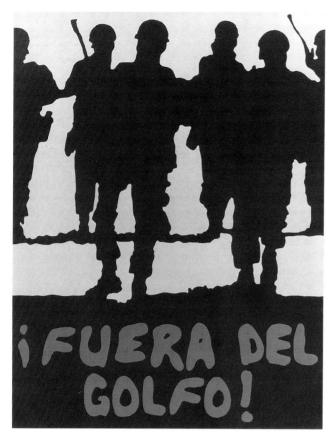

FIGURE 69. *Fuera del Golfo*, 1971, silkscreen, 30¼ × 23", Collection of Rupert Garcia.

become a kind of revered icon for feminists everywhere and Chicana artists in particular. The memorable 1975 image of Frida Kahlo is also among the works by Garcia in the excellent and provocative exhibition entitled CARA (Chicano Art: Resistance and Affirmation) which is running at the Wight Art Gallery at UCLA concurrently with the Garcia show in San Francisco. This multimedia exhibition, intelligently curated by committees of the Chicano community, is divided into twelve topical sections. One of these, titled "cultural icons," focuses on Kahlo as well as the UFW eagle, the sign of radical resistance. It also focuses on Our Lady of Guadalupe, considered a guiding star to Mexicans and Chicanos, and on Emiliano Zapata, the peasant rebel who fought for the redistribution of land to the Mexican peasantry. All of these "cultural icons" have been subjects of Garcia's work, and he is well represented in the CARA exhibition.

In later lithographs made in tribute to artists Garcia turns to the diptych format, which he had been using in certain of his pastels and oil paintings, and in which the greater complexity gives access to double meanings. There is a portrait of Courbet in a lower panel with a stylized and modernized version of the Vendome column collapsing in the upper half. Manet is curiously paired with a trivialized image of the flaming heart of Jesus in a work titled *The Geometry of Manet and the Sacred Heart.*

Most poignant, and the strongest among all of the posters in the exhibition, are those concerned with death. For a 1970 poster protesting the killing of stu-

dents at Kent State University Garcia does not use the famous and tragic news photograph of a girl wailing over the body of a murdered student, but depicts, instead, four of the victims with smiling faces, perhaps photographs from the school yearbook. The blackness of the background of this silkscreen appears again as the foil for a skull in two of his most ardent visual statements, *Fuera de Indochina!*, which was printed for the National Chicano Moratorium in 1970, and *Attica is Fascismo*, protesting the killing of rebellious prisoners in the New York State Penitentiary under Governor Rockefeller's orders in 1971. *El Grito de Rebelde*, 1975, shows a blindfolded political prisoner, bound against a stake and about to be shot. Here the artist has transformed a well-publicized photograph of the political repression under the Shah of Iran into a powerful image of strong color planes. Even more poignant is Garcia's *Bicentennial Art Poster* which depicts the severely foreshortened torso of a murdered man with striking spots of blood on his white shirtfront. The fact that this silkscreen is done in large, almost monumental planes of primary colors adds to the impact of this accusatory work. The dominant colors of the Bicentennial message is in red, white and blue.

In recent years, Rupert Garcia has made accusatory posters dealing with the U.S. invasions in Grenada (1987) and Panama (1989). In both of these works helicopters as death machines are the prominent and horrifying features.

Seventy years ago George Grosz exclaimed:

I considered as futile any art which does not offer itself as a weapon in the political struggle. My art . . . was to be a gun and sword: my drawing pens declared to be empty straws as long as they did not take part in the fight for freedom.[3]

24 OH SAY CAN YOU SEE?

FLAGS: JOHNS TO BURKHARDT

When Jasper Johns first appeared on the New York art scene with his *Flags* in 1955, the art world was provoked by the rich vibrancy of his encaustic technique, by his handling of the flat picture plane and by the cool, detached and neutral attitude toward his subjects, which seemed to some like a respite from the impassioned canvases of the Abstract Expressionists.* A few of us were bewildered, however, by the indifference to the meaning of the Stars and Stripes at the time of the greatest expansion of American economic and military power. When the Castelli Gallery exhibited these paintings in the late 1950s, just as American art too was becoming dominant in the Western world, people might have seen more in these paintings than merely the "integrity of the surface."

Some five years later Claes Oldenburg made rough fragments of the American flag in muslin, soaked in plaster, and then painted with tempera. These were irreverent renditions of the Stars and Stripes. Like all the items which he had in his "Store" at the time, they were meant to "attach materialistic practices and art" and can be seen also as parodies of the highly touted flags by Johns. Oldenburg questioned not only the values of the art world, but, beyond that, the attitudes of mass culture. "I am for an art that is political-erotical-mystical, that does something other than sit on its ass in a museum," he began his Statement of Purpose for the Ray Gun Theater in 1962. It's a lengthy statement, very worth while reading. It also has sentences like: "I am for an art that takes its form from the lines of life itself, that twists and extends and accumulates and spits and drips, and is heavy and coarse and sweet and stupid like life itself."

By the mid 1960s, with the Vietnam War in full gear, politically engaged artists began to use the image of the flag more intensively, employing it symbolically to protest the total immorality of that war in innumerable anti-war posters. Some were very powerful in their message, asking such questions as *Are We Next?* Or presenting the *Napalm Flag*, or again the *Genocide Flag* of 1967. Even Mr. Johns,

* This essay originally appeared in *Artspace*, Vol. 16, No. 3, May/June 1992, pp. 63–65. This magazine has ceased publication.

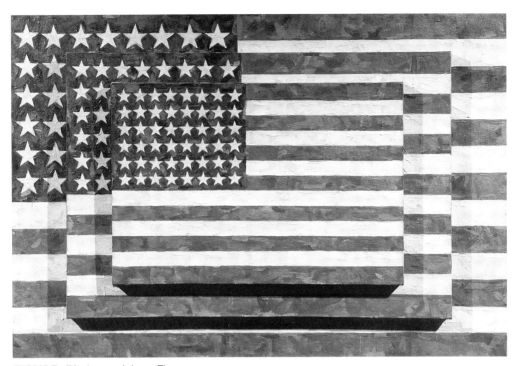

FIGURE 70. Jasper Johns, *Three Flags*, 1958, encaustic on canvas, 30⅞ × 43½ × 5", Whitney Museum of American Art, New York.

when prevailed upon, made his negative green, black and orange flag, *Moratorium*, for the environmental movement in 1969 – pretty mild compared to the other posters, but beautifully painted.

As the war continued and intensified in its mass killing, the messages in the anti-war movement also became more intense. One of the most effective anonymous posters of the period was called *Stars and Stripes Forever*. It consisted of a large number of wooden matches with their heads painted in red, white and blue and ready to burst into flames momentarily. In 1970, also, Sam Wiener made his powerful image: *Those Who Fail to Remember Are Condemned to Repeat It*. It is a small box lined with mirrors and with flag-draped coffins expanding infinitely into endless rows, much as the number of the body counts seemed to increase *ad infinitum*. This piece had the effect of a surreal dream of horrors, terrifying in its cool attitude toward death. Later, during the years of overt U.S. aggression in Central America – in Grenada, Nicaragua, Panama, El Salvador – Wiener made posters for mass distribution of this image.

The Chilean artist René Castro, now living in San Francisco, contributed to the San Francisco Art Institute's 1990 Annual Exhibition, *The Flag* – a show which opened in the fall of that year at the time when American troops were rallied around the Stars and Stripes protecting the oil wells of the Arabian desert. Castro's work, called *Burn, Baby, Burn*, consisted of a Posada-like skeleton of a man draped in a mutilated American flag, and wearing a large John Wayne–type Stetson hat. A vulture with a GI helmet is perched on his shoulder and a frieze of similar carrion birds decorate the top. The poignant message on the side reads: *By the time you reach my age, you don't need to be fucking around with the flag.*

In the same show was a strong image by Mason Byers, entitled *One Hundred Eleven Instruments of Counter Intelligence, Social Mobility and Selective Survival*, which was an assemblage of nine steel-jawed animal traps which were fixed to three large American flags. In the place of the bait, the artist placed 10-dollar bills and fake bags of cocaine. The phrase "Selective Survival" refers to the profits made by the drug dealers in cahoots with the CIA. The traps are for the victimized underclass. Byers stated the unfortunate truism that "through complacency, greed and misinformation the population does not question these actions." This work, like so many others in that provocative show, questioned the government's manipulation of the populace under the guise of patriotism. In a piece by Bernadette Ann Cotter, the flag was deconstructed, literally, that is, into thread, hanging from the wall and in little balls on the floor.

The organizers of that show also brought Dread Scott's work *What Is the Proper Way to Display the United States Flag?* from Chicago where it had caused a great uproar when exhibited at the School of the Art Institute in 1989. The piece consisted of photomontage, text, a shelf, a ledge and the flag, spread on the floor. The photos showed some South Korean students burning the U.S. flag, one of them holding up a sign, saying "Yankee go home, son of bitch." On the shelf was a ledger where visitors could write their responses to the question: "What is the proper way . . . ?" When displayed, people naturally had to walk on the flag on the floor, thus disgracing the national symbol with their feet.

But are feet really so inferior to arms which are lifted patriotically to salute the piece of cloth? Why is no one troubled by the cancellation machines that besmear the paper representation of the Stars and Stripes millions of times each day at U.S. post offices? The Veterans of Foreign Wars attacked the Scott piece, demonized the artist, and provoked some members of Chicago's City Council to demand that the Institute's board resign to be replaced by "honest Americans and Veterans." The school of the A.I. had its city and state funding cut. Demonstrations with as many as 2,500 veterans took place, but many of Scott's fellow students made it difficult for them when they painted flags on the grounds where they were about to march. A great deal of public debate was caused by this work and even President George Bush took notice of a work of art. There were also a number of flag burnings while we were "cleaning up" Panama. The enraged President managed to bring the issue of flag burning to the Supreme Court resulting in Justice Brennan's memorable decision: "We are aware that desecration of the flag is deeply offensive to many, but punishing desecration of the flag dilutes the very freedom that makes this emblem so revered and worth revering." With Brennan, and now Thurgood Marshall, off the Court, men who are being replaced by individuals of the extreme right, will the Court rule with the similar wisdom in the future?

In 1990, during the period designated by Mr. Bush as Operation Desert Shield and Operation Desert Storm the Los Angeles artist Hans Burkhardt painted an astonishing series of paintings based on the flag. Paintings of political commitment have been consistent throughout the career of this now 87-year-old painter. He had painted works protesting General Franco's bombardment of Spain's civilian population; he had made paintings of the concentration camps, and works protesting the bombing of Hiroshima.

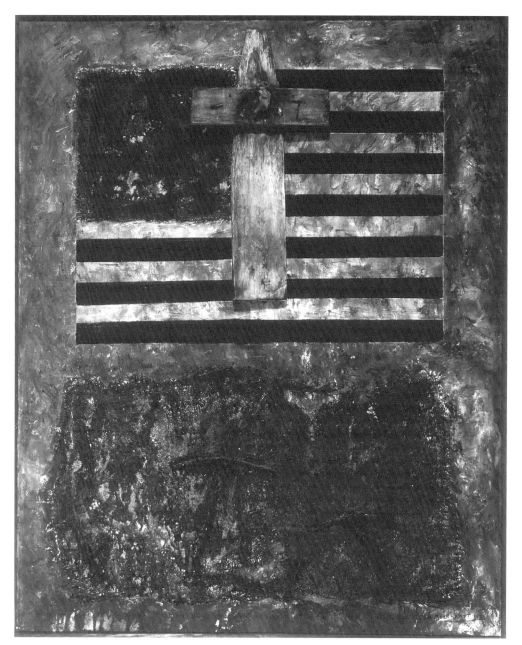

FIGURE 71. Hans Burkhardt, *Tar Pit*, 1991, oil and assemblage on canvas, Santa Barbara Museum of Art.

During the Vietnam War he infused human skulls into large canvases of thick, heavily painted textured greys, which Donald Kuspit counted "among the greatest war paintings – especially modern war paintings: summarizing the brutality and inhumanity not only of the Vietnam War, but also of the 20th century as a whole."

In most of the current Desert Storm paintings, Burkhardt juxtaposed the image of the Cross to the U.S. Flag. In *The Desert* he has nailed an old Mexican crucifix on top of a painting of the flag. Into the field normally reserved for the stars he glued a piece of old burlap, and some additional lengths of rotten burlap are

placed below the flag. The stripes are painted with great care and consummate craftsmanship, and a sensuous surface creates a drastic visual contrast to the crucifixion in the center. In a variant, *The Lime Pit*, a fragment of a crucifix with a headless Christ takes up the center of the painting and red paint is stained into the black burlap.

In *Tar Pit* Burkhardt simply nailed two pieces of raw board together and additional black crosses, made of pieces of cord, appear in the star field as well as in the blackened area below. In *Silent Storm*, the largest of the works in the series, he again made two crosses out of rope and placed them in the upper left field, while the white spaces between the black bands are sensitively brushed, creating shimmering chromatic surfaces which again seem in total opposition to the message of death. The bands of color in these works dialectically transfigure the suffering expressed by the dark crosses of death and suggest late medieval woodcuts of the Dance of Death. Burkhardt's works are executed with a masterful craftsmanship comparable to Goya's magnificently etched *Disasters of War*.

Jean Baudrillard asserts that our overstimulated world, in which "television is the ultimate and perfect object," signals the end of interiority and authenticity, threatening the self with becoming only a screen upon which networks of influence are projected. Such a condition suggests the end of creative originality and the construction of a simulated space of appropriation and *pastiche*. Jasper Johns's series of flag paintings can now be seen as replications, depicting material objects, as codified images without significant content. But some of the works mentioned here contradict Baudrillard's pessimistic stance vis-à-vis authentic art in our time. Hans Burkhardt's Desert Storm paintings, in particular, raise many of these issues not as theoretical problems, but in the form of major works of art. Now achieving an *Altersstill*, so rare in time, he has created these truly extraordinary paintings. I am reminded of Theodor Adorno, who formulated a tragic – rather than pessimistic – aesthetic in which he observed that, "The need to lend a voice to suffering is a condition of truth."

25 BEDRI BAYKAM

AMERICAN XENOPHOBIA AND
EXPRESSIONIST DRAMAS

In the early years of this century, when Modernism was at its apex, artists recorded their discoveries of art from non-Western cultures with positive fervor.* Now all art and its history is a grab-bag; everything is available and the aura bestowed by distance has disappeared. Many artists in this predicament simply respond to this *embarrass de richesse* by an appropriation of form and gestures of past eras without an authenticity of their own. Just as much of post-modern architecture is little but nostalgic surface decoration, so a good deal of the new painting is little but vehement pastiche. Eclecticism, at any rate, is unavoidable.

Much of Bedri Baykam's work, while necessarily and purposely reflecting the recent past and the current situation in art, is also essentially autobiographical. His brush has the stroke and drip of Abstract Expressionism. His imagery is indebted to Surrealism and to popular culture. His painting and his manner of working is partly derived from Performance and Action Art, and has been strongly affected by the fluid movement of the filmic image (Baykam has actually worked as a filmmaker). His painting is clearly concerned with politics and with the politics of art in particular; he has read and looked with great attention and has written critical pieces himself. He has absorbed the art from his own Turkish culture, as well as from the Western world, and fused it with his personal experience to create a vital, authentic art of activated color and passionate feeling.

However, although art from the whole history and pre-history of the human race has entered our pluralistic vocabulary, the art situation itself is still chauvinistic and protective of its central marketplace in Manhattan. In 1964, when Robert Rauschenberg was awarded the First Prize at the Venice Biennale, Alan Solomon, the U.S. Commissioner, announced this occasion as the official recognition of the hegemony of American painting. In 1970, Irving Sandler entitled his monograph on Abstract Expressionism *The Triumph of American Painting*; in 1983, the French art historian Serge Guilbaut analyzed the situation in a book called *How*

* This essay originally appeared in *Arts Magazine*, Vol. 61, No. 3, Nov. 1986, pp. 19–21. This magazine has ceased publication.

New York Stole the Idea of Modern Art. There is no doubt that New York is indeed the place where the main career decisions of the art world appear to be made, but New York has little more tolerance for outsiders than Paris granted them during its time as the center. It is, in fact, only during the last few years that any real attention has been paid to art from abroad, and even this turn of events was partly due to the unmarketability of Conceptual art. Now, unless the foreigner is German or Italian, his/her chances of gaining the attention of the establishment are limited. Residence in the "trans-avantgarde" is a restricted covenant for artists living in the West. Typical was the exhibition for the auspicious occasion of the re-opening of the Museum of Modern Art. Kynaston McShine's show was called an "International Survey of Recent Painting and Sculpture," but it included, in fact, out of a total of 165 only a single artist – Magdalena Abakonowicz – who was residing in a country outside the Western hegemony. In organizing the 1985 Carnegie International, the "director, curator and committee members decided to concentrate on Europe and America. For various reasons Japan, Australia, Latin America, Eastern Europe or the Third World were simply not considered."[1]

Here now is a young Turk who has been assailing this exclusive situation on his own behalf and that of his country. To a considerable extent he has encountered a wall, exemplified by the response of a staff member of a major museum when Baykam's request for consideration in an important exhibition was dismissed with the suggestion that he show in an alternative space with other Near Eastern artists. This particular official was undoubtedly not aware of the crass segregationist attitude of such a proposal, but it reflected an attitude which is not unusual.

I myself first met Bedri Baykam when, as a participant in a symposium at the San Francisco Museum of Modern Art for the exhibition *The Human Condition*, I received his manifesto which posed the question: "Is the Western world once again in the process of building modern art history as solely the history of occidental artists?" Baykam pointed at the cultural domination of the Western establishment, which, he stated in alarm, appears to certify that "we are going to present new expressionism as a purely western phenomenon in the future reference books that our descendants will read." He is an able spokesman for himself, but he also sees himself as the promoter of other Turkish and non-Western artists and feels that contemporary art history should not be a Western *fait accompli*.

Bedri Baykam has had thirty-five one-man shows in various countries. Some of these, to be sure, took place when he was a child prodigy. His totally coherent and vigorous drawings, made when he was four and six years old, were unlike those of ordinary children. They have a clear perception of shape in its relation to space, and indicate an unusually large, active, visual vocabulary. His childhood pictures of horses, of cowboys and Indians, airplanes and rockets show a development of representative symbols and a relationship between the drawing and external reality only found in the artwork of adults. But he never imitated the adult art of illustration. With amazing sensibility, Bedri was able to alternate the thickness and thinness of his line, delineating and revealing the subtleties of the planes of the body of a horse or a person. There were drawings of quick-fire action; there was a charcoal ink drawing of a head which has the force of a woodcut by

Emil Nolde; there were totally abstract paintings. Between the ages of six and ten, this Wunderkind had fifteen solo shows in Turkey, Switzerland, Austria, Paris, Rome, London, and New York. All met with great critical acclaim; his precocious talent was compared to that of Rimbaud, Pascal, Menuhin, and Mozart.

In the early 1980s, when Baykam came to the San Francisco Bay Area from Paris, most of the avant-garde artists were still largely involved in Photo Realism, Minimal and Performance Art. It was at that time, feeling a bit out of place with his local colleagues, that Baykam attached pieces of broken mirrors to a wooden panel. *The Prostitute's Room* (1981) was done before Baykam was familiar with Julian Schnabel's pictures with broken crockery. What Baykam offers viewers is our own distorted image from the mirrors which compose the man on the right. The moment of reflection also alters the image. In contrast to Picasso's *Demoiselles d'Avignon*, the client is very present in this prostitute's chamber; the painting is more concerned with psychological than formal values. Sitting on a hot red couch, the woman is disrobed and is waiting in a scene of dramatic tension.

Baykam discontinued the technique of embedding glass pieces into plywood panels because he was sending much of his work back to Turkey and the crating and shipping costs became prohibitive. By the mid-'80s, his work began to crystallize, but to crystallize into images with multiple associations and rich ambiguities. His paintings are narrative and autobiographical, but at the same time their meanings are not spelled out. The images are disjointed and enigmatic, forcing the viewer to engage in a participatory and active art decipherment.

Baykam made use of graffiti a long time before it became *de rigeur*, and he uses it for the purpose of communication – rather than for formal appearance. He knew all about graffiti in Turkey, where he saw the sprayed slogans of opposing political parties on the city walls. The graffiti was a political tool and carried weight. People killed each other over slogans and rallying signs. Later on, hoping to draw attention to himself, Baykam sprayed messages such as "Try Bedri" or "Meet the Turk" on the walls and sidewalks of West Broadway in Soho. Now, scribbles in English, Turkish, or French are often an integral part of his paintings.

Some of Baykam's works, however, evoke a sense of calm and were indeed carefully and methodically planned, rather than being executed in a spontaneous gesture. Frequently he paints the image of the wanderer, either alone or, as in *The Journey* (1986), with a child on his arm. This work was done slowly, with paint poured in layers and allowed to dry before the gold-enamel spray was applied; the figures were added at the end of the process. These dark and somber paintings of a man walking across the plane into an unexplored and infinite distance are metaphors of the artist's lonely journey into the risk of the unknown.

A painting like *Compromise* (1986) is based on the kind of narrative from which fairytales are made. The work was executed almost involuntarily. Instead of carefully applied blacks and golds, the colors are largely crudely painted blues and reds. The imagery of a mermaid on her rock and a snail coiled around an amphora is open to a multiplicity of interpretations. At about the same time, Baykam painted a vigorous landscape, *The Lighttower*. This painting attempts to convey some of the mystery and sense of fright of Gothic tales, of ghost and death ships. The moon resembles an eye floating in the night sky and the lighthouse sheds a mysterious penumbral light into the dark. The sea is black with stripes of bright

FIGURE 72. *The Myth*, 1986, mixed media on canvas, 5 × 7'. Collection of the artist.

FIGURE 73. *Awesome*, 1986, mixed media on canvas, 6 × 10'. Collection of the artist.

lemon-yellow, articulating the dark waves. The whole painting has a sense of uncanny loneliness, of swimming in a dark night across unknown waters where the horizon lines will always vanish. The shore does not promise a safe haven: it is a turbulently painted area in which four large black brushstrokes remind us of Franz Kline's paintings of assertive action. But the rough, energetic swatches are not autonomous, but indicate the slash of waves, while the stark white areas are depictions of an inhospitable beach. The demarcation of figuration and abstraction is no longer an issue for artists of Baykam's generation.

In *The Myth*, the artist himself, hatted and nonchalant, looks at the viewer, taking up almost half the painting's space. A naked, sensual girl with a gorgeous head of blonde hair is straining against the red Coca-Cola can. The Myth is that of Sysiphus, and in 1982, on the occasion of an exhibition in Ankara, Baykam had planned to give a live performance in which during a day and night a naked man would be pushing a ball up the slanted room. The event was meant to be an "Homage to Camus." Three years later, we see the erotic female, frustrated in her ongoing struggle with the essential trademark of American consumerism. The picture deals with the inevitable meaninglessness of desire. The title of the painting gives us a clue of its meaning, and for Baykam the name of the primary driving force, while at other times the titles occur after the work is completed. At any rate, the titles are a means of communication between artist and viewer, a way of interacting and connecting.

The Coca-Cola logo appears again in *Awesome*, one of his large Stripe Paintings, which he began early in 1986. These paintings, consisting of many individual panels, and up to 24 feet wide, lead the spectator's eyes over large, disparate fields of color in a rhythmic measuring of time. Once more, Baykam's wanderer makes his appearance, but the Pop Coke logo brings us back to the actual world with an almost Brechtian element of shock, which is that of the flat rectangle of the canvas. The left panel is a sensually painted scene of a tender and loving embrace. In contrast, the panel on the right is basically a line drawing of an unflinchingly sexual girl. A polyptych like *Awesome*, with its combination of popular kitsch material, true romantic feeling, Existentialist thought and Expressionist style, works primarily because the artist permits the viewer to see the process of its conception and allows for a dynamic interlocking relationship between image and surface.

NOTES

INTRODUCTION

1. *Odillon Redon, Gustave Moreau, Rodolphe Bresdin* (New York: Museum of Modern Art, 1962).
2. Umberto Boccioni, *Technical Manifesto of Futurist Sculpture* (1911), in Margaret Scolari Barr, *Medardo Rosso* (New York: The Museum of Modern Art, 1963), p. 62.
3. As late as 1970 George Heard Hamilton, in the standard text, *19th and 20th Century Art* (New York: Harry N. Abrams, 1970), wrote: "Futurist art erupting on the European scene in 1917 was a nine month's wonder soon extinguished by the First World War," p. 25.
4. Urs Frauchinger, Foreword, *Ferdinand Holder* (Zurich: Swiss Institute for Arts Research, 1994), p. 8.
5. Arthur G. Dove, "A Different One," in Waldo Frank (ed.), *America and Alfred Stieglitz* (New York: The Literary Guild, 1934), p. 243.
6. Max Beckmann, "On My Painting," lecture delivered in London, 1938, in Robert L. Herbert (ed.), *Modern Artists on Art* (Englewood Cliffs, NJ: Prentice Hall, 1964), p. 137.
7. Thomas Mann in K. Kerenyi, *Gespräche in Briefen*. Letter of 1 January 1947 (Zurich: Rhein Verlag, 1960), p. 146.
8. Cf: Fielding Dawson, *The Black Mountain Book* (New York: Croton Press, 1970); Martin Duberman, *Black Mountain: An Exploration in Community* (New York: Dutton, 1972); Nary Emma Harris, *The Arts at Black Mountain College* (Cambridge, MA: MIT Press, 1987).
9. When the catalogue appeared I found to my consternation that the curators had exhibited 252 works, but omitted not only Kienholz, but also Mark Tobey and Isamu Noguchi because they did not belong to the canon as it has come down.
10. Peter Selz, "Introduction," *New Images of Man* (New York: The Museum of Modern Art, 1959), p. 11.
11. Paul Tillich, "Prefatory Note," in *New Images of Man*, p. 10.
12. Serge Guilbaut, *How New York Stole the Idea of Modern Art* (Chicago: University of Chicago Press, 1983), inside flap.
13. Manny Farber, "New Images of (ugh) Man," *Art News* 58:6 (October 1959), 38–39, 58.
14. Emily Genauer, "Our Age of Anxiety Shown at Museum," *New York Herald Tribune*, October 4, 1959, p. 10.
15. What seemed marginal in 1959 was seen central some 36 years later: in 1995 Jean

Clair, as director of the 100th Venice Biennale, reappraised the formalist view of modernism leading to ever greater abstraction and presented the history of 20th-century art by displaying images of the human body from Degas to Bruce Nauman and wrote in the Introduction to the Catalogue, "Perhaps no other century has tried so intensely to restore – against encroaching deserts – human presence" (Jean Clair, "Impossible Anatomy 1895–1995," in *Identity and Alterity: Figures of the Body 1895/1995* [La Biennale di Venezia, Marsilio Editori, 1995], p. XXXI).

16. Billy Klüver, "The Garden Party," in Pontus Hulten, *Jean Tinguely* (Boston: New York Graphic Society, 1975), p. 130.
17. "Surge of Freedom," *Newsweek*, April 24, 1961, p. 92.
18. Peter Selz, "The Flaccid Art" (mis-titled "Pop Goes the Artist"), *Partisan Review* 30:3 (Summer 1963), 316.
19. Peter Selz, "Notes on Funk," in *Funk* (Berkeley: University Art Museum, 1968), p. 3.
20. James Johnson Sweeney, *Sam Francis* (Houston: Houston Museum of Fine Arts, 1967), p. 21.
21. Martin Heidegger, "Die Kunst und der Raum," quoted in Selz, *Chillida* (New York: Harry N. Abrams, 1986), p. 116.
22. Lawrence Weiner, *Statements* (New York: Seth Siegelaub, Louis Kellner Foundation, 1968), n.p.
23. Thomas W. Leavitt, "Introduction" in *Denes* (Ithaca, New York: Herbert F. Johnson Museum of Art, Cornell University, 1992), p. XI.
24. Dore Ashton, "Harold Paris and Modern Sculpture," in *Breaking the Mold: Harold Paris's Legacy of Innovation* (Berkeley: Judah L. Magnes Museum, 1994), p. 9.
25. Donald Kuspit, *Catastrophe according to Hans Burkhardt* (Allentown, PA: Muhlenberg College, 1990), n.p.
26. Rupert Garcia, "Media Supplement," unpublished M.A. Thesis, San Francisco State College (Now San Francisco State University), 1970.

CHAPTER I. FERDINAND HOLDER

1. B. in *Le Petit Genevois*, April 17, 1876, quoted in Jura Brüschweiler, *Ferdinand Hodler im Spiegel der zeitgenöschischen Kritik* (Lausanne, Editions Recontre, 1970), p. 16.
2. Hodler, "Mes tendances actuelles – 'La Nuit' " (1891), Bibliotheque Publique et Universitaire, Geneva, Ms. fr 2984/361–66.
3. Joséphin Péladan, Le Salon (Dixième Année), Paris, pp. 32–33.
4. Hodler in D. Baud-Bovy, "L'oeuvre de Ferdinand Hodler," *La Tribune*, Geneva, May 27, 1918.
5. Hodler, "Eurythmy: Five men representing humanity, marching toward death," in "Notes Ultimes, 1917–18. Geneva, Musée d'Art et d'Histoire, Ms. no. 1958/176–234.
6. Hodler, "The Mission of the Artist," Lecture, delivered Fribourg, 1887, published in Peter Selz, *Ferdinand Hodler*, (Berkeley, 1992), pp. 119–125.
7. I am indebted to Marilyn Kaye Hodson for some of the research on the relationship of Hodler to modern dance, which she carried out in a seminar paper at the University of California, Berkeley.
8. Stephanie Guerzoni, *Ferdinand Hodler, Sa vie, son oeuvre, son enseignment* (Geneva, Cailler, 1957).
9. Quoted from researched documentation provided by Jura Brüschweiler.
10. Peter Selz, in Selz and Constantine (eds.), *Art Nouveau* (New York, The Museum of Modern Art), p. 74.
11. Hodler, "The Mission of the Artist," published in Peter Selz, *Ferdinand Hodler*, (Berkeley, 1992), pp. 119–125.
12. Rainer Maria Rilke, "Herbst," from *Das Buch der Bilder*. Translation by the author.

CHAPTER 2. ART IN A TURBULENT ERA: GERMAN AND AUSTRIAN EXPRESSIONIST PAINTING RE-VIEWED

1. Charles Péguy, *Oeuvres en prose*, Vol. II, Paris, 1947, p. 299.
2. Edvard Munch, St. Cloud Diaries, quoted in Frederick Deknatel, *Edvard Munch*, New York, 1950, p. 18.
3. Oskar Kokoschka, "Edvard Munch's Expressionism," *College Art Journal XIII*, 1953, p. 32.
4. Georg Heym, quoted in *Expressionismus*, Marbach, Schiller-National Museum, 1960.
5. Ferdinand Tönnies, *Gemeinschaft und Gesellschaft*.
6. Donald E. Gordon, *Ernst Ludwig Kirchner*, Cambridge, 1968, p. 20.
7. Peter Selz, *German Expressionist Painting*, Berkeley and Los Angeles, 1957, p. 78.
8. Karl Schmidt-Rottluff, Letter to Emil Nolde, February 4, 1906, quoted in Selz, *op. cit.*, p. 84.
9. Gerhard Wieteck, "Der finnische Maler Alex Gallén-Kaellela als Mitglied der Brücke," *Brücke-Archiv*, Heft 2/3, 1968–69, p. 4.
10. E. H. Gombrich, *Oskar Kokoschka*, London, 1962, p. 14.
11. Kandinsky, quoted in Josef Rufer, "Schönberg-Kandinsky; zur Funktion der Farbe in Musik und Malerei," in *Hommage à Schönberg*, Berlin, 1974, p. 74.
12. Frank Whitford, "Arnold Schoenberg as Painter," *Times Literary Supplement*, July 13, 1973, p. 801.
13. Pablo Picasso, letter of 1897, quoted in Anthony Blunt and Phoebe Pool, *Picasso, The Formative Years*, New York, 1962, p. 8.
14. August Endell, in *Deutsche Kunst und Dekoration*, Vol. I (1897), p. 141.
15. Franz Marc, *Briefe, Aufzeichnunger und Aphorismen*, Berlin, 1920, Vol. I, #31.
16. Marc, "Vorwort zur zweiten Auflage," *Der Blaue Reiter*, Munich, 1914.
17. Paul Klee, in Felix Klee (ed.), *The Diaries of Paul Klee*, Berkeley and Los Angeles, 1968, p. 260.
18. Marc, *Briefe, Aufzeichnunger und Aphorismen*, Vol. I, p. 121.
19. Donald E. Gordon, *Ernst Ludwig Kirchner*, Cambridge, 1968, p. 102.
20. Selz, *Emil Nolde*, New York, 1963, pp. 71–72.
21. Hans Richter, *Dada Art and Anti-Art*, New York, 1965, p. 129.
22. Max Pechstein, "Was Wir Wollen," *An Alle Künstler*, Berlin, 1919, p. 19.
23. Sibil Moholy-Nagy, quoted in Wolf von Eckhardt and Sander L. Gilman, *Bertold Brecht's Berlin*, New York, 1975, p. 69.
24. Max Beckmann, *Schöpferische Konfession*, Berlin, 1920, pp. 63–64.
25. Stephan Lackner, *Max Beckmann*, New York, 1977, p. 17.
26. Paul Klee, *On Modern Art*, London, 1949, p. 45.
27. Wilhelm Hausenstein, quoted in Ida Katherine Rigby, "The Third Reich," in Orrel P. Reed, Jr., *German Expressionistic Art: The Robert Gore Rifkind Collection*, Los Angeles, 1977, p. 354.
28. Max Beckmann, "Meine Theorie der Malerei," Lecture at Burlington Gallery, London, 1938, in Benno Reifenberg and Wilhelm Hausenstein, *Max Beckmann*, Munich, 1949, p. 47.

CHAPTER 3. EMERGENCE OF THE AVANT-GARDE: ERSTER DEUTSCHER HERBSTSALON OF 1913

1. Herwarth Walden, "Vorrede," catalogue of *Erster Deutscher Herbstsalon*, Berlin, *Der Sturm* (193), pp. 5, 7.

"ein Ueberblick über die neue Bewegung. . . ."
"Ich fühle mich zur Veranstaltung dieser Ausstellung berechtigt, weil ich von

dem Wert der hier vertretenen Künstlern überzeugt bin. Weil ich mit den be-
teutendsten Künstlern der neuen Bewegung befreundet bin."

2. Wilhelm Worringer, "Zur Entwicklungsgeschichte der modernen Malerei," *Der Sturm,* II:75 (1911), pp. 597–98.
3. Paul Ferdinand Schmidt, "Die Expressionisten," *Der Sturm,* II:92 (1912), p. 734.
4. Walden, "Kunst und Leben," *Der Sturm,* X:1 (1919), pp. 10–11.

"Wir nennen in diesem Jahrhundert die Kunst Expressionismus um sie von dem
zu unterscheiden, was nicht Kunst ist. Es is uns durchaus bekannt, das auch
Künstler vergangener Jahrhunderte den Ausdruck suchten. Sie können ihn nur
nicht künstlerisch gestalten."

5. Filipo Tomaso Marinetti, "Manifest des Futurismus," *Der Sturm,* III:105 (1912), pp. 828–29.
6. Umberto Boccioni, Carlo D. Carra, Luigi Russolo, Giacomo Balla, Gino Severini, "Die Aussteller und das Publikum," *Der Sturm,* III:105 (1912), pp. 3–4.
7. Franz Marc, "Die Futuristen," *Der Sturm,* III: 132 (1912), p. 187.
8. Wassily Kandinsky, Letter to Paul Westheim: Der Blaue Reiter, *Das Kunstblatt,* XIV (1930), pp. 57–60.
9. August Macke, Letter to Herwarth Walden, March 21, 1913, quoted in National-galerie, Berlin, *Der Sturm: Herwarth Walden und die Europäische Avantgader Berlin 1912–1932,* Berlin (1961), p. 16.

". . . Köhler übernimmt die Garantie in Höhe von 4000 M (fur den Herbstsalon)
unter der Bedingung, ungenannt zu bleiben. Vielleicht sprechen Sie dann sofort
mit Apollinaire und Delaunay über die Vertretung der Pariser Kunst. Ich denke,
es ist vor allen Dingen wichtig, mit Matisse und Picasso zu verhandeln. Keiner,
der in diesem Berliner Herbstsalon ausstellt, darf bei Cassirer ausstellen. Über
Einzelheiten können wir ja noch sprechen. Ich werde Marc sofort schreiben. Das
Wichstigate ist, dass wir sofort die Hauptkräfte auf unserer Seite haben . . ."

10. Herwarth Walden, Letter to Delaunay, July 8, 1913, quoted in Karl-Heinz Meissner, "Delaunay Dokumente," in Peter-Klaus Schuster, *Delaunay und Deutschland* (Co-logne), 1985, p. 508.
11. Unfortunately no installation photographs of the Herbstsalon are extant. This is very surprising in view of Walden's constant eye to publicity. It may be assumed, however, that the exhibition resembled the Blaue Reiter show at the Galerie Thann-hauser, Munich, in the winter of 1911–1912.
12. Franz Marc, Letter to Kandinsky, September 30, 1913, quoted in Klaus Lankheit (ed.), *Wassily Kandinsky Franz Marc Briefwachsel,* Munich, 1983, p. 241.

". . . Meine leitende Idee beim Hängen und Wählen der Bilder war jedenfalls
die: die ungeheure geistige Vertiefung und künstlerische Regsamkeit zu zeigen –
und dieser Eindruck ist sehr wohl für die *Seele* bestimmt; ich glaube, ein Mensch,
der seine Zeit liebt und in ihr nach Geistigkeit sucht, wird nur klopfenden Her-
zens und voll guter Überraschungen durch diese Ausstellung gehen."

13. Guillaume Apollinaire, "Introduction," *Archipenko: 17th Exhibition of Der Sturm* (Berlin), 1913.
14. Franz Marc, Letter of Gabriele Münter, July 18, 1913 in Klaus Lankheit (ed.), *op. cit.* p. 235.

"Ja, Hartley wirkt entschieden ernsthaft, nicht reif aber doch fein."

15. Kurt Kuchler in *Haumburger Fremdenblatt,* February 12, 1913:

"... über lebensgrosse Arroganz ... den verwerflichen Sensationshungerr des Kunsthändlers, der seine Räume für diesen Farben-und Formwahnsinn hergibt ... Idiotismus."

16. Karl Scheffler, "Kunstausstellungen," *Kunst und Künstler* XII:2 (October 1913), pp. 119–120.

"Der Veranstalter hat mit dieser urteilslos organisierten Ausstellung der neuesten Kunst scher geschadet ... Unreinlichkeit der Phantasie ... proletarischen Geistesmilieu."

17. Lothar Schreyer, "Herwarth Waldens Werk," in Nell Walden and Lothar Schreyer, *Der Sturm* (Baden-Baden), 1954, p. 146.

"Unsere Lehre war die Lehre des STURM, war Herwarth Waldens Lehre."

CHAPTER 5. THE PERSISTENCE OF EXPRESSIONISM

1. Wilhelm Hausenstein, *Die Kunst in diesem Augenblick*, 1920, reissued by Prestel Verlag (Munich: 1960), 256.
2. Wilhelm Worringer, lecture to the Deutsche Goethegesellschaft, Munich, November 1920; published in *Künstlerische Zeitfragen* (Munich, 1921), 18.
3. Franz Marc, "Die neue Malerei," *Pan* 2 (1912), 556.
4. Richard Huelsenbeck, "Dadaist Manifesto," in Hans Richter, *Dada, Art and Anti Art* (New York: 1965), 104.
5. Walter Gropius, Program of the Staatliche Bauhaus, Weimar, April 1919, in Hans M. Wingler, *The Bauhaus* (Cambridge: 1969), 31.
6. Los Angeles County Museum of Art, October 9– December 31. The exhibition will be shown at the Fort Worth Art Museum, February 2– April 9; Kunstmuseum Düsseldorf, May 18– July 9; and Staatliche Galerie Moritzburg, Halle (GDR), August 9– September 30.
7. Wieland Schmied, "Neue Sachlichkeit and German Realism of the Twenties," in the Minneapolis Institute of Arts, *German Realism of the Twenties* (Minneapolis: 1980), 49.
8. Schmied, in *ibid.*, 46.
9. Käthe Kollwitz, Letter to Romain Rolland, quoted in Ida Rigby, *An alle Künstler* (San Diego: 1983), 10.
10. George Grosz, Letter to Otto Schmalhausen, December 15, 1917, quoted in Uwe M. Schneede, *George Grosz: His Life and Work* (New York: 1979), 54.
11. Stephanie Barron, "Introduction," in *German Expressionism 1915–1925: The Second Generation* (Los Angeles: 1988), 29.
12. Herzog's article appeared in *Der Sturm* X:1919. For more on the early use of the term "Abstract Expressionism," see Peter Selz, *German Expressionist Painting* (Berkeley and Los Angeles: 1957), 342, n. 49.
13. Johannes Molzahn, "Das Manifest des absoluten Expressionismus," *Der Sturm* X:6 (1919–20), 92.
14. Paul Tillich, "The Religious Situation," (1926), in John and Jane Dillenberger, *Paul Tillich on Art and Architecture* (New York: 1987), 68.
15. After this period, Albiker reverted to a more traditional idiom, and during the Nazi period he produced pseudo-heroic Fascist sculpture, including several huge male nudes for the 1936 Olympics in Berlin.
16. Barron, "Introduction," *German Expressionism: 1915–1925 ...*," 37.
17. Walter Rheiner, "Demands of the Dresdner Sezession Gruppe, 1919," quoted in Fritz Löffler, "Dresden from 1913 and the Dresdner Sezession Gruppe 1919," in Barron, *German Expressionism 1915–1925 ...*," 58.

18. Adolph Gottlieb and Marcus Rothko, Letter to Edward Alden Jewell, June 7, 1943, *New York Times*, June 13, 1943.

CHAPTER 6. GERMAN REALISM OF THE TWENTIES: THE ARTIST AS SOCIAL CRITIC

1. Wilhelm Hausenstein, *Die Kunst in diesem Augenblick* (reissued by Prestel Verlag, Munich, 1960), p. 256.
2. Ibid., p. 265.
3. Wilhelm Worringer, lecture to the Deutsche Goethegesellschaft, Munich, November 1920; published *Künstlerische Zeitfragen* (Munich, 1921), p. 18.
4. Franz Marc, "Die neue Malerei," *Pan* 2 (1912): 556.
5. Richard Huelsenbeck, "Dadaist Manifesto," in Hans Richter, *Dada, Art and Anti-Art* (New York, 1965), p. 104.
6. Gustav Hartlaub, "Werbendes Rundschreiben," 18 May 1923, in F. Schmalenbach, *Kunsthistorische Studien* (Basel, 1971), p. 21.
7. Roland März, Introduction to *Realismus und Sachlichkeit: Aspekte deutscher Kunst 1919–1933* (Staatliche Museen zu Berlin, 1974).
8. Bertold Brecht, *Gesammelte Werke* (Frankfurt a.M., 1967), Vol. 17, p. 161.
9. George Grosz, *A Little Yes and a Big No* (New York, 1946), p. 163.
10. Max Beckmann, "Schöpferische Konfession," Berlin 1920, as translated and published in Peter Selz, *Max Beckmann* (New York, 1964), p. 32.
11. Max Beckmann, "On My Painting," lecture given at New Burlington Galleries, London, 1938. English translation published in Robert L. Herbert, *Modern Artists on Art* (Englewood Cliffs, N.J., Prentice-Hall, 1964), p. 132.
12. Jürgen Kramer, "Die Assoziation Revolutionärer Bildener Künstler Deutschlands (ARKBD)" in *Wem gehört die Welt* (Berlin, 1977), p. 183.
13. Robert Jensen, "Political Constructivism: The Cologne Progressives" (unpublished masters' thesis, University of California, Berkeley, 1979), p. 50.
14. Paul Schultze-Naumburg, "Kampf um die Kunst," *Nationalsozialistische Bibliothek*, Vol. 36 (March 1932), p. 5.

CHAPTER 7. MAX BECKMANN: THE SELF-PORTRAITS

1. Max Beckmann, "On my Painting," lecture at the New Burlington Galleries, London, 1938. In *Max Beckmann* (exh. cat.), London, 1974, pp. 11–21. This is the text of a lecture Beckmann delivered at the New Burlington Galleries in London in 1938. It was originally written in German and translated into English soon thereafter in a cursory translation first published in *Centaur* (vol. I, No. 6, pp. 287–292) in Amsterdam in 1946. This text was then translated back into German and appeared in the first post–World War II monograph on the artist: Benno Reifenberg and Wilhelm Hausentein, *Max Beckmann* (Munich, R. Piper Verlag), 1949, pp. 47–54. The original German version was published in Peter Beckmann and Peter Selz, *Max Beckmann: Sichtbares und Unsichtbares* (Stuttgart, Belser Verlag, 1965), pp. 20–33. This was translated by P. S. Falla for the Marlborough Gallery catalogue of 1974 and the quotations in this essay are from that translation.
2. *Ibid.*, p. 19.
3. Friedhelm Wilhelm Fischer, *Max Beckmann: Symbol und Weltbild*, Munich, 1972; and Fischer, *Max Beckmann*, London, 1973.
4. Beckmann in Kasimir Edschmidt, ed., "Schöpferische Konfession." In *Tribüne der Kunst und Zeit*, vol. 13 (1920), pp. 62–67; transl. in Victor H. Meisel, ed., *Voices of German Expressionism*, Englewood Cliffs, N.J., 1970, p. 108.
5. Beckmann in Reinhard Piper, *Erinnerungen an Max Beckmann*, Munich, 1950, p. 33.

6. Beckmann in Stephan Lackner, *Ich erinnere mich gut an Max Beckmann*, Mainz, 1967, p. 88.

7. *Ibid.*, p. 96.

8. Beckmann, *Briefe im Kriege*, Berlin, 1916, letter of May 24, 1915.

9. *Ibid.*, letter of October 30, 1914.

10. James D. Burke, "Max Beckmann: An Introduction to his Self-Portraits." In Carla Schulz-Hoffmann, ed., *Max Beckmann*, St. Louis, 1984, p. 58.

11. The art historian Benno Reifenberg remembered seeing Beckmann dressed in a similar costume at a masked ball in Frankfurt. Reifenberg in Erhard and Barbara Göpel, *Max Beckmann: Katalog der Gemälde*, vol. I, Bern, 1976, p. 174.

12. Beckmann, "The Artist and the State." In Hans Belting, *Max Beckmann*, New York, 1989, p. 113.

13. Stephan Lackner, *Max Beckmann*, New York, 1977, p. 98.

14. Beckmann in a letter to Reinhard Piper, March 12. In *Die Realität der Träume in den Bildern, Aufzätzen und Vorträgen 1903–1950*, Leipzig, 1987, p. 102. It is probable that Beckmann referred less to original New Orleans jazz than to modern composers such as Edgard Varèse and Darius Milhaud, who incorporated such city noises into their work.

15. Fischer, *Max Beckmann: Symbol und Weltbild*, Munich, 1972, p. 81.

16. *Ibid.*, p. 133.

17. Beckmann, "Letters to a Woman Painter." In Peter Selz, *Max Beckmann*, New York, 1964, p. 132.

18. Mathilde Q. Beckmann in an interview with the author, New York, December 1963.

19. Beckmann, "Letter to a Woman Painter," *op. cit.*, p. 134.

20. Beckmann, *Tagebücher 1940–1950*, Munich, 1979, p. 26.

21. Fischer, *Max Beckmann: Symbol und Weltbild*, Munich, 1972, pp. 162–165.

22. Gert Schiff, "The Nine Triptychs of Max Beckmann." In *Max Beckmann: The Triptychs* (exh. cat.), London, 1980, p. 18.

23. Göpel has identified this individual as Herbert Fiedler rather than as the theater manager Ludwig Berger, as named by Gotthard Jedlicka in "Max Beckmann in seinen Selbstbildnissen." In *Blick auf Beckmann*, p. 129.

24. Beckmann in "The Artist in the State." In Belting, *op. cit.*, p. 113.

25. Beckmann, *Tagebücher 1940–1950*, p. 77.

26. *Ibid.*, p. 144.

27. Karen F. Beall, "Max Beckmann Day and Dreams." In *The Quarterly Journal of Library of Congress*, January 1970, p. 8.

28. Beckmann in a letter to Curt Valentin, March 1, 1946. In the Museum of Modern Art Archives.

29. Beckmann in Dorothy Seckler, "Can Painting Be Taught?" *Art News*, L:1 (1951), p. 231.

30. Beckmann, *Tagebücher 1940–1950*, p. 231.

31. *Ibid.*, p. 346.

32. Beckmann in a letter to Elizabeth Kerschbaumer. In Fritz Erpel, *Max Beckmann*, East Berlin, 1985, p. 93.

CHAPTER 8. DEGENERATE ART RECONSTRUCTED

1. Emil Nolde, *Jahre der Kämpfe 1902–1914* (Flensburg, Christian Wolff Verlag, 1957), p. 105.

CHAPTER 9. REVIVAL AND SURVIVAL OF EXPRESSIONIST TRENDS IN THE ART OF THE GDR

1. Herwarth Walden, "Vorrede," *Erster Deutscher Herbstsalon*, Berlin, 1913, p. 5. Unless otherwise indicated, all translations are by the author.

2. Paul Fechter, *Der Expressionismus*, Munich, 1914.

3. Paul Ferdinand Schmidt, "Die Expressionisten," *Der Sturm* II/92, 1912, p. 736.

4. Donald Gordon, *Expressionism, Art and Idea*, New Haven, 1987, p. xvi.

5. Wassily Kandinsky, in Kenneth C. Lindsay and Peter Vergo, eds, *Kandinsky: Complete Writings*, Boston, 1982, vol. I, p. 139.

6. Oskar Kokoschka, "Edvard Munch's Expressionism," *College Art Journal* XII, 1953, p. 32.

7. Stephanie Barron, ed., *German Expressionism 1915–1925: The Second Generation*, Los Angeles and Munich, 1988.

8. Max Pechstein, "Was Wir Wollen," in *An Alle Künstler*, Berlin, 1919, p. 19.

9. Ludwig Meidner, "An alle Künstler, Dichter und Musiker," in *ibid.*, p. 7.

10. Walter Gropius, program of the Staatliche Bauhaus in Weimar, April 1919, in Hans M. Wingler, *The Bauhaus*, Cambridge, MA, 1969, p. 31.

11. Wilhelm Worringer, lecture to the Deutsche Goethegesellschaft, Munich, November 1920, published in *Künstlerische Zeitfragen*, Munich, 1921, p. 18.

12. Wilhelm Hausenstein, *Die Kunst in diesem Augenblick*, reissued by Prestel Verlag, Munich 1960, p. 256.

13. Roland März, in his exhibition catalogue *Realismus und Sachlichkeit*, Berlin (East) Nationalgalerie, 1974, divides *Neue Sachlichkeit* into five groups along political ideologies. Among those on the Left are the "Proletarian Revolutionaries."

14. Georg Lukács, "Expressionism: Its Significance and Decline," 1934, quoted in Lukács, *Essays on Realism*, Cambridge, MA, 1981, pp. 87, 111.

15. Lothar Lang, *Malerei und Graphik in der DDR*, Leipzig, 1978, p. 38.

16. One painting by Rosenhauer was actually included in the Second German Art Exhibition in Dresden as early as 1949.

17. Huge exhibitions organized jointly by the Ministry of Culture and the Artists' Union and comprising all the fine arts, architecture, photography, and the applied arts have been held at four- or five-year intervals in Dresden since 1946. These panoramic exhibitions draw large and ever-expanding audiences. By 1982, the Eighth Art Exhibition of the GDR registered over a million visitors, and the number of viewers has increased since that time.

18. Willi Sitte, interview at studio visit, Halle, February 5, 1988.

19. Bernhard Heisig, interview at studio visit, Leipzig, February 6, 1988.

20. Ulrich Kuhirt, "Vom Wert und der Wirkungskraft des Erbes," *Bildende Kunst*, Heft 2, 1978, p. 74.

21. Heisig in Peter M. Bode, "Bernhard Heisig," *Zeitvergleich: Malerei und Graphik aus der DDR*, Hamburg, 1984, p. 103.

22. Matthias Flügge, "Walter Libuda," in Galerie Alvensleben, *Walter Libuda*, Munich, 1988, p. 4.

23. Franz Roh, *Nach-Expressionismus*, Leipzig, 1925, p. 37.

24. Herbert Marcuse, *The Aesthetic Dimension: Toward a Critique of Marxist Aesthetics*, Boston, 1978, p. 38.

25. Dietrich Mahlow, ed., *Schrift und Bild*, Amsterdam and Baden-Baden, 1963.

26. Gunar Barthel, *Michael Morgner*, Berlin, Galerie Unter den Linden, 1986, p. 4.

27. Gerhard Altenbourg, "Letter to Karl-Heinz Janda, Altenburg, 1955," quoted in Kunsthalle Bremen, *Gerhard Altenbourg*, Bremen, 1988, p. 50.

28. Gerhard Altenbourg, "Nebelrisse beim Durchstreifen jener Hügellandschaft," 1969, *ibid.*, p. 46.

29. Paul Klee, *On Modern Art*, edited by Herbert Read, London, 1948, p. 45.

30. Joerg Seyde, "Hommage à Max Beckmann," in *Mitteilungen*, Museum der bildenden Künste, Leipzig, vol. 7, Heft 1–2, 1984, p. 26.

31. Günter Schade, Peter Betthausen, and Werner Schade, "Introduction," in *Expressionisten – Die Avantgarde in Deutschland 1905–1920*, Berlin (East), 1986, p. 5.

32. Erhard Frommhold, "Politischer Expressionismus – expressionistische Politik," in *ibid.*, p. 67.

33. Willi Geismeier, "Aspekte der Aneignung expressionistischer Kunst," *ibid.*, p. 72.
34. Marcuse, *The Aesthetic Dimension*, pp. 32–33.

CHAPTER 10. EDUARDO CHILLIDA: SCULPTURE IN THE PUBLIC DOMAIN

1. Lewis Mumford, *The Culture of Cities* (New York, 1938), p. 438.
2. James Johnson Sweeney, *Eduardo Chillida* (Houston, Museum of Fine Arts, 1966), p. 21.
3. Chillida, quoted in Ellen Schwartz, "Chillida's Silent Music, de Kooning's Eloquent Ambivalence," *Art News* (March 1980), p. 71.
4. Rainer Maria Rilke, "Worpswede," in *Where Silence Reigns* (New York, 1978), p. 9.
5. Max Raphael, *The Demands of Art* (Princeton, N.J., Princeton University Press, 1968), p. 179.
6. *Chillida at Gernika* (La Jolla, Calif., Tasende Gallery, 1988).
7. Translated by Alan King.

CHAPTER 11. AMERICANS ABROAD

1. John Singleton Copley, letter to Benjamin West, Nov. 12, 1766; cited in John McCoubrey, *American Art 1700–1960: Sources and Documents* (Englewood Cliffs, N.J., 1965), p. 14.
2. Anonymous (M.D.?) "Comment," in *Blind Man* 2 (May 1917), n.p.
3. Joseph Stella, "Modern Art" (ms); cited in John I. H. Baur, *Joseph Stella* (New York, 1971), p. 29.
4. Clyfford Still, letter to Gordon M. Smith, Jan. 1, 1959; cited in *Paintings by Clyfford Still* (Buffalo, 1959), n.p.
5. Sanford Pollock, letter to Charles Pollock, July 1941; cited in Francis V. O'Connor, *Jackson Pollock* (New York, 1967), p. 25.
6. Jackson Pollock, "Response to Questionnaire," *Arts and Architecture*, LXI, February 1944, p. 14.
7. Philip Guston, conversation with the author, May 1980.
8. Hoffman taught at Berkeley in 1930 and 1931, then at his own school in New York from 1933 to 1958. Albers first taught at Black Mountain College from 1933 to 1949, and then was Chairman, Department of Design, Yale, from 1950 to 1958.
9. Romare Bearden, interview with Henri Ghent, June 1968, Archives of American Art.
10. Ellsworth Kelly, phone conversation with the author, May 20, 1992.
11. Michel Seuphor, letter to Ellsworth Kelly, Oct. 21, 1953; cited in *Ellsworth Kelly: Die Jahre in Frankreich* (Munich, 1992), p. 12.
12. After seven years in Paris, Francis then traveled to China and Japan but frequently returned to France.
13. Katharina Schmidt sees that "the entire field of Mediterranean culture – its myths, its history, its art, its poets, painters, and sculptors – acquired a constantly growing, changing and deepening, yet abiding significance in his life and work." In "The Way to Arcadia: Thoughts on Myths and Image in Cy Twombly's Paintings," in *Cy Twombly* (Houston, 1992), p. 12.
14. Roland Barthes, "The Wisdom of Art," in *Cy Twombly* (New York, 1979), p. 15.
15. In 1989, Kitaj published the First Diaspora Manifesto in London, in which he states, in the Prologue: "I offer this manifesto to Jews and non-Jews alike in the (fairly) sure knowledge that there be a Diasporic painting. . . ."

CHAPTER 12: THE IMPACT FROM ABROAD:
FOREIGN GUESTS AND VISITORS

1. Francis M. Naumann, "Frederick C. Torrey and Duchamp's *Nude Descending a Stair-case*," in *West Coast Duchamp*, ed. Bonnie C. Clearwater (Miami Beach, Fla.: Grass-field Press, 1991). This essay by Naumann corrects previous accounts of the provenance of this painting.

2. Naumann, 21.

3. Official catalogue of the Department of Fine Art, Panama-Pacific International Ex-position (San Francisco: Wahlgreen Co., 1915).

4. Gottardo Piazzoni, quoted in *Painting and Sculpture in California: The Modern Era*, ed. Henry Hopkins (San Francisco Museum of Art, 1977), 22.

5. Paul J. Karlstrom, "San Francisco," *Archives of American Art Journal* 16, no. 2 (1976): 24–25, and "West Coast," *Archives of American Art Journal* 24, no. 4 (1984): 39–40.

6. Hassel Smith, Chronology, written December 10, 1987, quoted in *Hassel Smith* (Bel-mont, Calif.: College of Notre Dame, Weigand Art Gallery, 1988), 27.

7. Galka Scheyer, collective letter to the Blue Four, October 19, 1925, in Galka Scheyer Blue Four Archive, Oakland Museum.

8. William Clapp, letter to Galka Scheyer, June 23, 1935, in Galka Scheyer Blue Four Archive.

9. Howard Putzel, in Galka Scheyer Blue Four Archive.

10. Diego Rivera, statement in *The Blue Four*, exh. cat. (San Francisco: California Palace of the Legion of Honor, 1931), n.p.

11. Maynard Dixon, cited in Bertram D. Wolfe, *The Fabulous Life of Diego Rivera* (New York: Stein and Day, 1963), 285.

12. Kenneth Callahan, letter in the *Town Crier* (Seattle), May 21, 1932.

13. George Biddle, letter to Franklin Delano Roosevelt, May 9, 1933, quoted in Biddle, *An American Artist's Story* (Boston: Little, Brown, 1939), 268.

14. Shifra M. Goldman, "Siqueiros and Three Early Murals in Los Angeles," *Art Journal* 33, no. 4 (Summer 1974): 321–27.

15. Glenn Wessels, in *San Francisco Argonaut*, July 13, 1934.

16. In 1930 Matisse also visited San Francisco. The three artists did not meet in the City by the Bay, but it is interesting to speculate on the discourse that might have taken place if they had.

17. Hans Hofmann offered to the University of California at Berkeley a donation of forty-seven paintings, selected by Erle Loran with my assistance. They represent the artist's work from 1935 to 1965. Hofmann also proffered a quarter of a million dollars on the condition that a proper art museum be constructed on the Berkeley campus; this gift was a major inducement to the establishment of the University Art Museum.

18. Alfred Neumeyer, letter to Pierre Matisse, September 17, 1940, Mills College Ar-chive.

19. Lyonel Feininger, letter to Alois J. Schardt, February 5, 1942, Mills College Archive.

20. Neumeyer, press release, Mills College, Oakland, California, summer 1937, Mills College Archive.

21. Feininger, letter to Alfred Frankenstein, October 15, 1937, Mills College Archive.

22. Karl Schmidt-Rottluff, letter to Alfred Neumeyer, April 4, 1938, Mills College Ar-chive.

23. Alice Schoelkopf, letter to Alfred Neumeyer, October 14, 1940, Mills College Ar-chive.

24. Sybil Moholy-Nagy, *Moholy-Nagy: An Experiment in Totality* (New York: Harper, 1950), 180–82.

25. Fernand Léger, quoted in André Warnod, "America Isn't a Country – It's a World," *Architectural Forum* (April 1946): 54.

26. Léger, quoted in Warnod, 62.

27. Léger, quoted in Charlotte Kotik, "Léger and America," in *Léger* (Buffalo, N.Y.: Albright-Knox Art Gallery, 1982), 52.
28. James Grote Van Derpool, letter to Alfred Neumeyer, November 5, 1941, Mills College Archive.
29. Peter Selz, "The Years in America," in Carla Schulz-Hoffman and Judith C. Weiss, *Max Beckmann Retrospective* (Saint Louis, Mo.: Saint Louis Art Museum; and Munich: Prestel Verlag, 1948), 167.
30. Nathan Oliveira, afterword to Peter Selz, *Max Beckmann – Portrait of the Artist* (New York: Rizzoli, 1992), 108.

CHAPTER 13. MODERNISM COMES TO CHICAGO: THE INSTITUTE OF DESIGN

1. Frank Lloyd Wright in Bruce Brooks Pfeiffer, ed., *Frank Lloyd Wright: Collected Writings*, vol. 1 (New York, Rizzoli, 1992), p. 59.
2. Papers of the Association Art and Industries, Chicago, Bauhaus-Archiv, Berlin.
3. *Ibid.*
4. James Johnson Sweeney. *Plastic Redirections in 20th Century Art* (Chicago, University of Chicago Press, 1934).
5. The concept of new "International Style" probably derived from a book by Walter Gropius, *Internationale Architektur* (Munich, Langen Verlag, 1925). This was the first Bauhaus book, a series of publications edited and designed by Moholy-Nagy.
6. Sue Ann Kandall, "C. J. Bulliet: Chicago's Lonely Champion of Modernism," in *Archives of American Art Journal,* 26, 2–3 (1986), pp. 21–32.
7. C. J. Bulliet, *Chicago Daily News,* Feb. 6, 1937.
8. C. J. Bulliet, *Chicago Daily News,* Oct. 10, 1942.
9. L. Moholy-Nagy, "Constructivism and the Proletariat," in *MA,* May, 1922.
10. In the same year Man Ray also achieved photography without a camera, which he called "Rayographs." Christian Schad had made similar experiments earlier during his Dada years in Switzerland, which are known as "Schadographs."
11. L. Moholy-Nagy, *Von Material zu Architektur*, Bauhaus Book 14 (Munich, Albert Langen Verlag, 1929) tr. into English as *The New Vision* (New York, Brewer, Warren & Putnam, 1932).
12. Edward Alden Jewell, "Chicago's New Bauhaus," *New York Times,* 12 September 1937, sec. 11, p. 7
13. This terminology became standard in most art schools and art departments throughout the United States.
14. Nathan Lerner, Interview with Laura Stoland, Chicago, March 21, 1994.
15. L. Maholy-Nagy in Charles Traub, ed., *The New Vision* (New York, Aperture, 1982), p. 49
16. It is interesting to wonder "what might have been" if Moholy had been successful in securing the services of all those he indeed invited to be on the the first faculty. Jean Hélion, Herbert Bayer, and Xanti Schawinsky were invited to teach painting, typography, and display, respectively, but none managed to get an American visa in time. Moholy, considering architecture an essential element in The New Bauhaus curriculum, approached Frank Lloyd Wright. But the sage of Taliesin, who had made such a decisive impact on modern architecture in Europe, was not a friend of the "Functionalism" and the International Style associated with Bauhaus, and furthermore, would certainly not teach at somebody else's school, especially as he just had set up his own apprenticeships at Taliesin. Moholy then turned to the Chicago Modernist George Fred Keck to teach architecture, but Moholy's proposal to establish a full-fledged architectural curriculum was discouraged by Gropius due to the difficulty of gaining accreditation for such a program. Furthermore, Moholy's attempt to coordinate The New Bauhaus's architectural program with that of Mies's program at the Armor Institute after the

latter accepted that position in 1938 was discouraged both by Mies and The New Bauhaus's parent organization, AAI.

Similarly, Moholy's hopes to have courses in art history met with no immediate success. He had hoped James Johnson Sweeney, a strong advocate of Modernism throughout his life, would teach The New Bauhaus courses on the history of art. But Sweeney had little faith in the AAI and declined to join the new school. Moholy then turned to Sigfried Giedion, a Modernist Swiss art and architectural historian and close friend of the Bauhaus; Giedion, however, decided to remain Zurich.

17. Nathan Lerner, "Memories of Moholy-Nagy and the New Bauhaus," in *The New Bauhaus/School of Design in Chicago*. Exhibition Catalogue (New York, Banning and Associates, 1993), p. 13

18. Richard Koppe, "The New Bauhaus," Richard Koppe papers at the University of Illinois, Chicago Circle. I am greatly indebted to Laura Stoland for bringing these papers and a great deal of material on the New Bauhaus and ID to my attention.

19. John Walley, "The Influence of the New Bauhaus on Chicago 1938–1943." John Walley papers, University of Illinois, Chicago Circle.

20. E. M. Benson, "Chicago Bauhaus," *Magazine Art*, vol. 31, no. 2 (Feb. 1938), p. 38.

21. "Bauhaus: First Year," *Time*, vol. 2, no. 2 (July 1938), p. 21.

22. Sibyl Moholy-Nagy, *Moholy-Nagy, Experiment in Totality* (New York, Harpers & Brothers, 1950), p. 156.

23. Papers on the New Bauhaus, Bauhaus-Archiv, Berlin.

24. "New Bauhaus School Closes; Director Sues," *Chicago Sunday Tribune* (Oct. 16, 1938). The lawsuit was settled out of court and Moholy used his payment for the benefit of the school.

25. Alfred H. Barr, Jr. in Ise Gropius, Walter Gropius, and Herbert Bayer, eds., *Bauhaus 1919–1928*, p. 5–6.

26. In 1940 Professor Alfred Neumeyer, chairman of the art department at Mills College, invited Moholy-Nagy and a number of other members of the ID faculty (Ehrmann, Niedringhaus, Prestini, and the painter Robert J. Wolff) to teach a summer session with courses in drawing, painting, photography, weaving, paper cutting, metalwork, modeling, and casting based on Bauhaus-ID principles. Simultaneously, the Mills college gallery mounted a large exhibition with paintings by Moholy and Wolff, photographs by Kepes, wooden bowls by Prestini, and a wall-hanging by Ehrmann. The summer session was attended by artists, art teachers, architects, and designers in the San Francisco Bay Area.

27. L. Moholy-Nagy, *Vision in Motion* (Chicago, Paul Theobald, 1946), p. 11.

28. Most of this information is from an interview with Robert Kostka, Berkeley, Dec. 12, 1993.

29. Mary Emma Harris, *The Arts at Black Mountain* (Bard College, Annandale-on-Hudson, 1987), p. 160.

30. Alex Nicoloff, Interview with Peter Selz, Berkeley, April 19, 1994.

31. Peter Selz, "Three-Dimensional Wood Engravings: The Work of Misch Kohn," *Print* (Nov. 1952), p. 44.

32. Robert Kostka, "Remembering Mrs. Varro," Unpublished Manuscript, 1990.

33. Victor Lowenfeld, *Creative and Mental Growth* (New York, Macmillan, 1957).

34. Peter Selz and Richard Koppe, "The Education of the Art Teacher," *School Arts*, vol. 54, (1955), pp. 5–12.

35. Harold Cohen, Talk at the Institute of Design Reunion, Chicago, Aug. 1, 1987.

36. Preface to the "ID Papers," Manuscript Collection, University of Illinois at Chicago Circle, Library.

37. Special Meeting of the Board of Directors, Institute of Design, November 22, 1949, ID Papers, Manuscript Collection, University of Illinois at Chicago Circle, Library.

38. *Ibid.*

39. Letter from Serge Chermayeff to Henry Heald, Archives of the Institute of Design, Bauhaus-Archiv, Berlin.

40. Letter from Walter Gropius to Henry Heald, Archives of the Institute of Design, Bauhaus-Archiv, Berlin.

41. John Walley, "Crisis in Leadership at the Institute of Design," Archives of the Institute of Design, Bauhaus-Archiv, Berlin.

42. John Chancellor, "The Rocky Road from the Bauhaus," *Chicago* (July 1955).

43. Jay Doblin, "Chicago Bauhaus: Past, Present and Future," Unpublished lecture, May 11, 1974.

44. Herbert Read in L. Hirschfeld-Mack, *The Bauhaus: An International Survey* (Croydon, Australia Longmans, 1963), p. 53.

45. George Rickey in Jane Allen and Derek Guthrie, "Institute of Design," *Chicago Tribune*, Jan. 16, 1972.

46. Jesse Reichek, Interview with Peter Selz, Petaluma, CA, May 1, 1994.

47. Gyorgy Kepes, *Language of Vision* (Chicago, Paul Theobald, 1944) p. 129.

48. Peter Blake, *Form Follows Fiasco* (Boston, Little Brown & Co., 1974), p. 167.

CHAPTER 14. NEW IMAGES OF MAN

1. Albert Camus, *The Rebel* (New York, Alfred A. Knopf, 1945) p. 46.

2. Guillaume Apollinaire, *The Cubist Painters* (New York, Wittenborn, Schultz, 1949), pp. 22–23.

3. George Heard Hamilton, *Object and Image in Modern Art and Poetry* (New Haven, Yale University Press, 1954), p. 5.

4. Francis Bacon [from a tribute to Matthew Smith, published in Smith retrospective exhibition catalogue, Tate Gallery, 1953], reprinted in *The New Decade* (New York, Museum of Modern Art, 1955), pp. 60–61.

CHAPTER 15. DIRECTIONS IN KINETIC SCULPTURE

1. Richard Buckminster Fuller, quoted by Calvin Tomkins in "In the Outlaw Area [Profiles]," *New Yorker*, Jan. 8, 1966, p. 36.

2. Medardo Rosso, quoted in Carola-Giedion Welcker, *Contemporary Sculpture*, New York, 1955, p. 14.

3. Umberto Boccioni, *Technical Manifesto of Futurist Sculpture*, April 1912; quoted by Joshua C. Taylor, in *Futurism*, New York, 1961, pp. 130–31.

4. *Futurist Painting, Technical Manifesto*, April 1910; quoted by J. C. Taylor, *op. cit.*, p. 127.

5. *Ibid.*, p. 125.

6. Naum Gabo and Antoine Pevsner, *Realist Manifesto*, Moscow, 1920.

7. László Moholy-Nagy and A. Kémeny, "*Dynamisch-konstruktives Kraftsystem*," *Der Sturm*, No. 12, 1922, p. 186.

8. Paul Klee, *Pedagogical Sketchbook*, translated by Sibyl Moholy-Nagy, New York, Frederick A. Praeger, 1953, p. 16.

9. Paul Klee, quoted by Will Grohmann, in *Drawings of Paul Klee*, New York, Valentin, 1944.

10. L. Moholy-Nagy, *Vision in Motion*, Chicago, Paul Theobald, 1947.

11. Peter Selz, *Alberto Giacometti*, New York, The Museum of Modern Art, 1965, p. 10.

12. P. Selz, "Arte Programmata," *Arts Magazine*, **39**:6 (March, 1965), p. 20.

13. George Rickey, "Calder in London," *Arts Magazine*, **36**:10 (Sept. 1962), p. 27.

14. Bruno Munari, "Programmed Art," *The Times Literary Supplement*, Sept. 3, 1964.

15. *Ibid.*

16. P. Selz, "Arte Programmata," *Arts Magazine*, **39**:6 (March, 1965), p. 21.

17. Jean Tinguely, quoted by Dorothy Gees Seckler, in "The Audience in His Medium," *Art in America*, **51**:2, (April, 1963).

18. Harold Rosenberg, "Hans Hofmann: Nature in Action," *Art News*, **56**:3, (May, 1957), pp. 34–36 and 55–56.

19. Jean Paul Sartre, "Introduction" [to the show catalogue], Paris, Gal. Louis Carré, 1946.
20. Paul Keeler, "Colossus in Space," *Signals*, **1**:3–4 (Oct. – Nov., 1964). p. 3.

CHAPTER 16. MAX BECKMANN IN AMERICA

This essay is dedicated to the memory of J. B. Neumann, who introduced Beckmann's work in America, and who was also a good friend and mentor to me.

Some of the research for this essay was done in the comprehensive research library of the Robert Gore Rifkind Foundation in Los Angeles. I want to extend my thanks to Robert Rifkind and his staff for graciously permitting me to use this important resource. P.S.

1. J. B. Neumann, "Sorrow and Champagne," in *Confessions of an Art Dealer*, p. 43 (typescript of unpublished manuscript in possession of Dr. Peter Neumann, Palo Alto, California, who graciously permitted me use of the manuscript).
2. Henry McBride in *Creative Art, v* (1920), p. 15.
3. Quoted in Alfred H. Barr, "Die Wirkung der deutschen Ausstellung in New York," *Museum der Gegenwart*, II (1931–32), pp. 58–75.
4. Lloyd Goodrich, "Exhibitions: German Painting in the Museum of Modern Art in New York," *The Arts* XVII (1931) April 31, p. 504.
5. James Johnson Sweeney, quoted in Alfred H. Barr, *op. cit.*, p. 71.
6. Georg Swarzenski, Introduction to *Beckmann*, Buchholz Gallery Curt Valentin, New York, 1946.
7. Frederick Zimmerman, *Beckmann in American* (address delivered before the Max Beckmann Gesellschaft in Murnau, July 1962), New York, 1967, p. 6.
8. "German Seeker," *Time*, XLVII, May 6, 1946, p. 64.
9. Beckmann, entry of September 17, 1946 in *Tagebücher*, p. 177.
10. Beckmann, "Ansprache für die Freunde und die philosophische Fakultät der Washington University, 1950," trans. Jane Sabersky, in *Max Beckmann*, Curt Valentin Gallery, New York, 1954.
11. *Ibid.*
12. Beckmann, entry for August 23, 1947 in *Tagebücher*, p. 214.
13. In 1946 the St. Louis City Art Museum had purchased his *Young Men by the Sea* from Curt Valentin's 1946 exhibition. The Washington University Gallery of Art acquired *Les Artistes with Vegetables* from the same show.
14. Beckmann, "Gedanken über zeitgemässe und unzeitgemässe Kunst," in *Pan* (1912), pp. 499–502. Translated in Peter Selz, *German Expressionist Painting*, Berkeley and Los Angeles, 1947, p. 240.
15. Dorothy Seckler, "Can Painting be Taught?" *Art News*, L:I(1951), p. 30.
16. Dore Ashton, *Yes, but*, New York, 1976, p. 64.
17. *Ibid.*, p. 73.
18. Philip Guston, "Faith, Hope and Impossibility" (lecture given at the New York Studio School, New York, May 1965), in *Art News Annual*, 1966, pp. 101–103, 152–53. It is interesting that among the leading American painters it was only Philip Guston who, going beyond abstraction, formulated paintings which are great visual allegories of the anxiety of modern life by turning into his own inner self toward the end of his life. Like Beckmann before him, Guston said in 1978: "The visible world, I think, is abstract enough. I don't think one needs to depart from it in order to make art." (Guston, Lecture given at the University of Minnesota in 1978, printed in *Philip Guston*, Whitechapel Gallery, London, 1982.)
19. H. W. Janson, "Stephen Greene," *Magazine of Art*, XLI (April 1948), p. 131.
20. Stephen Greene, letter to the author, November 14, 1982.
21. Nathan Oliveira, letter to the author, November 2, 1982.
22. Beckmann, "Letters to a Woman Painter," translated by Mathilde Q. Beckmann and Perry T. Rathbone, quoted in Peter Selz, *Max Beckmann*, New York, Museum of Modern Art, 1964, p. 133.

23. W. R. Valentiner, "Max Beckmann," in *Blick auf Beckmann: Dokumente und Vorträge*, edited by Hans Martin von Erffa and Erhard Göpel, Munich, 1962, p. 85.

24. Mathilde Q. Beckmann in an interview with the author, New York, April, 1964.

25. Beckmann, "On My Painting" (lecture originally delivered as "Meine Theorie in der Malerei") given at the New Burlington Gallery, London, July 21, 1938. English translation in Herschel B. Chipp, Peter Selz, and Joshua C. Taylor, *Theories of Modern Art*, University of California Press, Berkeley and Los Angeles, 1968, p. 188.

26. Beckmann, for example, always resented being called an Expressionist. In his Washington University lecture he said, "I personally think it is high time to end all isms."

27. Beckmann, "On My Painting," in Chipp et al., *loc. cit.*

28. Erhard and Barbara Göpel, *Max Beckmann, Katalog der Gemälde*, Bern, 1976, vol II, pp. 107–108.

29. Beckmann, "On My Painting," in Chipp et al., *loc. cit.*

30. Beckmann, entry for July 7, 1949, in *Tagebücher*, p. 339.

31. Beckmann's own interpretation as transmitted by his wife to the author.

32. Beckmann, entry for October 28, 1945, in *Tagebücher*, p. 140.

33. Beckmann, "Letters to a Woman Painter," in Selz, *Max Beckmann*, p. 132.

34. Margot Orthwein Clark, *Max Beckmann: Sources of Imagery in the Hermetic Tradition*, unpublished Ph.D. dissertation, Washington University, St. Louis, 1975, p. 333.

35. Göpel, *op. cit.*, vol. II, p. 497.

36. Friedhelm W. Fischer, *Max Beckmann*, London, 1972, p. 86.

37. Peter Beckmann (ed.), *Max Beckmann Sichtbares und Unsichtbares*, Stuttgart, 1965, p. 110.

38. Fischer, *op. cit.*, p. 85.

39. Selz, "Einführung," in Peter Beckmann, *op. cit.*, p. 5.

40. Selz in *Max Beckmann*, p. 97.

41. On June 19, 1950, writing in Carmel, he says that he finally learned the name of these exotic birds: "Corcorane." He was probably referring to the Cormorant, a large black aquatic bird found on the Pacific coast.

42. Fred Neumeyer, "Erinnerungen an Max Beckmann," *Der Monat*, IV (1952), pp. 70–71 and "Prometheus im weissen Smoking," *Der Monat*, VII (1955), pp. 71–73.

43. Beckmann, "On My Painting," in Chipp et al., *op. cit.*, p. 187.

44. Beckmann, unpublished letter to Curt Valentin, February 11, 1958, cited in Selz, *Max Beckmann*, p. 61.

45. Mathilde Q. Beckmann, in *Beckmann*, Catherine Viviano Gallery, New York, 1964.

46. This was pointed out to me by Robert Rifkind, who has both Beckmann's *Battle of the Amazons* and *Ballet Rehearsal* in his collection.

47. Göpel, *op. cit.*, I, p. 508.

48. *Ibid.*

49. Charles S. Kessler, *Max Beckmann's Triptychs*, Cambridge, Massachusetts, 1970, pp. 94–95.

50. Beckmann, entry for September 5, 1949, in *Tagebücher*, p. 348.

51. Beckmann, Letter to Peter Beckmann, December 17, 1950. Published in *In Memoriam Max Beckmann*, Frankfurt am Main, 1953.

CHAPTER 17. SAM FRANCIS: BLUE BALLS

1. Jean Fournier, "Waterloo ou Austerlitz," in *L'Ecrit-voir*, no. 5 (1984–85), p. 93.

2. James Johnson Sweeney, "Sam Francis," in *Sam Francis* (Houston, 1967), p. 21.

3. Sam Francis, conversation with Yves Michaud, May 15, 1988, in *Conversations with Sam Francis* (Galerie Jean Fournier, Paris, 1988), p. 48.

4. Bernard Schultze, letter to Anneliese Hoyer, in *Sam Francis* (San Francisco Museum of Art, San Francisco, 1967), n.p.

5. Barnett Newman, in Thomas Hess, *Barnett Newman* (New York, 1971), p. 35.

6. Sam Francis, conversation with Yves Michaud, *op. cit.*, p. 56.

7. Wasily Kandinsky, *Concerning the Spiritual in Art* (New York, 1947), Chap. VI.
8. Carl Gustav Jung in Joseph Campbell, ed., *The Portable Jung* (New York, 1971), p. 448.
9. Robert T. Buck, "The Paintings of Sam Francis," in *Sam Francis* (Buffalo, NY, 1972), p. 22.
10. Makoto Ooka, in *The World of Sam Francis, A Panel Discussion with Makoto Ooka, Yoshiaki Tono and Mamory Yoneburo* (Tokyo, 1987), p. 34.
11. Dr. S. Barandum, letter to the author, Bern, Nov. 16, 1990.
12. Sam Francis, conversation with Yves Michaud, July 1, 1985, in *Entretiens: Sam Francis – Yves Michaud* (Paris, 1983), p. 34.
13. Sam Francis, quoted in Betty Freeman, Sam Francis, "Ideas and Paintings" (unpublished manuscript).
14. Sam Francis, *Book of Aphorisms* (Venice, CA), n.d., n.p.
15. Maurice Merleau-Ponty, "Eye and Mind," in *The Primacy of Perception* (Evanston, IL, 1964), p. 180.

CHAPTER 18. AGNES DENES: THE ARTIST AS UNIVERSALIST

1. Unless otherwise indicated, the quotations are either from Agnes Denes's writings or from interviews I conducted with the artist in New York in 1989 or in Berkeley in 1990.
2. Agnes Denes, *Book of Dust: The Beginning and the End of Time and Thereafter* (Rochester, New York: Visual Studies Workshop Press, 1989).
3. Clement Greenberg, "Modernist Painting," *Art and Literature*, No. 4 (Spring 1965), p. 194.
4. Agnes Denes, "Dialectic Triangulation: A Visual Philosophy," in *Agnes Denes – Perspectives*, (Washington, D.C.: Corcoran Gallery of Art, 1974–75), n.p.
5. Agnes Denes, *Strength Analysis – A Dictionary of Strength* (New York: Franklin Furnace, 1970).
6. *Ibid.*
7. Agnes Denes, "The Human Argument," from *The Organic Notebooks*, 1971.
8. *Ibid.*
9. *Agnes Denes,* "4000 Years – If the Mind . . . ," in *Agnes Denes: Sculptures of the Mind* (Akron, Ohio: Emily H. Davis Art Gallery, University of Akron Press, 1976), p. 19.
10. Jeannette Murray, "The Scientific Tradition in Art," *Yearbook of Science and the Future* (Chicago: Encyclopedia Britannica, 1989), p. 29.
11. Agnes Denes, *"Study of Distortions,"* from *The Organic Notebooks*, 1971.
12. Agnes Denes, *Book of Dust*, p. 108.
13. Lynn Gumbert and Allan Schwartzman, *Investigations: Probe Structure Analysis* (New York: The New Museum, 1980), p. 9.
14. Paul Klee, *On Modern Art* (London: Faber and Faber, 1948), p. 47.
15. Agnes Denes, "Thought Complex," *Paradox & Essence* (Rome: Tau/ma Press, 1976), p. 25.
16. *Ibid.*
17. Agnes Denes, "Morse Code Message," from *The Organic Notebooks*, 1971.
18. Denes assured the privacy of all participants by deleting their names from the individual pieces. The artists were listed as a group in the exhibition, and the psychologists were identified only by their license numbers.
19. Agnes Denes, *Syzygy*, 1973.
20. Paul Klee, *Notebooks, Vol. II*, ed. by Jurg Spiller, tr. by Heinz Norden (New York: Wittenborn, 1973), p. 352.
21. Agnes Denes, *Isometric Systems in Isotropic Space: Map Projections* (Rochester, New York: Visual Studies Workshop Press, 1979), 3. Several of her *Map Projections* were featured in the exhaustive exhibition and catalog *Cartes et Figures de la Terre* at the

Centre Pompidou, Paris, 1980. Her *Snail* (helical toroid) appeared on the cover of the massive catalog as well as on posters of the exhibition at Paris kiosks in the summer of 1980.

22. Carlo Pedretti, *Leonardo da Vinci Nature Studies from the Royal Library at Windsor Castle* (Malibu, California: J. Paul Getty Museum, 1981), p. 49.
23. Agnes Denes, *Book of Dust*, p. 114.
24. *Ibid.*, p. 118.
25. *Ibid.*, p. 118.
26. *Ibid.*, p. 118.
27. Paul Tillich, *The Religious Situation* (trans. Richard Niebuhr), (New York: Meridian Books), p. 85.

CHAPTER 20. NOTES ON FUNK

1. David Gilhooly prefers to spell it Funck, while William Wiley seems to alternate funk with Phunk.
2. Harold Paris, "Sweet Land of Funk," *Art in America*, March – April 1967, p. 97.

CHAPTER 21. LLYN FOULKES' WORKS OF THE 1960S: IMAGES OF DISRUPTION AND ILLUSION

1. William G. Seitz, *The Art of Assemblage* (New York: Museum of Modern Art, 1961), p. 74.
2. Llyn Foulkes, letter to the author, July 11, 1987.
3. Peter Selz, *New Images of Man* (New York: Museum of Modern Art, 1959), p. 11.
4. Doug McClellan, "Llyn Foulkes: Paintings and Constructions. Pasadena Art Museum," *Artforum* 1:6 (November 1962), p. 46.
5. The suggestion of the cow pictures may also have come from Ivan Karp. See Andy Warhol and XX Hacket, *POPism: The Warhol Sixties* (New York: Harcourt, Brace, Jovanovich, 1980), pp. 17–18.
6. Sidra Stich, *Made in U.S.A.* (Berkeley: University Art Museum, 1987), pp. 171–72. Stich notes that she received this information from Betty Factor, the present co-owner of the painting.
7. Quoted in Jean-Clarence Lambert, *CoBrA* (Paris, 1983), p. 70.
8. Foulkes, interview with Sany Ballatore, in *Llyn Foulkes* (Newport Beach, Calif.: Newport Harbor Art Museum, 1974), n.p.
9. Ludwig Wittgenstein, *Philosophical Investigations* (Oxford, 1968), Proposition 129.

CHAPTER 22. HAROLD PERSICO PARIS

1. Belle Krasne, "Ten Artists on the Margin," *Design Quarterly 30* (Spring 1954), p. 22.
2. Harold Paris, tape-recorded conversation with Lawrence Dinnean, in Dinnean, "The Ceramic Walls," in Peter Selz, ed., *Harold Paris: The California Years* (Berkeley: University Art Museum, 1972), p. 13.
3. John Coplands, "Reviews: San Francisco," Artforum I:1 (June 1962), p. 36.
4. Harold Paris, letter to Paul Moczany, in *The Artist's Reality*, exhib. cat. (New York: New School Art Center, 1964), n.p.
5. Ever since Kurt Schwitters made his series of Merzbaus in Germany, Norway and England (1920–45) artists had thought of creating room-size environments. In 1942 Marcel Duchamp made a tangled web of string for the installation of the Surrealist show at the Art of This Century Gallery in New York. In 1951 Frederick Kiesler, the original designer of that gallery, exhibited his Galaxies – interconnected spiked forms of wood, which beckoned to be entered – at the Museum of Modern Art. A year later Mathias Goeritz almost filled the outdoor space in the forecourt of a night

club in Mexico City with his La Serpiente del Eco. The Independent Group in England organized environmental installations in 1956 ("This is Tomorrow," and in 1957 "An Exhibit"). In 1961 Herbert Ferber placed one of his welded sculptures into a room at the Whitney Museum, a work called Sculpture as Environment, but there was still no interrelationship between the biomorphic sculpture and the surrounding space. In the same year Edward Kienholz, working in Los Angeles, completed his first environment, Roxy's. However, this large assemblage of an imaginary whorehouse was a tableau that could not be entered, nor could Claes Oldenburg's Bedroom Ensemble of 1963. Arguably Harold Paris's Room I, 1964–65, was the first essentially abstract environmental sculpture – an important event in the continuum.

Soon rooms created as environments by sculptors became a widespread artform. Most important was Lucas Samaras's Mirrored Room of 1966. Jean Lipman in a presentation in Art in America (Nov. – Dec. 1970) suggested that the Metropolitan Museum acquire the contemporary rooms by Oldenburg, Paris, Samaras and Kienholz as well as a circular room by Louise Nevelson of 1970, an inflated environment by Will Bogart and an Infinity Chamber by Stanley Landsman. Yayol Kusama had built an Endless Love Room with mirrors in New York in 1965. In Europe sculptured environments were built by Gino Marotta and by Pini Pacali in Rome in the mid-sixties. In 1966 Niki de Saint Phalle, working with Jean Tinguely constructed Hon, an edifice in the shape of a woman through which 100,000 visitors walked at the Moderna Museet in Stockholm.

6. Dore Ashton, *Modern American Sculpture* (New York, Harry Abrams, 1968), p. 50.
7. Kurt von Meier, "Los Angeles Letter," *Art International X:3* (1966), p. 53.
8. Herschel B. Chipp, "The Souls," in Selz, ed., *Harold Paris: The California Years*, p. 51.
9. Robert Hughes, "Souls in Aspic," *Time* magazine (May 22, 1972), p. 66.
10. Alfred Frankenstein, "A Grand-Scale Departure," *San Francisco Chronicle*, October 21, 1976, p. 44.
11. Harold Paris had his first heart attack in 1965. His heart condition became increasingly serious as time went on. In July 1979 the fourth heart attack was the cause of death.
12. Harold Paris, statement in *Harold Paris*, exhib. cat. (Palo Alto: Smith-Andersen Gallery, 1975), n.p.
13. John Fitzgibbon, "17 Steps," in *Harold Paris*, exhib. cat. (San Francisco: Stephen Wirtz Gallery, 1979), p. 5.
14. This quote by the artist and much of the material on which research for this essay is based were derived from the Harold Paris Papers in the Archives of American Art. I thank the Archives and Paul Karlstrom, West Coast Regional Director, for making these papers available to me.

CHAPTER 23. RUPERT GARCIA: THE ARTIST AS ADVOCATE

1. Hilton Kramer, "Turning Back the Clock: Art and Politics in 1984," *The New Criterion*, April 1984, p. 68.
2. Pablo Picasso, Written Statement, March 23, 1945, quoted in Alfred H. Barr, *Picasso: Fifty Years of His Art*, New York, 1946, p. 248.
3. George Grosz, "Statt einer Biographie," *Der. 1*, vol. 2, no. 3, 1920–21, p. 50.

CHAPTER 25. BEDRI BAYKAM: AMERICAN XENOPHOBIA AND EXPRESSIONIST DRAMAS

1. Jan van der Marck, "Report from Pittsburgh: The Triennial Revived," *Art in America*, May 1986, p. 51.

INDEX

325

331